CW00677761

Fashion Stylists

Fashion Stylists

History, Meaning and Practice

Edited by Ane Lynge-Jorlén

BLOOMSBURY VISUAL ARTS

LONDON • NEW YORK • OXFORD • NEW DELHI • SYDNEY

BLOOMSBURY VISUAL ARTS
Bloomsbury Publishing Plc
50 Bedford Square, London, WC1B 3DP, UK
1385 Broadway, New York, NY 10018, USA
29 Earlsfort Terrace, Dublin 2, Ireland

BLOOMSBURY, BLOOMSBURY VISUAL ARTS and the Diana logo are trademarks
of Bloomsbury Publishing Plc

First published in Great Britain 2020
Paperback edition first published 2022

Selection, editorial matter, Introduction and Chapter 3 © Ane Lynge-Jorlén, 2020

Individual chapters © Their Authors, 2020

Ane Lynge-Jorlén has asserted her right under the Copyright, Designs
and Patents Act, 1988, to be identified as Editor of this work.

For legal purposes the Acknowledgements on p. xviii constitute
an extension of this copyright page.

Cover design by Adriana Brioso
Cover image: *Purple Fashion*, 'Anna Cleveland', 25 Year Anniversary Issue, F/W 2017.
Photography: Viviane Sassen. Styling: Roxane Danset.
Courtesy of Viviane Sassen and *Purple Fashion*.

All rights reserved. No part of this publication may be reproduced or transmitted in any
form or by any means, electronic or mechanical, including photocopying, recording,
or any information storage or retrieval system, without prior permission in
writing from the publishers.

Bloomsbury Publishing Plc does not have any control over, or responsibility for, any
third-party websites referred to or in this book. All internet addresses given in
this book were correct at the time of going to press. The author and
publisher regret any inconvenience caused if addresses have
changed or sites have ceased to exist, but can accept no
responsibility for any such changes.

A catalogue record for this book is available from the British Library.

ISBN: HB: 978-1-3501-1505-7
 PB: 978-1-3502-4293-7
 ePDF: 978-1-3501-1506-4
 eBook: 978-1-3501-1507-1

Typeset by RefineCatch Ltd, Bungay, Suffolk

To find out more about our authors and books visit www.bloomsbury.com
and sign up for our newsletters.

Danish Arts
Foundation

To Irma

Contents

Figures

Plates

Lotta Volkova

1 Balenciaga, S/S 2017. Photography: Harley Weir. Styling: Lotta Volkova. Courtesy of Harley Weir.

2 *Vogue Italia*, 'Chikinskaya', September 2018. Photography: Johnny Dufort. Styling: Lotta Volkova. Hair: David Harborow. Makeup: Nami Yoshida. Model: Gunce Gozutok. Clothing: Padded jacket of crumbled nylon with appliques, shirt with lace details, skirt in embroidered tulle, headgear with crystals: all GUCCI; earrings and necklace of gold metal: DOLCE & GABBANA; collier of Swarovski crystal: ATELIER SWAROVSKI BY ATELIER SWAROVSKI; jewel bag: vintage Bagteria PASSAGE ARCHIVES; tights: ANNA SUI. Courtesy of Johnny Dufort.

3 *System Magazine*, 'Italian Fashion Is Torn between Nostalgia and Progress', F/W 2018. Photography: Johnny Dufort. Styling: Lotta Volkova. Hair: Gary Gill. Makeup: Thomas de Kluyver. Model: Litay Marcus. Jumpsuit by Schiaparelli haute couture. Courtesy of Johnny Dufort.

4 *Re-Edition*, 'The Sovietsky Hotel', S/S 2015. Photography: Harley Weir. Styling: Lotta Volkova. Courtesy of Harley Weir.

5 *Re-Edition*, 'Jeju Island', F/W 2018. Photography: Harley Weir. Styling: Lotta Volkova. Courtesy of Harley Weir.

6 Prada Special, S/S 2019. Photography: Johnny Dufort. Styling: Lotta Volkova. Hair: Gary Gill. Makeup: Nami Yoshida. Set design: Polly Philp. Models: Lexi Boling, Litay Marcus & the kent nudists. Clothing by Prada. Courtesy of Johnny Dufort.

Benjamin Kirchhoff

7 *In Present Tense*, 'Mes Douces', issue 1, 2018. Photography: Andy Bradin. Art direction and styling: Benjamin Kirchhoff. Courtesy of Andy Bradin.

8 *Dust*, 'Georgia', issue 12, 2018. Photography: Alessio Boni. Art direction and styling: Benjamin Kirchhoff. Courtesy of Alessio Boni.

Anders Sølvsten Thomsen

Roxane Danset

Elizabeth Fraser-Bell

Vanessa Reid

Akeem Smith

Naomi Itkes

Notes on Contributors

Alice Beard is an independent scholar. Her research is focused on fashion media and the intersections between design, text and photography. Beard has curated exhibitions on beauty queens (2004) and *Nova* magazine (2006). Her publications include articles on fashion photography and curation for *Fashion Theory* journal, and chapters in *Fashion Media: Past & Present* (2012), and *Hair Styling, Culture and Fashion* (2008). She was awarded a PhD for her history of *Nova* magazine from Goldsmiths in 2014.

Maria Ben Saad is a Stockholm-based fashion writer, editor and curator. She was fashion editor of the niche fashion magazine *Bibel* and curator of *Swedish Fashion: Exploring a New Identity*. She is Senior Lecturer in fashion-related theoretical subjects at Beckmans College of Design in Stockholm and is Head of Department for Artistic and Contextual studies. Her main research interests are within the areas of fashion communication, contemporary fashion and critical fashion practice with an emphasis on gender expressions.

Philip Clarke is the course leader of Fashion Communication at Central Saint Martins, University of London, UK. He originally studied Textile Design at Winchester School of Art, University of Southampton, UK, and worked for more than ten years as a stylist and writer. His doctoral research explores the emergence of the stylist as a distinct freelance role in UK publishing in the 1980s, combining etymology and editorial research with oral history accounts of those living and working in London at the time.

Shaun Cole is Associate Professor in Fashion and Co-Director of the 'intersectionalities: politics – identities – cultures' research group at Winchester School of Art, University of Southampton, UK. His interests are in menswear and gay style, and publications include '*Don We Now Our Gay Apparel': Gay Men's Dress in the Twentieth Century* (2000), *Dialogue: Relationships in Graphic Design* (2005), *The Story of Men's Underwear* (2010) and *Fashion Media: Past and Present* (2013).

Francesca Granata is Assistant Professor in the School of Art and Design History and Theory at Parsons School of Design, New York, USA. Her research

centres on modern and contemporary visual and material culture, with a focus on fashion, gender and performance studies. She is the author of *Experimental Fashion: Performance Art, Carnival and the Grotesque Body* (2017) and the editor and founder of the non-profit print journal *Fashion Projects*.

Rachel Lifter writes about fashion, music and popular culture. She is the author of *Fashioning Indie: Popular Fashion, Music and Gender* (Bloomsbury 2019). Her writing also appears in *Fashion Cultures Revisited* (2013) and *Fashioning Professionals* (Bloomsbury 2018). She teaches at Parsons School of Design and Pratt Institute in New York City, USA. Rachel is also a critical consultant to the fashion industry. As Debbie's Little Sister, she offers cultural forecasting and facilitates implementation of insights into brands' DNA.

Ane Lynge-Jorlén is an independent scholar. Her research focuses on contemporary, niche fashion practices. Ane has held research and teaching positions in fashion studies at Lund University, Sweden, DIS Copenhagen, Denmark, and London College of Fashion, UK, and her research has been published in *Fashion Theory* and *Fashion Practice*. She is the author of *Niche Fashion Magazine: Changing the Shape of Fashion* (2017) and the director of the Nordic fashion graduate support platform, Designers' Nest.

Susanne Madsen is a widely published fashion writer. She is Writer-at-Large at *Dazed* and has contributed to titles such as *Another Man, Re-Edition* and the *Wall Street Journal Europe*. Susanne has a BA in Comparative Literature and Modern Culture from the University of Copenhagen, Denmark, and a BA (Hons) in Fashion Journalism from the University of the Arts, London, UK. Her book contributions include *London Uprising: Fifty Fashion Designers, One City* (2017) and *Utopian Bodies: Fashion Looks Forward* (2015).

Marie Riegels Melchior is Associate Professor in European Ethnology at the University of Copenhagen, Denmark. In her research and teaching she focuses on the cultural history of fashion, twentieth-century Danish fashion, museum studies and fashion in museums in particular. Her recent publications include a contribution on fashion curation to the edited book *Curatorial Challenges* (2019) and to the Danish encyclopaedia of fashion on the contemporary history of Danish fashion (2018).

Jeppe Ugelvig is a curator, historian and critic based in New York and London. His writing has appeared in publications such as *Frieze, ArtReview, Afterall, Flash Art International* and *Spike*. Jeppe completed his undergraduate degree

Communication, Curation, Criticism at Central Saint Martins, University of the Arts, London, UK, in 2016 and his MA degree at the Center for Curatorial Studies, Bard College, USA, in 2018. His book *Fashion Work, Fashion Workers* is forthcoming in 2020.

Paolo Volonté is Associate Professor of Sociology of Cultural Processes at the School of Design of Politecnico di Milano, Italy. He is co-editor of the *International Journal of Fashion Studies*. Recently he published articles about fashion in the *Journal of Consumer Culture, Fashion Practice, Fashion Theory, Poetics*, and the book *Vita da stilista* (2008). He is presently working on the segregation of fat bodies from the fashion system.

Philip Warkander is Assistant Professor and researcher at Lund University, Sweden and obtained his PhD in fashion studies at Stockholm University, Sweden, in 2013. Since then, he has worked as Assistant Professor in Gender Studies at Södertörn University, Sweden, guest lecturer in fashion design and visual communication at Beckmans College of Design, Sweden, and MA programme director at Istituto Marangoni Paris, France, and as Assistant Professor in fashion studies at Stockholm University.

Acknowledgements

This book is the result of the joint efforts and labour of several people who have been passionate about examining fashion stylists, their history and practice. From proposal to completion, it has been a joy to work with Bloomsbury Visual Arts. I owe a big thanks to Editorial Director Frances Arnold for her invaluable input and encouragement and Assistant Editor Yvonne Thouroude who guided me through the process with clarity and promptness.

I am grateful to the scholars and writers who have contributed to the volume and the stylists who have shared their reflections on their work, trusting us to put in writing what they usually express visually. Susanne Madsen – thank you for lending me your ears and your unwavering work with the stylist interviews. Thanks Anna G. Gantcheva at Print & Contact, Derek Medwed at Management +Artists, Lenny Harlin at Streeters, Philippe Bustarret at Bird Production and Sofie Geradin at Management +Artists for all your help in making the interviews possible.

Massive and very humble thanks to the many photographers and their agents who believed in the project and allowed us to reproduce their thought-provoking and delightful photos of styling. The list of featured photographers is long, and really quite impressive, and can be found in the lists of figures and plates at the beginning of this book.

I am grateful to Pernilla Rasmussen at the Division for Fashion Studies at Lund University who invited me on a visiting research fellowship that allowed me to embark on the book. Also thanks to my colleague Philip Warkander at Lund. The book was originally envisioned as part of an exhibition project, conceived jointly with Philip, but it grew as a book in its own right that provided a timely space for in-depth examination of stylists.

Helle Rytkønen at DIS Copenhagen and Tina Mangieri at DIS Stockholm made it possible for me to complete the book within the open-minded environment of DIS. Thank you!

Last, but certainly not least, huge thanks to The Danish Arts Foundation whose support has made the inclusion of colour images in the book possible.

Introduction

Ane Lynge-Jorlén

Since the 1980s, styling has moved from the shadows of fashion editing to the front stage of fashion where it is recognized as a profession in its own right. Its trajectory is linked to the changes taking place in the fashion press in the 1980s with an increased freelance workforce, new technologies and a focus on image-making. Today stylists perform a multitude of jobs – as creative consultants, personal stylists and image-makers for advertising, catwalk, magazines and red carpet, and beyond. In collaboration with the creative team – the photographer, model, hair and makeup artists and set designers, to name some – stylists create meaning of fashion.

Some stylists are worshipped as celebrities where their work is inextricably linked to their own bodies as a brand extension. At the other, more mundane end, the act of styling is more ordinary, as we on a daily basis *style* ourselves when we get dressed, selecting which combinations of garments and accessories to wear. Following Michel de Certeau, these everyday styling practices hold creative potential (de Certeau et al. 1988), but they are also acts of 'situated bodily practices' (Entwistle 2000a) that are managed according to the rules of the social world. Assembling our self-presentation articulates both the individual creative agency and the social context but also the influence of professionally styled images produced within the fashion system.

* * *

This book explores professional stylists as producers of fashionable looks across imagery. Their work is a balancing act of crafting looks that meet the needs of clients and fulfil their own creative agency, whilst at the same time being sensitive to the changes of fashion and its collaborative environment. What ends up in the picture is the result of the many choices a stylist makes that, in turn, are shaped by structural, cultural, symbolic and economic conditions, collaboration, shared

taste, fashion trends and individual style. But what is fashion styling in a professional sense, and how did it emerge? And what is the role of the stylist in the creation of the fashion photograph? Who propelled styling forward and, in doing so, changed the way images were made and looks put together? How have the conditions of styling changed in a digital era where professions are challenged, and everyone can claim to be a stylist? And how do contemporary stylists, working within commercial and editorial frameworks, produce work in relation to, and often against, norms of bodies, ethnicity, gender and identity, and creativity and commerce?

Fashion Stylists: History, Meaning and Practice is a collection of wide-ranging research chapters and interviews with contemporary stylists in one book. It bridges academia and the voices of some of the most influential stylists of contemporary fashion through examination of styling, its history, present incarnations, the frontstage and backstage in an Anglo-American–European context. The inclusion of several, extraordinary images not only allows styling to come alive visually, it also conveys the hybrid quality of this academic image-based book.

Polymath stylists

'They are like DJs, right? They are sampling.' My friend's immediate response, when I told her about stylists, has come back as a repeating motif in the process of editing this book. Sampling is an apt analogy to the work that stylists perform, as they take a piece from existing collections, items of clothes and accessories from an array of circuits and rework them, by adding other, sometimes even non-fashion, elements into a new harmony. By connecting items from disparate designers, sources and circuits, and sometimes making objects, and by adding a trademark *style*, styling is essentially a sampling exercise.

On a basic level, stylists are responsible for putting garments together for fashion imagery and beyond, and seeing the mood and style of image and look through. In one of the first academic accounts on stylists, Angela McRobbie (1998) identifies the stylist as one of the most significant developments for the representation of fashion design in the media:

> Located midway between the assistant to the fashion editor and photographer's assistant, styling became a recognised job as these various assistants (often with an art school training in fine art or photography) began to realise their own creative input into the fashion pages and the freelance potential of their work.

They planned and then put the whole image on the page together, including the combination of clothes (usually from a range of different designers), the look of the model, including hair and make up, the props needed for the narrative or non-narrative setting, the lighting, and the overall 'look' of the image or series of images.

McRobbie 1998: 157

The stylist emerged from the editorial field of the fashion press, from assistant ranks below the fashion editor, to gradually gaining more creative freedom as a freelancer working across magazines in the 1980s. Yet the role of stylists is more than simply interpret and translate fashion design, as an intermediary between the designer and the consumer or reader of magazines. Instead, they actively co-create the symbolic meaning and immaterial value in fashion imagery. Styling is an act, where something new is created by selecting, making or even designing items and putting them together in a new constellation. It can thus be said that styling is the act of providing style through conscious selection. While McRobbie acknowledges the encompassing nature of styling, its complexity has only increased since her work was published in 1998, pre-social media and a speeded-up fashion system. Stylists now perform the job of selecting clothes, assembling looks, making objects, casting models, coming up with ideas, themes and narratives for the shot, and much more, in a fashion system where increasing commercial pressures and growing numbers of collections, seasons and competitors and the rise of new roles shape their creative decisions. In commercial contexts, parameters are often given top-down by the brands controlling their image. Limitations certainly stimulate creativity, as a huge degree of styling, and creativity, is precisely problem-solving. There is at the same time, a turn to 'personal projects', predominantly in niche fashion magazines, which also articulate a resistance against the pressures of advertisers and 'full-look' styling. Here a vanguard of stylists pushes the boundaries of taste, fashion and art, confounding classification from within fashion magazines and expressing the 'curatorial mode' of styling (Balzer 2015: 111). Yet the commercial potential of styling is stretched to its limits in the world of social media that has exploded since Instagram was launched in 2010, where brands are now orchestrated into looks as part of influencer marketing.

As creative consultants, stylists assist in making creative choices in the building of a collection, such as stylist Marie Amalie-Sauvé with designer Nicolas Ghesquière, Katie Grand with Marc Jacobs, and Lotta Volkova for Demna Gvasalia at Balenciaga. Still how these collaborations exactly work and shape the actual design is kept behind the scenes. In an opinion piece, written in reaction

to Paris Fashion Week March 2015, fashion critic and writer Angelo Flaccavento bemoans the increasing influence of styling on the collections:

> The role of a stylist, similar to the editor of a written text, should be that of a 'cleaning lady.' A stylist is there to polish a vision and make it shine, to take away rather than add, to fine-tune rather than distort. But, if the cleaning lady suddenly turns into an interior decorator and, instead of tidying up the room, starts to refurbish it, well, that's a problem.
>
> Flaccavento 2015

According to Flaccavento, these 'over-stylised shows' are a result of the effect of marketing where the stylist gets increasing power over the collection with the aim of seducing the client with progressive image-making. Similarly, recent headlines such as 'Hollywood's Most Powerful Stylists Pose with their Star Clients' (McColgin 2019) and 'The Problem With "Full Look" Styling in Fashion Magazines' (Ahmed 2017) are testament to styling's ties to celebrity culture and the growing awareness of how commercial interests affect image-making.

Beyond the fashion press, a rising interest in stylists and their trajectories is witnessed by current books that span popular, academic and how-to books on styling. *Stylist: The Interpreters of Fashion* (Style.com et al. 2007) and Katie Baron's *Stylists: New Fashion Visionaries* (2012) are both popular, coffee table formats that offer a plethora of images and interviews with first-class stylists. There are also books about becoming a fashion stylist, such as Shannon Burns-Tran and Jenny B. Davies' *Stylewise: A Practical Guide to Becoming a Fashion Stylist* (2016) and Jo Dingemans' early handbook *Mastering Fashion Styling* (1999). Qualified analysis of the cultural meanings of stylists and their work is found in Angela McRobbie's book *British Fashion Design* (1998), where she provides critical analysis of the livelihood of stylists. In *Fashion Spreads*, Paul Jobling (1999) addresses the working relationship between stylists and photographers in the creation of image-making in fashion. While they are significant touchstone contributions, they do not focus on styling alone and were also published more than twenty years ago. Not only has the status of stylists changed with their increased influence on the actual fashion design, their working conditions are also affected by digitalization and intensified competition from peers and pressures from advertisers and press offices. Now academic work on styling and stylists is developing in tandem with the body of work on fashion professionals and creative labour in fashion. Rachel Lifter's 'Fashioning Pop: Stylists, Fashion Work and Popular Music Imagery' (2018), which offers new insights into the styling and image-making of female pop stars, is part of the

anthology *Fashioning Professionals* (Armstrong and McDowell 2018) that casts light on professions in the wider field of creative industries, such as artists, architects and design curators, and also includes work on the labour of fashion blogging (Rocamora 2018) and display mannequin designers (Rowe 2018). Elsewhere I have examined the aesthetic and economic practices of styling (Lynge-Jorlén 2016) and, as part of a wider analysis of niche fashion magazines, I have focused on the significance of styling in the production of fashion photography (Lynge-Jorlén 2017). The aesthetic and economic values of styling are shared with neighbouring fashion professions, such as photography (Aspers 2006; Shinkle 2008), modelling (Entwistle 2009; Entwistle and Wissinger 2012; Mears 2011; Wissinger 2015) and blogging (Pedroni 2015; Rocamora 2018). *Fashion Stylists: History, Meaning and Practice* offers in-depth analysis of stylists in their own right, as past and present image-makers, innovative and sensitive to the rules and instabilities of fashion.

Style and styling

Styling stems from 'style', and it is both a noun and a verb, with the '-ing' suffix indicating action. In his chapter in this volume, Philip Clarke argues that the version of 'style' commonly used in current English is anchored to '"*stilum vertere*", meaning to change the subject' (Clarke 2020, this volume). Subjects who are styled undergo a process of change; something is *done* to them that transforms their visual appearance. In the arts, style refers to the distinct way something is made (Dehs 2017). Style is also a central part of fashion studies, where it is used in tandem with, and often in opposition to, fashion, as stable, durable building blocks with specific, individual signature outside fashion's systemic change (see, for instance, Lifter 2014; Warkander 2013). Style is endowed with a certain hollowness whereas fashion is doomed to the realms of ephemerality and capitalism (Wilson 2010). First-wave theories on style developed in subcultural studies on post-war subcultural styles coming out of The Birmingham Centre for Contemporary Cultural Studies in the 1960s and 1970s saw style as part of ideological resistance and opposition to the hegemony (see, for instance, Hall and Jefferson 1976; Lifter 2012). A central strand within the early writings on style sees bricolage as an expression of stylistic resistance of punk, and beyond (Clarke [1975] 2003; Hebdige 1979; Warkander 2013). Coined by Lévi-Strauss in his book *The Savage Mind* (1966), bricolage, put simply, is the re-ordering and re-assemblage of existing things in a new context, which is also highly relevant

to an understanding of styling. Many have since critiqued style as ideological resistance for ignoring the ways in which style is diffused in and part of the wider consumer culture (Evans 1997; Lifter 2012; McRobbie 1994). In 1990s cultural studies, style was re-theorized and was seen as created *inside* consumer culture where 'the binary divisions of inside–outside and authentic–manufactured collapse' (Lifter 2014: 59), and there was an increasing focus on individual self-creation. Related to this more ordinary approach, Susan Kaiser (2001) argues style is 'a process or act of managing appearance in everyday life'. In her work on style in the African diaspora, Carol Tulloch (2010) defines style as agency, part of the construction of self through assembling, self-styling, clothes and accessories. The ways in which we put our 'look' together, our self-styling, is 'self-telling, that is to expound an aspect of autobiography through the clothes choices an individual makes' (Tulloch 2010: 5).

Fashion styling in this book refers specifically to the occupational rise of the stylist, which became more formalized in the 1980s, but styling existed as a term in the car industry as far back as the 1920s, and self-styling as an assembling dress practice has existed long before its terminology.

Creative *and* commercial

No word carries more consistently positive reference than 'creative'.

Williams 1965: 19

Throughout the field of fashion, both insiders and scholars make sense of fashion by categorizing its creative and commercial value (Aspers 2006; Entwistle 2002, 2009; Lynge-Jorlén 2016, 2017). Styling, like wider creative work, is both creative and commercial, and while the two are inextricably linked, hierarchies and different degrees of legitimization still exist between the two, as both the chapters and interviews in this volume show. Commercial styling often comes to represent low value, whereas creative jobs are endowed with prestige and high cultural value. In their work on identities in the creative industries, Leah Armstrong and Felice McDowell note that creativity from a socio-economic perspective 'forms an important dialectic with work and labour histories' (2018: 6). This centres, for instance, on The Frankfurt School's much cited work on the culture industry (Adorno and Horkheimer [1944] 1997) and the rise of the creative class (Florida 2002). Pierre Bourdieu's seminal text on the 'new cultural intermediary' (1984) is also widely used to make sense of the intermediary quality of the new jobs emerging in the creative industry in the post-war years. Essentially, a stylist

performs many jobs and the valuing of these jobs varies according to context, as Philip Warkander's chapter in this volume shows. David Hesmonhalgh and Sarah Baker aptly argue that while there are tensions and contradictions between creativity and commerce, it 'is not the same thing as adopting a romantic position where creativity and commerce should always be opposed to each other' (2011: 9). This argument is also found in research into cultural economy (Du Gay and Pryke 2002) and aesthetic economy (Entwistle 2002, 2009), which focuses on the hybridization of the two. There is a need to acknowledge 'how capitalism organises the functioning of creativity' (Hesmonhalgh and Baker 2011: 57) and that all markets are cultural and built upon shared values and meaning (Entwistle 2009: 11). While creative and commercial are not mutually exclusive within styling, the majority of the stylists analysed and interviewed for this volume seem to be concerned with creative agency, or rather what Hesmonhalgh and Baker coin 'aesthetic autonomy' (2011: 32) and 'creative autonomy' (2011: 40). The creative labour of styling is inherently collaborative – with photographer, model, hair and makeup artists, editor/client and so on – but the experience of creative autonomy, and in turn the stylist's sense of identity, seems to represent the holy grail, at least in the context of editorial styling, as the place where the creative juices flow more freely. This is an issue of workplace autonomy, which is 'the degree of self-determination that individual workers or groups have within a certain work situation' (Hesmonhalgh and Baker 2011: 40). It will be clear throughout this volume the ways in which stylists, both past and present, navigate in the creative labour of styling, creating both their professional identity and stylistic distinction.

Outline of the book

Since the book is placed within the scholarly field of fashion studies, which is characterized by a multi-methodological and interdisciplinary approach to fashion (Granata 2012), different methodologies and materials are employed throughout the chapters. They span archival research, sociological work into the socio-cultural production of value and meaning, and theoretical analysis of the styling of gender, identities and bodies, and seminal stylists. They include primary interviews, oral history, past and contemporary images, and different geographies and Anglo-American–European case studies. The book is divided into three parts that zoom in on diverse aspects of the history, meaning and practice of styling. Primary interviews are integrated into the book, interwoven

with the academic chapters, with stylists talking about their work, stylistic identity and trajectories. While diverse routes and cultural backgrounds shape their visual language and approach to styling, together they straddle high fashion and experimental fashion as they collaborate with some of the leading photographers of our time for publications including *Re-Edition*, *Dazed*, *POP* and *Purple*, and fashion houses such as Missoni, Balenciaga, Helmut Lang and Acne Studios. What unites them is the ways in which they produce new, inclusive images with regards to issues of gender, ethnicity, body norms, sexuality, taste and ideals of beauty. The degree of research and awareness that goes into the aesthetic labour of styling becomes clear throughout the interviews. Merging the academic chapters with interviews with actual practitioners provides a holistic prism through which to understand the work, key themes and articulations of styling.

Part 1: History and Profession of the Stylist within and beyond Magazines

The occupational history of the stylist is tightly linked to the development of the roles of those creating images for fashion magazines. Social change and class often act as drivers for new professions, which historically is linked to the rise of urbanism, industrialism, capitalism and new markets. Larson argues that 'the word "professional", the idea of something "professionally done", connote competence and dedication and perhaps a hint of immunity, for professionals should not be questioned by lay people [*sic*]' (2018: 36). Yet unlike a doctor or a lawyer, laypeople do not have to trust the expertise of the stylist. The stylist title is not legally protected nor does it require a university degree (although it can be studied at college), but it does involve specialized knowledge carried out in practice which can lead to positions of power within the field of fashion. Styling emerged in tandem with the changes in the production of magazines in the 1980s, which is tied to the formation of a new freelance economy and technological advancements. In the following decade, styling underwent professionalization and as a result became a distinguished, specialized and prestigious professional occupation, yet without the monopoly and regulation enjoyed by traditional professions. Styling's increased external validation through 'frontstage' activities can be viewed as a process that Larson refers to as the 'production of producers' where the service of professionals is made recognizable and branded as superior (2018: 29). Entrenched in the process of 'production of producers' is the stylists' own sense of professional self as an

'ongoing formation of identity and practice in the expression of self and individuality' (Armstrong and McDowell 2018: 11). Issues relating to the stylists' individual distinction, sense of self, style and their link to cultural and social contexts run throughout the stylist interviews and essays in the volume.

Co-existing with professional styling, which is carried out in work contexts, styling is also articulated in acts of dressing as an everyday practice in non-professional settings, which 'reveal an ongoing engagement with fashion on a scale from extraordinary through to the ordinary' (Buckley and Clark 2017: 7). As Buckley and Clark argue, compared to the extraordinariness of high fashion, ordinary fashion of the everyday often fails to stand out. Thus, one definition of style, proposed by Kaiser above, as an act of managing our appearance in the everyday (Kaiser 2001) is anchored to the creative potential of everyday life. Yet the creative agency of 'backstage' everyday styling of the self does not exist in a vacuum, but is shaped by the structure of, for instance, the catwalk, the magazine and the department store (see Chapter 2).

Part 1 covers both historical and contemporary aspects of styling, identifying formations and shifts and the different roles of styling. The chapters there discuss the history of the stylist and the different positions that styling can play in different contexts and modes, such as the everyday, as a profession, and the learning curve involved in becoming a professional stylist, and different experimental, conceptual and political strands of styling work. Chapter 1 establishes the context for understanding the etymology of the styling. Here Philip Clarke traces the early uses and definitions of styling and its linguistic ties to style. He goes on to examine the early legitimization and solidification of the role of styling as linked to the style press of 1980s London as the centre of the new occupation, and the ways in which styling work has been credited in magazines. Chapter 2 looks at the ways in which styling has been carried out before it became a profession. Using a Danish case study, Marie Riegels Melchior examines the practices of styling ensembles and looks at the act of dressing, renewing and combining clothes in the dress maker's atelier, fashion photography and shows and the ways in which these practices were translated into private spheres in the first half of the twentieth century. Styling here, understood as an extended act of dressing and grooming, articulates embodied bourgeois values of the time, but also an act of managing one's appearance and adhering to etiquette in everyday life. With the historical context established, Chapter 3 explores experimental styling within spreads from contemporary niche fashion magazines. Ane Lynge-Jorlén addresses the styling tropes 'the homeless' and 'the hunchback' as examples of a new material aesthetic in a fashion magazine

context through experimentation with shapes and materials, disrupting the norms of bodily containment. The spreads articulate a heightened level of the creative, shape-shifting qualities of styling, playfulness and critique of norms, as an extended role of styling at the edge of artistic practice. Following on from the academic essays, Danish-born Anders Sølvsten Thomsen is interviewed in Chapter 4. Sølvsten Thomsen studied towards a degree in styling at the London College of Fashion, but left before graduation to become Katie Grand's assistant, and he was soon after made fashion editor at *POP* and subsequently fashion director at *LOVE*. In interview with Susanne Madsen, Sølvsten Thomsen talks about his move from being affiliated with a magazine to working freelance with emerging designers, using layers and being drawn to weirdness. Unlike many other contemporary stylists, beauty is not a taboo for the British stylist Elizabeth Fraser-Bell. In interview with Susanne Madsen in Chapter 5, Fraser-Bell, former senior fashion editor at *Dazed*, speaks openly about making mistakes in her early days of assisting and the process of understanding who she is as a stylist. Appreciating the moment, Fraser-Bell is unafraid of grand gesture beauty and nature and allows her styling to be multi-layered and not being 'one thing'. Chapter 6 features Jamaican-American Akeem Smith who is a key stylist on New York's fashion underground scene working with brands such as Hood by Air and Section 8. Born into a dancehall family, where clothing was an integral part of the creative environment, Smith went to study costume design, but left to pursue a career in styling which led to work for Kim Kardashian, Helmut Lang and Yeezy. In interview with Jeppe Ugelvig, Smith discusses his research-oriented approach, ethnicity and the importance of historical awareness.

Part 2: Identity, Gender, Ethnicity and Style Narratives

Identity in fashion relating to, for instance, class, gender, ethnicity and sexuality, is complex and contradictory, and it plays out tensions between artifice and authenticity, between self-styled and natural (Entwistle 2000b: 113). Styling work in fashion magazines is not 'natural' inasmuch as it is concerned with image-making, yet it connects to central issues of professional identity of the stylists and representations of gender and ethnicity, to name some. These are subject positions, which are tied to hierarchies and positions of power. Susan Kaiser notes that these subject positions 'involve processes of self-labelling (i.e., agency, subjectivity) as well as subjection to labels and stereotypes supplied by others' (Kaiser 2012: 75). Gender and ethnicity are part of self-styling but cannot be separated from social structures, and thus involve navigating and

renegotiating 'between processes of belonging and differentiating' (ibid.), which also include the ways in which stylists produce styling and how they identify themselves. Throughout the literature on fashion, women's and men's magazines, issues of gender representations have been examined, especially questions relating to femininity (see, for instance, Ballaster et al. 1991; Ferguson 1983; Gough-Yates 2003; McCracken 1993; McRobbie 1978, 1996, 2000; Winship 1987) and masculinity (Crewe 2003; Edwards 1997; Jackson et al. 2001; Nixon 1993). Yet identity is negotiable and fluid, and fashion images can also propel non-binary awareness beyond hegemonic stereotypes. The more recent intersectional approach, stemming from feminist theory, views issues of gender, race and class as overlapping subject positions. Coined by Kimerberlé Crenshaw, intersectionality calls for integrated analysis of systems of oppressions that intersect with each other, and all relate to issues of identity (Berger and Guidroz 2009).

Throughout the book autobiographical details and retrospective 'life narratives' (Smith and Watson 2010) are included both through the stylists' own voices but also in the essays of this part of the book that zoom in on the work of key stylists as producers of new representations of gender, ethnicity and communities. Life narratives represent 'acts of self-presentation of all kinds and in diverse media that take the producer's life as their subject' (Smith and Watson 2010: 4). These life narratives write history, using collective remembering, memory as meaning-making and experience, and they help us understand the lived experiences and perspectives of the styling work both past and present. Carol Tulloch sees a layperson's styling as autobiographic 'style narratives' (2010: 4–5), which could also encompass professional styling which is telling of the many choices made by the stylist to create a specific look.

The chapters and interviews in Part 2 explore identities, gender, sexuality and ethnicity in the narratives of styling work and by the stylists in their own practice. Articulations of feminism and inclusiveness run through this part of the book with examples of empowering practices and representations of what Kaiser refers to as a 'soft assemblage' (2012: 124). In Chapter 7, Alice Beard examines the seminal work of Caroline Baker. The origin of the stylist, as we now understand it, can be traced back to the work she was undertaking for *Nova* in her role as Fashion Editor from 1967 to 1975. Going against the status quo of bourgeois representations of women, led by other magazines of the times, she used her own highly inventive ways of putting empowering looks together, using army surplus, second-hand and work-wear, customizing and subverting the norms of use and function of clothes. An ideological dress reform project informed Baker's feminist work as a

way to both challenge the fashion system and empower women to create their own unique looks. In Chapter 8, Shaun Cole explores the influential work of the late stylist Ray Petri as a central figure within the Buffalo Collective, styling new masculinities by mixing an array of cultural references drawn from Jamaican street culture, Native American, London Gay clubs, sports and the military. The casting of models was significant to Petri's styling of new masculinities, across ethnicities, gender and sexuality, and this, together with his juxtapositions of culture, is a touchstone in the creation of styling in British style press of the 1980s. Chapter 9 focuses on the pioneering music stylists June Ambrose and Misa Hylton's work as Afrofuturistic creative practice. Rachel Lifter examines Ambrose's 'Michelin Man' puffy suit for rapper Missy Elliott and Hylton's breast-exposing lilac jumpsuit for rapper Lil' Kim, and argues that Ambrose and Hylton, who were instrumental to re-imagining black lives and female visibility through hip-hop's images in the late 1990s, have not yet been written into histories of hip-hop. Chapter 10 features French stylist Benjamin Kirchhoff who began his career as one part of London cult label Meadham Kirchhoff. Leaving behind the label, Kirchhoff began to style for clients including Maison Margiela, *Arena Homme+* and *POP*, and is now fashion director of *Replica*. Producing identity ambiguity, his work often portrays marginalized figures and non-traditional models. In interview with Susanne Madsen, Kirchhoff talks about going against norms, subversion and how he prefers to escape definitions. In Chapter 11, Francesca Granata interviews the French stylist Roxane Danset who began her career in men's pattern cutting, and then started working at Maison Martin Margiela, when Martin Margiela was still at the company. Here Danset learned the process of being a stylist organically without knowing it was styling. She speaks about the influence from Margiela, her ongoing collaboration with photographer Viviane Sassen, the female gaze and alternative female beauty. The British-Spanish stylist Vanessa Reid made the move from cinema studies to assisting French *Vogue*'s Marie-Amélie Sauvé. Reid later branched out on her own and formed close working relationships with photographers Juergen Teller, Mark Borthwick and Harley Weir alongside brands, such as Missoni and Acne, and *POP magazine*. In Chapter 12, Reid talks with Susanne Madsen about using women that do not fit into sample size, female empowerment and 'building' sculptures.

Part 3: Global Fashion Media and Geographies of Styling Practices

It may seem, at least in an imaginary sense, that we live in what Marshall McLuhan back in the 1960s referred to as 'a global village' ([1964] 2007) – and

increasingly so since digital technology and Facebook (2004) and Instagram (2010). As a result of increased communication, the world has shrunk, leading to 'tensions between cultural homogenization and cultural heterogenization' (Appadurai 1996: 32). The effects of globalization are contradictory, and according to Susan Kaiser, this 'tendency toward both increased variety within geographic locations and a homogenizing effect across locations represents a global paradox' (1999: 110). Such paradoxical tensions are also articulated through cultural negotiations across styling practices, in for instance Milan (see Chapter 13) or Stockholm (Chapters 14 and 16), where the ways of doing are both embedded in the specific local culture as well as the wider global practice. Things and people may be lifted from local contexts into another, such as Russian Lotta Volkova who has styled campaigns and shows for the French fashion house Balenciaga (see Chapter 15). As a case of cultural hybridity, Volkova's Russian tastes are merged with a Parisian high-fashion house, creating new articulations of fashion and practices. Using a weaving metaphor, Appadurai argues there is a warp of stable communities shot through with the woof of global disjunctive flows (1996: 33–34). Practices are entangled in each other, and they both, through individual freelancers like Volkova or big companies such as high street brands Zara (Spain), Topshop (UK) or indeed Sweden's H&M, 'represent hybridization as they absorb and appropriate cultural and national differences' (Kaiser 2012: 60).

Part 3 focuses on the practice and different forms of capital within geographies of both local and global sections of the field of fashion in contemporary fashion styling work and experience. Styling in local settings is linked to global styling practices but it is also shaped by the cultural locality where issues tied to geographic positioning and roles are played out. Chapters 13 and 14 offer ethnographic fieldwork into contemporary stylists working within the different geographies of Milan and Stockholm. Both chapters convey how the specific cultural contexts of the cities are embedded into the styling carried out there and the ways in which stylists respond somewhat lamenting to the changes prompted by the digital environment and social media. In Chapter 13, Paolo Volonté argues that while Milan is part of the four fashion capitals, it holds an inferior status in terms of the status of the styling carried out by Milan-based stylists who compete with foreign favoured stylists for prestigious Milanese jobs. In addition, the pressures from new technologies and the competition of non-professional influencers are felt among Milan-based stylists. Chapter 14 looks specifically at commercial styling within Sweden's largest fashion brand, H&M. Philip Warkander has spoken with in-house and freelance stylists working primarily

with e-commerce styling in the big fashion corporation. The commercial nature of their work impacts greatly on how they see their role and identity, reflecting both the less creative nature of their work, and while H&M is widely recognized as a fast fashion epitome of globalization, offering new merchandize to consumers every few weeks, the specific, local Swedish cultural setting and political ideology shape the stylists' work–life relationship. In Chapter 15, Russian stylist Lotta Volkova speaks to Susanne Madsen about her taste and cultural references. After studies at Central Saint Martins in London, Volkova set up her label in 2004, but moved to Paris and became an integral member of Demna Gvasalia's Vetements and Balenciaga collectives along with her work with Gosha Rubchinskiy. Volkova's work transgresses conventional beliefs about East and West, internalizing Russian and Western culture with a postmodern hybridity whilst at the same time articulating a distance to the idea of 'bad taste'. In the closing Chapter 16, Swedish Naomi Itkes talks to Maria Ben Saad about her trajectory from working for Swedish *Bon Magazine* to later launching her own magazine *Litkes* that combined fashion and literature. Itkes works with local Swedish labels and French *Purple Fashion* magazine, as well as collaborating with the artist Robyn with whom she also collaborated on *RBN*, a limited capsule collection, for the legendary Swedish brand Björn Borg. Itkes discusses Swedish consensus culture, orderly chaos and working with Scandinavian photographers Anders Edström and Casper Sejersen.

References

Adorno, G. and M. Horkheimer ([1944] 1997), *Dialectic of Enlightenment*, New York: Verso Books.

Ahmed, O. (2017), 'The Problem with "Full Look" Styling in Fashion Magazines', in *The Business of Fashion*. https://www.businessoffashion.com/articles/intelligence/the-problem-with-full-look-styling-in-fashion-magazines [accessed 26 April 2019].

Armstrong, L. and F. McDowell, eds. (2018), *Fashioning Professionals: Identity and Representation at Work in the Creative Industries*, London: Bloomsbury.

Appadurai, A. (1996), *Modernity at Large: Cultural Dimensions of Globalization*, Minneapolis, MN: University of Minnesota Press.

Aspers, P. (2006), *Markets in Fashion: A Phenomenological Approach*, London: Routledge.

Ballaster, R., M. Beetham, E. Frazer and S. Hebron (1991), *Women's Worlds: Ideology, Femininity and the Woman's Magazine*, London: Macmillan.

Balzer, D. (2015), *Curationism: How Curating Took Over the Art World and Everything Else*, London: Pluto Press.

Baron, K. (2012), *Stylists: New Fashion Visionaries*, London: Laurence King.

Berger, M.T. and K. Guidroz (2009), 'A Conversation with the Founding Scholars of Intersectionality: Kimberlé Crenshaw, Nira Yuval-Davis, and Michelle Fine', in *The Intersectional Approach: Transforming the Academy through Race, Class, and Gender*, 61–79, Chapel Hill, NC: University of North Carolina Press.

Bourdieu, P. (1984), *Distinction: A Social Critique of the Judgment of Taste*, Cambridge, MA: Harvard University Press.

Buckley, C. and H. Clark (2017), *Fashion and Everyday Life*, London: Bloomsbury.

Burns-Tran, S. and J.B. Davies (2016), *Stylewise: A Practical Guide to Becoming a Fashion Stylist*, London: Bloomsbury.

Clarke, J. ([1975] 2003), 'Style', in S. Hall and T. Jefferson (eds.), *Resistance Through Rituals*, 175–191, New York: Routledge.

Crewe, B. (2003), *Representing Men: Cultural Production and Producers in the Men's Magazine Market*, Oxford: Berg.

de Certeau, M., L. Giard and P. Mayol (1988), *The Practice of Everyday Life*, vol. 2, Minneapolis, MN: University of Minnesota Press.

Dehs, J. (2017), 'Stil', in *Den Store Danske*, Copenhagen: Gyldendal. http://denstoredanske.dk/index.php?sideId=165021 [accessed 24 April 2019].

Dingemans, J. (1999), *Mastering Fashion Styling*, London: Palgrave Macmillan.

Du Gay, P. and M. Pryke, eds. (2002), *Cultural Economy*, London: Sage.

Edwards, T. (1997), *Men in the Mirror: Men's Fashion, Masculinity and Consumer Society*, London: Cassell.

Entwistle, J. (2000a), 'Fashion and the Fleshy Body: Dress as Embodied Practice', *Fashion Theory: The Journal of Dress, Body and Culture*, 4 (3): 323–348.

Entwistle, J. (2000b), *The Fashioned Body: Fashion, Dress and Modern Social Theory*, Cambridge: Polity Press.

Entwistle, J. (2002), 'The Aesthetic Economy: The Production of Value in the Field of Fashion Modelling', *Journal of Consumer Culture*, 2 (3): 317–339.

Entwistle, J. (2009), *The Aesthetic Economy of Fashion: Markets and Value in Clothing and Modelling*, London: Bloomsbury.

Entwistle, J. and E. Wissinger (2012), *Fashioning Models: Image, Text and Industry*, London: Bloomsbury.

Evans, C. (1997), 'Dreams That Only Money Can Buy . . . Or, the Shy Tribe in Flight From Discourse', *Fashion Theory: The Journal of Dress, Body and Culture*, 1 (2): 169–188.

Ferguson, M. (1983), *Forever Feminine: Women's Magazines and the Cult of Femininity*, London: Heinemann.

Flaccavento, A. (2015), 'In Era of Image, Stylists Rule Paris', in *The Business of Fashion*. https://www.businessoffashion.com/articles/opinion/era-image-stylists-reign [accessed 5 October 2018].

Florida, R. (2002), *The Rise of the Creative Class. And How It's Transforming Work, Leisure, Community and Everyday Life*, New York: Basic Books.

Gough-Yates, A. (2003), *Understanding Women's Magazines: Publishing, Markets and Readerships*, London: Routledge.

Granata, F. (2012), 'Fashion Studies In-Between: A Methodological Case Study and an Inquiry into the State of Fashion Studies', *Fashion Theory: The Journal of Dress, Body and Culture*, 16 (1): 67–82.

Hall, S. and T. Jefferson, eds. (1976), *Resistance Through Rituals: Youth Subcultures in Post-War Britain*, London: Hutchinson.

Hebdige, D. (1979), *Subculture: The Meaning of Style*, London: Methuen.

Hesmonhalgh, D. and S. Baker (2011), *Creative Labour: Media Work in Three Cultural Industries*, London: Routledge.

Jackson, P., N. Stevenson and K. Brooks, eds. (2001), *Making Sense of Men's Magazines*, Cambridge: Polity Press.

Jobling, P. (1999), *Fashion Spreads – Word and Image in Photography Since 1980*, Oxford: Berg.

Kaiser, S. (1999), 'Identity, Postmodernity, and the Global Apparel Marketplace', in M.L. Damhorst, K. Miller and S. Michelman (eds.), *The Meanings of Dress*, New York: Fairchild.

Kaiser, S. (2001), 'Minding Appearances: Style, Truth, and Subjectivity', in J. Entwistle and E. Wilson (eds.), *Body Dressing: Dress, Body, Culture*, 79–102, Oxford: Berg.

Kaiser, S. (2012), *Fashion and Cultural Studies*, London: Berg.

Larson, M.S. (2018), 'Professions Today: Self-criticism and Reflections for the Future', in *Sociologia, Problemas e Práticas*, Issue 88. http://journals.openedition.org/spp/4907 [accessed 1 October 2019].

Lévi-Strauss, C. (1966), *The Savage Mind*, Chicago, IL: University of Chicago Press.

Lifter, R. (2012), *Contemporary indie and the construction of identity: Discursive representations of indie, gendered subjectivities and the interconnections between indie music and popular fashion in the UK*, PhD thesis, University of the Arts London.

Lifter, R. (2014), 'From Subculture to Queer Pop: Resistance, Style and Cultural Studies', in A. Lynge-Jorlén and M. Christoffersen (eds.), *Clash. Resistance in Fashion* [Exhibition catalogue], Herning: HEART – Herning Museum of Contemporary Art.

Lifter, R. (2018), 'Fashioning Pop: Stylists, Fashion Work and Popular Music Imagery', in L. Armstrong and F. McDowell (eds.), *Fashioning Professionals: Identity and Representation at Work in the Creative Industries*, 51–64, London: Bloomsbury.

Lynge-Jorlén, A. (2016), 'Editorial Styling: Between Creative Solutions and Economic Restrictions', *Fashion Practice: The Journal of Design, Creative Process and the Fashion Industry*, special issue on Fashion Thinking, 8 (1): 85–97.

Lynge-Jorlén, A. (2017), *Niche Fashion Magazines: Changing the Shape of Fashion*, London: I.B. Tauris.

McColgin, C. (2019), 'The 25 Most Powerful Stylists in Hollywood 2019', in *The Hollywood Reporter*. https://www.hollywoodreporter.com/lists/25-top-stylists-hollywood-2019-1192120 [accessed 1 May 2019].

McCracken, E. (1993), *Decoding Women's Magazines from Mademoiselle to Ms*, New York: St. Martin's Press.

McLuhan, M. ([1964] 2007), *Understanding Media: The Extensions of Man*, London: Routledge.

McRobbie, A. (1978), *Jackie: An Ideology of Adolescent Femininity*. Stencilled Occasional Paper, Centre for Contemporary Cultural Studies, Birmingham: University of Birmingham.

McRobbie, A. (1994), *Postmodernism and Popular Culture*, London: Routledge.

McRobbie, A. (1996), '*More!* New Sexualities in Girls' and Woman's Magazines', in J. Curran, D. Morley and V. Walkerdine (eds.), *Cultural Studies and Communications*, 172–195, London: Edward Arnold.

McRobbie, A. (1998), *British Fashion Design: Rag Trade or Image Industry?*, London: Routledge.

McRobbie, A. (2000), *Feminism and Youth Culture*, Boston, MA: Unwin Hyman.

Mears, A. (2011), *Pricing Beauty: The Making of a Fashion Model*, Berkeley, CA: University of California Press.

Nixon, S. (1993), 'Distinguishing Looks: Masculinities, the Visual and Men's Magazines', in V. Harwood, D. Oswell, K. Parkinson and A. Ward (eds.), *Pleasure Principles, Explorations in Ethics, Sexuality and Politics*, 54–70, London: Lawrence & Wishart.

Pedroni, M. (2015), 'Stumbling on the Heels of My Blog: Career, Forms of Capital, and Strategies in the (Sub)Field of Fashion Blogging', *Fashion Theory: The Journal of Dress, Body and Culture*, 19 (2): 179–199.

Rocamora, A. (2018), 'The Labour of Fashion Blogging', in L. Armstrong and F. McDowell (eds.), *Fashioning Professionals: Identity and Representation at Work in the Creative Industries*, 65–81, London: Bloomsbury.

Rowe, J. (2018), 'Designer Unknown: Documenting the Mannequin Maker', in L. Armstrong and F. McDowell (eds.), *Fashioning Professionals: Identity and Representation at Work in the Creative Industries*, 145–162, London: Bloomsbury.

Shinkle, E., ed. (2008), *Fashion as Photograph: Viewing and Reviewing Images of Fashion*, London: I.B. Tauris.

Smith, S. and J. Watson (2010), *Reading Autobiography: A Guide for Interpreting Life Narratives*, 2nd edition, Minneapolis, MN: University of Minnesota Press.

Style.com, S. Mower and R. Martinez, eds. (2007), *Stylist: The Interpreters of Fashion*, New York: Rizzoli.

Tulloch, C. (2010), *The Birth of Cool: Style Narratives of the African Diaspora*, London: Bloomsbury.

Warkander, P. (2013), '*This is all fake, this is all plastic, this is me*': An ethnographic study of the interrelation between style, sexuality and gender in contemporary Stockholm, PhD thesis, Stockholm University.

Williams, R. (1965), *The Long Revolution*, Harmondsworth: Penguin.

Wilson, E. (2010), *Adorned in Dreams: Fashion and Modernity*, revised and updated edition, London: I.B. Tauris.

Winship, J. (1987), *Inside Women's Magazines*, London: Pandora Press.

Wissinger, E.A. (2015), *This Year's Model: Fashion, Media, and the Making of Glamour*. New York: New York University Press.

Part One

History and Profession of the Stylist within and beyond Magazines

Stylist: Etymology and History of a Role

Philip Clarke

Introduction

The fashion stylist, an occupation primarily based on that of the magazine fashion editor, achieved recognition as a distinct freelance role in the 1980s. Although similar roles had existed previously, the legitimation of styling as an occupation is said to have coincided with the advent of British, independent 'style press' publications and, in broader terms, with a heightened awareness of the currency of stylistic difference in postmodern culture. The *Oxford English Dictionary* 2017 definition of a 'stylist' is:

> A person hired to advise on clothing, accessories, hairstyle, etc., either in a specific context (such as a photo shoot, film, etc.) or for a particular person (usually a celebrity).

The remit of the contemporary stylist extends beyond the fields of fashion, clothing or body adornment. Stylists now work within, or across, a variety of disciplines; for example, there are those that specialize in interior decoration or the photography of food. On a practical level, a stylist is responsible for sourcing, collecting and selecting the items that will be presented in a photographic image, performance or event. In more abstract terms, a stylist could be framed as a cultural intermediary; they operate at the interstice of fashion, commerce and communication and act as gatekeepers in the production of taste (Bourdieu 2010; Kawamura 2006; Lynge-Jorlén 2016).

This chapter offers an etymology of the term 'stylist' and examines its adoption within the context of fashion editorial and advertising photography. Etymological research is supported with analysis of British fashion editorial content and data from oral history interviews with stylists and fashion editors and their peers, collated as part of a doctoral research project (carried out at Middlesex

University). In total, sixteen interviews were conducted; with people who had largely worked as freelance stylists in the 1980s, such as Mitzi Lorenz, Paul Frecker, Simon Foxton and Zee Shore, and those who had also fulfilled roles as fashion editors – Caroline Baker, Caryn Franklin, Debbi Mason, Sarah Miller and Iain R. Webb (see figure 1). The photographers Mark Lebon and Roger Charity, art director Robin Derrick and agent Ziggi Golding, provided the perspective of collaborator or co-worker. In addition, those who lived and socialized with stylists, such as the milliner Stephen Jones and DJ Jeffrey Hinton, described the social context and creative scene of London at that time.

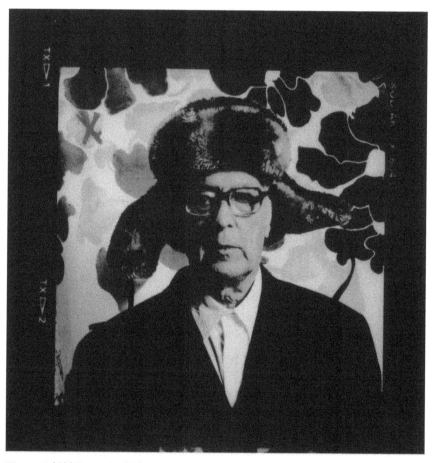

Figure 1 'Old Favourites'. Photography: Robert Ogilvie. Fashion editor: Iain R. Webb. *Blitz*, January 1987. Courtesy of Iain R. Webb/Robert Ogilvie.

An etymology of 'style'

All style-related words are ultimately descended from terms that describe objects used for pointing and for etching or engraving; Partridge (1958) lists the derivatives of style ('stylish', 'stylist', 'stylistic', 'stylize') under the noun 'stick'. Onions' *Oxford Dictionary of English Etymology* (1966) includes the first known uses of each term or adopted meaning of those terms; he recognizes that style is a derivative of 'stylus' and states that its first use in a transferred sense (i.e. closer to the version of style we commonly use in current English) is in eighth-century Latin: '*stilum vertere*', meaning to change the subject.

A direct link to the word's relation to etching or writing tools is later used in the fields of literature; it is likely that these applications of the term have led to its wider association with other creative or artistic pursuits. Style has since been employed to mean the 'manner' or 'fashion' of a range of things, being applied to actions or behaviour, to art, design, dress, hair, architecture or typography. Definitions in the *Collins English Dictionary* (2017) include this sense of the noun but also 'elegance, taste, chic, flair'; to *have* 'style' is to express good taste in the way that one dresses or comports oneself. The use of style interchangeably with the word fashion dates from the fifteenth century. Kawamura defines the difference between the two interrelated terms:

> As synonyms of the word 'fashion', words such as mode, style, vogue, trend, look, taste, fad, rage and craze are mentioned, although there are slight differences in their meanings. 'Style' is sometimes the equivalent of fashion but also denotes conformity to a prevalent standard while 'vogue' suggests the temporary popularity of a certain fashion. Therefore, it seems agreed that fashion is never fixed and ever-changing.
>
> 2006: 3

The word 'stylist', as a derivative of 'style', has been employed in many contexts and across a range of fields, some linked to fashion and clothing and others, such as sport, not linked to artistic practices or modes of cultural production.

The stylist through history

The first use of the term 'stylist' is noted by the *Oxford English Dictionary* historical thesaurus as being used by W. Taylor in *Monthly Rev.* (1795). The first definitions relate to literature, a stylist being 'a writer who is skilled in or cultivates

the art of literary style'. Consequently, the analytical field of 'stylistics' is a study of style in language and literature.

'Stylist' was first used in a context beyond that of literary style in the fields of sport and music; someone who 'plays with style' is classed as a stylist. This is supported by definitions in the *Collins English Dictionary online*; its first use in connection with musical flair is credited as 1969 in *Listener* magazine, relating to a clarinettist. The British Library catalogue includes series of musical recordings, featuring popular American and British musicians, who are collectively labelled as 'song stylists'.

Collins currently lists a stylist as someone who pays 'a lot of attention to the way that they write, say, or do, something so that it is attractive and elegant'; or, in a specifically British context, as 'a person who performs, writes, or acts with attention to style'. The use of the term to refer to someone who maintains an interest in current cultural trends can be traced as far back as the beginning of the last century: as early as 1905, an early version of a lifestyle publication entitled *The Stylist* presented editorial features on 'new designs and styles' to a readership of consumers of fashionable clothing and home decor. In a different context but similarly describing a person who 'has style' or 'is stylish', the term was adopted within the Modernist (or Mod) subculture from the mid 1960s onwards. Richard Barnes claims that the terms 'Stylist' and 'Individualist' were adopted by the original Mods who wanted to 'differentiate themselves' from the more generic, popular forms of Mod that they had seen emerging in the suburbs and provinces (1979: 122).

A further use of stylist in the context of tailoring, linked more closely with design and construction of items of clothing, is consistent with uses of the terms '*styliste*', in French, and '*stilista*' in Italian (Volonté 2008) where the terms translate as 'fashion designer'. The first example of the term being used to describe a similar role to that of the contemporary fashion stylist is that of Taubé Coller. A magazine article printed in the US publication *Delineator* claims that in 1917 Coller was the first person within the fashion industry to label herself as a stylist; her expertise is defined in the article as 'someone who knows from experience, better than anyone else, what styles you are going to like best and what will be most useful to you' (Anon 1937: 24). It would appear that she operated predominantly as a brand consultant, acting as a cultural intermediary or style influencer, in way that is consistent with the current definition of the role.

The value of style as a marker of cultural capital, and its role in differentiating the quality and desirability of a product, has been referenced as a postmodern phenomenon during the latter part of the twentieth century (Adamson and

Pavitt 2011; Bauman 1992; Bourdieu 2010). However, the importance of a distinct aesthetic in the marketing of products was also clearly acknowledged by certain manufacturers in the first part of the century, as industrialization contributed to increased production of commodities. The term 'styling' was primarily used in this context in the field of car design. General Motors and Ford were competitors and 'stylists' were employed by the former to gain the upper hand over Ford, who continued to favour function over the shape and decoration of the car. GM's Art and Colour team, founded in the 1920s, later changed its name to the Styling Staff (Gartman 1994). The stylist's job was to adapt the design of otherwise mechanically identical, mass-produced cars to create individualized products, generating successions of new and varied designs that appealed to an increasingly style-conscious consumer.

Promotional material produced by General Motors in Britain in the 1950s pinpoints 1927 as the 'beginning of modern automotive styling as we know it' (1955: 37). It describes the occupation as analogous to that of the industrial designer. The debate around style in the early part of the last century was linked to advances in manufacturing processes, such as the pressing of steel in vehicle production (Hebdige 1988). The General Motors promotional material makes a point of highlighting the commercial awareness of the stylist and also their knowledge of contemporary taste; it makes the comparison between the stylist and the artist or writer, suggesting that all are expected to communicate with the 'minds and emotions of the viewer' (1955: 6). Despite this, the stylists were not always popular with the engineers, who felt that their contribution to the design process was unnecessary and unjustified (Gartman 1994).

The earliest example found for this study of a stylist working in the field of image production for a photo shoot or film is a credit for the front cover of a 1963 ICA publication called *Living Arts*; it was produced by the British artist Richard Hamilton and stylist Betsey Scherman in a fourteen-item list of props and crew. According to the 2004 *International Who's Who* (Europa 2003), Scherman was the wife of the artist Richard Smith but neither the feature itself or the latter listing gives any insight into her professional role or her contribution to the feature.

Further editorial analysis contradicts etymological entries in the *Oxford English Dictionary*, which attributes the earliest printed acknowledgment of the word stylist in an editorial context to an article in a US publication, the *New York Times*, on 29 June 1982. The article associates the role of stylist with that of fashion editor, profiling the career of China Machado, who worked as a fashion editor for *Harper's Bazaar* magazine and as a stylist for film and television. The

role can however be found listed in *Interview* magazine as far back as January
1977, where 'stylists' Peter Lester and Richard Bernstein are credited on the page
next to portrait shots of Jodie Foster and Grace Jones. From this moment
onwards, *Interview* continued to credit the role, also using the terms 'styled by'
and 'styling' to indicate who held creative responsibility for the outfit worn by the
model in an image.

The stylist is also credited in UK publishing prior to 1982. *Cosmopolitan*
magazine in 1980 devotes four pages to a career profile of Zee Shore, a
'photographic stylist'. The feature describes the practical activities that constitute
'styling' and defines how the role forms part of a network of creative roles. She is
described sourcing and gathering accessories, 'rooting around in shops, markets
and prop houses', 'talking with the art director or photographer about the feeling
they want to get across in the photograph' and being on the phone to PRs and
photographers (D. Hall 1982: 192). Interviewed for my own study, Shore recalls
the moment in the early 1980s when she realized that she was a stylist, saying
that her agent started telling her she was a stylist and marketing her as such so
she became one 'by default'. Caroline Baker, who worked as a fashion editor for
Nova, Vogue and Cosmopolitan magazines, supports this, recalling a time in the
1980s when she suddenly started to be aware of the term (Baker 2017, personal
communication, 13 January; Shore 2017, personal communication, 16 August).

'Style' in postmodern culture

The postmodern era is acknowledged as a period where the term 'style' was
heavily referenced in relation to shifts in contemporary culture. Postmodernism
or postmodernity are recognized as existing in Western societies from the late
1960s or early 1970s and have been associated with pop culture and with a re-
evaluation of the validity of previously 'low-end' forms of cultural production,
such as advertising design and fashion (Adamson and Pavitt 2011; Jameson
1991; York 1980). York defines the 1970s as being one of 'conscious stylisation'.
He says that the terms 'style' and 'stylish' gained currency as ways of denoting
fashion capital or credibility (1980: 48).

Postmodernism is said to represent the commodification of all aspects of
lifestyle. Members of postmodern society seek the acquisition of 'symbolic
tokens of belonging', essentially shopping for composite elements of their own
identity or constructing a visible identity to demonstrate allegiance to particular
'agencies' or tribes. The value or worth of these tokens is given credence by

authorities of expertise, or by perceived mass following or popularity (Bauman 1992: 195). The cause for this apparent societal shift has been attributed to post-industrialization and the subsequent expansion of a progressively well-educated middle class, one with more leisure time and disposable income. The burgeoning middle class of postmodern society expends increasing amounts of time and effort in developing a sense of taste and maintaining an awareness of the 'new styles, experiences and symbolic goods which consumer culture and the cultural industries continue to generate' (Featherstone 1991: 109).

Despite being synonymous and widely interchangeable with the term 'fashion', the word 'style' was adopted in the 1980s by those who purported to promote an alternative to the trend-led, designer-controlled system of fashion (Gough-Yates 2003; Lorenz 2000). The prevalence of debate around the concept of style relates

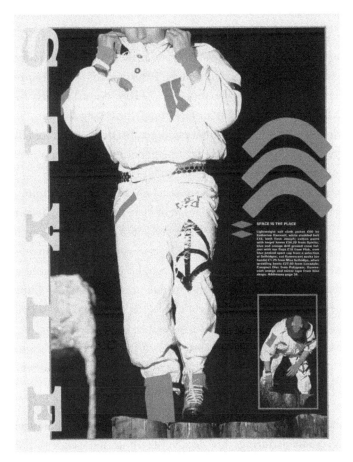

Figure 2 'Style: Space is the Place'. Photography: Jamie Morgan. Styling: Helen Roberts. *The Face*, July 1983. Courtesy of The Archive/Jamie Morgan.

more specifically in Britain to the launch of a new genre of publication in the 1980s: the 'style press'. Although interested in the field of fashion, or even working within the fashion industry itself, the distrust of traditional fashion practices amongst those working for these publications was made explicit: 'Style' reflected individualism, it was based around the notion that personal identity is built from unique influences and interests, it operated outside of the trends dictated by fashion authorities. It is through this discourse around style and increased currency of the term 'style' that, within British editorial and advertising, the stylist gained recognition as a role and occupation, initially in fashion publishing, then further afield.

1980s: The decade of the stylist

Despite evidence to the contrary, Godfrey asserts that during the 1970s 'there was no such thing as a stylist' (1990: 208) and makes the claim that the new wave of independent lifestyle publications in the 1980s, such as *i-D*, *The Face and Blitz*, created the role. Nick Logan, who founded *The Face*, doesn't entirely support the claim, but he does concede that 'in unwittingly inventing the term Style Press', they provided a platform for fashion photographers who were not afforded the same degree of creative license by existing publications and for 'a new breed of contributor', namely the stylist (Lorenz 2000: 147).

As stated, style was being presented as an anti-fashion attitude. Fashion, according to the style press, was the remit of mainstream publications, it was 'top down' and perpetuated a system that represented control and hierarchy. Style represented freedom of expression and personality, it was generated on the streets and within the London club scene, rather than by recognized arbiters of taste, by the established designers and fashion press. The aim of *i-D* initially was to document style – it was intent on displaying the range and scope of styles being explored amongst the various subcultural groups, both in London and further afield. *The Face* was predominantly a music publication when it first launched in 1980 – again, its role was also primarily to record and represent the styles of the bands being featured on its pages.

Further examination of editorial content from a broad range of British fashion and lifestyle publications has pinpointed when and how stylists were first being credited during this decade. As these independent publications became more established, they moved beyond merely documenting what people were wearing, to producing staged, narrative-driven fashion photographs, in a

format that in some ways aligned with the practices of existing fashion publications. *The Face* first credited 'styling' in 1982, where the photographer Sheila Rock was listed for the 'photography and styling' of images that featured the Bauhaus lead singer Peter Murphy and the pop group Bananarama in a selection of 'the latest ethnic style'. Rock continued to be listed for both roles as the publication incorporated increasing degrees of fashion content. The term 'styling' began to be credited on a progressively regular basis in the magazine, indicating an increased awareness or willingness to name the activity that contributed to the production of the image in broader terms than merely the photography (see figures 2 and 3).

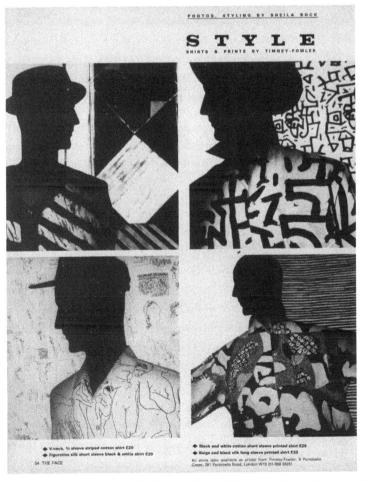

Figure 3 'Style: Shirts and Prints by Timney Fowler'. Photography and styling: Sheila Rock. *The Face*, August 1983. Courtesy of The Archive/Sheila Rock.

Ziggi Golding, who worked as an agent for stylists, defines the year when the stylist emerged as 'either 1983 or 1984' and Simon Foxton, who started being credited as a stylist for *i-D* in 1984, supports this, asserting that it did not exist as a role in the early 1980s. Golding says that prior to the term being used, freelance stylists were called wardrobe, whereas fashion editors, who fulfilled a similar role, worked for magazines (2017, personal communication, 6 February).

Because its focus was initially on showing what real people were wearing, *i-D* magazine actually started crediting styling much later, in March 1984. Again, the term 'styling' is used consistently, rather than using the label 'stylist'. The names of those responsible for styling are included in the masthead list of contributors from February 1985; many of them, such as Simon Foxton, Toby Anderson and particularly Ray Petri, went on to contribute to the recognition and legitimation of the role (see figure 4). McRobbie uses the term 'occupation' to denote the informality of the role at this time; editorial work was frequently unpaid, and the true remit of the stylist was often unknown, even to the stylists themselves (Lifter 2018; McRobbie 1998). Interviewed for my own research project, the former stylist Paul Frecker recalls his first experience:

> The first shoot I did I knew absolutely nothing. I didn't even know what a stylist's responsibilities were. I turned up with a huge roll of black and white linoleum to use as the infinity cove and ... It's just not the stylist's job to do that but, you know, I just didn't know.
>
> 2018, personal communication, 4 January

Styling was in fact credited in certain established fashion magazines before it appeared in *The Face*, *i-D* or *Blitz*, although at the time fashion content was produced almost exclusively by in-house fashion editors. As an example, the August 1980 issue of *Cosmopolitan* magazine credits the cover image as 'styled by' Kezia Keeble and Paul Cavaco. Both worked as stylists in the US and had previously been credited in *Interview* magazine. Despite the use of the term in US publications much earlier than its adoption by the style press in Britain, it is the degree of hype around the role, and a willingness to establish styling as a distinct occupation, that makes this period in UK publishing worthy of discussion in relation to the legitimation of the role. Notably, when the British version of *Elle* magazine was first launched in November 1985, the editor Sally Brampton made a point of employing, and crediting, stylists from the outset, a further marker of acknowledgment of the role at the time.

The differences and similarities between the roles and responsibilities of the stylist and the established, in-house fashion editor should be defined: a fashion

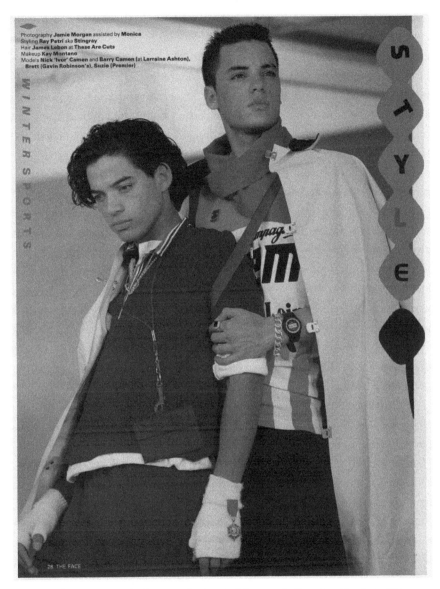

Figure 4 'Winter Sports'. Photography: Jamie Morgan. Styling: Ray Petri aka Stingray. *The Face*, January 1984. Courtesy of The Archive/Jamie Morgan.

editor oversees the production of fashion content, liaising with writers and photographers on a creative level, but also with agents, PRs and other collaborative parties working outside of the magazine. The fashion editor can equally be seen as a cultural intermediary, in that they act as gatekeepers or tastemakers (Kawamura 2006; Lantz 2014; Lynge-Jorlén 2016); they maintain

awareness of contemporary trends in fashion through direct access to brands, designers and their representatives, and communicate with the magazine's audience through the production of appropriate editorial content. Nonetheless, in direct comparison with the stylist, a fashion editor is also often physically involved in the production of photographic imagery. In addition to coordinating and captioning content, they can be the person within the editorial team that casts and dresses the model on set, working alongside the photographer and taking responsibility for all of the clothing-related aspects of the image.

Amongst the participants in the oral history interviews conducted for my project were some who had worked as a fashion editor for magazines. Some of them had been employed by mainstream publications in a more traditional sense, such as Caroline Baker or Sarah Miller, and others had adopted or been given the role of fashion editor for one of the new, independent youth titles. Iain R. Webb became fashion editor of *Blitz* magazine in 1983 and Caryn Franklin had taken on a similar position for *i-D*. Despite being considered innovative and working to a more flexible format, the production responsibilities and job titles in these new publications mirrored those in established fashion media, albeit in a more ad hoc sense. However, what differentiated the stylist from the outset was that it was a specifically freelance role, contributing to the editorial content, but not being a fixed member of the team.

The milliner Stephen Jones lived and worked in London during the early 1980s and the new wave of young stylists emerging at the time were amongst his peers. Jones points out that fashion editors have existed since the 1920s or 1930s. He credits economic constraints in publishing as leading to the labelling of part-time fashion editors as 'stylists', saying that even fashion editors did not necessarily have permanent jobs in the 1980s (2017, personal communication, 12 April). Ziggi Golding sees the role of the fashion editor as being somehow less free than a stylist; she says that a stylist could allow their own taste to come through, whereas the fashion editor was obligated to create styled content 'with that magazine in mind', i.e. in accordance with the magazine's editorial direction (2017, personal communication, 6 February).

Legitimation of a role

The freelance nature of the emerging fashion stylist's role in the 1980s could be seen as a direct consequence of political or social shifts in Britain, of their subsequent impact on all fields of cultural production and, more specifically, on

the publishing industries. Freelance stylists were free to operate across both commercial and editorial platforms, and were able to apply their skills or specialist knowledge to a range of differing fields within the broader context of fashion media. The 1980s has been referenced as a period when entrepreneurial activity became more commonplace (Lynge-Jorlén 2016; McRobbie 1994) and was being promoted by the neoliberal conservative government. The publishing industries in Britain were experiencing a period of change; the previously 'rigid structures of publishing, printing and distribution' were being questioned by publishers, who were trying to adapt to a changing cultural and political situation, trying to respond proactively to shifting consumer demands. Shifts away from the union-controlled systems and traditional printing processes in publishing had affected all areas of the media industries. Gough-Yates (2003) speaks of the subcontracting of roles and of an increasing attitude of 'free-market entrepreneurialism' at this time, leading to occupations within the magazine industry becoming more multi-faceted and multi-skilled; she says that organisational structures became 'more organic'.

The development of the freelance fashion stylist's role during this decade coincides with a more widespread incidence of new creative roles in fields of commercial communication, in postmodern society. Western production became 'progressively dehumanised and etherialised', focused around information and image as commodity (Hebdige 1988: 165). McRobbie compares fashion media to the pop video industry, where the need for new specialist roles often comes about as jobs are created and 'gaps and opportunities' are identified in related areas; she cites Tunstall (1971) and Elliott (1977), who argue that this flux within industries led to constant re-evaluation of roles, augmented labour mobility and the introduction of new job titles 'almost overnight' (McRobbie 1994: 155). Within this context, women's magazines such as *Marie Claire* operated with a minimal team of full-time staff members and commissioned contract workers to address specific needs.

Jeffrey Hinton, a DJ and artist who lived and worked with stylists throughout the 1980s says that the decade was a really exciting time for stylists but that it 'became a job' in the 1990s (2017, personal communication, 23 June), suggesting that the role achieved further legitimation during this period. If the stylist was indeed fully recognized as a legitimate occupation in the 1990s, it gained even more status after the turn of the century, as the cultural capital afforded to the role led to fashion stylists being accorded a degree of celebrity, at least within the fashion industry itself. 'Stylist of the Year' was first given to Katy England in 1999 at the British Fashion Awards.

However, styling remained misunderstood as an occupation. In 2002, Tamsin Blanchard wrote an editorial feature in *The Observer* magazine, interviewing a number of practising stylists in an attempt to provide clarification on what she considered to be a behind-the-scenes, anonymous role. If the role had achieved legitimation amongst fashion professionals, it had still not achieved widespread acknowledgement at that time. More recently, stylists such as Nicola Formichetti and Mel Ottenberg have gained public recognition through their association with pop performers (Lifter 2018), and social media platforms have provided further opportunity for stylists to self-promote.

Academic interest in fashion styling has also increased; Beard (2013) has examined the work of Caroline Baker as fashion editor of *Nova* in the 1970s, and Penny Martin (2009) highlights the importance of the stylist Simon Foxton's contribution to fashion photography over the last thirty years. Martin curated the 2009 exhibition at the Photographer's Gallery of Foxton's work; the show was unique in that it prioritized the creative role of the stylist in the image-making process over that of the photographer. Furthermore, a recent retrospective of the career of Judy Blame, at the ICA, demonstrates the influence of the stylist in fashion editorial and advertising.

Evidence of styling being incorporated into popular culture includes television and film coverage; for example, the television series *Style the Nation* (2011) was a game show where contestants competed for the opportunity to become a 'stylist for a day'. A development on this theme is the acknowledgment of the role in fictional work. *The Hunger Games* (Collins 2008–2010) is a series of fictional books that have since been adapted into successful films. The plot follows participants in a reality TV game show, a futuristic version of the historical gladiator events. In the film, the public profile of the competitors is key to their success and the role of each contestant's stylist is intrinsic to this profile; these fictional stylists have achieved celebrity status in line with that of their real-world counterparts. There are even children's books: *Hello Kitty: Fashion Stylist* and *Hello Kitty: Super Stylist* target the eight-plus market and encourage young aspiring stylists to 'design, create and style [their] own fabulous fashions'.

There are now programmes of study within higher education in the UK teaching students the specialist skills they need to work as a stylist. London College of Fashion offers a three-year degree course in Fashion Styling and Production; Middlesex and Leicester De Montfort universities offer BA honours degrees in Fashion Communication and Styling; the BA Styling and Image-making degree at Salford has achieved a certain critical acclaim, and Southampton Solent runs a Fashion Styling and Creative Direction degree.

Whether fashion styling could be considered a profession is to be debated. Lifter (2018) points out that the loosely structured nature of styling as a career in the 1980s warranted the label 'occupation', rather than 'profession', but she implies that it has graduated to the status of a professional role. The close association of styling practice with street style, and having been established through a process that defined itself as anti-fashion and counter to the conventional system of fashion dissemination, could also be seen as contributing to its devaluation as an occupation.

Fashion itself has traditionally struggled with being identified as 'low culture'. Fashion design, in line with the way that fashion is viewed more generally, has been through a process of presenting itself as an academic field and this was reflected in the way that it has been taught in UK institutions, where an aspect of history and theory tends to support the teaching of technical skills; McRobbie points out that, 'to have degree status must mean being difficult, abstract and theoretical' (1998: 42). Despite this, one could question whether or not a qualification is necessary, to achieve financial success or critical acclaim as a stylist. Decades earlier, Bourdieu examined the professional photographer's role in a similar way. He claims that:

> the acquisition of a school qualification does not systematically lead to the practice of those specialisations which seem most specific. It does not increase the chances of practicing photography as a craft, or the chances of running larger businesses. For an employee, it is even less of a promise of higher salary, since the hierarchy of incomes varies in an inverse ratio to qualification.
>
> Bourdieu 1990: 152

A similar 'inverted economy', or system where artistic credibility holds more value than commercial success, is particularly applicable to the ways of working and attitudes of the young creatives producing editorial content for the style press in the early 1980s. Despite a distrust or undervaluing of work conducted in commercial fields, the symbolic capital gained from working for free for a respected publication continues to be used to achieve greater financial gains through advertising or other forms of promotional work (Lantz 2016; Lynge-Jorlén 2016). In part, this could be attributed to attitudes within the British education system, which, in some ways, affect the way that art practices are framed and the way that fashion is taught in UK institutions (McRobbie 1998). However, Simon Foxton claims that the younger generation are more likely to be business-minded and strategic about working for specific types of client (Fury 2010).

Conclusion

The validity of the stylist's occupation continues to be discussed. As with many creative fields, the development of the Internet, and the consequent adoption of social media platforms to disseminate fashion information, have thrown into question the influence of established gatekeepers and authorities of legitimation. It is now possible for a fashion stylist to be trained to degree level in the UK, but despite this styling is often still seen as an innate skill and one that can be developed through practice or work experience rather than academic training. Simon Foxton, among the most recognized and established British stylists, is sceptical of the possibility of teaching styling as a skill.

> I believe that there are courses in styling but it fascinates me as to how they teach styling. I've never been asked to teach on a styling course, maybe for good reason ... I don't know, I'm almost fascinated, I'd like to know how they teach styling because I couldn't imagine doing it myself, being taught it. I had to make it up as I went along. I don't know if there is a right or a wrong way.
>
> 2017, personal communication, 3 February

Regardless of the status of the role, in terms of exclusivity or degrees of professionalism, the stylist is nonetheless acknowledged as an established role within a variety of contexts. Even in relation to the clothing industries, both freelance and salaried stylists work in the creation of photography for advertising and selling clothing, and for editorial content for both online and print platforms; they collaborate with fashion designers in the design and editing of a collection, and in the production of promotional events, in the form of catwalk shows and live presentations; stylists continue to work as wardrobe assistants in the film and television industries, and are employed to dress musicians and actors for both public appearances and performances.

Nonetheless, 'style' as a term no longer holds the same cultural capital as it did in the 1970s and 1980s. The inherent obsolescence of a fashion trend could equally be applied to a fashionable term. As mentioned, Peter York claims that the 1970s were the beginning of style becoming a fashionable word and, latterly, the designer Stephen Jones jokingly situates the demise of style at the end of the following decade:

> ... people started to use the word style, for fashion, for magazines, the fashion editors, they didn't have permanent jobs, so they had to call them something, so they called them stylists. And then, absolutely the kiss of death for stylists was when *The Sunday Times* bought out the *Style* magazine, and nobody in their

right minds would ever use the word 'style' ever again. End of story. Because it was naff as knickers.

<div align="right">2017, personal communication, 12 April</div>

Despite the inverted economy being applied to the types of work being carried out by stylists, with regards to the way that they frame their practice as either art or commerce, the role has arguably been incorporated into the mainstream. However, as the job title becomes normalized, stylists aspire to more prestigious roles, that accord greater cultural capital. The hierarchy within styling is not clearly defined; although 'creative director' or 'art director' could be seen as senior roles, the terms imply greater levels of creative responsibility. Interviewed for Showstudio in 2013, Nicola Formichetti was questioned on why he preferred to be labelled an 'art director', rather than a stylist; he discusses the transition he has made from one role to another: 'When I was a "stylist" I was never doing the stylist's job. I couldn't care less about the clothes. I was much less into the clothes than the person I was shooting. I was never like a proper stylist ... so I never wanted to do that.' Nevertheless, despite the adoption of new roles, Formichetti continues to be credited for the 'styling' of editorial features.

In Ray Petri's obituary, which featured in the October 1989 issue of *The Face*, the writers state that a stylist is 'at its most prosaic, the person on a fashion shoot who selects the clothes for the models', but they go on to say that 'styling' is inadequate as a term to define what Petri did (Logan and Jones 1989). Decades earlier, those working for the Styling Section at General Motors were often dismissed in a similar way (Gartman 1994); referred to as 'fairies' or 'pantywaists', their role was associated with decorative, superficial aspects of a car's design and with the whims of fashion. The stylist, in the context of British fashion media, gained legitimation through association with an anti-fashion movement, that promoted style over fashion. The creative scene that conceived the style press initially operated in a way that deliberately countered the tactics of mainstream modes of fashion communication. 'Style' continues to be used interchangeably with the term 'fashion' (Kawamura 2006); it is arguably no longer used to represent an alternative to fashion or in conjunction with a collective resistance to traditional fashion practices. The direct association that the role has with clothing and dressing, coupled with the broader association of styling with the ephemeral, decorative aspects of design, could be considered obstacles in the legitimation of the stylist, with those who fulfil the role aspiring to label themselves in a way that fully acknowledges their contribution to the image-making process.

References

Adamson, G. and J. Pavitt (2011), *Postmodernism: Style and Subversion 1970–1990*, London: Harry M. Abrams.

Anon. (1937), 'Presenting Tobé', *Delineator*, April: 24.

Barnes, R. (1979), *Mods!*, London: Plexus Publishing.

Bauman, Z. (1992), 'A Sociological Theory of Postmodernity', in M. Drolet (ed.), *The Postmodern Reader*, London: Routledge.

Beard, A. (2013), 'Fun with Pins and Rope: How Caroline Baker Styled the 1970s', in D. Bartlett, S. Cole and A. Rocamora (eds.), *Fashion Media: Past and Present*, 22–34, London: Bloomsbury.

Blanchard, T. (2002), 'The Style Council', *The Observer*, 17 November: 45–53.

Bourdieu, P. (1990), *Photography: A Middlebrow Art*, Cambridge: Polity Press.

Bourdieu, P. (2010), *Distinction: A Social Critique of the Judgement of Taste*, London: Routledge.

Collins, S. (2008), *The Hunger Games*, New York: Scholastic.

Collins, S. (2009), *Catching Fire*, New York: Scholastic.

Collins, S. (2010), *Mockingjay*, New York: Scholastic.

Elliott, P. (1977), 'Media Organisations and Occupations: An Overview', in J. Curran, M. Gurevitch and J. Woollacott (eds.), *Mass Communication and Society*, 142–174, London: Edward Arnold.

Europa (2003), *The International Who's Who 2004*, Hove: Psychology Press.

Featherstone, M. (1991), *Consumer Culture and Postmodernism*, London: Sage.

Fury, A. (2010), Interview with Simon Foxton, Showstudio. http://showstudio.com/project/in_fashion/simon_foxton [viewed 27 January 2015].

Gartman, D. (1994), 'Harley Earl and the Colour Section: The Birth of Styling at General Motors', *Design Issues*, 10 (2): 3–26.

General Motors Styling (1955), *Styling the Look of Things*, Detroit, MI: General Motors.

Godfrey, J. 1990. *A Decade of i-Deas*, London: Penguin.

Gough-Yates, A. (2003), *Understanding Women's Magazines: Publishing, Markets and Readerships*, London: Routledge.

Hall, D. (1982), 'Zee Makes Dreams Come True', *Cosmopolitan*, November: 192–195.

Hebdige, D. (1988), *Hiding in the Light: On Images and Things*, London: Routledge.

Jameson, F. (1991), *Postmodernism, or the Cultural Logic of Late Capitalism*, London: Verso.

Kawamura, Y. (2006), *Fashionology*, London: Bloomsbury.

Lantz, J. (2016), *The Trendmakers: Behind the Scenes of the Global Fashion Industry*, London: Bloomsbury.

Lifter, R. (2018), 'Fashioning Pop: Stylists, Fashion Work and Popular Music Imagery', in L. Armstrong and F. McDowell, eds., *Fashioning Professionals: Identity and Representation at Work in the Creative Industries*, 51–64, London: Bloomsbury.

Logan, N. and D. Jones (1989), 'Obituary: Ray Petri', *The Face*, 2 (13): 10.

Lorenz, M. (2000), *Buffalo*, London: Westzone.

Lynge-Jorlén, A. (2016), 'Editorial Styling: Between Creative Solutions and Economic Restrictions', *Fashion Practice: The Journal of Design, Creative Process and the Fashion Industry*, special issue on Fashion Thinking, 8 (1): 85–97.

Martin, P. (2009), *When You're a Boy: Men's Fashion Styled by Simon Foxton*, London: The Photographer's Gallery.

McRobbie, A. (1994), *Postmodernism and Popular Culture*, London: Routledge.

McRobbie, A. (1998), *British Fashion Design: Rag Trade or Image Industry?*, London: Routledge.

Onions, C.T. (1966), *The Oxford Dictionary of English Etymology*, Oxford: Oxford University Press.

Partridge. E. (1958), *Origins: A Short Etymological Dictionary of Modern English*, London: Routledge & Kegan Paul.

Tunstall, J. (1971), *Social Sciences: Foundation Course: Stability, Change and Conflict*, Milton Keynes: Open University Press.

Volonté, P. (2008), *La vita da stilista: Il ruole sociale del fashion designer*, Milan: Mondadori Bruno.

Webb, I.R. (2014), *As Seen in Blitz: Fashioning '80s Style*, London: ACC Editions.

York, P. (1980), *Style Wars*, London: Sidgwick & Jackson.

In the Changing Room: A Study of the Act of Styling before 'Styling' in Danish Fashion, 1900–1965

Marie Riegels Melchior

Introduction

The fashion scholar Joanne Entwistle writes in *The Aesthetic Economy of Fashion* (2009) that the favoured styles or looks of a season arise out of the work of a vast range of different actors who collectively produce, select, distribute and promote these new ideals before moving on to the next season. This is not only a modern phenomenon, orchestrated by professional stylists. Long before the profession of stylist began to be formalized in the 1980s (Lynge-Jorlén 2018), much of the work of styling was performed by the wearers of fashion themselves, who so to speak continuously rehearsed their styling competencies while getting dressed and consuming fashion, as they strove to meet the prevailing bourgeois ideal of fashionable dress that was an accepted part of being a good citizen.

In this chapter I argue that before the advent of mass fashion, the act of styling was key to wearers of fashion and tied into the many micro practices of being fashionably dressed, and can thus be viewed as a cultural competence (Ehn and Löfgren 2006). Thus, styling can be viewed as a process of getting dressed very deliberately and as a way of becoming in the world (Kaiser 2001: 86). 'Doing style' is something that is learned and developed over time through practices often trivial and both invisible and visible in order to represent prevailing ideals of beauty and to express one's personality. Before mass fashion brought about the so-called democratization of fashion (English 2007), the looks of a new season in the first half of the twentieth century with the rise of consumerism and thereby fashion consumption did not correspond literally for most people with investing in a new fashionable outfit as fast as the narrative of advertisements.

Not many could afford to. Instead, the season's new style was most often sampled by updating or adjusting one's existing wardrobe, which made styling skills valuable as cultural competences in order to maintain a fashionable look. Some, of course, had access to professional help in (re)styling their wardrobe, while others did it themselves, guided by what they had read or seen about the new fashions of the season in etiquette books, fashion publications or women's magazines.

In this chapter, the concept of styling is used more broadly than in its professional sense. Similar to Susan Kaiser's (2001) study of the relationship between style, truth and subjectivity, styling is understood as a framework for understanding how we express ourselves through dress in everyday life. Styling is understood as both a process and a practice, not limited to professional or commercial settings, but also as encompassing individual contexts. Styling is a cultural competence, and in contrast to what Entwistle (2000) has termed 'dressing' as a situated bodily practice, I would like to use the term 'styling' to emphasize the aspirational aesthetic dimensions of the practice as well as the embedded bourgeois norms and values of being properly and fashionably dressed. Through styling practices, women in the first half of the twentieth century would become part of the social world, and at the same time conform to the norms of aesthetics dominant in bourgeois culture.

In the years 1900–1965, being fashionable and well-dressed was mandated, not a choice, in contrast to the latter half of the twentieth century when fashion consumers began to be expected to continuously construct their visual appearance in accordance with their chosen lifestyle. As sociologist Diana Crane writes, 'Consumers are no longer perceived as "cultural dopes" or "fashion victims" who imitate fashion leaders but as people selecting styles on the basis of their perceptions of their own identities and lifestyles' (2000: 15). This quote implies the development from the negative position of 'fashion victim' to a more positive one offering freedom of choice. However, the point of this chapter is neither to judge nor to question the changes that may have occurred over time, but rather to understand these supposed 'fashion victims' and the role that styling played in their daily practices as they strove to be fashionable, since this work was believed to give them meaning beyond being passively victimized.

The chapter is positioned within the long tradition of the Danish academic field of European ethnology studies of everyday practices, dress and fashion (e.g. Andersen 1986; Bech 1989; Cock-Clausen 1994; Nielsen 1971; Venborg Pedersen 2018), and contributes to the younger field of interdisciplinary fashion studies highlighting fashion as part of everyday life (see Buckley and Clark 2012). As such,

the chapter seeks to explore styling as a cultural competence that served a purpose beyond consuming new fashions – that is, a means to support and construct personal identity. Thus, this perspective rejects Crane's implied linear trajectory during the twentieth century from passive to active fashion consumption, as I believe it oversimplifies a much more complex situation; notably, it fails to explain why, with the Western world's 'youth quake' and the general critique of capitalist and bourgeoisie society that was widespread in the 1960s, it was so important to visually reject 'proper' styling and instead embrace anti-fashion, anti-aesthetic, etc. The changes were a revolt against the cultural curriculum, not changes and dictates by fashion designers of the new look or style per se.

The focus of this chapter is thus style as a practice, as a doing, as a cultural competence used to make as well as practise fashion as a cultural and economic phenomenon. It is based on research material generated from an ongoing cultural and micro-historic study of Danish fashion history in the first half of the twentieth century.[1] Two settings will be highlighted where styling takes place: the individual setting, wherein the wearer learns to style fashion through various fashion publications, and the commercial setting, enacted by professionals in the context of fashion shows, fashion photography and the fashion house.

By highlighting this historic knowledge about the act of styling, the chapter adds nuance to the complex value of styling in fashioning clothing and, as such, to the production of fashionable meaning in a complex interaction with the representation and negotiation of identity formation. In the following section, I explore the understanding of the concept of styling in the first half of the twentieth century.

Le style, c'est l'homme même[2]

In broad terms, style is typically considered today to be a subjectively defined concept, not a universal one. To 'have style' is an embodied aesthetic representation that cannot be rationally codified, as Entwistle has stated based on her study of fashion buyers at the London department store Selfridges (Entwistle 2009). Being stylish, having style and the act of styling are based on tacit, experimental practices that are measured against a contextual sense of what is normatively perceived as beautiful, or the opposite. Style is therefore not especially dependent on function.

In 1753, Georges-Louis Leclerc, Count of Buffon, wrote, *'Le style, c'est l'homme même'* – style is the man himself. Buffon considered style to be the representation

of a person's identity, a mark of character of the person 'having style'. Style could not as such be strictly, rationally explained or forecasted, as it had ontological status; it *was* the person's character, performed through acts of writing when referring to Buffon ([1753] 1921), but as I would also argue, through acts of getting dressed and acts of wearing.

And such understanding of style continued to hold sway in the first half of the twentieth century. Having style was considered an important part of being a superior human being, being an ideal citizen – a sign of civilization one might say (Niessen 2010). Developing style was therefore part of one's education: an aesthetic educational achievement expressed through one's taste and sense of order, tidiness, and beauty – as well as one's sense of what is disproportioned, asymmetrical and untidy, as the Danish encyclopaedia *Salmonsens Konversationsleksikon* states in its 1916 edition.[3] Around the turn of the twentieth century, having style – a result of numerous styling practices – was considered an aspirational achievement and discipline in the daily work of being in control of oneself and cultivating one's personal aesthetic and self. In this context, having style was dependent on the act of styling, on actively shaping one's expression, one's way of being dressed and of presenting one's body.

At the time of its publication, the book *Vort hjem* (*Our Home*) was a respected reference work about the life and culture of the bourgeoisie. On the subject of women's dress, it stated that to have style was the ideal, as it would bring the good life, a life in balance and harmony (Gad 1903: 93). The book implied that mastering the act of styling, of visually expressing and managing oneself, would lead to social acceptance. But as fashion scholar Christopher Breward has pointed out, it also offered the potential to formulate a substantial visual critique of established norms and values, as demonstrated by late nineteenth-century dandies like writer Oscar Wilde (1854–1900) and his flamboyant and lavish way of dressing (Breward 2000: 164).

One's representation and visual appearance were acknowledged at the time to be a communicative tool as well as part of one's self. Since 'having style' would express being in balance, performing one's social status, it was advised at the time to be careful not to disrupt this balance by mindlessly following new fashions, as the quote below indicates.

The debate over whether certain stylings were excessive, and thus risked overshadowing other personal qualities or values, was a recurring one. In the weekly women's journal *Hus og Hjem* from 1913, one contemporary novelist expressed his opinion about these issues:

Clothes make the man and flesh the horse, as an old saying has it, and it is still true today. How often is the conspicuous clotheshorse much more honoured than the truly praiseworthy man who stays out of the way and attracts the crowd's attention neither with his dress or behaviour! To be well-dressed is a natural thing. But when it is the clothes that make the man, that is not good, it is more like a caricature. There have always been people who just want to be the centre of attention. We know them as fops, dandies, coxcombs, Brummells, violet boys, etc. Though their nicknames and fashions may change, they remain the same. Even though the fashionista or playboy still vies for our attention, in our time we have learned to look at things more rationally, and judge a man by his achievements. But the old saying that 'Clothes make the man' still holds some truth and will probably never be entirely out of date.

Kronstrøm 1913: 800–801

As the quote shows, having style was considered a matter of self-control – controlling the temptation to give in to ever-new launches of fashion and seeking instead to express the virtue inherent in disciplined action.

Understanding style in this historic context differs radically from the postmodern perception of style as expressed in the latter part of the twentieth century by academics such as cultural studies scholar Dick Hebdige in the book *Subculture: The Meaning of Style* ([1979] 1988). To Hebdige, style is bricolage, a blend of different aesthetics, a definition that does not apply in the historical case examined by this chapter. Instead, in the first half of the twentieth century, style was considered a virtue, a sense of disciplined order. The modern perception of style as bricolage suggests a stronger belief in its positive influence on the wellbeing of a person having style, being styled and mastering the act of styling. This follows not only the ideas of Buffon, but also those of German historian Friedrich Schiller (1759–1805), who argued that style ought to be part of aesthetic education, since having style and favouring what was aesthetically beautiful and well-proportioned would lead to a person's freedom and self-realisation (Schiller [1795] 1970).

In order to better approach the case study of the act of styling before 'styling' in Denmark in the first half of the twentieth century, I will briefly describe the Danish fashion system (a system of the provision of clothing through interrelated practices of production, distribution, consumption and use) of the time. This will allow an understanding of the context within which the act of styling in everyday life was practised and why it was considered a valuable cultural competency.

The Danish fashion system before 'Danish fashion'

Around the turn of the twentieth century, fashion as we now understand it –
following the latest looks in clothing design and as a cultural and economic
activity – was not perceived or practised as something under local influence in
Denmark. New fashionable styles were mainly imported from European fashion
centres such as Paris, Vienna and London (Gad 1903: 79). This was made possible
by international fashion magazines as well as local weekly women's journals
reporting from abroad about the latest looks and providing patterns and sewing
instructions for reproducing them; such features were printed alongside news
articles on politics and international affairs, recipes, as well as advice intended to
improve housekeeping and wardrobe maintenance.[4] Styling a distinctly 'Danish
fashion', which would become a vital focus of the Danish fashion industry in the
latter half of the twentieth century, was not on the agenda, but bringing the latest
international fashions to Danish fashion consumers was (Cock-Clausen 1994;
Melchior 2013).

Discussion of a Danish fashion system in the first half of the twentieth century
is only possible insofar as it mirrors international fashion systems. The mediation
and styling of fashion took place in local fashion magazines, department stores
located in Copenhagen and other large cities, and through the new fashion
communication 'technology' of the fashion show, which is believed to have been
introduced to the country in 1911 by the Copenhagen-based department store
Fonnesbech.[5]

The visibility of and investment in fashion was most prominent in the
country's capital, Copenhagen, but with the gradual distribution of ready-to-
wear fashion beginning at the end of the nineteenth century, and with rising
numbers of haberdashery shops, fashion also became visible in rural towns. This
pattern followed the demographics. At that time, most people still lived in the
countryside or outside the capital,[6] so it made sense to distribute fashion news
throughout the country, a trend that was accelerated by the introduction of mail-
order shopping. In 1911, the company Daells Varehus began its mail order
business, offering access to affordable, ready-to-wear fashion and other home
consumer goods via sales catalogues distributed to all officially registered Danish
households (Cock-Clausen 2011).

The speed at which news of the latest fashion travelled approached that of the
present day. Advertisements from 1909 and 1910 in the monthly journal
Modejournal Chic (*The Fashion Journal Chic*) reveal that new styles and patterns
were presented by fashion retailers and distributed around the country not only

monthly, but sometimes weekly, offering fashion-oriented persons of means (i.e. time and money) information about new styles. In addition, the tailors' trade journal, *Skandinavisk Skrædder-Tidende*, distributed fashion reports from Copenhagen (considered by the journal to be the fashion capital of Denmark, Norway and Sweden) to tailors nationwide, offering for sale by mail order new patterns for fashionable men's, women's and children's wear, along with tricks of the trade on how customers could be fashionable.[7]

So new fashions and styling knowledge appear to have been available across the country, and the great variety of offerings would suggest that the majority of people made acquiring such knowledge a priority. Even if you were not in a position to be able to buy or make new outfits, modifying old clothes to follow new styles was an option. It was a time of deep structural changes in society, as from the mid-nineteenth century Denmark had abandoned absolute rule in favour of representative democracy,[8] which accelerated social mobility and aspirations for bourgeois ideals as it was the bourgeoisie that from this period in Danish history held the power base in the country.

It is important to keep in mind, however, that the size of most people's wardrobes in the first half of the twentieth century was limited by today's standards. Austerity characterized the wardrobes of the majority of people, however they might aspire to the expansive collections of the bourgeois ladies who had a choice of outfits for a variety of social and private occasions. According to the 1903 reference work *Vort Hjem* (*Our Home*), a lady's wardrobe ought ideally to contain a home dress, a 'tailor-made' street dress for use in the streets of one's urban environment, a visiting dress for social encounters in the afternoon, a sports dress for activities such as bicycling, riding, rowing or swimming, and finally a formal evening dress (Gad 1903). The book acknowledges the obvious fact that not everyone would be able to afford such an extended and multifaceted wardrobe, and dedicates long passages to how one might manage to dress fashionably with a limited budget by possessing skills of styling to adapt to changing fashions. Just as importantly, however, the book notes the importance of dressing according to one's body type and personality, achieving a 'stylish' fit, and developing a well-proportioned look using colours suited for multiple situations. The chapter of *Vort Hjem* on 'Fashion and economy' states:

> . . . it is impossible to deny that expectations are great, and the task of dressing oneself can seem overwhelming. There is no doubt that it costs either a great deal of time and interest or lots of money to be beautifully dressed. But luckily, less complicated solutions can be found for those who have neither an excess of time nor money to spend. The lady who has a profession to attend to and who can

afford neither the expense nor time to own a morning dress, a walking dress, a sports dress, a tea gown, a house dress, an evening dress, and whatever other lovely things one might name, can, without offending good and educated taste, wear a plain dark blue or black woollen dress in the morning without any accessories but a clean white collar and cuffs, and still perform her work, do her errands, receive her friends, and eat dinner in the same dress and still be in our opinion very suitably dressed. Indeed, she may even go for walks and visits if she has a jacket – which can easily match two skirts – made of the same fabric as the dress.

Gad 1903: 124–125

As the quote makes clear, the styling of a limited wardrobe is important, not just in order to live up to the fashion ideal in itself, but to be fashionable, to reproduce the values of social encounters. Styling, understood as a practice of dressing in a way deemed proper, has links to social interaction, to showing respect and enjoyment within the social group. The way of styling one's dress was not without importance. It was viewed as essential to respectful social interaction – indeed, to being an ideal citizen.

Making, mending and altering dresses were part of the styling activities embedded in the local fashion system and were skills valued in everyday life. The value of these activities is marked by the fact that tailors, seamstresses and department stores would offer such services for those not able to sew or mend garments themselves. The practice of styling in this context points at a connection to the act of caring for one's dresses and wardrobe. Valuing styling leads to the continuous handling and care of what is worn, to work with the clothing that goes beyond merely keeping it clean and ironed.

The Danish fashion system in the first half of the twentieth century can be characterized as a complex system crossing national borders with the aim of providing the latest fashion trends to the country, which involved local producers of fabric, importers of fabric, local producers of ready-to-wear dresses, local tailors and seamstresses, editors of fashion magazines and women's magazines, trade journals, tailors' trade magazines, retailers of fashion, and fashion communication through media such as fashion shows, store windows and other kinds of store displays. Danish fashion was on the receiving end of fashion in an international fashion system context, but it existed because of what can be seen as a need for fashion in the Danish cultural context. Danes, like others in Western societies, wanted to achieve a fashionable visual appearance through styling, as this was considered an indication of discipline and cultivation, values to which everyone was supposed to aspire.

Styling with authority for fashion communication

In this section, attention is given to what the professional practices of styling are and how they are used to communicate fashion: to teach consumers how to be fashionable, well-dressed and confident, and how to maintain styling knowledge as fashions change. I examine specifically the fashion show, fashion photography and shop window display as articulations of authoritative styling practices in the first half of the twentieth century.

As it still does today, styling played a central role in communicating fashion in the period under study. The early part of the twentieth century was in many ways a formative period for fashion communication, especially fashion communication technologies like the fashion show, fashion photography and the shop window display. Here, the purpose of fashion styling practices was to stimulate fashion consumption, most often by staging an idea about 'the new', as well as by making a reliable record of the coming mode (Breward 2007: 278). Communication regarding the latest fashions should appeal to potential consumers and further lead to the act of personal styling when integrating the new acquisition into the existing wardrobe.

What is at work in these channels of communication could be said to be 'styling with authority'. Indeed, leaders in the Danish fashion system derived their authoritative status from their links to international counterparts in major cities abroad. Such authority belonged to the fashion designer, the photographer, the decorator, and to the products of their collaborations. In order to have a sense of what might be the next new fashionable trend, Danish fashion designers, photographers and decorators sought inspiration in the international fashion centres of Paris, Vienna and Berlin. These links not only provided new inspiration, but also the foundations of their claims to authority.

Styling and being styled were entangled practices that served a variety of entangled interests, such as developing the volume and earnings of the fashion business, and also living up to the moral values of the time of being well-dressed, well-behaved and demonstrating good character through one's visual appearance. Styling straddled the business of fashion and the practice of wearing fashion in a mutually dependent commercial and moral relationship.

Styling the Danish fashion show

In the early 1930s, it was reported that the first fashion show to be held in Denmark took place in September 1911. It was modelled after the Parisian

fashion parades of 1910, using live mannequins to present the new collection of a fashion house. The department store Fonnesbech introduced the phenomenon to Denmark, hosting the first event of its kind in-house with live models presenting the new designs for an exclusive group of invited guests. The following year, Nimb, a restaurant and entertainment destination connected to Tivoli Gardens, became the preferred location for fashion shows, first for Fonnesbech, and beginning in 1913 for the department store Magasin du Nord. These first shows were 'theatrical presentations' held just once a year (see figure 5), but by the end of the 1910s, they had become biannual events hosted by an increasing number of department stores and local fashion houses, held at luxurious venues such as Nimb and The Palm Garden at the exclusive Hotel D'Angleterre.[9] Thus, the role of the fashion show in the local fashion system was less structured and ritualized in these formative years. The fashion shows were consumer-oriented, and as in Paris, were intended to stimulate customers to buy from the new season or take elements from it to update their existing wardrobe.

How were fashion shows relevant to the development of the cultural competency of styling? The settings of these early fashion shows were established

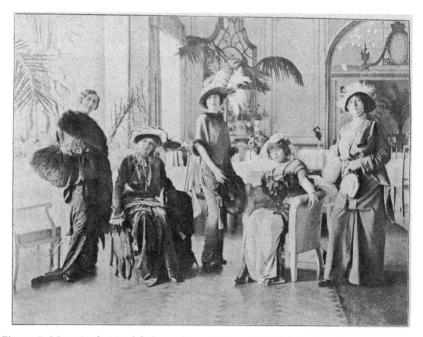

Figure 5 Magasin du Nord fashion show at Nimb, 1913. It is both a theatrical performance enacting 'new' fashion of the season and an educational situation, building the audience's sense of styling as a cultural competence. Photographer: Unknown. Image reproduced with permission from Magasin du Nord Museum.

places of entertainment for the bourgeoisie, which is an indication of the events' target group. The fashion shows were typically invitation-only events accompanied by afternoon tea. Each dress would be presented by number, as the fashion show speaker informed guests about what fabric it was made from and for what occasion it was intended, while highlighting its fashionable features. This practice makes it possible to argue that the fashion show served an educational purpose for attendees, enabling them not only to make purchases, but also to learn about styling. The shows were therefore both social events, where meetings were facilitated between those interested in fashion, and events that expanded the knowledge of fashion and how to dress in style.

Styling fashion photography

For the dissemination of fashion, photography was both more efficient and widespread than many of the other forms of communication known at the time. Photography made it possible, like fashion drawing before it, to circulate new fashions and ways of styling them at relatively low cost. As photography and its reproduction developed, fashion photography became a more common source of styling information (de la Haye and Mendes 2014). Fashion photography was reproduced in fashion magazines, women's magazines and newspapers. The composition of these photos was not especially varied. Live models would be dressed by the fashion designer and styled for the photo session at a fashion house or photo studio, often next to some element of interior design or furniture– a chair, chest of drawers or a mirror – to create an atmosphere and contextual background for the fashion presented (see figure 6). Fashion photography often served a dual purpose – documenting the clothing and staging the photograph – in which a narrative around the latest fashion was created through the model's pose, the light setting and the props used in creating the image.

In print media such as women's magazines, fashion photography was often accompanied by sewing patterns, making it possible for readers to reproduce the designs and style them according to their own measurements and preferences. Thus, reading a fashionable dress as both an image and a technical pattern was a necessary competency for a follower of fashion, particularly for those who did not have access, for geographical or economic reasons, to 'interpretation support' from a fashion designer, tailor or other professional. For this reason, an explanatory text would most often accompany the image in order to guide the reader in understanding how the design was envisioned, and such text would function as the key to understanding a new fashion, with reference to its shape,

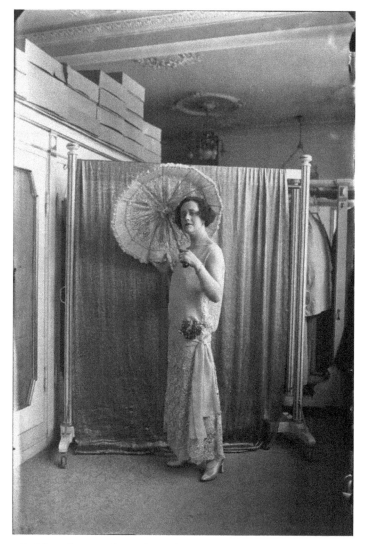

Figure 6 Fashion photography in the making. The model poses for the camera in the fashion studio of the department store Illum in Copenhagen. The new fashion is communicated through the styling of the dress with umbrella and the sideways pose. Photographer: Holger Damgaard (1870–1945), c. 1920. The Royal Danish Library.

fabric, colour or styling context. This dissemination of fashion was perceived as normative, as something it was possible to dictate, because it conveyed a particular essence of proper styling to its users. Through fashion photography, the viewer was expected to learn how to decipher the ways in which fashion was dictated.

Styling by the fashion designer

Via private sessions with their customers, fashion designers could also disseminate their styling authority in a more intimate setting reserved to a limited group of fashion consumers.

Jørgen Krarup, fashion designer and former head of fashion at the Copenhagen department store Fonnesbech (1847–1970), explained in a 1980 radio broadcast how the daily work of the fashion designer would be to edit a customer's wardrobe according to the latest fashion changes.[10] In the tradition of Charles Frederick Worth (1825–1895), the 'father of couture', fashion designers styled customers according to the fashion being promoted at the time (Breward 2000: 29). Mastery of this practice demanded knowledge of a customer's lifestyle and the contents of his or her wardrobe, and sometimes this would include adding a new fashionable dress to their collection. But it might just as well mean making smaller changes, such as adding 'accents' (ribbons, flowers etc.) to a dress or just finding new combinations with different accessories (see figure 8).[11] The development of friendships between fashion designers and customers was not uncommon, since the work required intimate knowledge for it to be done well, stimulating a social bond during the time spent together at fittings (Verge 2018) (see figure 7). As in other teaching situations, trust between teacher and pupil was important to achieve the most efficient transmission of knowledge. Trust was required to be in the changing room for fittings with the fashion designer or tailor, but the situations were at the same time a space in which to build trust.

Buying a fashionable, hand-made dress of the best quality, which was a common practice during the first half of the twentieth century, may have been costly and time consuming, but it offered a masterclass in standards of beauty and dress for observant customers eager to learn how to style themselves in sync with the preferred look of the moment. Buying a bespoke fashionable dress required numerous fittings in the fashion atelier, usually in front of a mirror and surrounded by an interior that exuded the essence of bourgeois culture, enabling the buyer to observe and internalize what was considered well-proportioned, what counted for good quality in fabrics and trimmings, what the current fashions consisted of, and how one might style one's existing wardrobe to suit the current fashion.

Birthe Schaumburg (b. 1928), who worked at the department store Magasin du Nord around 1950, and who was also the great-granddaughter of the store's founder Emil Vett (1843–1911), remembers how the work of styling in the

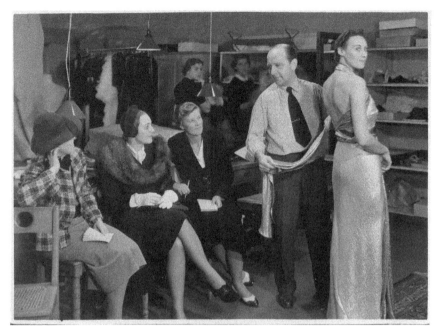

Figure 7 Styled by authority in the fashion studio of Magasin du Nord. The three women are taught by the head of the department, Ejnar Engelsbert, how to understand the fabric used for the fashionable dress being made. Photographer: Unknown. Image reproduced with permission from Magasin du Nord Museum and VISDA.

fashion salon was like any other job at the department store and required record-keeping, analysis and action plans in order to develop the store's business model.[12] It was not simply an aesthetic practice performed by the fashion designer, but a collaborative effort in which the *directrice* would keep records of customers' wardrobes, lifestyle information, and wardrobe performance requirements, and combine this with information about new fabric and fashions being launched internationally, what items the department store was able to acquire, and knowledge of consumer requests in general.[13] This bookkeeping formed yet another part of the customers' education in styling skills, since it was used to plan how to develop each individual customer's wardrobe in accordance with expectations around what it meant to be properly outfitted.

In this way, styling formed a complex network of activities keeping the fashion business alive while also increasing customers' skills and knowledge regarding the aesthetics and bourgeois norms that were woven into their wardrobe.

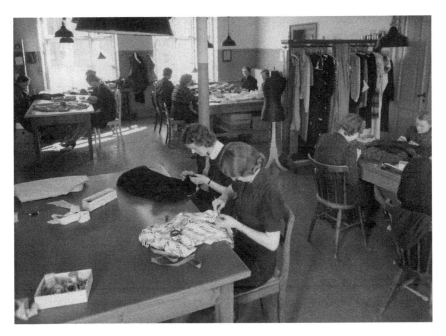

Figure 8 Women at work in the Repair and Changes Room of the department store Magasin du Nord in Århus, 1940. The act of styling and making adjustments to one's wardrobe required work and care either by oneself or as a bought service.
Photographer: Unknown. Image reproduced with permission from Magasin du Nord Museum and VISDA.

Learning how to style as a fashion consumer

As described above, styling played a much more important role in society than simply tempting people to buy clothes, even though it became evident as the twentieth century progressed that such temptation was becoming more widespread. In this context, it is important to emphasize the role of styling as more than simply commercializing a certain look, promoting a business or creating a visual identity. Perhaps the situation is not so different today, but when looking back at the first half of the twentieth century, it becomes clear how the act of styling played a key role in negotiating, learning, embodying and materializing bourgeois culture, understood as the norms and values that defined the era and circumscribed the aspirations of the good and proper life of citizens.

In the fashion magazines and women's magazines I have examined, the possession and acquisition of cultural competencies is approached as a question of education. The readers of magazines are expected to be able to learn the

competencies expressed in order to be 'fashionable', 'chic' or 'stylish', in the words of the magazines themselves.

> One hears so often how French and American women are praised for their great taste in dress, and their elegance and chic is credited to one famous fashion designer or another. This not always the case, however. To always be elegantly dressed is so costly that only the very few can afford the luxury of wearing celebrity designs at all times. The majority of people take inspiration from what they see at fashion shows and choose from there what they can adapt to their personal needs. They give their dresses the same distinctiveness that a gifted housewife gives her home. They choose the fabric, accessories, and fit; make old into new; make a detail out of nothing; and develop superior skills with a minimum of instruction. Ask the heads of the great fashion studios in Paris, where they studied? They invariably reply: Nowhere! It just happened. Ask our gifted housewives where they learned to cook such lovely food? They taught themselves, perhaps by studying different recipes, and by listening here and there. Once you are on the right track and have learned the basics, then practice makes perfect.
>
> *Hus og hjem* 1921: 276–277

The quote demonstrates that being a self-taught expert is considered to be a common virtue within the fashion industry, and encourages the reader by its tone to do the same – but by accepting the curriculum presented in the magazine. The cultural competencies of styling are, as such, based on an experience-oriented education founded on curiosity, novelty-seeking, aesthetic interest and ambition to achieve the best result.

Essentially, it is normative values that prescribe styling: perfection, ambition, quality, proportion, taste and order. Women were expected to adhere to these values, make them part of their character, in order to master their own styling practices. But as women's magazines of the period show, they also had to be very practical and prepared to take action to maintain their styling and presentable appearance.

A feature in the fashion magazine *Madame* called 'Little bright ideas' suggested styling and maintenance ideas to its readers, such as the one below from 1943:

> If you are at a dinner party and your dress gets stained, you naturally know that most stains are best removed quickly. . . . But once the stain is removed, you are left with a wet spot on your dress that catches everyone's eye. Do you know what you can do? Take an electric bulb that has been switched on long enough to be hot. Iron the wet spot on your dress until it is dry and flat again.
>
> *Madame* 1943: 21

This practical advice shows how the magazine communicated its attitude towards being well-dressed to its readers, helping them find ways to meet their goal of dressing stylishly, as if their own sense of dress would not suffice. Through such micro practices, along with training of the consumer to style and be well-dressed, we can appreciate the purpose of styling beyond an immediate aesthetic experience, and how it served to regulate behaviour and secure a fashionable and well-dressed public appearance that communicated good citizenship, as was expected by bourgeois culture.

In conclusion

Understanding the act of styling as a practice and cultural competency within the first half of the twentieth century has been the focus of this chapter. Taking this perspective has shown how styling can be seen as serving not only the purpose of materializing new fashionable styles, but as tied to other practices of becoming and particularly valued as a citizen in possession of good manners, aesthetic education and self-control.

In the decades up to the turn of the twentieth century, Denmark had been undergoing deep structural changes in society, resulting in the ascendancy of bourgeois culture. The act of styling can be seen as a competence that needed to be learned in order to fulfil the ideals of bourgeois norms and values. How a person dressed mattered, and the acts of styling and learning to style were an investment for both the fashion industry and its consumers. It was time-consuming to style, whether one was fortunate enough to be able to buy a bespoke dress or had to sew one oneself. Fashion communication aimed at educating consumers, or even fashion dictates, could just as easily be understood as a transmission of knowledge in order to develop fashion consumers' cultural competence in styling in order to live and express the bourgeois value of being in balance: neither a fashion victim, nor out of fashion. One should dress to flatter the symmetry of one's body, in good quality fabrics, in colours that suit one's complexion, in clean clothes appropriate to the occasion at hand.

To feel at ease with these ideals and to possess these cultural competences must have required a great deal of work for most people. As indicated at the beginning of this chapter, the perception that fashion developed over the twentieth century from passive dictates to active choices appears in this context to reveal an inadequate narrative of the understanding of the role and meaning of fashion and the act of styling in the first half of the twentieth century.

Specifically, this notion appears to rely on a postmodern understanding of fashion and styling as a bricolage practice that composes identity unconstrainedly, as Hebdige would say, leaving an opening for the profession of styling to emerge in order to help guide people and companies in styling practices in the absence of restrictive norms and values.

The work presented in this essay suggests that fashion both 'dictates' and invites its consumers to be actively engaged in complex ways, much like recent fashion studies research shows (Kaiser 2012). It also raises the question of why the dictates of fashion came under such strong critique in the 1960s. Ambitious to question bourgeois culture and to seek new perspectives on societal structures, fashion became a flashpoint of change precisely because it is a social marker, and because it was one of the principal materializations of bourgeois norms and culture. As a result, fashion dictates became passé. Freedom of choice, diversity and experimental looks that acted as expressions of opposition became the trend. Fashion and styling survived but in a new context shaped by anti-bourgeois ideals that criticized fashion and styling for being superficial and trivial, representing outdated cultural competences. It was supposedly just about surface, flagging social position, and not about inner values and seeking one's own identity, which would become the aim of the more diverse fashion industry that followed and which catered to new consumers convinced of forming their individual identity through dressing in an anti-fashion fashion manner (Polhemus 1978).

An exploration of what fashion and styling consisted of before this transition, along with an interrogation of the dominant discourse on fashion, seem to have the potential to lend new insights to understanding fashion history. Notably, they can contribute to challenges currently faced by fashion companies and the fashion system arising from climate change and requiring sustainable practices to minimize over-consumption and cultivate ethical handling of fashion in its place.

Perhaps styling competencies could find new relevance in our current context as a good deed of citizens, as a way to improve the longevity of garments and thus the sustainability of fashion. Styling may have untapped potential, through wardrobe management, to limit the volume of garments consumed and to build a new set of values around appreciating and caring for one's wardrobe as well as for one's personal identity as a renewed cultural competence in an Anthropocene world. Styling, as practised in the first half of the twentieth century in both private and commercial spheres, seems to be a key to renewal. Through understanding historical styling practices there is a potential to drive change

today, if through our knowledge we also see the good we can do for the environment when it comes to fashion.

Notes

1 The sources for the study are various and many: women's magazines (*Hus og Hjem, Hver 8. dag, Vore Damer*), fashion journals (*Modejournal, Gera Modejournal, Modejournal Chic, Madame, Tidens Kvinder*), trade journals (*Skandinavisk Skrædder-Tidend, Textile*), books of etiquette (*Vort hjem, Takt og tone*), press cuttings from the archive of the department store Magasin du Nord (founded in 1868). Characteristic for many of these sources as historical evidence is that they are created as a potential, yet imaginary worldview, which means that they say more about values and ideas than about daily life (see, for example, Lees-Maffei 2003; Olden-Jørgensen 2001). Sources for the study focusing on everyday life experiences include interviews with selected individuals who have been close to and have experienced Danish fashion in the first half of the twentieth century. These interviews have been conducted since 2013.

2 Comte de Buffon ([1753] 1921), *Discour sur le style*. Paris: Librairie Hachette.

3 *Salmonsens Konversationsleksikon*, vol. V, 1916, p. 749.

4 The first Danish fashion magazine is believed to have been published in 1831, though it is not until the 1850s that Danish fashion magazines become more common. Still, much fashion content was international (Frøsing and Thyrring 1963: 353).

5 According to a newspaper article from 1932 about the history of fashion shows in Denmark (Nyholm 1932).

6 In 1911, the Danish population numbered approximately 2.7 million individuals, of whom approximately 560,000 lived in Copenhagen, somewhat fewer in the provincial towns (*c.* 550,000), and the rest in the countryside and rural towns (*c.* 1.6 million). See https://danmarkshistorien.dk/leksikon-og-kilder/vis/materiale/danmarks-befolkningsudvikling/ [accessed 15 December 2018].

7 *Skandinavisk Skrædder-Tidende*, 1. og 2. årgang, 1906–1907.

8 In 1849 Denmark changed from being an absolute monarchy, with its sovereign king, to a representative democracy.

9 Inger Nyholm (1932), 'Moden er lundefuld og skifter hurtigt. Den første danske Mannequin-opvisning for 21. år siden og Udviklingen derefter' (Magasin du Nord Scrapbook 10/12 1930–9/4 1934).

10 'Familiespejlet' with interviewer Janne Hovmand, Danmarks Radio, 1980.

11 'Alle disse absurde ting vi ta'r på', Radio broadcast by Danmarks Radio, 23 June 1980. Guest: Jørgen Krarup, interviewer: Janne Hovmand.

12 Interview with Birthe Schaumburg, 28 Feebruary 2013.
13 Interview with Birthe Schaumburg, 28 February 2013.

References

Andersen, Ellen (1986), *Danske dragter. Moden I 1790–1840*, Copenhagen: Nationalmuseet og Nyt Nordisk Forlag Arnold Busck.

Bech, Viben (1989), *Danske dragter. Moden 1840–1890*, Copenhagen: Nationalmuseet og Nyt Nordisk Forlag Arnold Busck.

Breward, Christopher (2000), *Fashion*, Oxford: Oxford University Press.

Breward, Christopher (2007), 'Fashion on the Page', in Linda Welters and Abby Lillethun (eds.), *The Fashion Reader*, 278–281, Oxford: Berg.

Brøndum-Nielsen, Johs and Palle Raunkjær, eds. (1915–1939), *Salmonsens Konversationsleksikon*, Copenhagen: J.H. Schultz Forlagsboghandel.

Buckley, Cheryl and Hazel Clark (2012), 'Conceptualizing Fashion in Everyday Lives', *Design Issues*, 28 (4): 18–28.

Cock-Clausen, Ingeborg (1994), *Danske dragter. Moden I 1890–1920. Historicisme og nye tider*, Copenhagen: Nationalmuseet og Nyt Nordisk Forlag Arnold Busck.

Cock-Clausen, Ingeborg (2011), 'Konfektion, modetøj og forbrugervalg', in Marie Riegels Melchior, Solveig Hoberg, Maria McKinney-Valentin, Kirsten Toftegaard and Helle Leilund (eds.), *Snit: Industrialismens tøj i Danmark*, 165–190, Copenhagen: Museum Tusculanum Press.

Comte de Buffon, Georges-Louis Leclerc ([1753] 1921), *Discour sur le Style*, Paris: Librairie Hachette.

Crane, Diana (2000), *Fashion and its Social Agendas, Class, Gender, and Identity in Clothing*, Chicago, IL: University of Chicago Press.

de la Haye, Amy and Valerie D. Mendes (2014), *The House of Worth: Portrait of an Archive*, London: V&A Publishing.

Ehn, Billy and Orvar Löfgren (2006), *Kulturanalyser*, Århus: Forlaget Klim.

English, Bonnie (2007), *A Cultural History of Fashion in the Twentieth Century*, Oxford: Berg.

Entwistle, Joanne (2000), *The Fashioned Body: Fashion, Dress and Modern Social Theory*, Cambridge: Polity Press.

Entwistle, Joanne (2009), *The Aesthetic Economy of Fashion*, Oxford: Berg.

Frøsing, Hanne and Ulla Thyrring (1963), 'Klæder', in *Axel Steensberg: Dagligliv i Danmark i det nittende og tyvende århundrede*, 325–358, Copenhagen: Nyt Nordisk Forlag Arnold Busck.

Gad, Emma, ed. (1903), *Vort hjem*, Copenhagen: Det Nordiske Forlag.

Hebdige, Dick ([1979] 1988), *Subculture. The Meaning of Style*, London: Routledge.

Hus og hjem (1921), 'Kursus i Tilskæring af Elna Fensmark', *Hus og hjem*, 13 (26): 276–277.

Kaiser, Susan (2001), 'Minding Appearances: Style, Truth, and Subjectivity', in J. Entwistle and E. Wilson (eds.), *Body Dressing: Dress, Body, Culture*, 79–102, Oxford: Berg.

Kaiser, Susan (2012), *Fashion and Cultural Studies*, London: Berg.

Kronstrøm, J.I. 1913. 'Klæder skaber Folk', *Hus og Hjem*, 34 (18): 800–801.

Lees-Maffei, Grace (2003), 'Introduction Studying Advice: Historiography, Methodology, Commentary, Bibliography', *Journal of Design History*, 16 (1): 1–14.

Lynge-Jorlén, Ane (2018), 'Stylisten. Fra fodnote til supernova', in Mads Nørgaard and Anne Persson (eds.), *Dansk modeleksikon*, 72–76, Copenhagen: Gyldendal.

Madame (1943), 'Smaa lyse ideer', *Madame*, September, vol. 1.

Melchior, Marie Riegels (2013), *Dansk på mode. Fortællinger om historie, design og identitet*, Copenhagen: Museum Tusculanum.

Nielsen, Henning, ed. (1971), *Folk skaber klæ'r. Klæ'r skaber folk*, Copenhagen: The National Museum.

Niessen, Sandra (2010), 'Interpreting "Civilisation" through Dress', in Lise Skov (ed.), *Berg Encyclopedia of World Dress and Fashion*, vol. 8: *West Europe*, 39–43, Oxford: Berg.

Nyholm, Inger (1932), 'Moden er lunefuld og skifter hurtigt. Den første danske Mannequinopvisning for 21. år siden og Udviklingen derefter', *Berlingske Tidende*, 14 August 1932.

Olden-Jørgensen, Sebastian (2001), *Til kilderne. Introduktion til historisk kildekritik*, Copenhagen: Gads Forlag.

Polhemus, Ted (1978), *Fashion and Anti-Fashion*, London: Thames & Hudson.

Schiller, Friederich ([1795] 1970), *Menneskes æstetiske opdragelse*, Copenhagen: Gyldendal.

Venborg Pedersen, Mikkel (2018), *Den Perfekte Gentleman*, Copenhagen: Gads Forlag.

Verge, Marieanne (2018), *Modekongen Holger Blom. En livshistorie*, Copenhagen: Gyldendal.

Primary sources

The women's journal: *Hus & Hjem*, 1912–1938.

The women's fashion magazine: *Madame*, 1943–1944.

The scrapbooks of the department store *Magasin du Nord* in Copenhagen, 1900–1940.

The tailors' trade journal: *Skandinavisk Skædder-Tidende*, 1906–1908.

Denmark's Radio broadcast: 'Familiespejlet' by Jane Hovmand, 23 June 1980. Interview with Jørgen Krarup, former head of the fashion department of the department store Fonnesbech.

Interview with Birthe Schaumburg, 28 March, 2013.

The Homeless and the Hunchback: Experimental Styling, Assembled Bodies and New Material Aesthetics in Niche Fashion Magazines

Ane Lynge-Jorlén

Introduction

In a spread in *Purple* A/W 2017, French stylist Roxane Danset has created a series of surrealist DIY looks. Model Anna Cleveland is featured sitting on a discoloured foam mattress on a sparse green spot on the side of an asphalt road, wearing a headpiece of used plastic bottles held together by a string of fabric. In another picture her coat-and-trouser look is crowned by a headpiece made out of large pieces of bread held together by what looks like strips of wide beige plaster. This chapter explores experimental styling that has emerged in recent years in niche fashion magazines. Marked by a new resourcefulness and materiality, the bricoleur stylist adds objects from outside the field of fashion, using self-made, 'poor' objects, seemingly inexpensive clothes, even discarded items, and bodies staged within trashy environments. The looks in *Purple* are striking: the model is dressed in ragged cardboard boxes on top of a red suit (see plate 21), while elsewhere in the spread, a 'skirt' is made of a variety of bras, attached to an elastic band, and on her head the model wears a saucepan lined with tin foil. Assembled with mundane objects, rendering a self-made and hand-made style, they bring to mind the Dada artist Sophie Taeuber Arp in a costume for the 1916 Cabaret Voltaire with cardboard placed around her arms with strips sticking out representing fingers and a mask with an integrated crown. Yet trawling through the credit text of the *Purple* spread reveals that the found materials are paired with high fashion labels: Givenchy, Céline, Chanel and Rick Owens, to name but some. While combining garments from across fashion and

beyond is far from novel in styling,[1] the extent to which stylist Danset is at work, assembling layered silhouettes and making eccentric, body-altering and 'poor' looks, is arresting.

The editorial entitled 'What Can't be Said Will be Swept' in German *Dust* in 2018, styled by Katie Burnett and shot by Étienne Saint-Denis, expresses another related trope within contemporary styling. In a black and white image (see figure 9), a long-haired male model is semi-squatting, clad in layers of unidentifiable garments that seem to be tied or rolled around an ambiguous body. The torso is padded with an 'item' that mimics the anatomy of a large person's torso, as an abstraction on plump breasts and tummy rolls. Among the many high fashion labels, the text credits *'padding stylist's own'*. The transformative potential of styling is at the fore within this strand of styling where bodies are modulated

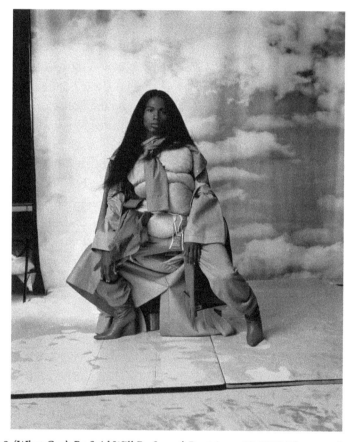

Figure 9 'What Can't Be Said Will Be Swept', *Dust*, issue 12, 2018. Photography: Étienne Saint-Denis. Styling: Katie Burnett. Courtesy of Étienne Saint-Denis.

through stuffing and cumbersome, absurd-looking objects that transform the anatomy of the depicted bodies. While such a body may be unwanted in a corporeal reality, it produces striking images that bring attention to the creation of both image and body.

These two snapshots from contemporary niche fashion magazines articulate experimental styling by mixing high fashion and self-made and mundane items to create 'poor' looks and bulky figures. Furthermore, they produce alternative bodies that, at least on the surface, resist the idea of bodily improvement through optimizing 'glamour labour' (Wissinger 2015) and discipline. I analyse the tropes 'the homeless' and 'the hunchback' as examples of styling that embody a new material aesthetic in niche fashion magazines through experimentation with shapes and materials, disrupting the norms of bodily containment. I draw parallels between experimental styling and the *assemblage*, as a method and style practised by Dada artists in the early twentieth century. To support the analysis, I use a range of concepts as a toolbox of theorization, such as Walter Benjamin's notion of 'rag picking' (Benjamin 1999; Evans 2003; Smith 2010), Deleuzian 'becomings' (Deleuze and Guattari 1987; Smelik 2016) and the Bakhtinian 'grotesque' in fashion (Granata 2016, 2017). Lastly, I discuss the experimental styling as an articulation of increased 'mediatization' of fashion (Rocamora 2017), as it is dependent on its media for its articulation.

Experimental styling belongs to the field that Francesca Granata coins 'experimental fashion', which refers to the kind of fashion that experiments with itself, its mode of presentation and its transformative and subversive significance and 'its potential for resignification of norms' (2017: 5). It also connects to 'critical fashion', noted by Adam Geczy and Vicki Karaminas as a practice within fashion that is 'designed as imbued with the critical qualities formerly afforded by art' (2017: 4). Overall, the field of experimental fashion and critical fashion is characterized by disturbance of norms and conventions by designers and image-makers across the fashion industry regarding bodies, identities and materials, among others. The disruptiveness of experimental styling is its use of unconventional materials to create images that if not dismantle fashion, then at least offer alternative ways of doing fashion from within the system that is experimental, self-conscious and deals with deviant, yet temporary bodies that are not easily categorized.[2] Labelled as the 'material turn' within fashion studies and beyond, there is an increased scholarly focus on 'practice, embodiment and experience' (Rocamora and Smelik 2016: 12). While this primarily deals with a shift in academic methodology and focus, the matter itself, the actual building blocks of the experimental styling, also calls for attention, as it represents

a 'new material aesthetics' (Bruggemann 2017), which is also part of an overall material turn in the arts (see, for instance, Lange-Berndt 2015).

The rag picker and the homeless

Across magazines, for instance in *Vogue Korea* (August 2013), *W Magazine* (September 2009) and *Antidote* (A/W 2011), and many more titles, images of what have been called 'trashion' 'homeless chic', 'tramp chic', 'landfill couture' and 'bag ladies' have proliferated in recent years. Seminal stylist Caroline Baker did a tramp story for *Nova* Magazine as far back as 1971 (see Alice Beard, this volume). When fashion flirts with homelessness it often causes moral outcry; for instance, the homeless Chinese man named Brother Sharp became a viral fashion icon (Mackinney-Valentin 2011), and Vivienne Westwood's Menswear A/W 2010, Japanese label N. Hoolywood A/W 2017 and Balenciaga's window display in 2018 in Selfridges in London, all have been criticized for capitalizing on underprivileged people living on the edge of society and aestheticization of poverty (Iversen 2017; Newton 2011; van Elven 2018). A spread published in *Vogue Germany* (September 2012), titled 'Signs of the Time', featured a bag lady, styled in layers of expensive gear with tons of dapper handbags. In one shot, the model, dressed in warm clothes covered with a transparent rain poncho, pushes a shopping trolley filled with stuffed plastic bags and four leather bags. She is crossing the street and in the background the storefront of Céline emerges. These examples of glamourized, overblown homeless styling are different from the renderings in niche fashion magazines where self-made and cheap, obsolete, found objects are transformed into new cultural objects, making the meaning-making of the materials used and the featured silhouettes more complex.

Before turning to the niche fashion magazine examples, it is worth providing contextualization of how the issue has been tackled in fashion studies. In her work on status ambivalence in contemporary fashion, Maria Mackinney-Valentin relates homeless chic to Fred Davis's notion of 'conspicuous poverty' (Mackinney-Valentin 2017: 43). According to Mackinney-Valentin, homeless chic is an example of 'perfectly wrong' when fashion inverts a social taboo for edgy effect (2017: 31). Yet, the somewhat structural idea that fashion uses poverty as a strategy for inversion of status markers only, leaves little room for creative agency and experimentation outside calculated shock value. While the motivations of stylists and other creatives involved in the making of the image are outside the scope of the text, context is provided for nuance. Experimental

styling is placed within niche fashion magazines, which, from the 1990s onwards, have been the breeding ground for radical photography (Lynge-Jorlén 2017) that, similar to the style magazines of earlier times, renders 'cultural and social themes extend[ing] beyond the scope of fashion' (Cotton 2000: 6). Many freelance stylists and photographers of the 1980s and 1990s sought inspiration outside fashion, including personal projects and fine arts, a shift Charlotte Cotton in her work on fashion photography of the 1990s has labelled 'the personalising of fashion' (ibid.). A similar personal project seems to be at work with Roxane Danset's *Purple* spread, discussed above, with the 'down-and-out' on the mattress in the urban space. The eccentric creativity and somewhat sombre mood of the spread brings to mind the stylish, yet unconventional and poor Edie Beale of Grey Gardens. Unlike the stylization of poverty in the *Antidote* and *Vogue Germany* examples, the rag picking and homeless styling found in niche fashion magazines encompasses a more experimental and personal approach to its setting and a strong focus on the mundane materiality of objects that sits well with Ulrich Lehmann's view on fashion photography: 'The fashion magazines now champion what previously would have been classified as "fine art" photography' (Lehmann 2002: T5). This is not an attempt to rescue experimental styling from its 'weird-for-the-sake-of-weird' and potential capitalization of its inversion effect, yet there is a noticeable agency, creativity and experimentation at play on the levels of materials, silhouettes and setting through visionary, even arty, articulation. Susan Kismaric and Eva Respini also note that 1990s' 'editorials were born not from trends seen on the runway, but rather from a conceptual beginning, either a literal, cinematic or psychological impetus that made for a compelling story' (2008: 34).

In May 2018, *Dazed Digital*, the online sister to the print magazine *Dazed*, featured a spread where garbage and trash were components of the setting of the shot.[3] Shot by Pascal Gambarte and styled by Jamaican-American Akeem Smith, it features clothes from the alternative New York fashion label Section 8, for which Smith has been a spokesperson (see Jeppe Ugelvig's interview with Akeem Smith in Chapter 6, this volume). The models are posing in and around a recycling centre: one sits on a billowing pile of cans, another is standing on top of flat and bundled cans (see figure 10), and in a third image a model has found her way to the cardboard site. The objects at the recycling centre have lost their original value and purpose as soft drink cans, precisely as fashion loses value over time. Adding to the idea of loss is the fact that the Section 8 label, the clothes featured in the images, was at the time of its inception a collaboration by a group of anonymous individuals, and in that sense prohibiting a point of origin. While

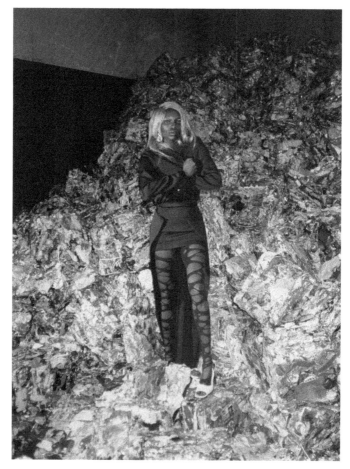

Figure 10 'Section 8', *Dazed Digital*, 2018. Photography: Pascal Gambarte. Styling: Akeem Smith. Courtesy of Pascal Gambarte.

the featured clothes are all new, the recycling environment adds symbolic value not just to the clothes but the overall aesthetic of the series of images, re-evaluating the norms in fashion. Writing on the trash exhibited in museums, in fact not very different from the cultural consecration of trash when shown in fashion magazines, Sonja Windmüller notes that 'discarded things have been identified as a cultural reservoir with a special validity' (2010: 39). There is a transferal of value at work in the spread: the rubbish becomes imbued with fashion status by its fashion magazine context, and the clothes, the shot, everything before the camera, are re-evaluated as 'rebel cool' that feeds into Section 8's alternative outsider identity.

Fashion's fascination with remains, trash and waste is far from new. Even stylists, as far back as Caroline Baker in the 1960s and 1970s (see Chapter 7 in this volume), used army surplus clothes, and Caroline Evans has called the stylists of the 1990s 'charity shop stylists' (2003: 25). To stage his avant-garde fashion show in 1989, Martin Margiela used a wasteground on the outskirts of Paris. On the surface, fashion and rubbish are opposing terms, with fashion carrying the promise of alluring newness and rubbish heralding death and disgust that disturb the pristine order of things. Yet the transitory, transformable features of waste is also embedded in the ephemeral features ascribed to fashion. Throughout fashion studies, it is argued that fashion has a built-in obsolescence, primarily concerning the social mechanisms with people wanting to replace garments although their existing garments are in mint condition (see, for instance, Black et al. 2013; Entwistle 2009; Fletcher and Tham 2014). While garbage, quite literally, is in a state of change and decay, fashion is through both the social mechanism and its capitalist structure of seasons also doomed to deteriorate.

In her seminal work on contemporary fashion designers' work with the traces of history, Caroline Evans notes the ways in which the past is transformed into new objects. Evans uses Walter Benjamin's metaphor of the rag picker as a person who rummages through history, picking up traces of history and putting them together in new forms, much like the work that Evans performs herself as a historian (Evans 2003). Benjamin based his rag picker on the poet Charles Baudelaire as an embodiment of the modern dandy who used the cultural debris of the city of Paris as building blocks for his poetry. The Parisian rag pickers of the nineteenth century made a living from collecting refuse – paper, cloth, glass, even dead animals – which was sold by weight and then converted into more valuable material. Collecting other people's trash and transforming it into clothes and shelter is part of the living conditions of the homeless whose clothing and lodging bear the mark of necessary improvisation.

A sense of improvisation is precisely articulated by French stylist Roxane Danset in the fashion story, 'In Nation of Ulysses', in the Finnish niche fashion magazine *SSAW Magazine* (A/W 2017), shot by Bibi Cornejo Borthwick. With an empty expression on her face, wearing clothes that are literally taped together, model Achok Majak is rummaging around clothes and food street stalls in, what looks like, New York. In an arresting image, she is wearing a combination of clothes, some are by high fashion label Calvin Klein, and paper dress and shoes made 'by the stylist'. The asymmetrical brown paper dress is taped to the other garments by brown gaffer tape in an improvised manner, resembling a destitute

who is inventive with what is at hand. While the fashion spread reads as an allegory for homelessness, it is offset by the high fashion garments. The narrative effect of the spread is highlighted by the serial layout with several images of the same look on the same page that capture the model's different activities in movement. In his work on East End London fashion, Alastair O'Neill notes that the distinction between the real rag picker and fashion designers using waste as part of their methodology is the first trades the rags into money and the latter operate within a different value system (O'Neill 2007). When asked about her use of 'poor' objects, Roxane Danset says: 'I don't have a judgment value on pieces, which is funny working in this field where everybody will rush for the new Balenciaga sneakers. To me that has little value' (Danset interviewed by Francesca Granata in Chapter 11, this volume). More than highlighting the idea of the homeless chic, Danset's work casts light on this use of found objects, as a re-evaluation of their aesthetic status. The title of the spread, 'In Nation of Ulysses', might also be a nod to the political punk band Nation of Ulysses whose leftist ideology and societal critique, exemplified for instance by their album *13 Point Program To Destroy America*, may run as an undercurrent in the spread, suggesting a critique of the current political state of America.

Danset's styling, both the *SSAW* example with brown gaffer tape holding the garments together and the *Purple* example with cardboard boxes and empty water bottle-headpiece in the introduction to the chapter, resembles the *assemblage*, as practised and pioneered by artists such as Robert Rauschenberg, Kurt Schwitters and Marcel Duchamp, whose mixed media art works were three-dimensional collages that incorporated discarded items, mechanical items and natural materials (Lumbye Sørensen 2018). Danset's tinfoil-lined saucepan and plastered bread for headpieces relate to assemblage as accumulation and joining of things, a method practised by the Dada movement that used unconventional, random materials that were cut up and glued together in collages or photomontages (Richter 1965). In the case of Danset, the body becomes a collage, albeit a moving one, which is frozen as an installation for the photo. Ties from Danset's work to Marcel Duchamps's ready-mades are also evident. Duchamps's work based on *objects trouvés*, which Geczy and Karaminas aptly note is also the French term for 'lost property' (2017: 93), are evoked in her work where the sense of lost property comes to the fore with the models' attire being connected by objects whose original use seems, if not lost, then disorientated. Yet the assembled body in *Purple* is captured beautifully by Viviane Sassen with a calming and proportioned, golden section framing that is pleasing to the eye. In their work on abjects of desire, Kutzbach and Mueller (2007)

address the 'aestheticization of the unaesthetic' where materials and items conventionally deemed unattractive are used in ways and in contexts that relocates their meaning. Danset's aestheticization (styling) of the unaesthetic (homelessness) also calls upon re-evaluation of the worth of objects and bodies.

Padding the hunchback

Aestheticization of the unaesthetic and material experimentation are also articulated in the styling of padded, 'hunchback' bodies in niche fashion magazines. Probing the shapeshifting style of the British stylist and fashion director of *Dazed* magazine, Robbie Spencer, proves to be a rich visual archive into styling's transformative effect on bodily borders. Spencer's work is marked by layering, excessive padding added to obtain new shapes and the assembling of variety of materials, textures and fabrics, sourced both within and outside fashion. For *Garage Magazine* (Fall/Winter 2015), in a series of images entitled 'Shape Shifters' shot by Patrick Demarchelier, several balloons are placed under the model's clothes with the many balloon knots resembling nipples. In other pictures, pillows are tugged in or strapped on to the body with belts or ropes, cut-up foam boards are fastened to the body, and industrial cling wrap, decorated with brooches, join two models together as Siamese twins. The visually loaded spread balances funny costume humour with strangely familiar uncanniness.

Sigmund Freud notes that 'the uncanny is nothing else than a hidden, familiar thing that has undergone repression and then emerged from it' ([1919] 2004: 94). By linking the uncanny with the familiar, as something that is close to home, Freud argues that it becomes estranged and frightening through the process of repression. The foundation – the professional, disciplined model bodies – that are made to look liminal by the work of Spencer, remind us of the potential grotesqueness of the human body if undisciplined and unmanaged, like the leper, the hunchback, the untreated, the 'body-out-of-bounds' as Granata coins it (2017: 2). But it is at arm's length, as the styling only provides an added layer of illusory flesh and deformation to a 'real' bodily foundation that is disciplined and fashioned, making the familiar and grotesque come together in one body, precisely as Freud's theorization of the uncanny.

In 'The New Aesthetic' for *Dazed Magazine* shot by Roe Ethridge (August 2015), Robbie Spencer styled 14 pages of primarily head shots of quirky models with modulated and manipulated faces with the help of mouth pieces, tape, sticky paint/lipstick and magnifying glasses. In the series of humorous images,

one stands out: the model is wearing fake discoloured, crooked teeth with a wedge of exposed gum. Only her shoulders and a bit of her torso are visible, dressed in a Phillip Lim satin bomber jacket. The clothes are not primary, but rather a conceptualization of a 'new aesthetic'. While the instability of the styled bodies is temporary, since as soon as the shot is captured they bounce back to their original shape, the link between the unaesthetic and bodily instability is significant to the field of experimental fashion. In her analysis of the experimental fashion designers, Francesca Granata points out that the grotesque body is not only related to the repressed, traumatized and diseased, as explored by Caroline Evans in her work on fashion design in 1990s, but also the 'sanguine and humorous' which are central aspects of Bakhtin's original concept (2017: 5). The false teeth intact with exposed gums and the modulation of the face by tape accentuate the more humorous dress-up quality of the spread. The DIY fabrication and deliberate grotesqueness of the looks are not concealed, but are precisely a central part of the overall style, foregrounding the self-made look. The 'new aesthetic' the spread seems to propose is twofold, as it is tied up with an understanding of normative aesthetic and a departure from it.

Granata's work on experimental fashion (2017) and the fashioning of the grotesque (2016) provides support in reading the styled awkward and bulky bodies as cultural ruptures. Tracing the linguistic meaning of 'grotesque', Granata notes that 'monstrous figures' (2016: 98) are intrinsic to the appropriation of the term in visual culture. She traces 'bodies-out-of-bounds' (2017: 2) that have proliferated since the 1980s and provides rich examples of body-modifying garments, rendering grotesque bodies, made by Leigh Bowery, Georgina Godley and Rei Kawakubo's Comme des Garcons, to name a few. Granata explores the experimental properties in the work of designers and performance artists as properties of monstrosity, critique of norms and standards of bodies and beauty. The rise of experimental styling is part of this study of experimental fashion as an example of the production of fashioned out-of-bound bodies and inclusion of unconventional objects. This shifts the focus from the intermediary job of styling as a go-between of the designer and the consumer/reader/viewer, to foregrounding the creative agency of the stylist.

For the fashion shoot 'Inflate', published in *Dazed* (September 2010), Robbie Spencer had commissioned prop designer Gary Card to create a piece for the story:

> Robbie Spencer asked me to design some bizarre padded pieces/head gear and plaster accessories. I've wanted to make Cronenberg/Naked Lunch inspired

outfits for ages so this seemed like the perfect opportunity. Robbie and I played a kind of 'human buckaroo' with the models while they baked under about ten layers of Lycra, latex and fashion finery.

<div style="text-align: right">Card 2010</div>

The inspiration from David Cronenberg's *Naked Lunch* (1991), a gloomy film inhabited by insect-typewriters, shape-shifting creatures and alien-looking beings does not translate literally in Spencer's styling and Gary Card's prop design. Instead, the bodies are built up by layers of somewhat unidentifiable inflated material, padded body parts strapped on the body and an assemblage of materials. The 'buckaroo' comparison is forceful, as models are literally strapped and weighted down with blankets, rolls, pads and objects made by Gary Card for the shoot as well as high fashion garments. Some elements of the padding resemble the stitched-up white cloth figures by Louise Bourgeois, especially in one image where what looks like a buttock, a leg with a foot drapes from the shoulder, as if it is carried by or integrated into the model. The majority of the bodies are unidentifiable in terms of gender identity, as body shapes and facial expressions are concealed. Some silhouettes resemble Elizabethan menswear with tight stockings and puffy paned trunk hose, but most of them are an assemblage of non-Western, medieval silhouettes and dystopian film costumes. Through the process of adding layers to the bodily foundation on the model, the alien bodily shape is transformed processually.

In her work on translating the theorizations of Gilles Deleuze and Félix Guattari to a fashion studies context, Anneke Smelik uses their concept 'becoming' as a prism for understanding the processual quality of bodies and identities in high fashion (Smelik 2016). With reference to the work of avant-garde designers, Smelik demonstrates fashion's possibilities of 'becoming-animal' – with animalistic fashion, feathers, fur and reptile prints – and 'becoming-machine' (2016: 170) – with 'cybercouture' through integrating advanced technology into transformable and multipurpose garments. 'Becoming' refers to a process of transformation, even metamorphosis, and intrinsic to this is the body's instability and possible mutation, as a body open to being reshaped. If all bodies are capable of transformation, Smelik argues that 'fashion designs provoke a dynamic process of multiple becomings' (2016: 171). Some of these multiple, hybridized and rather deformed bodies, as exemplified by the 'Inflate' spread, are exactly becoming-other, as their layers of stuffing, mutant and even parasitic forms render them unstable regarding gender, form and borders. The excessiveness to which the padding, layers, different materials and face masks are

assembled, not only hides and transgresses the identity and gender of the model, but the body on which these layers are added is modulated, deformed and distanced from its corporeal foundation. The assemblage is also at play within Deleuze and Guattari's (1987) theoretical framework, which is fitting in this context. An assemblage is the joining of different elements, the arrangement of 'all kinds of heterogeneous elements . . . materials, colors, odor, sounds, postures, etc.' (1987: 323). Central to their work is the idea that the assemblage lacks organization, it is unstable and open to constant variations. This is an apt prism through which to understand the styled body that is open to constant variations through assembling materials on, to and around it (for more on 'assemblage' in contemporary fashion, see Bruggemann 2017).

These bodily becomings speak about themselves, their meta-level, as their shapes and silhouettes are made purely for the image. No effort is made to conceal their 'unprofessional' renderings, as they are meant to look like fabrications on a body-in-process and under construction. While the 'Inflate' credit text names high fashion designers, the garments are offset by other items that are manipulated, layered and weighted down, and thus hardly recognizable representations of what could be purchased in the shops at the time of publication.

The spread 'Sarah by Pascal', shot by Pascal Gambarte and styled by Akeem Smith, in the niche fashion magazine *Re-Edition*, is a nod to one of the most cited and seminal examples of body altering fashion design: Comme des Garcons' 1997 Spring/Summer collection 'Body Meets Dress, Dress Meets Body', often referred to as 'Lumps and Bumps' (see figure 11). The collection has been described in great detail elsewhere (see, for instance, Evans 2001, 2003; Geczy and Karaminas 2017; Granata 2017). In *Re-Edition*, in fifteen images shot in the streets of a city, possibly Paris, a female model is dressed in variations of suits, dress and tailleurs. In the series of images, bumps are stuffed under her garments so that enormous mono-breasts, an eccentric and uneven bustle, irregular hips and a hunchback protrude from her body. The professional-looking business over-garments (suit and tailleurs) are disrupted by the strange and lop-sided stuffing. Female suiting harks back to the young, urban professional look that was emulated by women in the 1980s that deals with the embodiment of enterprise as a way to embody the idea of dressing for success (see, for instance, Entwistle 1997, 2003; Molloy 1980). The awry power suiting in 'Sarah by Pascal' is a far cry from the self-improving technologies of the self that lies within power dressing (Entwistle 1997) and the body optimizing glamour work that Wissinger (2015) notes in relation to modelling and beyond. Unlike the seminal Comme des Garcons 1997 collection, where down feather pads where sewn into

Figure 11 'Sarah by Pascal', *Re-Edition*, 2017. Photography: Pascal Gambarte. Styling: Akeem Smith. Courtesy of Pascal Gambarte and *Re-Edition*.

the garments and thus integrated, albeit removable, the looks in *Re-Edition* are temporal with the padding stuffed in the void between the body and garment, bringing attention to both the gap between body and clothes and the stuffing's provisional effect on the new haphazard shape. The look's reshaping of the body lacks the idea of self-improvement of power dressing, but instead reforms the expectations of how bodies are styled to perform within a fashion magazine.

A similar display of ambiguous self-improvement is articulated in the spread 'Vanity Beauty' in *DANSK Magazine*, A/W 2017, styled by Danish designer Freya Dalsjø and shot by Josephine Svane. In one image, a model, with her back turned to the camera, is wearing a pinkish beige bra and dark beige stockings stuffed on the hips with visible filling (see figure 12). This is very different from the perfect padding seen on the television series 'RuPaul's Drag Race' where viewers learn the importance of drag contestants' mastering of accurate padding in their quest to get (passable) womanly curves. In 'Vanity Beauty', deliberate sloppiness is rendered with white batting peeping out from under tights cut off like biker shorts with red briefs and tights visible underneath. Placed on the thighs, the batting resembles lumpy cellulite that is usually unwanted, hidden and only visible off-stage. While highlighting the areas of bodily 'issues', a reversal takes place whereby new, revealed and uncontained body representations are produced and legitimized.

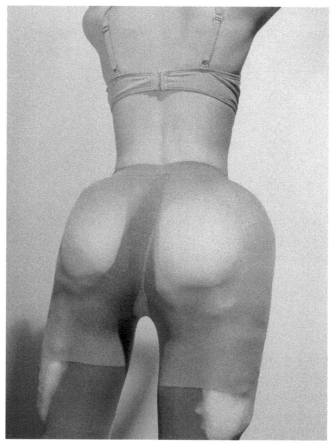

Figure 12 'Vanity Beauty', *DANSK Magazine*, 2017. Photography: Josephine Svane. Styling: Freya Dalsjø. Courtesy of Josephine Svane.

In 'Powers of Horror', Julia Kristeva develops the concept of 'the abject', which is, put simply, a body between subject and object that transgresses the idea of order, function and cleanliness (Kristeva 1982). The abject is the breakdown of interior and exterior bodily form, through decay and fluids like semen, blood, urine, pus but also tumour and lumps. To Kristeva, abjection is 'what disturbs identity, system, order. What does not respect borders, positions, rules. The in-between, the ambiguous, the composite' 1982: 4). Abjection has been used within fashion studies (see, for instance, Bancroft 2012; Evans 2003; Granata 2016, 2017; Jobling 1999) to examine the work of Leigh Bowery, Martin Margiela and Comme des Garcons, to name a few. Burnett (see figure 9), Spencer, Smith and Dalsjø's styling render bodily abjects with rolls, padding and lumps that

transgress the containment of the body and disturb the norms of representations of beautiful bodies and identities in fashion magazines. Through a process of aestheticization of the unaesthetic they create fascination and disgust, yet at the same time point to their fabrication and inauthenticity as fashioned bodies.

Mediatization and stylization of bodies

Contemporary fashion media is bound up with newfound, multiple possibilities, where digital platforms now co-exist with older print formats and even hybridize, and image-makers now proactively find new ways to balance artistic impetus with commercial interests for which niche fashion magazines represent an outlet that favours the first. Niche fashion magazines require a high degree of cultural and fashion capital of the reader (Lynge-Jorlén 2017), and compared to large-scale women's glossies, they represent a bastion of editorial and creative 'freedom'. Knowledge of its media is inscribed into experimental styling, as its self-made, imperfect rendering and the alternative body 'building' appeals to be captured by the camera, rather than translated into a real-life, socially acceptable act of dressing. It is not only conscious of its media, it is conceived within it, assembled to be photographed. In her work on mediatization in fashion, Agnes Rocamora (2017) argues how the media have become central to the shaping of fashion, which is now increasingly geared towards experiences aided by an integration of media in the articulation of fashion. Rocamora shows the ways in which the production, consumption, circulation and articulations of fashion are moulded by media through examples of live-streaming of catwalk shows, fashion retail and blogs. Thus, central to mediatization of fashion are the ways in which the media now shape not only its presentation, but also the creative decisions. For instance, when Maison Margiela, with John Galliano at the helm, presented its Spring 2018 Haute Couture, the audience members were asked to turn their cameras to flash, as another dimension of the fabric would materialize that was not detectable to the human eye. Fabrics that looked black turned fluorescent in the camera flash. This way, Maison Margiela integrated the functions of media into its very collection, which was, in the words of Rocamora, 'dependent on the media for its articulation' (2017: 509). Similar to these examples of mediatization of fashion, experimental styling, through the examples of the homeless and the hunchback, casts light on the meta-level of how these bodies, appearances and looks are put together for the camera. The looks exist for the image and fall apart as soon as the padding, cardboard and tape are removed. The styled bodies are endowed with a 'self-awareness' that points to exactly their

fabrication, moulded for the image alone. Consequently, the styling is not a backstage handling, hidden from view with the aim of producing a believable, authentic, uninterrupted body. It is exactly a *stylization* of the body. The hunchback and homeless stylizations in niche fashion magazines fail to 'present a reliable identity or a stable body' (Gutenberg 2007: 150), as they are temporary, made for the image in hybrid shapes that are both monstrous, fascinating and compelling, and highly knowing of their materiality.

Conclusion

Writing off experimental styling as an articulation of fashion's overpowering structure that feeds on shock effect and change only, would be to ignore both its playfulness and self-investigatory quality, but also the criticality and consciousness of body and identity issues that seem to be embedded in it. Central to Geczy and Karaminas's (2017) discussion on critical fashion is precisely that some of the criticality that was previously found in art criticism only now has entered into the realm of fashion, and experimental styling is an articulation of such norm-bending.

In the examples of experimental styling discussed here, the styled body is an assemblage of heterogeneous elements that question the idea of seamlessness relating to the contained body and the status of the materials used. While bodily perfection is easily accomplished with digital possibilities that have opened the body up to infinite change, experimental styling represents a move away from the 'synthetic ideal' that de Perthuis (2008) ascribes to the fashion bodies in an age of digitalization. Unlike the millennium hyperreal bodies that de Perthuis addresses, they are marked by deliberate 'anti-professional' traces in a turn towards stylized authenticity. In an age of digital renderings, the paradox is that the materials used as styling building blocks are 'low tech' and ordinary used to create exaggerated, asymmetrical, large and disproportionate anatomy and 'poor' bodies.

In addition to the disruptive quality of these styled bodies, there is also another layer of resistance at work. Experimental styling unsettles the 'total looks' requirement (Lynge-Jorlén 2016), whereby brands exercise all kinds of limits on how their clothes must be featured in editorial work, whether they can be mixed with other brand names or only as envisioned by the designer. Using non-fashion articles, agreement on editorial exposure made between the magazine and the advertiser can be sidestepped, and the stylist can reclaim a sense of creative autonomy and perform the assembling work that is at the core of styling.

Experimental styling emphasizes the materiality of the objects and the craft of hands. The wide-ranging materials used to create the intricate looks, point back to the work of the stylist who assembles articles that straddle high and low to create complex looks that mark a new material aesthetic conceived within and for its media. While it may be used as a strategy for inversion of status, it certainly articulates a space for experimentation and re-evaluation of how bodies and materials can perform in the context of styling.

Notes

1 See Chapters 7 and 8 on Caroline Baker and Ray Petri respectively, who were both early stylists using charity shop clothes, vintage and army surplus gear in combination with high fashion garments.
2 The stylists' motivation and point of view lie outside the scope of this chapter, yet they are addressed in the interviews in the book.
3 http://www.dazeddigital.com/fashion/gallery/25183/0/section-8-spring-summer-2018 [accessed 15 November 2018].

References

Bancroft, Alison (2012), *Fashion and Psychoanalysis: Styling the Self*, London: I.B. Tauris.
Benjamin, Walter (1999), *The Arcades Project*, trans. Howard Eiland and Kevin McLaughlin, Cambridge, MA: Belknap Press of Harvard University Press.
Black, Sandy, Amy de la Haye, Joanne Entwistle, Regina Root, Agnès Rocamora and Helen Thomas, eds. (2013), *The Handbook of Fashion Studies*, London: Bloomsbury.
Bruggemann, Daniëlle (2017), 'Fashion as a New Materialist Aesthetics: The Case of Viktor & Rolf', in Anneke Smelik (ed.), *Delft Blue to Denim Blue: Contemporary Dutch Fashion*, 234–251, London: I.B. Tauris.
Card, Gary (2010), 'Inflate. Dazed Shoot with Anthony Maule and Robbie Spencer' [Blog post]. http://garycardiology.blogspot.com/2010/09/inflate-dazed-shoot-with-anthony-maule_17.html [accessed 7 November 2018].
Cotton, C. (2000), *Imperfect Beauty: The Making of Contemporary Fashion Photographs*, London: V&A Publications.
Deleuze, Gilles and Felix Guattari (1987), *A Thousand Plateaus: Capitalism and Schizophrenia*, Minneapolis, MN: University of Minnesota Press.
de Perthuis, K. (2008), 'Beyond Perfection: The Fashion Model in the Age of Digital Manipulation', in E. Shinkle (ed.), *Fashion as Photograph*, 168–181, London: I.B. Tauris.

Entwistle, Joanne (1997), '"Power Dressing" and the Construction of the Career Woman', in Mica Nava, Andrew Blake, Iain MacRury and Barry Richards (eds.), *Buy this Book: Studies in Advertising and Consumption*, 311–323, London: Routledge.

Entwistle, Joanne (2003), *The Fashioned Body: Fashion, Dress and Modern Social Theory*, Cambridge: Polity Press.

Entwistle, Joanne (2009), *The Aesthetic Economy of Fashion: Markets and Value in Clothing and Modelling*, Oxford: Berg.

Evans, Caroline (2001), '"Dress Becomes Body Becomes Dress": Are You an Object or a Subject? Commes des Garcons and Self-Fashioning', *032C Magazine*, no. 4, October: 82–87.

Evans, Caroline (2003), *Fashion at the Edge: Spectacle, Modernity and Deathliness*, New Haven, CT: Yale University Press.

Fletcher, K. and Mathilda Tham, eds. (2014), *Routledge Handbook of Sustainability and Fashion*. London: Routledge.

Freud, Sigmund ([1919] 2004), 'The Uncanny', in *Fantastic Literature: A Critical Reader*, ed. D. Sander, Westport, CT: Praeger.

Geczy, Adam and Vicki Karaminas (2017), *Critical Fashion Practice*, London: Bloomsbury.

Granata, Francesca (2016), 'Mikhail Bakhtin. Fashioning the Grotesque', in Agnès Rocamora and Anneke Smelik (eds.), *Thinking through Fashion: A Guide to Key Theorists*, 97–114, London: I.B. Tauris.

Granata, Francesca (2017), *Experimental Fashion: Performance Art, Carnival and the Grotesque Body*, London: I.B. Tauris.

Gutenberg, Andrea (2007), 'Shape-Shifters from the Twentieth Century Wilderness: Werewolves Roaming', in Konstanze Kutzbach and Monika Mueller (eds.), *The Abject of Desire: The Aestheticization of the Unaesthetic in Contemporary Literature and Culture*, 149–180, Amsterdam: Rodopi.

Iversen, Kristin (2017), 'For Many Designers, Homelessness Is a Trend. This Is a Big No', *Nylon Magazine Online*. https://nylon.com/articles/designers-homeless-style-political-fashion [accessed 16 November 2018].

Kismaric, S. and E. Respini (2008), 'Fashioning Fiction in Photography Since 1990', in E. Shinkle (ed.), *Fashion as Photograph: Viewing and Reviewing Images of Fashion*, 29–45. London: I.B. Tauris.

Kristeva, Julia (1982), *Powers of Horror: An Essay on Abjection*, trans. Leon S. Roudiez, New York: Columbia University Press.

Kutzbach, Konstanze and Monika Mueller, eds. (2007), *The Abject of Desire: The Aestheticization of the Unaesthetic in Contemporary Literature and Culture*, Amsterdam: Rodopi.

Jobling, Paul (1999), *Fashion Spreads – Word and Image in Photography Since 1980*, Oxford: Berg.

Lange-Berndt, Petra, ed. (2015), *Materiality*, Cambridge, MA: MIT Press.

Lehmann, Ulrich (2002), 'Introduction', in Ulrich Lehmann and Jessica Morgan (eds.), *Chic Clicks*, T4–T6, Berlin: Hatje Cantz Publishers.

Lumbye Sørensen, Ann (2018), 'Assemblage', in Den Store Danske. Copenhagen: Gyldendal. http://denstoredanske.dk/Kunst_og_kultur/Billedkunst/Billedkunst,_stilretninger_efter_1910/assemblage [accessed 1 November 2018].

Lynge-Jorlén, A. (2016), 'Editorial Styling: Between Creative Solutions and Economic Restrictions', *Fashion Practice: The Journal of Design, Creative Process and the Fashion Industry*, special issue on Fashion Thinking, 8 (1): 85–97.

Lynge-Jorlén, Ane (2017), *Niche Fashion Magazines: Changing the Shape of Fashion*, London: I.B. Tauris.

Mackinney-Valentin, Maria (2011), 'Er den gode smag blevet hjemløs?', in L. Dybdal and I. Engholm (eds.), *Klædt på til skindet. Moden kultur og Æstetik*, 71–89, Copenhagen: Forlaget Vandkunsten.

Mackinney-Valentin, Maria (2017), *Fashioning Identity: Status Ambivalence in Contemporary Fashion*, London: Bloomsbury.

Molloy, John T. (1980), *Women: Dress for Success*, New York: Peter H. Wyden.

Newton, Matthew (2011), 'The Unintentional Comedy of Vivienne Westwood's "Homeless Chic" Collection', *Thought Catalogue*. https://thoughtcatalog.com/matthew-newton/2011/01/cannibalize-the-homeless-the-of-vivienne-westwoods-homeless-chic/ [accessed 16 November 2018].

O'Neill, Alastair (2007), *London: After A Fashion*, London: Reaktion Books.

Richter, Hans (1965), *Dada: Art and Anti-Art*, London: Thames & Hudson.

Rocamora, Agnès (2017), 'Mediatization and Digital Media in the Field of Fashion', *Fashion Theory: The Journal of Dress, Body and Culture*, 21 (5): 505–522.

Rocamora, Agnès and Anneke Smelik, eds. (2016), *Thinking through Fashion: A Guide to Key Theorists*, London: I.B. Tauris.

Smelik, Anneke (2016), 'Gilles Deleuze: Bodies-without-Organs in the Folds of Fashion', in Agnès Rocamora and Anneke Smelik (eds.), *Thinking through Fashion: A Guide to Key Theorists*, 165–183, London: I.B. Tauris.

Smith, Douglas (2010), 'Scrapbooks: Recycling the Lumpen in Benjamin and Bataille', in Gillian Pye (ed.), *Trash Culture: Objects and Obsolescence in Cultural Perspective*, 113–128, Oxford: Peter Lang.

van Elven, Marjorie (2018), 'Balenciaga Criticised for "Homeless Chic" Window Display at Selfridges', *Fashion United*. https://fashionunited.uk/news/retail/balenciaga-criticized-for-homeless-chic-window-display-at-selfridges/2018091238847 [accessed 16 November 2018].

Windmüller, Sonja (2010), 'Trash Museums: Exhibiting In-Between', in Gillian Pye (ed.), *Trash Culture: Objects and Obsolescence in Cultural Perspective*, 39–58, Oxford: Peter Lang.

Wissinger, E.A. (2015), *This Year's Model: Fashion, Media, and the Making of Glamour*. New York: New York University Press.

Examining Uncertainty: An Interview with Anders Sølvsten Thomsen

Susanne Madsen

Anders Sølvsten Thomsen didn't follow the traditional trajectory for a stylist, arriving later to the discipline than most. But when he came to fashion in his mid-twenties after leaving his native Denmark for London, his entry was quite impressive: a meeting with the stylist Sally Lyndley on a show he was helping out on through his flatmate landed him a job as Lyndley's assistant when she was made fashion editor at *POP*. From here, he quickly made first assistant to editor-in-chief Katie Grand, also working with her on her styling for luxury brands, a position that made him leave his studies in Fashion Photography and Styling at the London College of Fashion. When Grand's team next launched *LOVE*, it was with Sølvsten Thomsen first as fashion editor and then fashion director. Now freelance since 2014, he shoots for titles such as *Document*, *Replica Man* and *Re-Edition* and dedicates a large part of his time to working with emerging designers alongside clients such as Louis Vuitton and Burberry. Sølvsten Thomsen's styling explores abstract shapes that exist somewhere in the sphere between fashion and art. He crafts slightly surreal or poetically absurd scenarios, using layers both literal and figurative, and often weaves in themes around angst and uncertainty.

Susanne Madsen: When I look at your work, and in particular the images you've selected for this, there seems to be a uniting theme of layers.

Anders Sølvsten Thomsen: Layers in more than one way. There are the graphic, more abstract shaped things and then the way in which I think I do that without piling on all the layers. You can create the same mood without actually adding *any* layers, like the *Replica* story (see plate 18), which is super stripped back from a styling point of view but has other layers metaphorically. It's important for me when I approach an idea that there's always that element.

SM: Something more than 'just' clothes?

AST: Yes, a little bit of a weirdness, something that's always a bit 'off'. Even when I work for a more commercial publication where I don't have the same freedom. It can be the casting, location, mood, setting, anything.

SM: What is it about weirdness that is so interesting?

AST: I think it's the attraction to the unknown. I come from a very typical, very normal Danish nuclear family upbringing. In my teenage years I was always attracted to the outcasts, people who were unapologetically themselves. Even at a young age I always felt I had to be performing, achieving. I put a lot of pressure on myself to always do things the right way. And I felt that in my work was a way where I was able to run away from that idealism I put on myself. Growing up, one of my obsessions was Larry Clark and all the characters in his films who were a bit off from society. So far removed from my daily life and who I was as a person, but I'm never going to be able to personally let myself be free enough to just have that sort of *laisse-faire* lifestyle and not be affected by what goes on around me.

SM: Does weirdness hold an intelligence to you that the glamorous fantasy perhaps doesn't?

AST: I never think that my approach is that I want it to be for brainy people but I do want it to be an image that you can respond to and that might sit with you for a longer time. By creating something that's a little bit strange you're sort of forced to stop. It's not anything I've sat down and wondered 'why am I so obsessed with that?' But if you look at it just in terms of image-making, how to make an image more interesting is to create something that's slightly off. It's not necessarily always intellectualizing it. It's just, everyone is potentially going to be shooting this look this season or creating stories around the same clothes, so how can I make my version and my interpretation of it different to everyone else's. Regardless that it might not always be the most commercially friendly work. Some clients can get scared when they see my work but I'm not willing to compromise on the vision and how I want to be as a stylist. But working within fashion, and it is a very commercial industry, I always feel like I have to put a lid on myself even when I work for independent publications because I can't just have a portfolio that's just how my mind is. Although I wish I could do that.

SM: I take it that's because the money jobs wouldn't necessarily understand?

AST: I wouldn't be making any money at all. I think the most important thing to being a stylist is being able to adapt to different clients. That's what we do constantly. Adapting how I see things to different clients. You can have a sportswear client, a high-end client, a high street client, and they all want a little bit of you. I did a project with Burberry recently where they invited me in for the re-launch of the trench coat and they basically told me I was free to do as I wanted, there were no limitations. So I went into a much more abstract and conceptual way of thinking than I usually would be able to.

SM: I do think there is an interesting conceptual dialogue in your work between art and fashion.

AST: Well, no one likes to say they're an artist and I'd be the first one to never, ever call myself that. Maturing into being a stylist and sometimes thinking back, I do wonder if I could have changed direction then I maybe would have taken it in a slightly different way. But that's when it's important to keep doing personal projects and live out some of those ideas, which are harder to realize in commercial publications.

SM: Yes, this makes me think of your story for *Office* that you chose for this with the big, swaddled figure (see plate 16).

AST: That's very much me. The whole idea was to create these slightly strange characters. There were no faces but still there was life injected because it was built on a human so I could give it shape. I called them my little monsters and I sort of applied that to a lot of my work since. It's an ongoing project that I want to take further and continue working on but in a non-fashion scenario.

SM: What do you like about the monster?

AST: I think it goes back to this thing of the unknown that you can't quite place anywhere. It's not that I'm attracted to horror films. I just called them my little monsters.

SM: You could say it's quite the opposite of fashion where we're so obsessed with perfection?

AST: Yeah, completely. What was really funny about this story was that you're creating everything from clothing but not in the conventional way. It was a mix of young Central Saint Martins' MA students and high-end designers. It's all garments. In those particular images there's no fabric used.

SM: That must have been a lot of credits.

AST: (*laughs*) No one was particularly happy with it!

SM: Some might say that you're playing against fashion a little, or confronting it?

AST: I went to see an Eddie Peake talk and he said something about his relationship with the art world that really sat with me. How he hated it but loved art so much. It made me think about my own ambivalent relationship with the fashion industry. I love fashion, I love clothes, I love the show, the drama, but there are so many elements of the industry . . . I don't hate it but I don't know how to be in it. My images and my styling are my escape and my response and I think maybe that's why there's this weirdness and these creatures, these characters that I sometimes portray. And it probably does come from feeling like I don't always belong. Because I rose so quickly from assisting Katie [Grand] to suddenly being fashion director of what at that time was probably the most influential publication, I always felt like I hadn't earned my right to be here and I wasn't good enough. Like, 'I don't belong in this job title, people must look at me and think "He is completely out of his depth"'.

SM: Which I'm sure no one thought.

AST: But that's how I felt. And it's that amount of pressure that you put on yourself. Whilst I was there I wasn't able to express that [creatively] because it's a more commercial publication and there are a hundred or so advertising clients that have to be fitted in. I think I managed more in my last few issues there. I did a shoot with Juergen Teller and Lily McMenamy where it completely came to life and I think that was potentially the first time I did something I was really, really proud of.

SM: Something that felt like you?

AST: Yeah. I'd dealt with a lot of surrealism in all of my shoots that I did for other publications on the side, but I could only do one a season. It was either an obvious surrealism or something very subtle. And then that shoot happened and I think I found what was me. It was quite an epiphany. Then I did a shoot with Glen Luchford just after that had a similar sort of feel. Unusual characters in a motel room in Atlantic City, super stripped back, super raw, quite honest. It was part of me finding out who I was.

SM: It's interesting to think, had you been at an aesthetically different magazine, would you have gone through that same evolution?

AST: I do think it's easier to evolve as a stylist on a very youth-led publication as they're really good at letting stylists experiment than it is at a slightly more commercial, bigger publication. Every job had to be in line with the aesthetic of the publication, which of course makes perfect sense.

SM: I suppose it does set you up for future client jobs?

AST: Yeah, I think I always had that. You know, I wasn't a twenty-year-old assistant. I was twenty-six when I realized the direction I wanted to go in. So I think I always had a maturity where I knew how to deal with clients. I'm *extremely* calm even when I'm exploding on the inside and I think that works really well when you're with designers who can often be erratic and struggling to make decisions, which is natural because there's so much on the line for them. I think I've always been very good at being like, 'no, this is what I think you should be doing'.

SM: Editing, in a way?

AST: That's an element of it. One of the biggest jobs is editing, and that's where you often end up in the biggest discussions with designers because the stylist often wants to edit more than the designer. It's about being able to compromise. Some stylists have a different approach and it's very much their vision or no vision. I'm much more in the middle of the road. I will always say how I think it should be but I'm always willing to have the discussion of, say, why a section should stay in the show. Because what I do love the most about working in the industry is the collaborative element.

SM: With the images you've chosen, there's such a sense of – I'm not sure if storytelling is the right word?

AST: Narrative.

SM: Yes, narrative. I immediately want to know what the story behind an image is.

AST: I often start from a narrative. I need to have a character, which might not come across as relatable or recognizable in the final outcome, but the starting point is a strong character that doesn't fit into the usual surroundings. I think I see things in short clips. I have a lot of conversations with myself. I make up dramatic situations in my mind that have never happened. And from that a narrative or situation arises.

SM: Like a daydream scenario?

AST: Yeah, but it's always a dramatic daydream. There's always drama, often a conflict. My point with this is I think I link this into the characters in my shoots. There's an oddness to it.

SM: I think your oddness is quite Lynchian in a way.

AST: Perhaps. You can't always put your finger on what it is.

SM: Like the image from Cape Town, the Pieter Hugo one with the latex cape (see plate 13).

AST: Yeah. We were casting local characters in Cape Town and got them in a car and just drove around for four days, got to know each other, understood their personalities, and took loads of pictures. Nothing about that situation was forced and there was a lot of trial and error. It felt more like Pieter and I were doing a personal project than a fashion story, like a road trip with six people we'd never met.

SM: It's so sculptural.

AST: That's where I think Peter's vision as an artist and my vision from a fashion point just merge really well together. I wanted to create structures and shapes and put them into an unexpected environment but we didn't want anything to feel forced and we wanted to shoot it in the most calm and nature-esque surroundings.

SM: They still feel quite abstract despite the simplicity.

AST: The particular image I chose for this, the colour of the cape is nearly the same colour as her skin and it creates, as you say, this abstract and slightly strange illusion, shot in water. For some people it could just be a girl standing in water but for me there's a fear element to water. In Japan, rain in films is often a symbol of dread, which sits well with me. I have the deepest respect for the ocean. When I go swimming it takes me two or three days before I get comfortable and the fear leaves my body because I've become sort of familiar with the ocean.

SM: It's funny you say familiar, because the opposite of that, the unfamiliar, is perhaps a word we could apply to your work? Unfamiliarity. The many layers of things like in your Hill & Aubrey story with the kids (see plate 14).

AST: Actually, that whole shoot is based around the unfamiliar, the slightly surrealist. They're all kids but in adults' clothing. It's that innocence of a child who is unaware of what's going to happen over the next fifty years. The layer

upon layer upon layer of life. They were all kidulthood age and just about to become young men. I wanted to illustrate all the different layers of life through fashion. You maybe can't see it in the image but he's probably wearing forty to fifty layers. I didn't want it to be chaotic so it's all done in a colour range, beginning with black into the browns and then it moves into brighter colours, so it's a positive message. I know this is adding a lot of depth to a fashion image. (*laughs*) I think I did that shoot before the monsters one. I've always worked with layers. I've never been the one to just put a dress on and be done with it. You get the best model, the best dress by Louis Vuitton, a great photographer, we can all take that picture. It's still going to be an incredibly beautiful image but there are people better and more famous than me that will take that image so then it comes from, how do I make my stand and my interpretation of this?

SM: When I looked at that image I also saw this thing of piling on clothes to be seen, which much of fashion feels like today.

AST: I think that's great. It can be interpreted how you want. It's also very comical. We wanted it to have a sense of humour. It shouldn't feel overly conceptual regardless of how I came up with the concept. We wanted it to be fun because they are kids and we were trying to make them feel like they were meant to wear these types of clothes. There's another image where there's a guy in a very big shouldered, checked suit resting against this ginormous balloon, so it's all about dealing with the battles that are about to hit you in adulthood but you don't actually want to leave your childhood behind. And that's something I can completely relate to. I'm hitting forty soon and I still do not feel in any way like an adult. I don't feel like I belong in adult land. Maybe it's just part of getting older and the internal personal battles that we have, but what's great is having an outlet for that and it's a certain form of therapy. We, the team, we're just creating fashion images but there's a little bit more in there than the girl in the dress on a beautiful beach.

SM: And the *Replica Man* story with the upside-down guy on the back stretcher (see plate 18)?

AST: It was taking a very suburban type house and then having this slightly mad character, portrayed by Kiki Willems, who got the character straight away when Thurstan [Redding] and I explained it to her. I'd had these bodysuits made because there was a male character too. The idea was that we have these different aspects to our personalities. I wanted to illustrate that first through a beautiful image of a girl dressed quite simple but in this mad setting and then replicate

that exact position but completely taking away all personality so there's nothing recognizable except the human form. *Replica Man* is another publication that gives you the freedom to explore whatever you want to do.

SM: I'd be interested to see if you do something outside of styling at some point.

AST: I do sometimes think that if I'd ended up in a different creative profession I would have been able to push things even further creatively. But I don't know what else I can do. I try to always have a good balance of more conceptual shoots but I'm also a business as well as also doing shoots that are more traditional fashion ideas. I don't think any of my ideas are extreme. The Kiki one is actually a Fendi advertorial.

SM: That's interesting that you can work the advertiser boundaries like that.

AST: I think if it's subtle you can push things a lot further. My agent often tells me my work is really strong but I don't see it like that. Maybe it's a lost in translation thing but by strong I often think that it's something that's in your face and aggressive and I think my work is the opposite. I think there's a little bit of sarcasm there, a calmness. Even with the shapes and the graphicness it's never aggressive. And that's very intentional. I think it's the subtle things that might just make you open your eyes and smile or at least have an opinion about the image.

SM: Well, even monumental, massive works of art can be serene.

AST: Serene is another good word. I also think it might come from being Scandinavian. Look at some of the most beautiful Danish furniture design that's ever been made. Yes, they are *fantastic* shapes but everything belongs, nothing feels out of place, it's not been put in there to create a reaction. It's there because there's a sense of it needing to be there.

SM: The Nordic connection is interesting because I'd venture your work is in no way your garden variety Scandinavian minimalism.

AST: No, and I also think that notion of Scandinavian minimalism is nonsense anyway. You go into Scandinavian homes and there are so many layers and textures, just different to how it feels to walk into a British home. I've been asked that before, if I thought being Scandinavian had influenced my work. I always thought I had one leg in the British camp and one leg in the Scandinavian camp

and it was a bit like, do I need to take a side? Do I need to jump onto a British aesthetic? Or do I try and merge the two? And I'm still not entirely sure.

SM: Perhaps there's an interesting frisson in the meeting between the two? Saying that, there was a lot of bonkers British stuff in your work for *LOVE*.

AST: Yes, there's definitely a British eccentricity in there, in a way that I think is a lot more obvious than what I do now.

SM: Now it's perhaps more about the absurd?

AST: Yeah, and I can't always explain it, which is why I don't always know how to put it into words except that was my thought process and how I was feeling at that particular time. But then you also move on from that. Obviously I can see a common denominator in my work and sometimes it intensifies and then it dies down, but it's still variation on the same ideas.

SM: Does that come with knowing yourself and maturity? Exploring aspects that all fall within a field of your particular interest.

AST: Yes, and sometimes you do step outside of that and you won't feel particularly happy. You feel like you've either wasted your time or other people's time and that you haven't achieved what you set out to achieve. That definitely comes with maturity. It's also understanding when to say no to jobs, which is even harder being freelance because when you have a quiet period, which happens every season and you freak out every season, you are just more inclined to accept these jobs even though you know it's not anything you want to do. I really rarely work with celebrities for the reason that I find it hard to make it collaborative. There are so many other people involved that you have to go through, like managers, agents.

SM: You also seem to consistently work with emerging talents.

AST: I find the idea of not doing that ludicrous, not trying to see who you could help, and help not for your own benefit. Every shoot I do I try to incorporate young designers or I work with young designers for free.

SM: How does that sit with magazines in terms of advertisers?

AST: Obviously, with some magazines I still try to squeeze it in there but then it gets edited out. It's just, I remember how hard it is when you're fresh out of university. I was really lucky in asking the right person who then took me with her to a magazine as her assistant and then from there I never really looked back.

I've never forgotten that. I have worked with the MA students at the London College of Fashion and was mentoring them for three seasons leading up to the graduate fashion show at London College Fashion Week. I'm not a designer, so it's more sort of giving constructive criticism on their collection than I would if I were working with an established designer. What they could add, what could be taken away, silhouettes, working on fittings and looks. I also work with Feng Cheng Wang, who was a Fashion East designer, for several seasons on a consultancy basis and it's a great collaboration. It's a small company but it's super exciting to see them progress. I also think it's important to stick with it. You can't just dip in and give all these ideas or advice only while there's hype. You have to follow through afterwards when it's no longer, say, a Fashion East or New Gen brand.

SM: Yes, that is where fashion can be a bit fickle. So you want to develop them?

AST: Yeah, you saw something exciting in them at first and that hasn't gone. But if anyone could tell you how to become a successful, hyped brand overnight they'd all be there, so it's anyone's guessing game and it's as much about luck and the right people at the right time. Trial and error.

SM: One thing we've not talked about is how you studied fashion styling. Is styling something you can study?

AST: No. I'm going to be completely blunt. You can't study styling but what was beneficial about the course for me was I needed a little kick up the butt to start testing and creating things. I didn't *learn* anything from being there but they set you some different creatives and you went out and found your teams. I made most of the clothes and even took the pictures in the beginning. I don't believe you can teach someone to be a stylist but you can give them the push they need to find their vision, what kind of stylist they are, so they can go out and explore those ideas. But just because you came out of college with great marks there is no guarantee you will ever work in the industry because it's much more complicated than that. I'd never recommend someone spend three years paying for a styling degree when what you should do is just start testing and assisting. I was looking at one of my first shoots from university the other day and it was very much along the themes that I'm still working around. A little melancholic, a little weird, but still done in what I think is an aesthetically pleasing way. I think there's a little bit of melancholy in my work as well. Not that it's sad but I think it all links to something a little bit off, slightly melancholic.

SM: Angsty?

AST: Yeah, angsty. Maybe that's what I mean instead of melancholy. There's a little bit of angst, my version of angst and how I quietly deal with my anxiety, which is in a very calm and slightly subdued way.

SM: Anxiety to me is very linked to uncertainty, which I think again ties in to your work. Not being sure what we're looking at.

AST: Completely. And with anxiety you're always questioning everything that you do. As you said, there's an uncertainty. Just on a personal level, you're never sure that it's right or it's good. I actually think that's probably a better word. It's angst, it's anxiety, but not done in the usual erratic way.

SM: Yes, there's a softness to it, and yet your images are very arresting. And they make you think.

AST: Or just look twice. Hopefully for the right reasons. (*laughs*)

Finding Beauty in the Moment: An Interview with Elizabeth Fraser-Bell

Susanne Madsen

In her role as senior fashion editor at large at *Dazed*, Elizabeth Fraser-Bell has cultivated a visual language that strikes a mood that is both joyful and pensive, often embracing oddball awkwardness but equally unafraid of unadulterated, grand gesture beauty. Fraser-Bell first joined the magazine as an intern, coming up through the ranks and working as the title's senior fashion editor for several years before going freelance, and has been a significant factor in shaping the title's identity as well as spotting and nurturing relationships with new photographers that are now major industry names. With a background at Central Saint Martins, she became interested in styling after a work placement with Jonathan Saunders' design team. She draws from eccentric characters and pop culture phenomena in her styling, crafting characters, universes and moments based on personal interests outside the fashion sphere. In addition to her work for *Dazed*, Fraser-Bell consults and works on shows and campaigns and for a number of other titles.

Susanne Madsen: You chose an image for this from your Scotland story with Tom Johnson, which I think really embodies this sense of unbridled beauty I see in your work (see plate 28).

Elizabeth Fraser-Bell: That experience was just so beautiful. We were on Loch Lomond in the Highlands and there's absolutely nothing around. We're on the mound over from a man playing bagpipes, and we're just watching him with silence all around us apart from these bagpipes. I've never had such a moment. Tom at one point forgot to shoot because we were all just sitting there like, 'this is amazing'. And real. It's catching moments like that, not necessarily creating them. A sense of atmosphere. But that's also very much the photography side. It's really hard not to talk about collaboration in this because it is so important. But I guess it's not what we're here to talk about! (*laughs*)

SM: How did you find the process of editing your work down to six images for this book?

EFB: I've always struggled with that because you're meant to know what your work is and I don't! (*laughs*) Some of my friends say that it's very British and youthful and there's always a sense of humour in it, but it's not really what I aim to do and it's not what I find particularly beautiful or interesting either. What I aim to do is just something beautiful and something that inspires me in that moment or at the time that I'm prepping it. So in the edit process of this, to try to find what I'm about as a person, as a stylist, is really confusing because I still don't understand. And I don't think I'm meant to say that in this. It's funny because you always know what somebody else's style is. You can see it straight away. But when you look at your own work it's like ... What is that? It's just something that I wanted to do.

SM: I think this word 'beautiful' is interesting. It's a word that's used all the time, but what does it mean to you?

EFB: It's so hard to define. But I guess that's what's so great about this and what we do as a whole. It's so subjective. What I find beautiful others may find boring or ugly. Ugliness is in the eye of the beholder! I think it's something with meaning or emotion behind it. For example, I did a story about objectasexuals (see plate 30), which came about because years before I'd watched a documentary on Channel Four and it's always stuck with me. The woman who married the Eiffel Tower. Incredible. But objectasexuality isn't a beautiful thing. Really it's almost an illness, an obsession that develops due to a trauma in someone's life. So basing a story on something like that is difficult. And yet the imagery that we got out of it I find beautiful. From something ugly there's always something beautiful that can be made out of it. But perhaps that's also highly insensitive. Which fashion is. It can also be an amazing moment whilst your shooting where the hair moves in just the right way or there's a facial expression you catch where the model isn't posing. That's beautiful. It's so personal.

SM: It also sounds like beauty to you is perhaps linked to something very human?

EFB: Yeah, very human. Actually that's a *really* good way of putting it because so much of my work is about being human and I don't like things looking perfect. I never like to plan too much as you end up creating limitations for your creativity. I have a great appreciation of the moment and what that may bring. In fact, I hate

it when something looks highly styled. I always like to have something out of place or something creased or something that isn't perfect because I am not perfect in the way that I dress. It can be down to how, if the model shoves on a jacket over a top and it's all creased and doesn't sit right, I'll leave it like that because that's how it naturally sits without me 'styling' it and I like how awkward it looks. I think that's where it becomes personal because no matter what I'm doing I don't want it to be fake. I want it to be human. Not necessarily relatable because fashion is meant to be aspirational, but I want it to relate to me. And that's how I find solace in the situation. (*laughs*)

SM: In working in fashion, you mean? So it becomes a sort of exercise in job reflection or therapy?

EFB: Yeah. I suppose my work is a very intuitive reaction to things, regardless of the larger concept behind a story. I think that natural response is all I really want to do. It seems weird because I do push myself but I don't want to push myself out of something I would do anyway.

SM: How do you feel about a word like romance in terms of your work?

EFB: It depends what kind of definition you're going with. I think really the only way romance would come into my work is the choice of photography maybe?

SM: I guess romance along the lines of the romantic period. Big emotions, wild nature, romanticism, all the great writers and painters portraying the grandeur of nature. I suppose it's because you shoot a lot in nature that I think this.

EFB: Yeah, I am really obsessed with nature and natural beauties. Say, for example, that old Harley Weir shoot (see plate 29). That was brought about because I wanted to do a set design with Janina Pedan that brought the outdoors indoors. In a way it's kind of conflicting because you're creating something that should be natural, but I think that's really beautiful because you're both enhancing and reducing it, so we would have this enhanced scape of flowers on a hill but then taking away the natural beauty of it by having a brown backdrop instead of a painted scene. I think it's about having that balance. But I think nature plays a huge part in what I do. It may also be because the only books I ever read are classics. I've noticed it really has an effect on me, down to changes in my language and the way I interact with people, when I read authors such as the Brontës, Joyce, Dickens or Hardy. So who knows what all that melancholic romance does to the creative side of my brain.

SM: Where do you think your fascination with nature comes from?

EFB: I have no idea. I grew up on an estate in Newcastle until I was eight, so there's nothing there. Maybe when we moved to Oregon, where we were surrounded by so much nature. Big cougars in the back garden, that kind of nature. Actually I think it's more living in London. I'm starting to really appreciate just being away from the city. That's my, to use that word again, solace. My escape. So I think maybe that's why it comes into my work so much because I'm not necessarily somebody that should be working in fashion. *(laughs)* I didn't even know styling was a job until I went to Saint Martins on foundation because I wanted to be a fashion designer, but it turned out I didn't have much proficiency for design. And then I started realizing that maybe magazines were the way to go. Before that, I didn't have a very big knowledge of fashion titles. It wasn't in my blood. My dad is a doctor in chemistry. It's not something that I should naturally have fallen into. And so quite often I feel like I need to escape, and nature and the countryside are my way of doing that so I think that's why it comes into my work so much.

SM: It's interesting that when you speak to stylists or designers, this desire to escape fashion often comes up. There's a certain irony to the fact that people work so hard to get into the industry and then want to escape it.

EFB: Yeah, and it doesn't come out until you do interviews like this. But a lot of really good work comes from looking outside fashion. I don't really see it as a bad thing. I think fashion has just become so dystopian. It's dark, not least because we tend to put some dark, twisted people at the top. It's only now with people being called out in other industries, starting with Weinstein, that we are saying things must change. Things like that are what make me want to escape. I will always love the creative side of fashion and that's why I really try not to let myself be caught up in the politics.

SM: You mentioned how you didn't know much at all about styling until you went to Saint Martins. How were you introduced to it then?

EFB: I liked the process of fashion design, putting everything together with the research and making a story out of it, but then the actual clothes were just a big old mess. So I dropped out of the fashion design bit and I don't think I ever actually completed my foundation. I think I've wiped it from my mind. So I went to work at Jonathan Saunders because I thought, I'm going to make this fashion design work. I did pattern cutting, toile making, screen printing, anything I could get my hands on.

SM: That sounds quite fun.

EFB: I was terrible! I ruined so many dresses. I just couldn't get my head around toile making at all. They'd always come out back to front or sewn on to the wrong bit. Obviously from that I was like, 'I am not a fashion designer'. So I wrote to loads of companies and *Tank* took me on as an intern. I'd learned what a stylist was at Jonathan Saunders when Marie Chaix walked in. I saw her consulting and putting things together and that's when I really thought, that's quite interesting. Maybe that's what I can do. So I went to *Tank* as their front of house girl and they sacked me after a few weeks. I was *terrible*. Like, forgot to put in schedules, fucked up coffees, the most basic of things I didn't do well.

SM: Through *Tank* you were introduced to *Dazed* as an intern and then assistant to Robbie Spencer. What were those early days like?

EFB: When I first assisted Robbie I still didn't understand the styling process because I'd only ever done crap money jobs or third assistant on an editorial. I'd never prepped before. So Robbie sends me his requests, I fax them off (*laughs*) and then all the clothes come in. I've worked really hard, through the night, blah blah blah, and he's going through the rails the night before the shoot and he's like, 'Where's the Prada look?' And I'm like, 'This is Prada'. 'No, where's the Prada look I requested?' Oooooh! Oh, you want the actual *looks*? Right, okay. (*laughs*) Well, basically what you've got here are the brands that you requested. Just that sinking, sick, cold sweat feeling. I've totally fucked up. It was a very *slow* and painful learning process.

SM: But to be fair, how would you have known?

EFB: Exactly. Well, he gave me look numbers, but ... I was like, Prada is amazing, surely you can have anything from Prada. (*laughs*) That was my foray into styling.

SM: Would you say *Dazed* has been a formative part of what you've gone on to do?

EFB: *Dazed* was my education. I didn't do a degree. Partly because I was so confused about what I was, what I wanted to do, what part of the fashion industry I could go into, but also because I hated institutional education. I learned everything at *Dazed*. You can't learn what I learned through going to university. I believe university is very good for meeting the right people, but you can't learn what I learned and have those experiences, so young as well, and have such

responsibility thrust upon you. There are so many politics that you can only learn through being in the industry and making mistakes when you're young. I made *a lot* of mistakes, as I've just told you. And so many more. But you have to do that. I mean, if you're wise you don't learn the hard way, but I think learning the hard way is a very good way of learning. You will never make that mistake again.

SM: Do you think *Dazed* has shaped your work in any way aesthetically?

EFB: I've always been really careful not to mimic the style of those around me. You see a lot of assistants kind of going down the same path as their bosses or really, their tutors. I was always very aware not to do that and I think naturally my style is different anyway. Perhaps it's shaped how I do things just because I'm used to adhering to the *Dazed* way of doing things, even with brand choices. For *Dazed* you do go for the avant-garde, and you find ways of making avant-garde your style but applying your true style to that. It's the same way as when I used to shoot for *Teen Vogue*, which I loved. You do adapt to all of the different jobs that you do. And that's why I find it really hard when people say, 'what's your thing?' Because I have many different things that I like to do. It's not being forced into it or fitting into that one job. I do different things because I like different things. I'm not always in a dark mood, I'm not always in a sculptural way. You just adapt. I do. Some stylists will talk about how they have 'a woman', 'the woman'. I don't think of a woman. I know you should . . .

SM: Should you?

EFB: Agents tell you that you should. But I find that really, really hard.

SM: Designers talk about their woman too, I suppose. But the idea of having 'a woman' could perhaps be viewed as problematic, like women are just one thing?

EFB: That's the other thing. Okay, so maybe you're not talking about women being a conglomerate, but you're talking about *a* woman being one thing. A woman is never one thing. A woman is multi-layered. Women even more so as a whole. So why would you limit yourself to one concept all the time? I hate that, and we constantly get told we need to have our woman or man by agents and by magazines. It really annoys me and I get bored. My interests are generally transient and fleeting and I don't mind my work reflecting that. I get it, it's for sales, it's for advertising yourself and helping people see that you do *this*. So all of those jobs that need that kind of thing, *you're* the person for it.

SM: But does that perhaps also commercialize creativity?

EFB: Totally. But it's all about being commercial. There are no stylists that don't want to earn money. It's not the eighties. But I can't help it, I like things that are multi-layered and don't easily tick a box. And also, you know how people will say, 'this is my woman' but then add something contradictory, a juxtaposition? Like, 'she's a warrior housewife'. (*laughs*) Okay. Doesn't mean anything, it's really silly.

SM: Yes, and I don't get those kinds of fashion tropes from your shoots. Aside from the objectasexual idea, how do you then approach your stories?

EFB: If it's coming from me and it's not a theme that's been given to me from a photographer or whatever job you're doing, I don't like it to come from fashion or photography books. I find that really difficult because everyone uses the same references. Idea Books, Claire de Rouen, just for example, they're incredible and I love looking at them. But everyone loves looking at them so why would you base a story on that because somebody else is going to do the same, either before or after you, and then it won't feel so special. I actually like to take from mainstream ideas. Things like FernGully. It's this tiny world where everything is so small but then everything around them is so vast. It's kind of where the Harley Weir flowerscape idea came from. FernGully is dark. It's sad and it's dark. It also came from an old family friend who had roots and ivy growing into her house. My work comes from a lot of personal experiences, which I think help because as Rei Kawakubo said in her SS19 show interview, which she normally never gives, there is nothing new you can do anymore, it has to be personal. And I so whole-heartedly believe that. It has to be personal, otherwise what are you creating? You're creating chuff, regurgitated chuff.

SM: Which again leads back to the human element. The human condition.

EFB: Yeah, nothing is perfect so why would you try to . . . I know all of this old school mentality, Alaïa era, high-intensity fashion is about that. Fabulous, fabulous fashion being unobtainable. It can't be like that anymore. Instagram won't allow it to be like that anymore. So in response to that, all I can do is make things personal. Because I *will not* try to compete with trying to do something new because it's all been done before. It doesn't matter what you see now, everything has been done before and it's taken from something. I mean, you look at Man Ray and Lee Miller and what they were doing. That's a type of original fashion imagery. Nothing is now. It's sad and perhaps pessimistic but realistic.

SM: You mentioned that some people see youth as a factor in your work?

EFB: I don't know why because again I don't think about doing that. I think it has a lot to do with shooting so much for *Dazed* because *Dazed* is youth, it's about youth culture. It just comes down to that I think. Because actually I find all ages inspiring, it just depends what it's for.

SM: When I see your teenage-y shoots, I see this celebration of awkwardness. A little geeky sometimes.

EFB: Oh yeah. I guess because I have very little patience for the overly confident. I'm not particularly fond of people that have no modesty and no reserve. I mean, you'd think I'd been brought up in a stately home. I grew up in Liverpool. (*laughs*) But I have no patience for people who are overly sure of themselves, probably because it's just unrelatable since I was never confident, so I find it quite abrasive. In youth I just find it so endearing when there's that kind of vulnerability.

SM: Vulnerability. That seems like a good word in relation to your work.

EFB: And true youth. Naivety. Because so many people grow up not having that. They grow into little adults very quickly, also because of the industry, and again it's this sense of escapism because I find the industry so overwhelming. I gravitate more towards kids like me. I wasn't interested in boys until I was sixteen. I cared about learning horse breeds and going for car rides with my friends, going for cigarettes in the woods behind my house, taking soap and water so my parents wouldn't be able to smell it. So I'm just naturally drawn to that vulnerability, naivety, geekiness, if you will, because that's what I was.

SM: It seems like there are these subtle autobiographical things in your stories? I've not seen it, but I was told of one of your early stories for *Dazed* apparently based on boys you knew when you were at school?

EFB: That was my first ever story! I'd based it on the boys I used to hang around with in the park. I made the models all of the bracelets we used to make for each other and the necklaces that they would wear, all the brands they used to wear. Really bad stuff, like Bench. (*laughs*) I based it around the characters there, the skater boys, the chavs. It's probably a really shit story now. I don't know where you'd find it though.

SM: Another aspect of your work that I find interesting is how you like to incorporate set designers. What does that bring to things?

EFB: I love working with set designers. You can get so lost in images where entire scapes, worlds, rooms and atmospheres have been created. I also find it

super inspiring on set as it helps the image become so much tailored to the story we're telling, much more personal.

SM: Was there a set designer involved in the Hill & Aubrey image with the giant papier-mâché ears (see plate 26)?

EFB: Yes. That was Georgina Pragnell. It was all based on an am-dram society that we named The Boggy Bottom Players. This very twee land of a cross-section of society in whatever village they're from. Georgina made it all by hand, the massive chicken legs and the big ears and the shoes that were way too big. And the carrot that the little boy is pulling out of the floor. That shoot for me was overly twee but I do love it because it's just fun.

SM: It's really witty. But there's also lots of gravitas to it, and in a way a little hint of sadness.

EFB: Yeah, you have to get the right balance. You don't want it overly twee or overly silly. There needs to be that stillness and that kind of caught in a moment that is very calm that I think helps that story in particular.

SM: Looking at styling today, how do you feel about influencers versus stylists?

EFB: Well, those are two extremely different things under the guise of the same thing. Because what they're doing is to instantly sell clothes. Whereas what I do and what stylists like me do is to inspire people into a thought process and a way of being and perhaps a creative process. *Dazed* and the stylists that style for *Dazed* and editorials that I style have never been about directly selling clothes. That's not how I think about things at all. Unless I'm doing e-com. (*laughs*)

SM: So when you say inspire a thought process . . .

EFB: You're creating a story. A character or a story or something. For me, the outcome is not about selling clothes. Quite selfishly it's just about creating work that I like. It's creating art, it's creating imagery, and you're using clothes as the tool.

SM: That's how I view the image you chose of Taylor Hill from your *Dazed* story with Charlotte Wales (see plate 27).

EFB: I wish the whole story had been like that. Those foils were in there to get curls in her hair, they weren't part of it. I don't really know what it was but it all just came together in that image.

SM: It's like some weird rococo dream with fetish silk stockings and things I can't quite put my finger on.

EFB: Yeah, I think sometimes it's nice for things to not make sense. I just had this idea in mind and didn't quite know how to execute it until I got on set. I hadn't discussed styling with Charlotte at all. It was really stressful, the build-up to it. I just got all of these things that I liked and just did it on set. And then the idea came. The t-shirt was a credit (*laughs*) and I was totally obsessed with white latex because everyone was shooting this gothic black and I loved this idea of it looking like kind of sickly skin with these ugly, clumpy sandals that aren't cool in any way. Nothing about it is ethereal and yet it feels ethereal. And I think the top layer was just nude tights cut into cycling shorts, which I also came up with on set. I had no references, nothing. I love the outcome of it.

SM: I think it really is so much like a painting.

EFB: Yes, and that is what you do when you're styling. You are painting a picture. You're creating a person, a character, and you're using those clothes to do that as well as hair and makeup and casting and photography and lighting and all those things. That's what it's about. It's not putting on clothes to sell them. Which I'm not belittling. But they're totally two different things that you often have to try to intertwine as a stylist. One's a business, one's an art. It's hard to explain, I only have how I feel about it.

SM: But that's what art is, isn't it? It's something that creates feelings. You put your feelings into something and someone else reads it with their feelings.

EFB: Yeah. Any of the worst work I've done, bad editorials, and there have been a few and I'm happy to admit that, have been because I haven't been able to relate to the idea or because I haven't had enough time. That's why they're bad. Again, it's just personal. You have to have a connection to it. *I* have to have a connection to it.

Styling Unpopular Knowledge: An Interview with Akeem Smith

Jeppe Ugelvig

Born in New York, raised in Jamaica, and returning to NYC as a teen, Akeem Smith became a prominent fixture of New York City's art/fashion scene of the late noughties, presenting his early work on digital platforms such as *DIS Magazine*. A multidisciplinary stylist spanning independent and commercial projects, Smith served as Kim Kardashian's stylist for several years, while doing work for brands such as Helmut Lang (see plate 40), The Row, and Yeezy. In 2018, he joined the roster of the creative agency Management Artist. While frequently producing editorials for *Dazed* (plate 37), *Arena Homme +* (plate 39) and *Re-Edition* (plate 41), Smith has been involved in several prominent brand projects; most significantly as an early collaborator of the New York design collective Hood by Air, and more recently, with his own collective, Section 8, which presented its second collection at Paris Fashion Week in September 2018. Compared to many of his contemporaries, Smith's approach to styling as well as design is deeply research-oriented and historical, drawing on colonial history, American race politics and club culture in his hybrid images that emphasize theatricality and story-telling. In 2020, he staged 'No Gyal Can Test' at Redbull Arts in New York, his first institutional exhibition. He remains based in Brooklyn, New York.

Jeppe Ugelvig: You were born in Jamaica?

Akeem Smith: I wasn't, actually. I was born in New York but raised in Jamaica. I moved there when I was about 6 months. I'm an anchor baby, meaning that your parents come to America to have you: I got my blue passport and was sent back to Jamaica until I was around 11.

JU: Do you remember your first consumption, or participation, in fashion?

AS: My family started a dancehall atelier. They were born in Jamaica but raised in New York, but there was a time in their early twenties when they thought 'ugh!

New York is so boring! Let's take what we've learned here and take it to Jamaica'.
So they had a real atelier set-up, but all the clothing they made was in the mode
of 'dancehall dress', so to speak. So it was always around me. I don't have a first
instance, because it's always been there: they must have started it in '93, I was
born in '91. So it feels super second-nature.

JU: How would you describe the energy in that space?

AS: I think, as a kid, I wasn't impressed by anything because my family seemed
to have it going on. I got to see people doing whatever they wanted to do first
hand. That sort of thing sets you up for either failure or success! I didn't have any
qualms about fashionability. It wasn't parallel to the Western mode of dress, to
high fashion: high fashion wasn't to me what it was to the rest of the world. And
I sort of figured that out as I was travelling a lot between Jamaica and New York.
I knew there was a difference.

**JU: That's an important observation, particularly as a child. Do you think
that difference has continued to inform your perspective on fashion?**

AS: To a certain extent. I want to somehow seek and celebrate the local and
unknown style icons in unpopular neighbourhoods and maybe bring them into
the high fashion context for a visit.

JU: You started really young?

AS: I skipped two grades, so I started working because I got out of school
earlier. I started styling assisting after high school. Originally I was going to go to
school for journalism or creative writing. I once was at this summer program at
the University of Iowa, and the people in the program were super smart – but I
realized that I needed a career that matched how I wanted to live my life. Then
styling just sort of made sense, because I knew I had a little knack for it. I was
interested in how brands build identities, and I knew that wasn't only the
designer's job. At first, I wanted to be the right-hand man to a designer and help
them build their thing because I knew I could do that very well. I think I have a
good knack for developing aesthetics.

JU: What was your first assistant job?

AS: I used to assist Jason Farrer – he was just great. He has a specific style that
was, I guess, relatable to me, and still felt like it was a part of another world. And
his style remains untouched territory.

JU: **And you studied costume design as well?**

AS: At one point, at eighteen, I felt 'I'm so over the city, it's so boring', and I went to Chicago and interned at Harpo Productions [Oprah's production company]. During that time, I also studied Costume Design at Columbia College Chicago. I learned a lot, costume is its own thing entirely, and there's a lot of things that go into it that may not meet the eye. A lot of it was character analysis, and that is the one thing I really draw from when bridging design and styling. You read about the character, you analyse it, and you ask, 'how do I make this come alive? How do you make a character based off words, words that do not describe their looks? Just based on what the idea the director or writer has of this person? Is this person black, is this person white?' It's super imaginative, and I draw a lot from that from styling. So when I usually have a styling story, I'm usually creating characters from scratch.

JU: **Did you finish your degree?**

AS: No! [laughs] I had gotten a job, and I thought this was the one I wanted. I was interning at Helmut Lang in the fabric development department, then I started working at Zaldy – the costume designer. He's great and working with him, you get to do everything. So I went back to New York. I went home for the break and never came back.

JU: **Did you ever regret it?**

AS: I only sort of regret it now, because now I'm in a place of like, 'ugh, fashion people are so dumb'. Sometimes you can't help but feel that your smartness is going away a little.

JU: **You came of age in the NYC scene of the late noughties that included GHETTOGOTHIK, *DIS*, and of course Hood by Air. It's a scene that fused art, fashion and music quite organically. What do you remember of that aesthetic and that milieu?**

AS: What was really weird about it was that we were definitely all in competition with one another about intellectual property. It was all competitive, and we were all fusing each other's likeness. Everyone was super inspired by each other, so we created opportunities for us to showcase each other's work.

JU: **Totally. Did you feel the multidisciplinary aspect of that scene was important?**

AS: Learning how to do a bunch of things? I didn't think it was important, I thought it was necessary. It was necessary because everyone was so protective

about their intellectual property that we really just wanted to do things ourselves and *then* present it. And then, when it was time present *it*, we wanted to do it on platforms that we really trusted, because we knew we sort of *had the juice*, a sense of what was next.

JU: **I see that the word 'underground' is often used to describe your career and work. Does that word mean anything to you?**

AS: Well ... I think just because I'm a bit tight-lipped about things that I've done, it seems that I am. I mean, out of the HBA girls, I'm the only stylist who's worked other places. I've worked at The Row doing design research, Yeezy, shit like that ... I mean, I styled Kim Kardashian for three years! I don't know how underground that makes me! I think it's more a tight-lipped thing. And I felt it should be like that at the time, because of my inexperience it seemed difficult to transition into other facets of my career.

JU: **How do you remember the early days of HBA? How did it begin?**

AS: Well I met Shayne [Oliver, founder of HBA] through our mutual friend Charles, and he used to invite me to things on MySpace all the time. They're all a lot older than me – but I started partying a bit too early. We always knew of each other, but were never really friends. I started working with Jason Farrer and he was doing his show – so that's how we became friends. Shayne and I have grown up very similar – we're cut from the same cloth. During his first hiatus we started just working together, doing mood shoots with Kevin Amato, that were also fittings, bringing research to him, draping, trying it on, wearing it out, seeing what the response was and just overall developing things until we had our debut show—at Spencer Sweeney's house, I think. What we were doing during that time was really building the DNA of HBA as it is known now. It sort of changed through that. It became less street.

JU: **What ideas were preoccupying you then, and what did you bring to HBA?**

AS: I definitely brought the feminization. The tailoring. I would always bring him archival pictures, tailoring ideas, and thought, 'why can't we finish a men's garment like it's a women's garment?' Just a lot of ripping and swapping and 'maybe this sort of style would look good on this sort of person?' Just building characters we weren't really seeing at that time. Not necessarily 'let's put a corset on a man' – it was a bit more complex than that.

JU: **What was it like growing up professionally in such a collaborative space?**

AS: It was actually pretty easy. It wasn't hard, we built the trust pretty early. It was more so me taking what I was learning from other professional jobs and trying to implement them in an HBA space. It was more so me trying to take my professional experiences and bring them into a space that was very DIY.

JU: **You've continued working together, and it seems that HBA is still a living entity. But you've also developed your own professional trajectory. Did you ever find it necessary to break off from the crew? The truly unique thing about HBA seems to be its family structure, but I wonder to what extent that works in fashion.**

AS: I was never really that much a part of what the media would call the 'crew'. I've only been in, like, one group shot with them – and that was also by choice. As much as it may have felt like a group from the outside, from the inside it was very not that. To analogize it, you know that one kid who does all the work in a group project? It was very that. I learned a lot working with HBA, I'm glad I was a part of it, and that I can come back to it. I really do think the best is still to come. I genuinely believe that the world hasn't seen what the project is really capable of.

JU: **How does the work you did with HBA relate to your own work?**

AS: It's not connected to it at all. Hood By Air is a brand and one of my jobs as the stylist is to infuse and give the client a vibe, energy and identity; and that basically is what I did based on HBA's own DNA and their trajectory. I think, in the long run, when you see all my work together, you may see a few bridges, but it doesn't really make sense piece by piece.

JU: **Was there a moment when you grasped your own success as a stylist?**

AS: I think that day is still to come.

JU: **You've worked as a stylist for more than a decade. Do you feel there are some tropes, themes, questions that return in your practice? Personally, I see a sense of longing or memory present in your work. It's very evocative, and it seems to gesture to a very particular space.**

AS: My everyday life really forces itself into my work, this is not by design, it just ends up that way. I feel in order to understand what is happening in society

– clothes, fashion, industries in general – you have to know history. Once you know history, everything else that's happening now starts to make sense. You start to see how the zeitgeist repeats itself. And I guess with styling, I try to sometimes use history as the idea. History isn't an image, really – it's just unpopular knowledge. For example, the images I did with Sharna Osbourne for Section 8, I was reading about 'Free, White & 21' (see plate 42). In America in the late nineteenth century, 'Free, White & 21' was a kind of law that gave permission to buy land to white males. And in the late 1920s/early 1930s, it became a slogan for white women, and it featured in a bunch of movies. This sentiment – 'Free, White & 21 – I can do whatever I want!' – there was something in that that just hit me, like 'wow, this is the epitome of confidence in today's society: I can do whatever I want'. There's really nothing holding you back. I wanted to translate this into an image. So we had this girl from Dakar, an Australian refugee; and we were in this gay church in Paris, and she had blue eyes and blonde hair, looking almost Aboriginal; and that's what I thought Free, White & 21 looked like and felt like. So that's just like an example of how an idea from history translates into my work.

JU: So you often use particular historical documents or concepts as a starting point in your work?

AS: Exactly. Spirituality and my belief in ancestral guides may be a part of it as well.

JU: I think you can definitely sense spirituality in your work. How does that relate to your own biography and identity – the history of Jamaica, for example?

AS: Not just Jamaica, the world I'd say. You know, as a black person, we don't know that much of our history. So when you don't know that much about your history, it's hard to know who you are exactly. We don't even have our own names, so it's interesting.

JU: Has blackness been an operative term for you – in your practice, in your work?

AS: No not at all, I just sort of go with whatever I feel looks the best at the moment. I don't see putting black people in this white space as if it's a rare thing. I see it as taking different nuances of blackness. I get that people are into that notion because Blacks and Brown people feel that people have always ripped away from them, always inspired but never included. I get that argument. It's just

not my thing. I don't see blackness as something super special when it's out of its environment. I like it when it's *in* its environment, if that makes sense.

JU: It seems that in the recent insurgence of identity politics in fashion there's been such a flattening of that visuality, that it comes down to trophy casting.

AS: And I get it, people want to see a world that represents them!

JU: Let me ask you about casting. Does it excite you? How do you engage it in your practice?

AS: Yes! Casting is great, because you can find a lot of commonality that isn't really based on looks. That's how I approach it. People can have the same vibe. I like to dress someone who I feel can travel through any socio-economic environment. Girl or guy, anyone who can hang around any environment without sticking out like a sore thumb. That's my ideal girl! I also like somebody who looks insecure. There's that really common thing of casting people saying: 'She doesn't look strong and confident!' I'm like, 'who looks strong and confident! Point me out someone who looks like that!'

JU: Your images are known to include non-binary models, POCs, gender fluid casting. Was that ever a conscious decision?

AS: That was done by accident, I would say – any of those categories you just mention, it had nothing to do with that. I think those points is something that other people have brought on in order to make sense of them. I thought the models I may have chosen that are under those categories, I really just thought they were cool looking and had a nice vibe going.

JU: Now you're represented by Management Artist, one of the most prominent agencies in the world. How does it feel being at that place, and having quite a prominent position in the international fashion world?

AS: You know what, I'm still not aware of it. (*laughs*) I'm surprised I even got signed. It wasn't exactly something I was looking for. The universe felt like I needed it, and whatever the universe is giving me, I'm taking it. Signing felt right. They are here for the long-haul, and it's super clear communication. They know where I want to go, and they want to help me achieve. The things I want to achieve and the way I want to do that, it's definitely not the paradigm, but they believe in it, they think it's feasible, and I think it's feasible.

JU: Where is it where you want to go, exactly?

AS: For me to know, for everyone to find out.

JU: How do you navigate the mainstream fashion industry?

AS: I don't think I'm a part of the mainstream yet, and I don't know exactly what that means. Am I mainstream if I do Yeezy? Or am I mainstream for doing more popular things, or is it a monetary thing? I'm not doing big-profile brands, but I think I will! That's the goal. You don't want to be the stylist that's brand-hopping. For the long-haul. Or maybe the hopping works, I don't know.

JU: What does it mean to have a voice, creatively, in a fashion world or cultural scene?

AS: Fashion is the place where people go for inspiration – there's no denying that. I think that's why it's been my forum to get my views across. I think I'm still trying to find that exact voice, but having a voice, from what I understand of it, could be not that great, because then they only think you can do *one thing*. Having a voice doesn't show how multi-faceted you can be. Having a voice isn't that important, but maybe having people discover their voice through what I'm doing, is more of a thing.

JU: There seems to be a politics at work in your practice – also hearing about your research, your point of view. Do you find there to be a political promise in your work, or in fashion? Or do you find a political space?

AS: Well, fashion – as much as it's its own cult-like thing, it has to reflect what's going on in the world. We just can't deny it. Politics can be inspiring. Hugo Boss made all the Nazi uniforms – there's no denying that. If you've ever seen the Hugo Boss Nazi uniforms and nurse costumes – they're gorgeous, like the best uniforms ever! It's *so well* thought out! The point I'm trying to make is that the world in general – the spaces we operate in – it's based off a real ugly foundation. I think it's about getting in there for some inspiration. You can find inspiration in that. It is what it is – it's based on a nasty, ugly foundation. Bringing it back into the present; bringing it back up, trying to make sense of it to educate – that's my project. It seems political … And yeah, let's call it that. I mean it could all be. Chanel could be a political project. A lot of stuff is all based around politics. It may not seem that way, but everything is politics. There's politics to everything, I think.

Part Two

Identity, Gender, Ethnicity and Style Narratives

'Rethinking Fashion': Caroline Baker and *Nova* Magazine 1967–1975

Alice Beard

Introduction

> You know, every now and again I think that probably a stylist does come out
> with a vision and a strength which might come from her own experience, to then
> inspire you to change the way you're wearing your clothing.
>
> <div align="right">Baker 2007</div>

A double-page photographic spread from *Nova* magazine picturing a host of
fashion editors arriving at the 1969 Autumn/Winter Paris collections suggests an
interest in fashion's 'backstage' that perhaps pre-empts today's mood of
fascination, where stylists are held up as celebrities and fashion editors are the
subjects of feature films (see figure 13). The recognisable names are there –
among them, Diana Vreeland (American *Vogue*), Ernestine Carter (*Sunday
Times*) and a young Grace Coddington (British *Vogue*) – and maybe less
well-known editors, such as Meriel McCooey (*Sunday Times Magazine*) who
were working for a new generation of fashion media: the Sunday newspaper
colour supplements. Caroline Baker from *Nova* magazine represents the
changing face of British fashion media, perhaps the first true 'stylist' who
would be responsible for picturing a street style now so resonant a part of our
fashion identity. Her outfit reveals an eclectic and individual style; she wears
'a brown dyed vest, Civil war belt and scarf from Kensington Market, beige
shorts by her dressmaker' (Keenan 1969: 59). The face-to-camera, head-to-toe
shot, framed against the backdrop of a city street and captioned with the
details of the subject's look signals the straight-up reportage popularized by
the style magazines of the 1980s, for which Baker would provide a critical
influence.

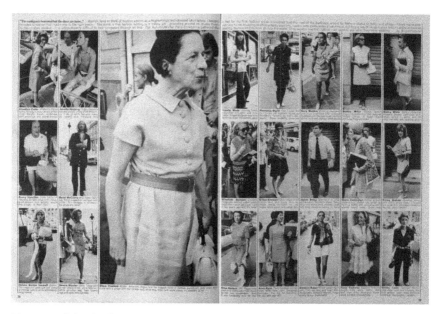

Figure 13 'The Cardigan Is Borrowed but the Shoes Are Mine . . .'. Editorial: Brigid Keenan. Photography: Steve Hiett. *Nova*, September 1967. © IPC Media 2013.

Caroline Baker is an important figure in the history of British fashion media and has enjoyed a career as a fashion editor and stylist spanning over forty years, yet few outside of the industry would be familiar with her name. Our contemporary understanding of the profession of a fashion stylist is a relatively recent one, and the origin of the role as we now understand it can be traced back to the sort of work Baker was undertaking for *Nova* in her role as fashion editor from 1967 to 1975; in this sense Baker is perhaps one of the first 'true stylists' (Godfrey 1990: 208). After perfecting her craft on *Nova* magazine in the late 1960s and 1970s, Baker went on to style for Vivienne Westwood and Benetton and created innovative fashion pages for *Deluxe, i-D, Cosmopolitan* and *Vogue*.

Whilst critical attention has been given to the medium of fashion photography and the creative practices of the photographer, until recently, less has been said about the fashion editors or the stylists, who dress the models, narrate the story and fashion the pictures on the page.[1] Also generally less discussed are the production networks at the core of fashion media; however, a growing interest in the processes of fashion image-making is seeking to redress this, and this is evident on a number of different platforms, notably the online broadcasting company SHOWstudio (Beard 2008). Fashion image-making extends beyond and behind the photographer and is a collaborative project that depends on the

interplay between photographer, model, fashion editor, stylist, art director and designer, to name a few. To better understand fashion media, its histories and future, it is time that these individuals, working practices and creative networks are both acknowledged and critically evaluated.

Information and ideas gleaned from a series of oral history interviews with Caroline Baker, set against an examination of the editorial text and images from Baker's fashion spreads for *Nova*, will reveal that her styling operated as an intrinsic part of both achieving a particular look and as a signifier of the new young fashionable consumer who read the magazine.[2]

This case study of Caroline Baker provides an insight into the working processes and collaborative practices of fashion styling. Learning her craft on the innovative women's magazine *Nova*, Baker's approach to fashion on the page was unconventional, inventive and visionary. At *Nova*, Caroline Baker began an innovative project of dress reform by tackling hands on the fashion system's hierarchical structure, conventions and restrictions; in work wear, second-hand clothing and uniforms Baker offered her readers the ultimate antidote to fashion's relentless cycle and provided a response to the deepening economic recession faced by Britain in the seventies. In pioneering do-it-yourself approaches to fashion such as customization, and mixing designer and high street fashion, Baker empowered her readers to dress as they pleased. Baker's commitment to the aesthetic and practical qualities of a more functional way of dressing and her continuing interest in developing a concept of the 'natural woman' would result in styling that embraced sportswear, looser cut designs and unisex fashions. Baker encouraged a fashionability that was defined by individuality and freedom.

Distancing itself from traditional and mainstream fashion publications, *Nova*, the revolutionary magazine published in Britain from 1965 to 1975, aimed to be, as stated on its cover, 'a new kind of magazine for the new kind of woman', and this in part involved a new take on fashion, beauty and the body. Throughout the decade of its publication, *Nova* would challenge fashion's hierarchies and conventions and offer alternative, and sometimes controversial, images of fashionable and desirable feminine identities.

Nova's fashion pages were marked by the contribution of its two key fashion editors: Molly Parkin, from 1965 to 1967, and Caroline Baker, who took over the role in 1967 and continued until the magazine's closure in 1975. These two women would ensure *Nova*'s fashion pages were eye-catching, visually dynamic and daring. Both Parkin and Baker were afforded the freedom and encouragement to create 'different' fashion pages by their editors. Because *Nova* was never simply a fashion magazine, its fashion pages offered readers a unique perspective. Its

choice of editors who were arguably inexperienced at appointment meant that their craft of fashion editing was learnt at the magazine and supported through collaborative practices with art directors, editors and photographers.

Nova's fashion editorial actively encouraged readers to use the magazine to fuel their own creative projects; from pinning up pictures from its fashion pages, to customizing their own clothing, sourcing garments from second-hand markets, or simply creating their own unique 'look' (Beard 2002). This creative directive to readers was initiated by the collaboration between Molly Parkin and art editor Harri Peccinotti, whose fashion pages focused on colour and shape, and would later be taken up enthusiastically by Caroline Baker and art director David Hillman, whose daring and inventive strategies urged readers to start 'rethinking fashion'.

Under the direction of Caroline Baker, fashion in *Nova* became less about what was worn and more about how it was worn. Baker's task of styling a model through clothing, accessories, hair and makeup was critical – her pages were presented to magazine readers as a means to achieve both a complete look and as a way of adding that important mark of individuality. Importantly, Baker was not simply reporting fashion – she was creating it. Collaborating with David Hillman and photographers such as Harri Peccinotti, Helmut Newton, Sarah Moon and Hans Feurer, Baker produced fashion pages which were, according to Peccinotti, 'almost an insult to fashion' at times, and the result of this was often what appeared to be an 'anti-fashion' statement (Williams 1998: 106).

DIY dressing: A new approach

Baker had made the leap from home assistant to fashion editor in October 1967 by way of a brief stint helping out her predecessor, the maverick Molly Parkin. She was employed by her editor, Denis Hackett, because she looked like she was into fashion, and from her initial appointment Baker's instruction was to do something different:

> At that time it was very early days for ... fashion editors. The word 'stylist' hadn't been coined ... and most fashion editors were society women because fashion was very society-driven. My editor said to me 'I don't want you to do what is in *Vogue* or *Queen* magazine or *The Times* ... I just want different fashion.' I was always interested in fashion media, a compulsion to follow fashions mixed with the fact that there wasn't the money to buy designer clothing, meant me having to resort to DIY interpretations – this led me into finding a new way to dress

myself and using clothing which I then introduced to my fashion pages ... I think, in retrospect, that was very, 'street'. Street style came about because I started using elements of what people on the streets were actually wearing and dressing models appearing on my fashion pages in clothing inspired by what I had seen.

<div align="right">Baker 2007, 2010b</div>

With a radically open remit from her editor and working on a limited budget, Caroline Baker clothed and styled her models as she chose to dress herself, sourcing menswear, ethnic jewellery, uniforms and second-hand clothing from Portobello and Kensington Market and the King's Road. Army surplus stores such as Lawrence Corner and Badges and Equipment were filled with US uniforms from Vietnam, and these provided the raw materials for spreads such as 'Dressed to Kill: The Army Surplus War Game' (1971), photographed by Harri Peccinotti (see figure 14).

Baker took her inspiration from contemporary music, film and television, and what young people were wearing on the street. This was alternative fashion – not versions of the surplus look produced by designers such as Katherine Hamnett and Kenzo, which would also feature on *Nova*'s pages some five years later, but authentic drill uniforms which were pre-worn and cheap to buy and

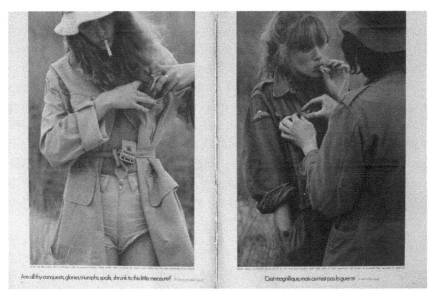

Figure 14 'Dressed to Kill: The Army Surplus War Game'. Editorial and styling: Caroline Baker. Photography: Harri Peccinotti. *Nova*, September 1971. © IPC Media 2013.

then customized by Baker, who cut up and dyed the garments for the shoot. For Baker, this choice of a way of dressing was articulated as an act of rebellion:

> I was going against fashion at the end of the sixties and early seventies . . . I began to fight this thing of always having to be groomed and wear lipstick and have your hair set, and to look like this woman – a really girly look . . . I was breaking this down. The 'Ban the Bomb' protests were going on and people were beginning to wear army surplus jackets, and I was picking up a lot of references and looking at alternative fashion as well . . . I really got into shopping from places where maybe waiters bought their clothes, or second-hand shops, and putting women into menswear. *Nova* was a really interesting magazine in that you were quite free to do all these things.
>
> Baker 2007

One of Baker's aims was to challenge established notions of ideal femininity, in particular the sort of conformist, dolled-up, girlish look that she saw as dominating the pages of other women's magazines (Baker 2007). In 'Dressed to Kill', the styling of clothing on the body, the hair, makeup and accessories all contribute towards the construction of a more natural look; the models wear their hair loose and their skin bare, suntanned and freckled. The colour palette is carefully considered; a dull wash of khaki greens interrupted with splashes of bright red. Makeup is used minimally to accessorize key details of the clothing; red painted lips and varnished nails are perfectly colour matched by a simple star-shaped enamel brooch and fine coral bead bracelet. The use of menswear operates to both conceal and reveal the models' bodies; the garments are soft, creased, worn and frayed, and the fit is loose and large, but by folding up sleeves, cutting off trousers into short shorts and tying the oversized shirts tightly on the model's body, this masculine attire serves to emphasize feminine attributes rather than disguising them. In adopting both men's clothing and a 'cool' stance, seen here for example, with the elegant yet casual gesture of the model smoking a cigarette gripped between her finger and thumb, these women convey a challenging and very modern image of femininity. The detail of styling transforms the look from a soldier's old uniform into a cool new chic; it presents an image of contemporary, cutting-edge fashion and a portrait of *Nova*'s new kind of woman.

Anti-fashion: A fashion statement

Caroline Baker's editorial for *Nova* was consciously set against mainstream fashion, and her motivation was both political and aesthetic, as she describes:

Fashion had got so terribly grown-up then, so bourgeois. How we dressed was totally in the hands of the designer and society women like Jackie Kennedy ... the beginning of my being a fashion editor was the beginning of breaking down that role, and their power over the people began to diminish ... you began to have more of a mass movement of women who were thinking for themselves when they dressed ... I was going against the status quo and against perceived ways of dressing and how one should present oneself. The magazine was my theatre ... every month I would try and bring in a relevant, up-to-the-moment story that would be as creative and ground-breaking and original as I could make it ... Once you have an audience and a theatre to perform in, you are inspired to encourage readers to try out new ways of dressing. I suppose I became more and more rebellious as it all seemed to work.

Baker 2007, 2010b

Notably, Baker demonstrated an irreverent attitude towards the fur industry; in 'Every Hobo Should Have One' (1971), photographed by Saul Leiter, Baker removed fur coats from their context of glamour and wealth and used them as props to dress her model as a tramp, posing her on a litter-strewn city street (see figure 15). The graffiti-scarred walls act as a signifier for a gritty urban realism that became a defining element of the style magazines of the 1980s (Rocamora and O'Neill 2008). Baker styles the model with dog at heel, pushing a pram containing all her worldly

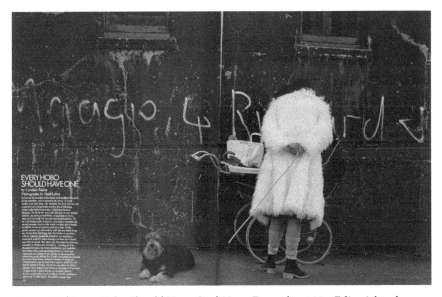

Figure 15 'Every Hobo Should Have One', *Nova*, December 1971. Editorial and styling: Caroline Baker. Photography: Saul Leiter. © IPC Media 2013.

belongings. Across these pages she is pictured slumped on the pavement, bundled up in newspapers and sleeping rough in a park. The fur coat in each shot performs the essential task of keeping the woman warm – whether it is wrapped around her loosely or spread out over her body like a blanket as she sleeps on the grass. Her costume constructs a bulky figure, with Baker's signature look of the model wearing at the same time 'thigh-high socks and socks rolled down' layered over woolly tights and thickly laced, crepe-soled boots (Baker 1971c: 67). The furs remain luxuriant in texture, colour and cut, but the proximity of the model's companion dog draws attention more to the coat's function as a warm hide than an ostentatious status symbol. Baker's styling presents a provocative image of femininity; the woman is a tramp, destitute, her fingerless gloved hands clenched against the cold, her unsmiling face obscured, cast in shadow by her oversize hat and thick loose hair. Baker diffuses the glamour and the power of the fur by creating an unsettling scene. Baker recounts the initial concept behind the story:

> I had become aware of people who were living on the streets. There was this woman in particular, who was a down and outer, and I began to see her out there with her pram and all her stuff, and her dog . . . The model was Leiter's girlfriend, and I did her as if she was a tramp. I had her tied up in strings and I had socks and flat shoes on. But the fur industry were absolutely furious . . . 'Sleeping in the park with the pram?!' . . . But it was encouraged, you see. [*Nova*] really liked that . . . You were pushed always to find something controversial to do.
>
> Baker 2007, 2010a

It was not the first or last time that Baker and the *Nova* team would court controversy and push the boundaries of their fashion pages; in its decade of publication *Nova* magazine earned itself an enduring reputation for its 'shocking' and 'provocative' content. But Baker was not interested in creating shock for shock's sake; her motivation lay in a desire to innovate and challenge the medium of fashion editorial, as she explains: 'Clothes are not necessarily one of the strongest visual leads ideas-wise for fashion stories – and it's easy to fall into a cliché situation, so you have to think deeply into how best to portray a certain style so that it is visually arresting and extraordinary' (Baker 2010b).

Adding up the look

Fashion in the 1970s can be defined by the choice of styles and looks on offer. Valerie Steele has argued that during this decade 'fashion was not in fashion' but

became 'optional' (1997: 280). Certainly, Caroline Baker encouraged a fashionability that was defined by individuality and freedom, and her fashion pages for *Nova* demonstrated that style was less a matter of what to wear and more how to wear it. As she explains, 'This notion highlighted the way clothes were worn by the individual as being the most important aspect of getting dressed, as opposed to doing what was the done thing and wearing clothes to be accepted in society' (Baker 2010b). In an editorial for *Nova*, Baker writes: 'Fashion depends more upon the way an outfit is put together than upon the clothes themselves. The bits and pieces added make the look' (1973: 88). In Baker's styling, this could be perfectly illustrated by her idea of 'letting a safety pin do the work of a button or a zip' (Baker 1972a: 66) (see figure 16) or 'wearing a shirt un-tucked, and leg warmers over trousers, showing off your underwear or putting on more than one brooch' (Baker 2010b). She offered suggestions for customizing existing wardrobes, and subverting design function, readers could experiment by: 'dressing up figure hugging suits with no blouses ... bow ties, large and floppy ... worn with men's shirts ... tying pieces of veiling around your neck ... mixing jade with clear and plastic bangles ... in large quantities of course, sometimes on both arms' (Baker 1973: 88).

As well as providing visual and textual ideas on what to look like, Baker offered advice on how to achieve these looks and encouraged an active

Figure 16 'Safety Last', *Nova*, March 1972. Editorial and styling: Caroline Baker. Photography: Harri Peccinotti. © IPC Media 2013.

participation in self-styling through a constructive do-it-yourself approach that promoted bricolage and experimentation in making, customizing and sourcing clothing and accessories. This process was demonstrated explicitly in the feature 'Head for the Haberdashery'; the title of the shoot revealing for readers the source of her materials. Her editorial mapped out the context, acknowledging that 'fashions will go on changing endlessly ... Today it is the accessory that gives you away ... that indicates fashionability, individuality. You need that very much as clothes become more mass-produced. The way you wear your clothes ... has become the most important part of today's look' (Baker 1970a: 41). The model's body, dressed only in ropes, tassels and fringing, was photographed as three frames by Hans Feurer, and the images were positioned lengthways, back to back across three consecutive double-page spreads. By buying two copies of the magazine and pulling out and pinning up the images together, a five-foot poster could be made. Caroline Baker's looks were designed to inspire – to be copied or created, deconstructed and reassembled on both the body and the wall.[3] Baker recalls her inspiration:

> I love rope and string, and strips of leather ... I didn't have those rules and restrictions around me telling me it was ridiculous ... I have a more 'out there' streak in me ... to have a go at this or that and inspire people to do it ... I got famous for tying things around the waist to make it fit ... I always used to have fun with ... pins and rope.
>
> Baker 2007

All dressed up: Narrating fashion

At its most literal level, the fashion photograph functions to advertise clothing, accessories and makeup which can then be consumed by the reader, but rather than promoting specific garments, Baker's fashion editorial expressed the fun to be had in playing with fashion and encouraged the creative activity of constructing different fashionable personas through the process of dressing up (Baker 1970b: 64). In 'All Dressed and Made Up' (1972), photographed by Harri Peccinotti, a young girl is pictured in her bedroom playing with a life-sized doll (see Figure 17).

Baker's styling offers a tone and mood; the pastel colours, soft textures and fuzzy, gauzy fabrics construct a hazy dreamworld emphasized by low lighting, a grainy filter and soft-focus camera work. Paul Jobling suggests that such imagery 'beckons us into a world of unbridled fantasies by placing fashion and the body

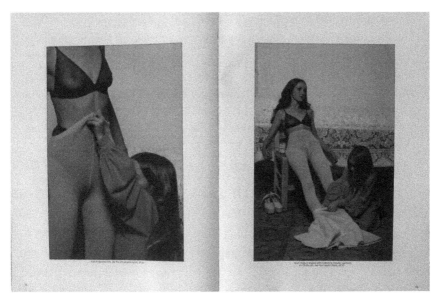

Figure 17 'All Dressed and Made Up', *Nova*, November 1972. Editorial and styling: Caroline Baker. Photography: Harri Peccinotti. © IPC Media 2013.

in any number of discursive contexts' (Jobling 1999: 2). Paradoxically, whilst Baker's fashion pages can be seen to encourage experimentation and promote creativity in the active production of a look, the model here is seemingly rendered passive by the work of the designers, photographers and stylists, who create the products and the image. Baker's editorial text makes explicit reference to this process of transformation, proposing for those readers 'who would rather be dressed than dress themselves – to save themselves thinking, searching, confusion and headaches, there are two girls, designers extraordinaire, who do it all for them: from the very first layer that goes on the skin to the final one that's painted on. They are Mary Quant and Biba' (Baker 1972b: 62). It is as if the gesture of submitting to a total ready-made look has pacified the model; she is posed stiffly and doll-like but is at the same time soft and compliant in the routine of being 'all dressed and made up'. The act of creativity here lies in the hands of the little girl (and in turn the reader who is addressed), who dresses and styles the model by building up layers from underwear to outerwear; she is pictured pulling up tights, folding down the collar of a coat and carefully adjusting a net veil. Baker's own craft of styling lies in creating and communicating the detail of the look as it would appear on the magazine page. She explains her working processes in constructing a fashion image:

I'm seeing what I'm doing, I know what the camera is going to capture ... As a
fashion editor, as a stylist, you are completely responsible for the look of all the
people in front of the camera. So you work very closely, and you stand right next
to the photographer and you're watching every picture ... You have to make it
perfect ... As I dress somebody I'm looking at it and thinking: 'Hmm, how can I
make this more interesting, or make it more fitted, or do something with it?' So
I'm getting the clothes and doing some work as a designer ... and maybe showing
them a different way of wearing it.

 Baker 2007

In 'All Dressed and Made Up', Baker conveys her task of styling through the
actions of the little girl. Baker's 'work as a designer' is revealed in the snap shots
at the end of each chapter of the fashion editorial where the model doll is dressed
in a series of finished outfits photographed from overhead, her body carefully
arranged with eyes closed and laid out flat on her back on the young girl's bed.

Jennifer Craik has observed that 'fashion images are consumed both
compliantly and defiantly by readers who lust for the pleasures of the image as
much as the clothes they depict' (1994: 114). *Nova's* readers were seduced by the
aesthetic of the fashion pages as well as the garments they featured. The interlinking
roles of title, text, photograph and graphic design are crucial in introducing the
theme of the photo story and in establishing tone and pace. Within the narrative
sequence of this spread and framed by its wide expanse of white border, each
image resembles a page in a children's picture book. The progressive element of
clothes accumulating on the model's body as the little girl dresses her suggests the
chronological passing of time and drives the narrative forward. In a fashion
spread, images are tied together by the thematic sequence of an unfolding picture
story or by common formal concerns and motifs, such as layout, design, colour,
and so on. Therefore the creation of every fashion image relied on a series of
interdependent and often very personal working relationships, as Baker explains:

When you're going to produce a photographic story, you have to communicate
with your photographer, explain what you want to do. Then they would have an
idea, and so you'd go ahead – the clothes, the hair, the makeup, and the model,
and make it happen. You'd create this story ... Quite often you'd find that a
photographer and a stylist would fall in love with each other. You worked very
well with each other and then you were just constantly getting ideas ... The
photographer needs the fashion editor because you are giving them their
photograph ... you are creating a scenario and making a story. So they are
recreating their fantasies through fashion editors.

 Baker 2007, 2010a

Dressed overall: Fashion, function and reform

In the 1970s, Caroline Baker conceptualized a new way of dressing and an approach to styling that went beyond mere decoration and ornament. An interest in the relationship between fashion and function, articulated through both word and image, characterized her fashion editorial for *Nova*. From the 1960s, developments in the technology of photography had allowed for 'outside' fashion (Harrison 1991), and this shift in fashion photography away from the location of the studio helped construct a new feminine ideal – the woman who was dynamic, physical and 'on the move' (Radner 2000). During its decade of publication, *Nova* magazine offered a 'running portrait' of this new kind of woman (Williams 1998: 105), and Caroline Baker's models were often defiantly active; an eye on clothes that were fit for this purpose led Baker to the continued use of sportswear on her fashion pages.

In 'High as a Kite and Twice as Flighty' (1971), girls jump about on a trampoline, caught in mid air by Hans Feurer's camera (see figure 18). Baker's accompanying editorial responded to what she acknowledged could be an almost overwhelming sense of freedom and choice in fashion. For those women who were 'confused as to mood, style and trend', Baker refused simple didactic

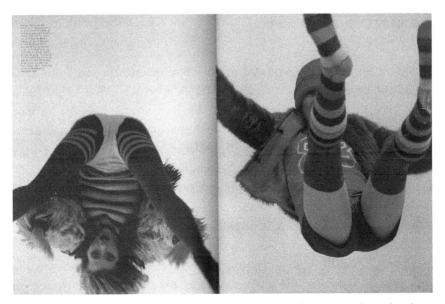

Figure 18 'High as a Kite and Twice as Flighty', *Nova*, October 1971. Editorial and styling: Caroline Baker. Photography: Hans Feurer. © IPC Media 2013.

instruction; instead, she conferred the creative responsibility onto each reader by explaining, 'It's now entirely up to you to decide what you are going to wear, and how' (Baker 1971b: 64). The task for this shoot was not simply to select clothing that would look good in the air and on the page; Baker also had to work out which garments moved, stretched and allowed for the most impressive acrobatics. Her process of styling was responsive to both the photographer's wishes and the demands of the location, and as this was a story that was concept led, it was Baker's responsibility to visualize and materialize the photographer's ideas, as she explains:

> The photographer came to me with the idea; he had found these trampolines on a beach near Brighton and he wanted to do pictures of girls in the air captured when they were jumping. I knew I had to think what clothes would work best in movement – and the sportswear theme was beginning as a source of inspiration for designers, but at that time there were quite a few shops selling second-hand American sportswear which I then mixed with shorts and skinny trousers and tights and leg warmers – using ideas from sports and dance and layering clothes up in a colourful way adding fluffy bolero-like jackets for richer texture. I collected suitcases full of gear that could work and then in the back of the location bus I tried outfits on the models, layering them up to make it look as interesting as I could – then once the girl started jumping you could see if the clothes were working visually for the lens or not and change things if necessary. I would stand right next to the photographer, just behind so I could see exactly what the camera was capturing.
>
> Baker 2010b

Baker's interest in the aesthetic and practical qualities of functional dress would also develop in to her 'Layered on Thick' approach (Baker 1974c: 79). It was a look inspired by at least two very different sources: ballerina warmup clothing and traditional Peruvian knitwear; she put together layers of legwarmers worn over tights and thick, loose cardigans worn over chunky jumpers. Baker's styling transformed the bulky into the sublime; she turned the jumpers and gloves inside out to reveal the abstract patterns of their knits and snipped and sewed together football socks to create extra-long legwarmers, which she showed worn over jeans and pulled right up to the inseam.

At *Nova*, Caroline Baker began an innovative project of dress reform by tackling hands on the fashion system's hierarchical structure, conventions and restrictions. Work wear and uniforms offered Baker the ultimate antidote to fashion's relentless cycle and provided a response to the deepening economic recession faced by Britain in the 1970s. In 'Dressed Overall' (1974), photographed

by Terence Donovan, Baker announced that 'fashion as we know it, with its bi-annual change of mood and style, will have to come to an end. A new approach to dressing will be needed … That universal, uniform look must be a practical one … The changes will have to be rung by each individual' (Baker 1974a: 39) (see figure 19).

The black-and-white photographs reveal a bleak urban landscape in which a solitary woman cuts a striking figure. The setting for the shoot may be dystopian, but the clothing is beautiful in its simple functionality: 'classic classics in lovely shadowy camouflage colours, muted and un-extravagant, but very chic' (Baker

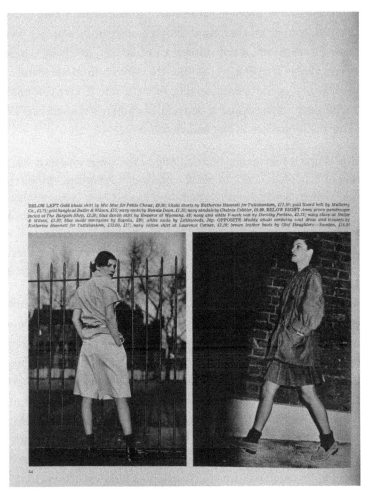

Figure 19 'Dressed Overall', *Nova*, March 1974. Editorial and styling: Caroline Baker. Photography: Terence Donovan. © IPC Media 2013.

1974a: 39). While Baker's writing emphasizes the formal and aesthetic quality of the clothes, it does not address the reader through the imperative tone of voice of 'directional fashion writing' (Lynge-Jorlén 2017: 35) found in women's glossies. Desire for the fashion image and the fashion product is shaped through the relationship between the words and pictures on a page, and it is often these descriptions that render the image 'intelligible' (Barthes 1984: xii). As Laird Borrelli points out, 'Both image and word function to articulate fashion and to create its narratives' (1997: 248). Baker's interest in the aesthetic and practical qualities of clothing developed into a concern for the relationship between fashion and function, articulated through both word and image.

In 'Dressed Overall', the garments construct the narrative: fatigue jacket, blue-black velour sweatshirt, green gabardine Oxford bags, cobalt-blue cotton skirt and a striped cotton, sheered waist blouse; accessories add key details: a gentlemen's diver's watch, a tiny antique pearl choker, an ebony bangle, gold identity tags. Baker's styling transforms the wearer from standardized and uniformed factory worker into an original modern chic. Baker's commitment to core functionality of dress and a revision of fashion's conventions kept her questioning the limitations of women's clothing:

> I was looking at menswear, and thinking 'why don't we wear what men wear? We don't need handbags ... we can put our hands in our pockets. We don't need lipstick, we don't need hairdos ... I don't have to wear heels to get myself a guy, or to keep my husband. I want to wash my clothes – I don't want to have to have them all dry-cleaned. I don't want stiff clothing, I want loose things – I have to run for the bus!' ... All these kind of feelings surfaced into my styling work.
>
> Baker 2007

Baker's continuing interest in developing her concept of the natural woman would result in styling for *Nova* that embraced practical clothing, looser cut designs and unisex fashions. In 'Lady on the Loose', photographed by Hans Feurer, Baker abandoned the hair and make-up artist all together and created a story set around the idea of 'a shared wardrobe for all the family' (Baker 1974b: 60–61). As her text describes, the look was 'big and baggy, borrowed from the male – which means more to spend on the holiday and less on the clothes ... no problem with the fit, the bigger the better' (ibid.). The oversize look would continue to inspire Baker well into the 1980s and is notable in the styling she contributed to Vivienne Westwood's 'Nostalgia of Mud' collection (1982–83). In 1975, the final year of *Nova*'s publication run, Baker dedicated a number of features to the philosophical premise and aesthetic qualities of the 'smock-shape',

which represented 'the end of fashion and the start of something new' (Baker 1974b: 60–61). As she explained to her readers, 'The smock-shaped shirt-dress fits fat and thin, young and old and goes with everything. If we women don't want to be judged on sex appeal, why don't we adopt enthusiastically the one practical uniform we've been offered?' (Baker 1975b: 67). By her final issues on *Nova*, Baker appeared to dismiss the fashion system altogether; her article on denim entitled 'You Can Take a Blue Jean Anywhere' revealed a firm anti-fashion sentiment as she argued that 'couturiers and fashion magazines report po-faced on this and that look, and we waver between what we think we should like and what we know we do like ... The only thing that changes year to year is the gimmickry, and even that is of no great importance' (Baker 1975a: 29). A double-page spread of a close-up of a woman's bottom tightly clad in a pair of faded, worn-in Lee jeans celebrated denim as a sartorial solution, a default way of dressing which stood outside of fashion's waxing and waning. The following pages profiled Baker's favourite denim looks and offered a taste of the images she would construct for *Deluxe* and *i-D* magazines a few years later. For Baker, denim offered the ultimate solution: it was all at once uniform, practical, comfortable, affordable, versatile, unisex and sexy, and importantly it allowed the individual wearer to dress and stage her own identity.

Conclusion

Caroline Baker was offered relative 'free reign' as fashion editor on *Nova*, and her pages challenged ideal images of femininity and subverted conventional notions of good taste and sartorial common sense. Baker's editorial for *Nova* was consciously set against mainstream fashion, and her motivation to create an 'anti-fashion' statement was both political and aesthetic.

Nova's fashion editorial did not only reflect the ideals of the context in which they were originally produced, but also served to present new versions of femininity and fashionable identity. As well as a continuing agenda towards the promotion of a 'natural' look, Caroline Baker produced provocative images of femininity; her depictions of models dressed up as tramps, prostitutes, refugees, strippers and drunk party girls certainly offered a challenge to conventional images of glamour, but these images were arguably a more honest and direct acknowledgement of the seductive images of femininity that circulated through other forms of visual culture [i.e. *Belle du Jour* (1967) and *Klute* (1971)]. This defiance of 'dolled-up' prettiness was taken up by the street style of *The Face* and

i-D, which Baker helped to launch, and can be seen in the raw, gritty aesthetic of Corrine Day's photographs of Kate Moss styled by Melanie Ward for *Vogue* in 1993.

Caroline Baker's fashion pages for *Nova* reveal that styling is integral to the achievement of an overall look, but equally significant, it encourages a way of dressing as a means to a way of being. In effectively defining the activity of styling through her work as fashion editor on *Nova* and approaching this as both ideologically and aesthetically driven, Baker was able to communicate a series of fashion statements; the words and pictures of her fashion editorial play a crucial role in articulating the narratives of new and desirable feminine identities. Baker's fashion editorial for *Nova* changed the way fashion appeared on the magazine page and inspired a generation of young women to dress as they pleased. For Baker, the privilege that came with her role as a fashion editor lay in her ability to show by example, as she explains:

> Somehow or other it's quite brave to make that decision by yourself – to say 'I'm just going to go out wearing my pyjamas and my sneakers!' But if you see it somewhere, you think 'yes, I could wear my clothes like that' and I think that that is the power of the fashion editor . . . I always used to think I did a service to people . . . you actually were saying to women like yourself: 'Yes, this is what I feel like wearing now'.
>
> <div align="right">Baker 2007</div>

Acknowledgement

An earlier version of this chapter was published as 'Fun with Pins and Rope: How Caroline Baker Styled the Seventies', in Bartlett, D., S. Cole and A. Rocamora (2013), *Fashion Media: Past and Present*, London: Bloomsbury. I am grateful to Bloomsbury Publishing for allowing me to reproduce this chapter.

Notes

1 See D. Bartlett et al. (2013), *Fashion Media: Past and Present*, London: Bloomsbury; K. Nelson Best (2017), *The History of Fashion Journalism*, London: Bloomsbury; A. Lynge-Jorlén (2017), *Niche Fashion Magazines: Changing the Shape of Fashion*, London: I.B. Tauris.

2 This research draws on two oral history interviews (2007, 2010a) and written communication (2010b) with Caroline Baker.

3 *Nova*'s treatment of fashion and beauty editorial and its focus on design and layout
 marked out its specific appeal and difference to other women's magazines. As I have
 argued previously, *Nova*'s fashion pages encouraged an activity beyond buying the
 clothing or accessories featured; these images were actively consumed, torn out of
 the magazine, cut up and pinned to walls (Beard 2002).

References

Baker, C. (1970a), 'Head for the Haberdashery', *Nova*, February: 42–47.

Baker, C. (1970b), 'Fancy Dressing', *Nova*, December: 64–73.

Baker, C. (1971a), 'Dressed to Kill: The Army Surplus War Game', *Nova*, September:
 48–53.

Baker, C. (1971b), 'High as a Kite and Twice as Flighty', *Nova*, October: 64–73.

Baker, C. (1971c), 'Every Hobo Should Have One', *Nova*, December: 60–67.

Baker, C. (1972a), 'Safety Last', *Nova*, March: 66–67.

Baker, C. (1972b), 'All Dressed and Made Up', *Nova*, November: 62–71.

Baker, C. (1973), 'Adding Up to Something Good', *Nova*, March: 88–91.

Baker, C. (1974a), 'Dressed Overall', *Nova*, March: 39–44.

Baker, C. (1974b), 'Lady on the Loose', *Nova*, July: 60–69.

Baker, C. (1974c), 'Layered on Thick', *Nova*, November: 78–85.

Baker, C. (1975a), 'You Can Take a Blue Jean Anywhere', *Nova*, July: 28–35.

Baker, C. (1975b), 'Is This the End of Fashion and the Start of Something New?', *Nova*,
 September: 66–73.

Baker, C. (2007), Personal communication with Alice Beard, 23 February.

Baker, C. (2010a), Personal communication with Alice Beard, 19 September.

Baker, C. (2010b), Personal communication with Alice Beard, 27 September.

Barthes, R. (1984), *The Fashion System*, London: Jonathan Cape.

Bartlett, D., S. Cole and A. Rocamora (2013) *Fashion Media: Past and Present*, London:
 Bloomsbury.

Beard, A. (2002), 'Put in Just for Pictures: Fashion Editorial and the Composite Image in
 Nova 1965–1975', *Fashion Theory: The Journal of Dress, Body and Culture*, 6 (1):
 25–44.

Beard, A. (2008), 'Show and Tell: An Interview with Penny Martin, Editor in Chief of
 SHOWstudio', *Fashion Theory: The Journal of Dress, Body and Culture*, 12 (2):
 181–195.

Borrelli, L. (1997), 'Dressing Up and Talking about It: Fashion Writing in *Vogue* from
 1968–1993', *Fashion Theory: The Journal of Dress, Body and Culture*, 1 (3): 247–260.

Craik, J. (1994), *The Face of Fashion: Cultural Studies in Fashion*, London: Routledge.

Godfrey, J. (1990), *A Decade of i-Deas: The Encyclopaedia of the '80s*, London: Penguin.

Harrison, M. (1991), *Appearances: Fashion Photography since 1945*, London: Jonathan
 Cape.

Jobling, P. (1999), *Fashion Spreads: Word and Image in Fashion Photography since 1980*, Oxford: Berg.

Keenan, B. (1969) 'The Cardigan is Borrowed but the Shoes Are Mine . . .', *Nova*, September: 58–59.

Lynge-Jorlén, A. (2017), *Niche Fashion Magazines: Changing the Shape of Fashion*, London: I.B. Tauris.

Nelson Best, K. (2017), *The History of Fashion Journalism*, London: Bloomsbury.

Radner, H. (2000), 'On the Move: Fashion Photography and the Single Girl in the 1960s', in S. Bruzzi and P. Church Gibson (eds.), *Fashion Cultures: Theories, Explorations and Analysis*, 128–142, London: Routledge.

Rocamora, A. and A. O'Neill (2008), 'Fashioning the Street: Images of the Street in the Fashion Media', in E. Shinkle (ed.), *Fashion as Photograph: Viewing and Reviewing Images of Fashion*, 185–199, London: I.B. Tauris.

Steele, V. (1997), 'Anti-fashion: The 1970s', *Fashion Theory: The Journal of Dress, Body and Culture*, 1 (3): 279–296.

Williams, V., ed. (1998), *Look at Me: Fashion Photography in Britain 1960 to the Present*, London: British Council.

'Looking Good in a Buffalo Stance': Ray Petri and the Styling of New Masculinities

Shaun Cole

Introduction

The title of this chapter is taken from the lyrics of Swedish-born singer-songwriter Neneh Cherry's 'rap' that featured on the B-side of Morgan McVey's debut 1986 single 'Looking Good Diving' and later as Cherry's own 1988 solo debut single 'Buffalo Stance'. The emphasis on style and appearance, in lines such as 'Who's looking good today? Who's looking good in every way? No style rookie', 'Looking good, hanging with the wild bunch' and 'Looking good's a state of mind', goes some way to summing up the new masculinities and contemporary men's fashion presented by Ray Petri and his Buffalo collective between 1984 and Petri's death from AIDS-related conditions in August 1989. Cherry recalled that the song was 'about our gang, our time and our mentor, Ray' and 'what we were feeling, what we'd been through' (cited in Limnander 2007 and Rambali 2000: 173).[1]

Significantly, Petri and his Buffalo collaborators 'explored attitude, creating a "modern man" from the remnants of punk and Ray's own eclectic taste' (Logan and Jones 1989: 10). Petri and his group were by no means alone in presenting new approaches to men's fashion and style. Other stylists and photographers, such as Simon Foxton and Nick Knight, addressed similar concerns and identities.[2] However, Petri had a clear sense of how he saw contemporary masculinity and how style and attitude could be presented. The impact Petri had on the practice and understanding of fashion styling and on men's fashion and 'identity' in the last decades of the twentieth century and into the new millennium is significant. This chapter will explore some of the ways in which Petri used his own background and interests – drawn diversely from Jamaican street culture, Native Americans, sport, London gay clubs, Africa, the military, westerns and

B-movies, rock and roll, the royal family, and punk graphics – and those of his collaborators to attend to *fin de siècle* men's fashion and style. It will address how Petri used this personal image bank to inspire his styled ensembles, combining men's high fashion designer items with utilitarian uniform or workwear garments and sports clothing accessorised with jewellery and found objects. In this way, he created new and exciting visions of contemporary men's style, reflecting socio-economic conditions in Britain and inspiring men not just to copy fashion pages but to experiment and be creative. His practice of using and re-using the same or similar elements of dress on the same models across his relatively short career as a 'stylist' reveals how he honed his skill and played with notions of tradition and newness, while reflecting a changing and maturing audience progressing from *i-D* and *the Face* to *Arena*. The chapter will offer perspectives on how Petri simultaneously referenced traditional tropes of masculinity whilst pushing the boundaries for the 'modern man', through the pages of eighties lifestyle magazines *i-D*, *The Face* and *Arena*.[3]

The 1980s were difficult economic times in Britain. Coinciding with Margaret Thatcher's Conservative government there had been record numbers of unemployed, the miners' strikes and the race riots in inner-city areas in the early 1980s. Against this there had been the increasing rise of consumerism, the rise of the Yuppie. For much of the youth of Britain this produced a spirit despondency, although there was also a particular surge in British forms of creativity in the arts coming out of British arts schools and manifested in areas such as music and fashion. Petri plundered and mixed up existing styles and icons to create new images of masculinity that were, photographer Jamie Morgan recalled, 'strong and sensitive – they showed you didn't have to drink beer and beat people up to be tough' (cited in 'Nature Boy' 1989: 60). Petri's constructions of 1980s masculine identity were very much in contrast to contemporaneous hegemonic masculinity, that preferenced men over women and subordinated the weak, feminine or homosexual and was the 'most honored way of being a man [requiring] all other men to position themselves in relation to it' (Connell and Messerschmidt 2005: 832). Petri's images chimed with (and indeed have been included in) discussions of the 'new man' that seemed to respond to the crisis in masculinity and the impact of feminist thought on gender relations.[4] As Frank Mort has argued, 'masculinity is multiform, rather than unitary and monolithic' (1996: 10) and thus it is important to consider masculinity both in the plural and through intersections with other subject positions such as race, ethnicity and class (Connell 2005; Smith 1996). In creating his 'modern men', Petri looked to icons of masculinity – cowboys, Native American 'Indians', sailors, soldiers, lifeguards,

boxers, workmen and gangsters. Some of these had been knowingly adopted by the 1970s gay pop group The Village People. That these are icons of masculinity means that they are not necessarily 'new'. However, Petri took these iconic images and re-presented them for men's fashion imagery in new combinations that also reflected the 'subcultural capital' of his collective's members. Petri's strength was in taking the connotative key elements of the visual styles of cowboys and boxers, for example, and re-working them juxtaposed against contemporary streetstyle elements in a new postmodern *fin-de-siècle* context.[5]

Setting the scene

Petri's biography has been well rehearsed elsewhere, especially in Paul Rambali's (2000) essay. However, it is worth offering an abbreviated version here to indicate both how he drew on 'his own transnational hybrid experience' (Tulloch 2011: 183) and came to work collectively and creatively with his fellow Buffalo members. Petri was born in Dundee in Scotland on 16 September 1948. Aged 15 his family moved to Australia, first settling in Brisbane before moving to Melbourne, where Petri formed a band named The Chelsea Set. In 1969 he returned to London, where he took an antiques course at Sotheby's, ran a stall at Camden Passage street market and worked as an assistant for photographer Roger Charity. After returning to London Petri subsequently travelled to India on the hippie trail, to Rhodesia to visit his parents and to New York and Paris in search of alternative metropolitan lifestyles and experiences. The peace of the Indian Ashram, the gritty reality of Salisbury boxing clubs and the urban gay styles of New York and Paris were all to emerge in the multiple inspirations and eclectic juxtapositions of Petri's work.

Petri began 'styling' by putting together looks for Charity who recalled, 'he just wanted to do the styling and the casting ... he was very interested in making boys look brilliant' (cited in Rambali 2000: 165). It was through Charity that Petri met both the aspiring model Nick Kamen and photographer Cameron McVey, who in turn introduced Petri to photographer Mark Lebon. Petri moved into a flat belonging to McVey's sister below that of photographer Jamie Morgan, who had met Lebon at college. Lebon's brother, James, worked at the fashionable hair salon Cuts and ran the rap music night 'The Language Lab' in London. Morgan recalled that the collective 'met in clubs, at parties, on the street, [and] we would transfer our lives to the studio and start working' (cited in Graham 2015). The tightknit group of friends that formed the core of the 'Buffalo'

collective allowed its members to play to their strengths, to be inspired by their varied cultural backgrounds but to find a common language drawn from their approach to fashion and music that grew out of 'the fact that none of us fitted into any class, race or social background that we could really feel was our own' (Lorenz 2000: 13).

The name Buffalo was 'drawn from a Caribbean expression to describe people who are rude-boys or rebels. Not necessarily tough, but hard style taken from the street' (Petri, cited in Jones 2000: 157) and was 'inspired by a group of friends in Paris. It's just a name to cover what I wanted to do – something "creative" but tough and street at the same time' ('Ray Petri' 1985: 44). The Parisian inspiration was Jacques Negrit's private security company, who wore cobalt blue US Air Force MA1 flight jackets, with the company name stencilled on the back. Negrit gave Petri one of these jackets and it became a key part of his own personal uniform.

Creating the look(s)

Petri and Lebon's first styled image for *i-D* appeared in the September 1984 issue; a full-page image of Nic Camen [*sic*] wearing a layered outfit of two sleeveless denim jackets over a black Cerutti dinner jacket and white Marks and Spencer's vest and black Levi jeans. A black felt hat decorated with gold tie clips and a string of pearls wrapped around a Calvin Klein t-shirt worn as a scarf complete the look. The elements of later Buffalo styling are all here and mirrored Peri's own personal style of 'crisp, expensive white shirt over a Hanes t-shirt, Levi's *sans* belt hanging low off his hips, and pork-pie hat' (Rambali 2000: 170). Another version of Petri's style, including a garment that became synonymous with Buffalo and London's mid-eighties club scene, appeared in *i-D* in December 1984. Titled 'Ray goes to Manhattan' (photographed by Charity, with 'style & fashion' by Petri 'AKA Stingray'), the model wears black jeans, t-shirt and beret with a black MA1 flight jacket, decorated with a religious prayer card. The MA1, cut short and tight at the waist revealing crotch, bottom and legs and usually in olive green, had been a staple of the gay clone's hypermasculine wardrobe in the late 1970s and early 1980s.[6] As a gay man active on London and New York's gay scenes, Petri would have been familiar with the MA1. Petri's influences were partly grounded in urban gay culture, perhaps most notably in the contact he made between the model and the audience, which Mort believes drew on the visual contact involved in gay men's 'cruising' for sex (1996: 71–72). A two-way

influence between Petri's stylised shoots and the young gay urbanites of London's Soho emerged: 'there is a certain image, a very sort of Soho look ... the flat-top, the black jacket and the DM shoes, or whatever – I think they might be gay, but not necessarily' (cited in Mort 1996: 184).[7]

Considerations of sexuality, ethnicity and class were important to Petri's selection of models, and his use of black and mixed race models went counter to the fashion industry convention. Indeed, when Petri first met Nick Kamen, he was the only model of colour on the books of his agency, listed as 'Black' despite his mixed heritage of Burmese-Irish father and French-Dutch-English mother. Morgan recalled that in his and Petri's casting they wanted to 'be original and create something that hadn't been created, use models from the street that hadn't been used' (Morgan, cited in Rambali 2000: 170). What interested Petri when casting was the individual, a sense of character, declaring 'the important thing in good styling is casting ... once you have the right face it all falls into place' ('Ray Petri' 1985: 44) and 'style is important and I dress people to enhance the way they already look' (cited in Jones 2000: 158).

Sportsmen and boxers

In 1983, Morgan was encouraged by the teenage stylist Mitzi Lorenz who worked for *i*-D to approach *The Face* with images he had created with Petri, inspired by 1930s photographs of swimwear by George Hoyningen-Huene in *Vogue* (Rambali 2000). Two appeared as a double-page spread 'tour de force' in the September 1983 issue: 'Biker' Peter Fisher wears black and white sports tops, black Katherine Hamnett trousers and leather chaps, with a martial arts defence mask and studded wristbands; 'Cyclist' features Wade Tolero wearing a multicoloured cycling top, shorts and gloves accessorised with studded wristbands and a sticking plaster over one eyebrow. Their combination of sportswear, designer clothes and subcultural accessories is typical of Petri's ongoing approach. Editor of *The Face* Nick Logan recalled, 'we were trying to introduce fashion' (2000: 147) and he commissioned more leading to Morgan and Petri's first cover for *The Face* in January 1984.[8] Over two double-page spreads titled 'Winter Sports', Petri mixed multicoloured cycling tops and designer shirts with white sailor's trousers and sweatpants from Multisport and designer Stephen King, fireman's and policeman's jacket accessorised with badges, bracelets and diamante brooches. On the cover, in a close up half-profile portrait shot, Nick Camen's [*sic*] black coat and knitted hat contrast with his

bright orange ribbed balaclava worn as a scarf and yellow sticking plaster over one eyebrow.

The bright colours in 'Winter Sports' reappeared in *The Face* eighteen months later in another sport themed spread, titled 'Float Like a Butterfly sting Like a Bee … Check Out the Beef' photographed by Morgan. Over eight pages and the cover, six male models are presented in a bricolaged mix of Lonsdale boxing and cycling shorts, dyed sleeveless Jockey polo necks, hats, boots and pastel coloured silk waistcoats from Tommy Nutter. The models strike poses reminiscent of the boxing ring that reflects Richard Martin and Harald Koda's declaration that 'the embodiment of physical prowess is the traditional ideal of the athlete' (1998: 22). On the cover, boxer Clinton McKenzie sets the tone in an assertive pose (see figure 20). Morgan recalled of McKenzie that he 'was a real boxing champion, from a tough street background. This was his first fashion shoot, but he got it

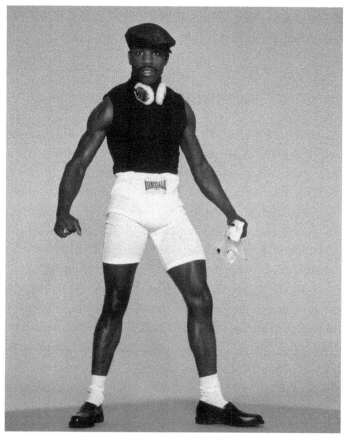

Figure 20 'The Young Contender', boxer Clinton McKenzie for *The Face*, June 1985. Photography: Jamie Morgan. Courtesy of Jamie Morgan.

straight away . . . He was actually a really sweet, gentle man and this is what Ray wanted to show: that a man could be really strong and sensitive at the same time' (cited in Compain 2017). McKenzie appears in a single-page black and white portrait in *The Face* in August 1985, wearing a black fedora, a boxing champion belt and a plaster on one eyebrow.

A similar combination of Lonsdale and Bodymap lycra shorts, Nutter waistcoat and Versace hat (worn on the cover of 'Float Like a Butterfly . . .') is paired with a jacket from catering outfitters Denny's and bomber jacket from design duo Bernstock and Spiers in a two-page spread in i-*D* August 1985, shot on location on the streets of West London (this time photographed by Robert Erdman). The sporting styling and the Jamaican slang title quote, 'wild youth takes a wicked stance on the corner – they sing and dance wearing brand new rub-a-dub selection', were revived in 'Max Raggamuffin' photographed by Morgan in *The Face* in October 1985. Whilst the model Maxwell is not dressed in boxing gear – instead, a black Bernstock and Spiers jacket and Matsuda trousers accessorized with a New York fireman's hood, sheepskin 'gauntlet', leather glove, 'US Army' belt buckle and Judy Blame necklace – he reads as a 'boxer' gearing up for a fight. These studio and street shoots, styled by Petri, featuring sport-inspired designer garments combined with surplus store and real sport clothing, reflect Martin and Koda's observation that the 'clothing of the athlete, heroic by dint of its functionalism, takes part in the largest game of modern life – leisure activity' (1998: 26).

The sticking plasters that Petri placed over his model's eyebrows became a 'Stingray' trademark. Paul Rambali (2000) recalled that Petri told him this had been inspired by Visconti's 1960 film *Rocco and his Brothers*, in which French actor Alain Delon plays a poor southern Italian who becomes a boxer and spends much of the film with a plaster over his eyebrow from injuries sustained fighting. In discussing 'the masculinity of the boxer', Judith Halberstam has observed that 'the most macho of spectacles is the battered male body' (1998: 275). Visconti's presentation of a particular form of violent masculinity and the 'battered bodies' he represents on film was taken by Petri and juxtaposed with a seemingly feminine over-interest in clothes and appearance that has been identified as typical of the eighties 'new man'. Petri had been attracted to the 'tangible sign of acceptance in a virile fraternity' (Wacquant, cited in King 2018: 26) he saw in the boxing gyms in Salisbury, Rhodesia. This chimes with Angela King's use of Kath Woodward's 2004 ethnographic study to note that boxing acts as 'a site for negotiations of racialised and classed masculinities' and where 'anxieties and fragilities of masculinity' could be 'confronted' (King 2018: 22). In using a real boxer, McKenzie, and the signifiers

of boxing in his imagery, Petri was considering new masculinities in relation to race and class and how the anxieties of late twentieth-century masculinities could be negotiated through embodied appearance.

Cowboys

This consideration of newer masculinities, drawn from and referencing more historic iconic forms, is also presented in Petri's use of cowboy signifiers. Historically and culturally, the cowboy projected an image of all-American rugged outdoorsy hegemonic masculinity. Cowboys featured frequently in gay physique photography of the 1950s and 1960s, coinciding with the golden age of the Western film. In the early 1970s, the hypermasculine gay clones drew on this icon's associations of toughness, virility, strength and potency to create an image counter to gay effeminate stereotypes (see Cole 2000, 2014). Petri's creation of gentle, sensitive 'new men' styled as urban cowboys drew on his awareness of particular presentations of both hegemonic and diverse masculinities in popular and gay culture, making the photographic work of the Buffalo collective appealing to both gay and straight men of the 1980s.

On the final page of *The Face* in February 1985, the first of a series of black and white 'Fashion Expo' portraits, credited to 'Buffalo (Ray Petri/Brett Walker)', appeared featuring the model Alphonso Latino Tolero dressed in a black cowboy hat, white shirt and leather jacket. Staring directly into the camera, he raises his left hand as if he is about to tip his hat to the viewer; echoing scenes from many classic 1950s Westerns. In *Jocks and Nerds*, Martin and Koda identify the cowboy as 'one of the most significant fashion images of the twentieth century'. They note the rugged masculinity of the cowboy dress code and 'his hat is both helmet and shield and that, in its many variations [is] his most personal sign' (1989: 77). It is the hat as this 'most personal sign' that Petri uses to signify cowboy in his urban reconfigurations.

For *The* Face in June and October 1985, Petri uses cowboy styling in two spreads, the previously discussed 'Float like a Butterfly' as well as 'Pure Prairie London Cowboys Lay Down the Law Soldier Take Over' (both photographed by Morgan). In the former, Tolera reappears wearing a straw cowboy hat with black sleeveless polo neck, black shorts and wrist fur cuff, straddling a backwards facing chair. While the chair is reminiscent of Lewis Morley's portrait of Christine Keeler, the way Tolera holds the chair makes it read as a saddle. The pose is revisited in *Arena* in September/October 1988 in an image titled 'Blue Skies in

Chianti Country', where black model Leon Reid wears a straw 'cowboy' hat with a black cashmere coat and leather riding boots by Gianni Versace and leather waistcoat and jersey trousers by Jean Paul Gaultier.

Although the black felt hat with feather decoration in 'Pure Prairie London' connotes cowboy, Petri has styled black model Maxwell in a white Jockey polo neck sweater, and a black silk revered tailcoat from Hackett draped with a Union Jack flag. The more explicit cowboy reference is both in the spread's complex title and through a paired 'portrait' image of Simon de Montford, wearing a Native American headdress. Morgan recalled that for this shoot, 'we wanted to play with stereotypes taking the all-American white cowboy and making him black. We were also playing with the gay stereotype of the cowboy. We wanted him to be really sexy and tough but in a cool way' (cited in Compain 2017).

'Urban Cowboys' is explicitly used as the title for one of two New York themed spreads in *Arena* in September/October 1987, the other being 'Boys from the

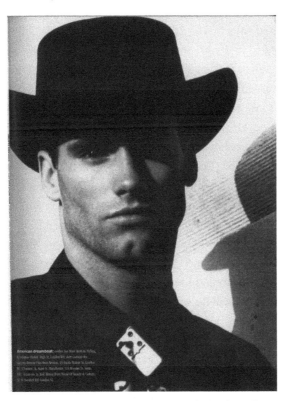

Figure 21 'American Dreamboat', the opening image from the Urban Cowboy spread in *Arena*, September/October 1987. Photography: Norman Watson. Courtesy of Bauer Media.

Bronx'. The former opens with 'American Dreamboat', a sepia toned black and white portrait featuring a black Comme des Garçons shirt, black cowboy hat and dominoes jewellery by Judy Blame (see figure 21). The same model reappears twice more with the same hat and variations on the outfit. In a shot titled 'Hard being Hard' (referring back to earlier Buffalo shoot titles), as the man in black with Stetson, shirt, jeans and BSA motorbike buckle, calling to mind country and western singer Johnny Cash and the New York street cowboys, gigolos and rent boys in John Schlesinger's 1969 movie *Midnight Cowboy*. Other images in the spread focus more on tailored jackets by Cerruti, John Flett and Rifat Ozbeck, creating a mix of rural historicism and urban grit, that is picked up in the following, 'Boys from the Bronx,' spread.

Men in suits / usurping tailored elegance

The collective's name appeared as the title for a five-page spread comprised mainly of tailored suits in *The Face* in September 1986. 'Buffalo: a more serious pose' demonstrated that Petri and Morgan could create images that nodded to a long tradition of classic men's tailoring but that could also keep the edgy combinations for which they were gaining a reputation. In the first image, Barry Kamen wears loose tailored black and white striped Komlan trousers with a black shirt and tie, Dr Martens and a black leather jacket from Jasper Conran. The other three images have models Kamen, de Montford and Joe wearing black suits (from Armani, YSL Rive Gauche and Tommy Nutter), echoing a gangster mafioso attitude that had been expressed eighteen months earlier in the groundbreaking 'The Harder they Come, the Better' shoot in *The Face* in March 1985.[9] Photographer Jean-Baptiste Mondino recalled that Petri 'was obsessed with "bad boys," ... He loved the idea of classic Italian tailoring done in a Caribbean way' (cited in Limnander, 2007) and these influences come across in 'Buffalo: a more serious pose' (1986) as well as the earlier 'The Harder they Come, the Better'.

The monochrome palette of black suits and white shirts that dominates 'Buffalo: a more serious pose' prefigures both his first and last shoots for *Arena* : 'Suits' in December 1986 and 'The Long Goodbye' in November 1989 (published after Petri's death in August of that year). In 'Suits', the British suits shot in the studio against white backgrounds are reminiscent of those in 'Buffalo: a more serious pose', whilst the Italian suits are shot on location with backgrounds that hint at Italy and in this respect reflect the more cinematic style of Petri's work for *Arena*.

In comparing Petri's Buffalo work with other men's magazine shoots of the mid to late 1980s, Sean Nixon identified a style he termed 'Italianicity ... "condensed essence" of a mythical Italian masculinity' (1996: 187). The models' skin tones, facial features, sensuality, machismo and a sense of *'spretzzatura'* – seemingly referencing masculinities presented in the films of Pier Paolo Pasolini, Luchino Visconti and Roberto Rossellini – all come together to create this 'Italianicity'. Petri focussed on Italy again in the May/June 1987 and September/ October 1988 issues of *Arena*. In the 1987 eight-page 'Dateline: Milan' spread, photographed by Norman Watson, the chiselled jawlines and broad shoulders of the Italian models are mostly complemented by Italian tailored suits and overcoats. Some of the same tailoring reappears in the eighteen-page spread, shot by Charity, entitled 'Tuscany', but now worn more casually in romantic rural settings and contrasted with images that invoke an earthy Italian peasantry, with shirtless muscular models presenting 'sensuality in the coding of masculinity [through] displaying the surface of the body' (Nixon 1996: 192). One image, 'Sweet Dreams of Youth', has the model, Leon Reid, reclining on a bed wearing a woollen sweater by Baljo with boxer shorts, reminiscent of the second spread from the inaugural issue of *Arena* in 1986 that combined cashmere sweaters and jeans. Herein lies one of the skills and pleasures of Petri's presentations of masculinities. Whilst themed for the shoot and focusing on a particular trope or style, he often inserted an 'interloper' or mixed up his references.

Andrew Bolton argued that Petri's stylings 'utilized typical items of men's apparel' such as the suit and as such 'modified rather than revolutionized the chief tenets of menswear' (2004: 279). In this way, according to Bolton, Petri and his manifestations of '"new man" continued to be wrapped up in the garb of "old man"' (ibid.). Whilst this may be true, one of the strengths of Petri's styling was the combination of staple items of traditional menswear with unconventional garments and accessories. It was his process of bricolage that made his work influential on approaches to men's fashion and style. Graphic designer Bill Wilson recalled Petri made 'you start thinking about clothes ... in an aesthetic kind of way ... old fashioned kind of clothes in a new context looked great' (Wilson in interview with Cole 1999).

New men in skirts

If we take Bolton at his word, then the most interesting and revolutionary element of Petri's styling was putting men in skirts. This was not about a form of

cross dressing or even 'genderfuck' styling (Cole 2000), but instead demonstrated Petri's particular skill in balancing a culturally perceived feminine garment with masculinity: 'I defy any stylist or photographer to take a picture of a guy wearing a skirt and make him look sexy but not stupid. That was Ray's power' (Morgan, cited in Bolton 2003: 25).

One of Petri's most iconic covers for *The Face* featured a man in a skirt beside orange capitalized text stating 'BOLD' and 'NEW'. Inside, an article by Glenda Bailey entitled 'Men's Where?' announcing that men 'are dressing up' in the increasing variety of available styles was accompanied by three images by Petri and Morgan, photographs by Sheila Rock and quotes from a variety of designers, stylists and educators on the state of men's fashion. Blond Caucasian cover model, Camillo Gallardo, stands with his hands on hips, legs akimbo, staring at camera, wearing a navy Jean-Paul Gaultier jacket open over bare chest decorated with gold medal-style brooches and a Union Jack flag. A green, black and yellow tartan mid-calf length skirt by John Richmond is held up by a gold medal brooch. The two other colour images in the shoot also feature Gallardo, apparently wearing 'skirts'. The fourth, black and white, image features Nick Camen [*sic*] wearing a grey Gaultier jacket over a white unbuttoned shirt, with black hat and Dr Marten's boots. His black leather knee length skirt from Hobbs is held up by a belt with a 'western-style' buckle.

Kamen's assertive pose here is contrasted in *i-D* (July 1984) in a photograph by Lebon, titled 'Boy Versus Girl', where he stands with his hands in front of him and head bowed as if in prayer; a more meditative 'eastern' aesthetic that was intended perhaps to reflect Kamen's mixed parentage.[10] His 'skirt' is a blue striped Kanga, brought from Nigeria for Lebon by his friend Yonne Gold (Bolton 2003: 24), worn under a long black Yohji Yamamoto coat embellished with red 'sashes' made from horse bandages and a black horse bandage headband with a French Legionnaire's badge. Kamen's leather skirt is also prefigured in *The Face* in May 1984, where he wears a long beige Allegri trench coat over white cotton jersey rugby shorts, that could be read as a mini-skirt, because of the positioning of his legs. Recalling this image Morgan explained it as his and Petri's version of 'that classic sexy fantasy image' of a woman wearing a fur coat and underwear and that they 'wanted to show that it was cool for men to play with being sexy too' (Morgan, cited in Compain 2017).

As anthropology and subsequently fashion studies have demonstrated the gendered links between items of clothing and masculinity and femininity are culturally and temporally specific (see, for instance, Barnes and Eicher 1992; Crane 2000; Edwards 1997; Entwistle 2000; Roach and Eicher 1965; Wilson

1985). As well as looking at the ways Western designers have created 'non-bifurcated garments' for men in his 2003 book *Bravehearts: Men in Skirts*, Andrew Bolton also addressed how skirted garments evolved in 'non-Western cultures' (2003: 64) and been used as inspiration by menswear designers. Petri's understanding of his own culturally diverse upbringing and that of his fellow Buffalo members perhaps accounts for the ways in which he integrated various seemingly disparate elements into his stylings. In the images where skirts appear, he used wraps, sarongs and flags as well as women's skirts and kilts (inspired specifically by his Scottish heritage). Both influencing and utilizing the garments made by top designers like Jean-Paul Gaultier, Petri challenged the established meanings of clothing items through his bricolage and juxtaposition, inviting questions about appropriate male attire, attractiveness and late twentieth-century masculinities. The influence of Petri's styled skirted men was also felt in London's nightclubs. One man recalls a first trip to a London club in January 1985 (just two months after the skirt cover of *The Face*): 'There were these two men … wearing white shirts, black shawl collared tuxedo jackets with huge diamante brooches pinned on them, white socks, black Dr Marten lace-up shoes and black ankle-length skirts' (cited in Cole 2000: 164).

Female masculinities

For *i-D* in October 1984, Petri styled two images of a ten-page feature entitled 'Scoop', inspired by newspaper headlines and with photos by Lebon. In one, responding to the headline 'Leaping Gurkha "ruined our Marriage"', Wade Tolero wears a black Vivienne Westwood wrap skirt, combined with a Naval purser jacket, a t-shirt from Browns, a studded bandana decorated with feathers, black lace-up brogues and studded wristbands over coloured socks (see figure 22). The rooftop location echoes Tolero's assertive pose, while his racial origin and styled outfit echo Nepalese national dress, drawing from the Gurkha news story. As Lebon noted of Petri's men in skirts, 'they were never effete or effeminate … The look was not intended to threaten a man's masculinity, it was intended to enhance it' (cited in Bolton 2003: 24).

Never one to be completely literal, Peri's combinations drew on notions of multiculturalism and varied perception of masculinities. The image that was paired with Tolero was inspired by the headline 'Bengali vigilantes seek revenge' and initially this blurred image appears to be a young Bengali man in a red suit (see figure 22). On closer inspection, this 'young man' is Buffalo collective

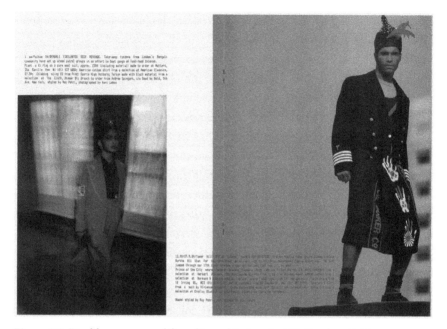

Figure 22 Double-page spread from 'Scoop' feature in *i-D*, October 1984. Photography: Marc Lebon. Left-hand side: Mitzi Lorenz in '1 am / Fulham Rd / Bengali vigilantes seek revenge'. Right-hand side: Wade Tolero in '12.00 / 27.9.84 / Tower Hill / Leaping Gurkha "Ruined our Marriage"'. Courtesy of Marc Lebon and *i-D* magazine.

member Mitzi Lorenz. Here, Petri's own 1970s made-to-measure jacket from Savile Row tailor Nutters, with a Union Jack flag applied to the sleeve, is combined with red trousers, an American sports shirt, black winkle-picker shoes, a climbing sling and a black 'turban' decorated with a brooch from jeweller Andrew Spingarn. Lorenz's biological sex is contrasted with her masculine gendered appearance, as well as a play on her mixed ethnic background (Pakistani Muslim father and English mother) that compares and contrasts with Tolero on the opposite page.

This is not the only time Petri styled Lorenz in a masculine way. For the 'Wardrobe Scrabble' spread photographed by Monica Curtin in *i-D* in November 1984, Micky (as she is named here) wears an oversized Prince of Wales check suit by Cerutti with a black t-shirt, black shoes, a pork pie hat 'customized' with a newspaper cutting reading 'KILLER'. Lorenz's pose, with hands in pocket, challenging stare at the camera and choice of name, invites the viewer to read her as a 'boy'. The use of the 'Killer' cutting in Lorenz's hat and her androgynous styling prefigures the presentation of child model Felix Howard both on the

cover and inside *The Face* in March 1985. His youthful smooth skin and challenging stare are those of Lorenz and his white polo neck sweater under a tailored jacket is repeated in the shoot when worn by Lindsay Thurlow. Like Lorenz, Thurlow and fellow female model Pim Aldridge initially appear to be of uncertain gender and present a different combination of hardness and softness, masculinity and femininity than de Montford, the other male model in the shoot. The juxtaposing of androgynous looking male and female models in both of these shoots echoes Halberstam's assertion that 'male and female masculinities are constantly involved in an ever-shifting pattern of influences' (1998: 276).

Lorenz's boyish androgynous style was catapulted into broader popular culture through Jean-Baptiste Mondino's video for Madonna's 1986 single 'Open Your Heart'. The video in which Madonna plays an erotic dancer ends with her meeting Buffalo collective member Felix Howard outside the peep show where she was performing for men who are dressed like stylized cameos from a Petri styled shoot. Howard and Madonna's almost identical outfits of grey suit, shirt, white socks, lace-up shoes and pork pie hat mirror that worn by Lorenz in the i-*D* shoot. Although Petri is not credited as styling the video, his influence is apparent; through Howard and Madonna's outfits, especially the pork pie hat, the cameos of spectators that mirror his collaborations with Mondino (and other Buffalo photographers) and Howard's presence echoing the cover of *The Face* in March 1985.

These renderings of female masculinity knowingly play with the genderbender styles of early eighties club and music cultures. Halberstam proposes that 'far from being an imitation of maleness, female masculinity actually affords us a glimpse of how masculinity is constructed as masculinity' (1998: 1), and it is in Lorenz's seeming male presentation that we understand how Petri considers other forms of masculinity presented through his male models. In this 'knowingness' there is, Nixon argues, 'a self-conscious sense of maleness that was pushed to the edges of camp' (1996: 184). The self-knowing, stylization and playfulness revelling in the idea of artifice identified by Susan Sontag in her 1964 'Notes on Camp' are all present in examples of Petri's work. For example, 'the boys in the band' spread from *Arena* in March/April 1987 references Mark Crawley's play and film of the same name that shed light on 1970s gay life but also presents characters and poses that could be drawn from the video for Nick Kamen's 1986 debut single 'Each Time you Break my Heart', directed by Jean-Baptiste Mondino and featuring many of the Buffalo models.[11] Similarly, Tony Felix's cowboy styled outfit on a double-page spread in i-*D* in August 1985 titled 'young gun go for it' is a knowing reference to both cowboy gunslingers and Wham's 1982 sing 'Young Guns (Go For it)'.

Conclusion

Reflecting on how he played with culturally ascribed gender attributes, Morgan recalled Petri 'loved playing with opposites, breaking down boundaries and stereotypes. Why can't a boy be sexy and tough at the same time? Why can't girls be tough and serious, not just pretty. Why not shoot young people, old people, black, white? After all, we are all essentially the same; that was our philosophy' (cited in Compain 2017). In his articulations of late twentieth-century masculinities, Petri drew on his own background, experiences and preferences and combined those with contributions from photographers and models to create strong memorable images of 'streamlined classicism, rough-edged and Brandoesque' (Logan and Jones 1989: 10). The mixed heritages of his friends and colleagues were dipped into and emerged in a coherent way that made sense but challenged the norms of traditional men's fashion styling and magazine presentation. While each of the photographers that Petri worked with both formally within the Buffalo collective and outside had their own aesthetic, there was a similarity of approach and a commonality that surfaced through Petri's styling. Fashion image production is a collaborative process, the most successful images demonstrating a synergy between the model(s), the photographer, the stylist, the hair and makeup team, and the assistants involved in particular shoots. In the collaborative photographic output of the 'Buffalo' collective, Petri was the lynchpin that 'brought everyone and everything together' (Morgan 2000: 14).

The early single images and double-page spreads Petri produced for *i-D* and *The Face*, where subcultural references mixed with sportswear and items from young designers, evolved and became more sophisticated, spreading over ten or twelve pages in *Arena*. The street locations and studio shots of early work were replaced with cinematic spreads in lavish rural and gritty urban locations with sophisticated tailoring and high-end designer items. In the early shoots he 'present[ed] the body as a surface on which objects and images can be plastered and hung' (Nixon 1996: 183). He also treated clothes in the same way, utilizing images from his scrapbook and decorating both smart tailored and more casual street wear with expensive accessories and other found items that became decorative 'jewellery'. The repeated motifs and items of clothing – Union Jacks, pork pie hats, items of jewellery and so on – formed an image bank that Petri dipped into and recombined in a self-referencing manner that created a recognizable Buffalo vocabulary. This continued throughout his later work, forming a continuous language of references to, and usurping of, iconic forms of masculinity. Even in his final (posthumously published) spread 'The Long Goodbye' (*Arena*, November 1989), which opens with an image

of Petri's trademark pork pie hat above a 'ragamuffin' tearsheet, the posing of the Kamen brothers as 'mourners' at a funeral in monochromatic tailoring continues earlier combinations – a Comme des Garcons jacket over a white football shirt, an Anthony Price suit with Johnsons biker boots – but now in a subtler, more reflective, romantic and melancholic manner. The sense of sensitive new masculinities that Petri had expressed even in his earliest image of Nick Kamen is present here. To cite Petri's repeated refrain and final words, the images were and remain to this day, 'Cool Still'.

Acknowledgement

I would like to thank Angela King for sharing her unpublished MA thesis, 'Reflections of a female apprentice boxer: On working class masculinity within a traditionalist East End boxing gym', which informed my thoughts on boxing and masculinities.

Notes

1 The members of the group alongside Petri were (in alphabetical order): Naomi Campbell, Roger Charity, Neneh Cherry, Simon De Montford, Tony Felix, Felix Howard, Barry Kamen, Nick Kamen, James Lebon, Marc Lebon, Mitzi Lorenz, Cameron McVey, Jamie Morgan, Jean-Baptiste Mondino, Howard Napper, Jack Negri, Leon Reid, Talisa Soto, Wade Tolero and Brett Walker. Morgan/McVey was a short-lived musical collaboration between Jamie Morgan and Cameron McVey, who later married Neneh Cherry.

2 For more on Simon Foxton, see P. Martin (2009), *When You're a Boy: Men's Fashion Styled by Simon Foxton*.

3 Petri's work was not limited to these three magazines. He created work for other magazines including *Tatler* and advertising for Pitti Trend in Italy and Dim underwear, amongst others. The scope of this chapter and particular approaches to masculinity allowed only for discussion of the magazines.

4 The term 'new man' was used to describe an emotionally involved man conscious of his nurturing domestic role but also a more narcissistic consumer engaged in grooming and his appearance. It has been argued that this was merely a media construct perhaps best remembered in the iconic 1986 Athena 'Man and Baby' poster. For more on debates about the new man, see Rowena Chapman and Jonathan Rutherford's edited *Male Order: Unwrapping Masculinity* (1988), Frank Mort's

Cultures of Consumption (1996), Tim Edwards' *Men in the Mirror* (1997), Paul Jobling's *Fashion Spreads* (1999) and Sean Nixon's *Hard Looks* (2003).

5 Carol Tulloch invoked Jean-François Lyotard's words from *The Postmodern Condition* ([1979] 1984) – 'Working without rules in order to formulate the rules of what *will have been done*' (2011: 183) to account for ways in which Petri approached his work and his practice could be viewed as postmodern.

6 For more on the gay clone, his masculine wardrobe and the MA1 jacket as a staple of a masculine gay wardrobe, see Cole (2000). Rambali recalled that 'Ray loved the macho cut that revealed the nape of the neck – his favourite part of the male anatomy – and their deep blue nylon sheen lent the jacket a nocturnal elegance' (2000: 169).

7 This became the 'nightclubbin' disguise' (Witter 1987: 98) of mid-eighties London clubs, such as the Wag where the 'ever-present Petriboys in their MA1s, 501s and D.M.'s . . . come to hear "rare grooves" [and] Chicago "House" music' (Sharkey 1987: 96).

8 This issue of *The Face* was released in the run up to the Winter Olympics in Sarajevo. A second double-page spread – 'Chain Charms: Male Jewellery' – photographed by Morgan and styed by Ray Petri aka Stingray, also appears in this issue.

9 This spread has been discussed in detail in Nixon (1996) and Tulloch (2011).

10 This photograph is part of an eight-page spread titled 'The Challenge'. Petri's image is paired on a double page with a shot by Lebon styled by Caroline Baker titled 'Girl Versus Boy'. Gabby, a muscular, unmade-up model with hairy armpits is posed athletically in sporty leggings and t-shirt. For more on Baker's styling, see the essay by Beard in this volume and Beard (2013).

11 Mondino also directed the video for Nick Kamen's debut 1986 single 'Each Time you Break my Heart' (written and produced by Madonna and Stephen Bray), released prior to Madonna's 'Open your Heart'. It is set in a nightclub with Kamen preforming his song on stage. Other Buffalo male models including Howard and de Montford appear like moving stylized Buffalo photo shoots wearing versions of outfits seen in Petri's images. The homoeroticism is tempered by a film of a female model, Kamen's then girlfriend and Buffalo member Talisa Soto, being projected onto Kamen's back and Howard flicking through photographs of Soto. Like the Madonna video, it ends with Kamen dancing down a street outside the club (alone) and eight seconds before the end of the video the words 'Kool Still' appear. These were to be Peri's last words. A second less homoerotic version, also directed by Mondino, was made. Here the focus is on Kamen's stage performance interspersed with 'holiday film footage' of Soto waving at Kamen.

References

Barnes, R. and J. B. Eicher, eds. (1992), *Dress and Gender: Making and Meaning in Cultural Contexts*, Oxford: Berg.

Beard, A. (2013), 'Fun with Pins and Rope: How Caroline Baker Styled the Seventies', in D. Bartlett, S. Cole and A. Rocamora (eds.), *Fashion Media: Past and Present*, 25–44, London: Bloomsbury.

Bolton, A. (2003), *Bravehearts: Men in Skirts*, London: V&A Publishing.

Bolton, A. (2004), 'New Man/Old Modes', in M.L. Frisa and S. Tonci (eds.), *Excess: Fashion and the Underground in the '80s*, 277–280, Milan: Charta.

Chapman, R. and J. Rutherford, eds. (1988), *Male Order: Unwrapping Masculinity*, London: Lawrence & Wishart.

Cole, S. (2000), *Don We Now Our Gay Apparel: Gay Men's Dress in the Twentieth Century*, Oxford: Berg.

Cole, S. (2014), 'Costume or Dress? The Use of Clothing in the Gay Pornography of Jim French's Colt Studio', *Fashion Theory*, 18 (2): 123–148.

Compain, H. (2017) 'The Buffalo revolution, as told by founding father Jamie Morgan' *Vogue*, 4 May. https://www.vogue.fr/vogue-hommes/fashion/diaporama/buffalo-style-ray-petri-jamie-morgan-80s-fashion/42791 [accessed 4 February 2019].

Connell, R.W. (2005), *Masculinities*, 2nd edition, Cambridge: Polity Press.

Connell, R.W. and J.W. Messerschmidt (2005), 'Hegemonic Masculinity: Rethinking the Concept', *Gender and Society*, 19 (6): 829–859.

Crane, D. (2000), *Fashion and its Social Agendas: Class, Gender and Identity in Clothing*, Chicago, IL: University of Chicago Press.

Edwards, T. (1997), *Men in the Mirror: Men's Fashion, Masculinity and Consumer Society*, London: Routledge.

Entwistle, J. (2000), *The Fashioned Body: Fashion, Dress and Modern Social Theory*, Cambridge: Polity Press.

Graham, M. (2015), 'How Buffalo Shaped the Landscape of 80s Fashion', *Dazed Digital*, 24 August. http://www.dazeddigital.com/fashion/article/26041/1/new-film-on-iconic-80s-buffalo-subculture-jamie-morgan-barry-kamen [accessed 4 February 2019].

Halberstam, J. (1998), *Female Masculinity*, Durham, NC: Duke University Press.

Healy, M. (2009), 'Unseen Buffalo', *Arena Homme +*, pp. 310–316.

Jobling, P. (1999), *Fashion Spreads: Word and Image in Fashion Photography Since 1980*, Oxford: Berg.

Jones, D. (2000), 'Buffalo Soldier', in Mitzi Lorenz (ed.), *Buffalo*, 157–158, London: Westzone.

King, A. (2018), *Reflections of a female apprentice boxer: On working class masculinity within a traditionalist East End boxing gym*, MA dissertation, London College of Fashion, University of the Arts London.

Limnander, A. (2007), 'Buffalo Soldier', *New York Times*, 11 March. https://www.nytimes.com/2007/03/11/style/tmagazine/11tpetri.html [accessed 4 February 2019].

Logan, N. (2000), 'Myths and Legends', in M. Lorenz (ed.), *Buffalo*, 147–148, London: Westzone.

Logan, N. and D. Jones (1989), 'Ray Petri', *The Face*, October: 10.

Lorenz, M., ed. (2000), *Buffalo*, London: Westzone.

Lyotard, J.-F. ([1979] 1984), *The Postmodern Condition: A Report on Knowledge*, trans. G. Bennington and B. Massumi, Minneapolis, MN: University of Minnesota Press.

Martin, P. (2009), *When You're a Boy: Men's Fashion Styled by Simon Foxton*, London: London College of Fashion.

Martin, R. and H. Koda (1989), *Jocks and Nerds: Men's Style in the Twentieth Century*, New York: Rizzoli.

Morgan, J. (2000), 'Foreword', in M. Lorenz (ed.), *Buffalo*, 14, London: Westzone.

Mort, F. (1996), *Cultures of Consumption: Masculinities and Social Space in Later Twentieth Century Britain*, London: Routledge.

'Nature Boy' (1989), *The Face*, November: 56–67.

Nixon, S. (1996), *Hard Looks: Masculinities, Spectatorship and Contemporary Consumption*, London: UCL Press.

Rambali, P. (2000), 'A Walk on the Wild Side', in M. Lorenz (ed.), *Buffalo*, 164–177, London: Westzone.

'Ray Petri' (1985), *The Face*, May: 44.

Roach, M.E. and J.B. Eicher, eds. (1965), *Dress, Adornment and Social Order*, New York: Wiley.

Sharkey, A. (1987), 'Black Market', *i-D*, June: 96.

Smith, P., ed. (1996), *Boys: Masculinities in Contemporary Culture*, Boulder, CO: Westview Press.

Sontag, S. (1964), 'Notes on Camp', *Partisan Review*, 31 (4): 515–530.

Tulloch, C. (2011), 'Buffalo: Style with Intent', in G. Adamson and J. Pavitt (eds.), *Postmodernism: Style and Subversion, 1970–1990*, 182–184, London: V&A Publishing.

Wacquant, L. (2004), *Body & Soul: Notebooks of an Apprentice Boxer*, Oxford: Oxford University Press.

Wilson, B. (1999), Interview with Shaun Cole, 10 August.

Wilson, E. (1985), *Adorned in Dreams: Fashion and Modernity*, London; Virago.

Witter, S. (1987), 'BPM/AM', *i-D*, July: 98.

Styling 1990s Hip-Hop, Fashioning Black Futures

Rachel Lifter

This chapter is about June Ambrose and Misa Hylton – two stylists who shaped the look of New York-based hip-hop and R&B in the 1990s. Both Ambrose and Hylton started their careers in the music industry in the early part of the decade as interns at Uptown Records. Hylton was a teenager at the time, and Ambrose had already begun a career in investment banking before realizing that the business field 'simply wasn't my dream and aspirational place to spend the rest of my career' (Mediabistro 2012: 0:34–0:40). Soon after starting their respective internships, each woman had the opportunity to style looks for up-and-coming acts signed by Sean Combs, a newly appointed A&R executive and Hylton's then-boyfriend. Combs's role in discovering and developing some of the biggest acts in New York-based hip-hop and R&B in the 1990s is well known, and his talent list included the artists Jodeci, Mary J. Blige and the Notorious B.I.G., among others. Working in collaboration with these newly signed acts and other upcoming stars in hip-hop and R&B, Hylton and Ambrose contributed to the development of artists' images by creating looks for them to wear in music videos, during live performances and at awards shows. On one hand, and like many other music industry personnel, Ambrose and Hylton worked (and continue to work) in the shadows of the stars they styled, mediating the musicians' star personae to potential audiences. On the other, and through their pioneering styling work in the 1990s, these two women established themselves as artists in their own right, fashioning a new image of hip-hop and R&B for the turn of the twenty-first century. Following these two threads, the chapter explores Ambrose and Hylton's styling work in the late 1990s, first as a form of creative service work within a rapidly changing hip-hop music industry and second as a feminist statement within the speculative artistic tradition known as Afrofuturism. Across the chapter, it becomes clear that, as Ambrose and Hylton

worked to fashion black images on stage and on screen, they also paved the way for future (female) black creatives on the ground.

Learning to create in a service industry

Today, stylists are recognized as key contributors to the production of musicians' images. I argue elsewhere that such recognition is a relatively recent thing (Lifter 2018). As several fashion stylists entered into well-publicized collaborations with pop stars in the early 2010s, the practice of styling for music and the creatives who do it were bestowed a new fashionable visibility. As a result, styling for music has emerged as an attractive career path for those people interested in careers in fashion and communications. Within this context, Ambrose and Hylton are recognized as pioneers in the field, routinely asked to speak about their career origins and trajectories. Emerging from their discourse are two themes: first, that there was no blueprint for styling hip-hop and R&B when they started their careers in the 1990s, and second, that the work of styling for music demands both creative and psychological expertise, as stylists are tasked with fashioning a look that is both visually stimulating and 'authentic' to the star.

'Back then being a fashion stylist wasn't a career choice,' Hylton said in a 2017 interview with *Billboard*'s Rashad Benton. 'I had no idea what to do or how to do it' (Benton 2017). Lacking a clearly-defined professional context, both women speak of their career starts in terms of being given the opportunity to translate their childhood passions for fashion into creative careers. Ambrose recalled to *E!*'s Catt Sadler, 'as a child, I used to literally cut up my grandma's curtains and design Barbie doll dresses, and I used to get into so much trouble. I was always making and designing stuff, still not knowing it was a career.' She explains further, 'Then I was doing fashion shows, junior high school, high school, I was doing it, I was producing these shows, coordinating it, styling it, still not knowing. You don't realize your talents sometimes until later on in life' (Simply 2015: 2:41–3:06). And for Hylton:

> When I was a pre-teen, the radio only played Hip-Hop on Fridays and Saturdays and was hosted by Mr. Magic & Kool DJ Red Alert. I would sit on the floor by the radio with my cassette tapes and record the music and while listening I envisioned wardrobe. There weren't many visuals out at that time; basically, there were none. So, you had to sit and imagine what these rappers looked like, what they should wear, what I would wear, and what my friends would wear.
>
> Benton 2017

Hylton was able to turn that childhood passion into a career, she explained further, as 'a "right place, right time" situation': in other words, by dating Combs, as he was stepping into a music industry role in artist development, shaping how musicians sounded *and* how they looked.

As Keith Negus explains, there is – and was at the time of Ambrose and Hylton's career starts – a whole industry at work in the service of 'artist development' (1992: 63). This industry, however, operates largely in the outsize shadows of the artists it shapes and sells. In his book *Producing Pop* (1992), Negus sheds light on this industry and its various creative workers, focusing in particular on the central collaboration between the artist and repertoire (A&R) and marketing departments. He explains, the A&R department is responsible for identifying and signing new talent (1992: 38), and the marketing department is in charge of putting together an image for those newly signed acts, packaging that image and selling it to potential audiences. He continues, stylists are part of marketing departments, making strategic decisions about what an artist will look like. The point of such work is to create an image for the artist that will come across as 'authentic' to existing and potential future audiences. Negus cautions, 'Notions of authenticity are not employed in the marketing of an act because staff hold romantic beliefs that the image should express the real experience and origins or innermost soul of an artist.' Rather, 'It is for the very practical reason that an artist has to live with their image and carry it convincingly in a range of settings [and also] the audience has to believe it' (1992: 70). Successfully done, the resulting image effectively obscures the work that went into it. In other words, when a musician's image appears 'authentic,' audiences fail to consider the vast array of creative workers – including stylists – who worked to shape it.

I offer the term 'creative service work' to describe this type of invisible creative labour, upon which the music industry relies to produce and market its stars. It is creative work; in the case of styling, it involves sourcing and fitting clothes onto musicians' bodies in ways that will be visually stimulating to audiences, in a crowd at a concert or watching television at home. It is not unfettered creativity, however. Rather, stylists and other behind-the-scenes music industry personnel work at the behest of both the music labels who pay them and the individual musicians, whose star personae they are fashioning. As Richard Dyer writes about the film industry, 'Stars are made for profit' (2004: 5). So too are the music industry's stars, and thus stylists and other industry personnel must make creative decisions that will maximize record label profits. Such creativity involves responding to both qualitative genre conventions and quantitative statistical

sales data. And yet stylists in particular also have a personal responsibility to the artists with whom they work. Dyer continues that in the film industry, stars can feel alienated from their images, 'turned into something they didn't control [yet] fashioned in and out of their own bodies and psychologies' (2004: 6). Again, there are parallels to the music industry. Because they work directly on and intimately with the bodies of musicians, stylists – more so than other music industry personnel – must respond to their clients' psychologies, how they want to see themselves as artists and people.

The term 'style' itself offers a theoretical access point into exploring the music stylist's creativity in the service of both commerce and star psychology. On one hand, the term has been theorized as a sartorial activity through which identities are forged. The scholars of the Centre for Contemporary Cultural Studies, for example, theorized style as the practice through which working-class subcultural identities were constructed, using garments and other tools from the commercial fashion industries, but assembled in new and strange ways to create a subversive look (Hall and Jefferson [1976] 2006). Extending from this pioneering work, 'style' has been mobilized as a theoretical tool to explore the dress practices of other social groups, minoritized on the grounds of race (Mercer 1994; Tulloch 2018), sexuality (Geczy and Karaminas 2013) or religion (Lewis 2015) – dress practices that respond to and resist the normalizing frameworks of dominant culture. Carol Tulloch (2010) offers a broader framework for fashion studies that places 'style' in dialogue with 'fashion' and 'dress.' Whereas 'fashion' refers to historically specific aesthetic trends, 'style' is 'part of the process of self-telling, that is, to expound an aspect of autobiography of oneself through the clothing choices an individual makes' (Tulloch, cited in Kaiser 2012: 6). On the other hand, as the chapters in this volume evidence, 'style' is also a professional practice, through which fashion is articulated on the magazine page (Lynge-Jorlén 2016). In this version of 'style,' the agency of the wearer fades from view. The model, like the photographer and any other creative personnel, might be a collaborator in the creation of the image, but the practice of 'style' in this instance is not about identity. Rather, as Ane Lynge-Jorlén (2016: 86) explains, the point is that 'the stylist's own aesthetic interpretations and dispositions' of fashion are articulated. Of course, Lynge-Jorlén continues, such creativity is tempered through industry-specific economic restraints, such as demands from magazine publishers to include the garments of those fashion houses who also fund the magazines through advertisements. Styling in the music industry stands at the intersection of these two definitions of 'style.' Celebrity styling does, too. In both instances, style is a form of professional expertise that articulates aesthetic knowledges for profit *and* constitutes identities that are keenly felt.

Clear within Ambrose and Hylton's discourse is that the personae they produce are deeply internalized by the musicians with whom they work. As a result, the stylists explain that the work of styling in the music industry involves coaxing and nudging, nurturing and pushing. In Hylton's words, the question stylists routinely ask themselves is: 'How can I make my client happy?' (Premium Pete 2017: 40:02–40:05). She elaborates,

> Understanding your client and continuing to talk to them. I always ask them to try it. 'You don't have to do it, but let's try it. Try this on, see how it looks, take a picture, look in the mirror.' And that usually works because I know what I'm talking about. You have to get people to open their mind and take a risk. Are there times when people just came out with something they might not be comfortable with, and they're about to perform and it may not be the right shoes for them? That definitely happens. And it's my job to find what works for them.
>
> Premium Pete 2017: 39:24–39:59

In Ambrose's phrasing, 'We're in a help industry, a life-changing industry' (Simply 2015: 16:40–16:43). Her celebrity makeover show, *Styled by June*, which aired on VH1 in 2012, offered a made-for-TV portrayal of styling as 'life-changing.' Working across music and celebrity, Ambrose is shown making-over 'celebrities in search of an image reboot,' including former teen-actress Misha Barton and 1990s hip-hop stars Trina and Da Brat (Terrie 2015).[1] Within the 'rebooting' process, Ambrose and her team of three assistant stylists draw from their stores of fashion garments and mobilize their connections to the fashion media to reposition the stars with whom they work. The goal of the episode with Trina, for example, is to take her 'from bootylicious rapper to crossover couture diva' (Terrie 2015: 0:43–0:48). In the episode, Ambrose is shown putting the rapper into a 'rocker look because I feel like this isn't something Trina has identified with yet' and then parlaying this new look into a shoot for *Paper* magazine and a listening event for her new album (Terrie 2015: 5:29–5:33). In one scene, Ambrose is shown coaxing Trina into wearing her hair in a high bouffant, leaving the room when Trina is resisting the look, returning to ask the rapper to trust her and her expertise – a strategy that she developed to allow an artist to cool off and calm down. In the end, Trina is quite happy with her new image, explaining her initial resistance as follows: 'I think June created totally something that was out of my comfort zone, and it worked. I fought with her, but in the end I really trusted her. And I feel good about that' (Terrie 2015: 16:05–16:14). Stylists perform this psychological labour, whether trained in the field or – more likely – not. Later in her career, Hylton gained such training by getting

certified as a life coach. Asked if she ever internalized her clients' problems, she responded, 'No, but as a stylist I did' (Premium Pete 2017: 1:05:07–1:05:09).

With no official training, Ambrose and Hylton started their styling careers in a music industry niche that was rapidly expanding, in both size and cultural visibility. As Negus (1999: 87) explains, as early as the 1920s the music industry began to identify and label black-produced music as 'race music,' but it was not until the early 1970s that major record labels established departments dedicated to black musical production (see also Roy 2004). In the 1980s, however, 'the major companies had neither the inclination, the understanding nor the skills to deal with rap' (1999: 90). Instead, Negus continues, many independent record labels were established in the decade – labels that, because of their small size, were understood to be 'in touch with "the streets"' (ibid.). These new labels were (at least partially) founded and owned by African-American men.

In 1984, Russell Simmons was a co-founder of Def Jam Recording, and in 1986 Andre Harrell started Uptown Records, where Ambrose and Hylton got their starts. The following decade saw the founding of Combs's Bad Boy Entertainment (1993) and Damon Dash and Jay-Z's Roc-A-Fella Records (1995) on the East Coast as well as Dr. Dre and Suge Knight's Death Row Records (1991) on the West Coast. These companies were incredibly successful, a success embodied by their owners. Combs, Simmons and Jay-Z, in particular, were identified as a new class of person, the hip-hop mogul, who was celebrated for his exceptional wealth and relied upon for his ability to 'identify and market black cultural knowledge and tastes' and to package those tastes for mass-consumption (Smith 2003: 75; see also Chang 2005 and Fleetwood 2011). Centring around these moguls' bodies and lifestyles, hip-hop took on an aesthetics of opulence, known at the time as 'bling' (Mukherjee 2006). As Hylton remembers about the period, 'We had the craziest budget – oh my god – because we bought everything' (Premium Pete 2017: 22:18–22:23). She is referring here both to hip-hop's deep coffers and the non-existent relationship between hip-hop and the fashion industry at the beginning of the 1990s, as she reports that no fashion houses would lend garments to her musicians. This relationship transformed over the decade with hip-hop's success and its profound impact on American society (Chang 2005; Smith 2003). Hylton again: 'I'd be in Chanel with Mary J. Blige and they said that her card declined, but it wouldn't be declining. It was crazy. And then fast forward a couple years later, and we were both getting invited to sit front row' (Premium Pete 2017: 21:44–22:00).

Fuelling hip-hop's changing status at the end of the 1980s was MTV's decision to embrace the form, after refusing to show or only reluctantly showing the

videos of black pop and R&B singers throughout the better part of the decade (Marks and Tannenbaum 2011). 1988 saw the start of *Yo! MTV Raps*, a thirty-minute television program that featured music videos by contemporary hip-hop artists, which soon became the most popular show on the network. Through its expansion to European, Asian and South American markets during the end of the 1980s and beginning of the 1990s, MTV began to broadcast hip-hop videos around the globe. By the time Ambrose and Hylton's careers began to take off in the mid to late 1990s, then, industry and media mechanisms were in place, so that the two stylists had the financial resources to make elaborate and fantastical sartorial looks – looks that would circulate beyond established hip-hop communities and throughout the world.

Afrofuturism on MTV

Perhaps the two best known looks by Ambrose and Hylton are Missy Elliott's 'Michelin Man' blow-up suit worn in the 1997 music video for 'The Rain [Supa Dupa Fly]' (Ambrose; figure 23) and Lil' Kim's breast-exposing lilac jumpsuit worn to the 1999 MTV Video Music Awards (Hylton; figure 24). These looks played a central role in the musicians' persona-making. That is, both stars are celebrated for their performative critiques of gender norms (on Elliott, for example, see Lane 2011; Sellen 2005; White 2013; and Witherspoon 2017), and the blow-up suit and breast-exposing jumpsuit work to this end, creating bodies that refuse the objectifying tropes of female representation.

In this section, I analyse how the looks enact this refusal by paying particular attention to how Ambrose and Hylton designed them to respond to the contexts of televisual representation of music, through which they would be seen. Both innovations of the MTV network, the rise of music video in the 1980s and the growth of what I call 'reality music television' in the 1990s altered the presentation of popular music to potential audiences, foregrounding the visual elements of music and, later, musicians themselves as forms of visual spectacle. What we see in Ambrose's blow-up suit and Hylton's lilac jumpsuit are responses to these prevailing modes of representation – responses that simultaneously mobilize and subvert these technologies of televising music. With this focus on technology, I locate Ambrose and Hylton's styling practice within the artistic tradition of Afrofuturism. Alondra Nelson explains, there is within Afrofuturism a desire to produce 'work that's speculative, it's pushing boundaries, it's outré' (Nelson 2010: 5:43–5:47). In reference to the 1960s girl group Labelle and the contemporary

artist Janelle Monáe, she continues, some of those boundaries have to do with gender; these artists exist 'outside of normative traditions' in music and, specifically, normative traditions of how women are visually represented in music (Nelson 2010: 4:20–4:24). Nelson compares Labelle's spacey ensembles with the 'normative and pretty in some ways' Supremes, who were the exemplary girl group of the late 1960s (2010: 4:42–4:44). Similarly, Missy Elliott and Lil' Kim are fashioned as responses to prevailing modes of female presentation. The blow-up suit and breast-exposing jumpsuit are outré and out of sight, creating female bodies that either pulsate, seemingly translating the television screen from two dimensions into three, or exaggerate the publicity camera's gaze to the point of its neutralization.

June Ambrose

Ambrose made what is commonly known as the 'Michelin-man' blow up jumpsuit for Missy Elliott to wear in the 1997 video for the rapper's break-out single 'The Rain [Supa Dupa Fly],' directed by Hype Williams. The video was nominated for three awards at the 1997 VMAs: Best Breakthrough Video, Best Rap Video and Best Direction for Williams. As Roger Beebe (2007: 316) explains, Williams's aesthetic as a music video director was easily identifiable; it was 'inescapable' in the late 1990s; and it was often copied. It included 'the use of extreme wide-angle and fish-eye lenses; highly reflective (metallic or wet) surfaces; [and] costume and set design in bold primary colors creating a number of specifically colored environments,' among other characteristics. Beebe does not give credit to Ambrose for her role in providing the costumes for many of Williams's early videos as well as the metallic/wet look of the videos, which was often produced through the combination of her choice of fabric and his methods of filming. Paying attention to her work allows further consideration of how the video functions aesthetically *and* provides a framework for thinking about how Elliott's body was represented visually. That is, Ambrose created a suit that expanded and contracted, as air moved in and out of it, thus subverting the potential objectification of Elliott's body on the music video screen.

Since the first airing of MTV in August 1981, music video has been identified as a visual site through which women's bodies are sexualized and objectified. In the 1980s and early 1990s, these critiques came from two opposed camps: 'concerned' parents and feminist cultural critics. The former group advocated for more censorship. For example, Tipper Gore, wife of then-Senator and future-Vice President Al Gore, addressed MTV directly, asking that the network 'cluster violent

or sexually explicit videos during evening hours [...] a suggestion that has not been accepted by MTV' (Anon. 1988). Feminist critics articulated their own critiques of music video several years later. Writing for *The New York Times*, Catherine Texier (1990) explained about music videos across the rock and rap spectrum:

> There is only one role for the girls in all of this: black, white or Latino, ice-queen blondes, spunky redheads or sultry brunettes, they glide across the screen or bounce up and down in bicycle pants, tight mini-dresses or tops with deep cut-out fronts, their perfect curves bursting out of molded spandex or, in more romantic moments, tulle or silk taffeta. They are the carrot, the candy, the dream girl, the fetish, no sooner consumed than discarded.

The documentary work of Sut Jhally, *Dreamworlds: Desire/Sex/Power in Rock Video* (1990), is often cited in academic analyses of gender representation in music video. Joe Gow (1996: 153) paraphrases Jhally's conclusions, 'women in the video world of the 1980s usually appeared as nothing more than objects designed to please men – "legs in high heels."' In Gow's own work, he is keen to explore whether MTV's censorship practices, which it took up in the late 1980s in response to such criticisms, had any effect on the modes of objectification in the videos it presented. Looking at the 100 most popular videos across the years 1990, 1991 and 1992, he concludes that women appear less frequently and then only in a restricted number of video roles. For example, whereas men get to play the role of 'Artist and Crowd Pleaser,' thus 'able to define themselves ... through activities such as exhorting an arena audience, strumming a guitar, and playing a keyboard or drumkit,' women are mostly reduced to the roles of 'Posers and Dancers,' roles that place a greater emphasis on appearance than talent (Gow 1996: 157). In the early 1990s, however, female artists began to challenge these broader misogynistic tropes of music video representation, in both rock and rap music. Writing contemporaneously to Texier, cultural theorist Tricia Rose (1990: 109) explains, 'Women rappers are vocal and respected members of the Hip Hop community, and they have quite a handle on what they're doing.' Highlighting the work of Salt-N-Pepa, MC Lyte and Queen Latifah, she argues 'that the subject matter and perspectives presented in many women's rap lyrics challenge dominant notions of sexuality, heterosexual courtship, and aesthetic constructions of the body' (1990: 114). She continues, these rappers are working in response to two broader categorizations of the black female body, the 'kind to take home to mother' and the 'kind you meet at three o'clock in the morning' (ibid.).

In 'The Rain,' Elliott is neither of these stereotypes. Rather, in different scenes she plays various roles: choreographed dancer, friend to producer and close

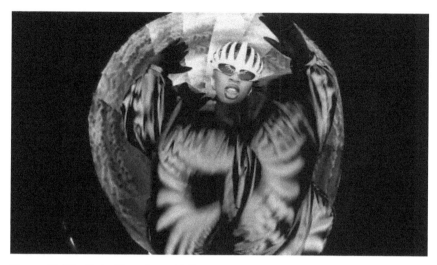

Figure 23 'The Rain [Supa Dupa Fly]'. Director: Hype Williams. © WMG on behalf of Atlantic Records 1997. All rights reserved.

collaborator Timbaland, and, most famously, nebulous and shifting blob-shape that pulsates to the beat of the song. The central set-up for 'The Rain' is in a studio with a circular shape projected onto the back wall. A number of guests appear in this set-up: Da Brat and Lil' Kim, for example, as well as Timbaland and Combs. They dance for the camera, showing how their bodies can move with the Timbaland-produced beat. On Elliott's body, however, the simple setting of the studio with circular backdrop comes to life. The camera framing is tight, so that she fills the circular background behind her. Williams also has a trick on the camera; as Elliott moves in closer, her features start to bulge and contract, tripping out the perspective of the camera's lens.

Central to the effect of Elliott's pulsating body is her puffy suit, created by Ambrose (figure 23). As Ambrose explains to *Elle.com*,

> The written treatment came from Hype. During that time, we were very in sync and he gave me such creative license. When I first heard the treatment, and I said, '*Michelin Man*'? That's like a white marshmallow. Like some tire man? And I was like, there's no way I'm going to make her into a white marshmallow. So this was my version of a black Michelin Man. I knew that I wanted it to feel kind of blob-ish. I knew I wanted it to be a mock-neck, something that would really kind of consume her. But I had never built anything like this before. I needed to find a contractor who knew how to build balloons. We started off with this catsuit and then it was about creating this balloon-like exterior.
>
> Ogunnaike and Ambrose 2017

Ambrose recounts, as well, the challenges she faced keeping the right amount of air inside. She explains that they first inflated the suit at a gas station, but then realized that it needed to be less inflated, so that Elliott could move and twist, inflate and deflate. Too filled, the costume was just static (Ogunnaike and Ambrose 2017). The end result is a figure that contracts and explodes, the video technologies of costume and camera lens working together to distort Elliott's shape.

In another scene, the connection between Ambrose's costuming and the Afrofuturistic theme of technology is visualized more directly. Still in her suit, Elliott stands in the centre of a bigger room, squatting on a pedestal as the mechanisms of a larger machine swing back and forth next to her; it appears almost like she is standing inside an industrial clock. The swinging of the clock's arms, too, plays with the perspective of the camera's lens, new mediating technologies warping the representation of industrial technologies. From this angle, Elliott is able to use the suit to great effect, squatting low, letting it puff out around her, shrinking and warping the shape of her body. Ambrose reflected, 'At that time in hip-hop, females were objectified, and it was all about being sexy . . . We could've played Missy as a curvy, full-figured, sexy hip-hop female rapper. But we didn't need permission to adjust how we saw women in hip-hop at the time' (Ogunnaike and Ambrose 2017).

Misa Hylton

In a video posted to YouTube in February 2018, which uses video footage watermarked Getty, Lil' Kim is shown arriving at the 1999 VMAs, stepping out of her limo, waving to fans and addressing the MTV cameras that were there to document the scene outside the awards hall. She looks directly into the camera and says, 'Hi MTV! I'm finally here and showing off my new outfit!' (Starstracks29 2018: 0:38–0:44). She embraces the camera's lens and relishes in the fawning gazes of the fans, who are penned in across the street from the official proceedings and screaming to be heard. The outfit – a lilac jumpsuit with one breast exposed, its nipple covered by a shiny pastie, accessorized with a purple wig and large platform shoes – was sensational from the start. One of MTV's producers recounted, 'I remember sitting in the truck and seeing the camera that was recording it and, I was like, 'Who just got out of the limo in that blue purply sequin thing and oh my God her boob's exposed!' We were psyched because who knows what crazy stuff is going to come out of that?' (Hoye et al. 2001: 30).

'Crazy stuff' – a euphemism for female spectacle – has been a central element of the MTV awards event since its first airing in 1984, when Madonna performed 'Like a Virgin.' Dressed in a playfully deconstructed wedding gown, the upcoming 1980s pop icon slowly descended from the top of a wedding cake to the floor, where she then lay down and writhed around, seemingly without a care for who could see what might be under her dress. The performance set a precedent that heralded a new form of televisual representation of music, reality music television, wherein stars are given the opportunity – they are called upon – to present themselves as visual spectacles on live television. The VMAs not only provides a platform for such self-spectacularizing. Rather, the producers worked hard to create such opportunities. According to one producer, 'MTV told me to strive for one surprise every half hour, which is sort of impossible – it's like five or six surprises' (Joel Gallen, cited in Burns 2006: 134). Certain frameworks for surprise were created throughout the years, many of which relied upon female stars making fools of themselves. In the preshow to the 1995 awards, for example, MTV's newscaster Kurt Loder was interviewing Madonna on a podium when, in his words, 'we heard this drunken shrieking down on the ground . . . We looked down and it was Courtney Love, and she was throwing compacts, throwing whatever was around, staggering around, just out of her mind.' He continues, 'Maddie's going, "Please don't invite her up here. I think she wants attention" . . . But somebody in my earpiece was saying "Get her up! It'll be great! They'll be Jell-O wrestling or something"' (Hoye et al. 2001: 188). The breast-exposing jumpsuit responds to MTV producers' desires, creating a spectacle from the moment Lil' Kim arrived in her limo through to the next morning's papers, in which the rapper featured prominently.

Hylton designed this infamous look with reflection to Lil' Kim's wider body of work and, one can assume, an understanding of the VMAs as a particular site for over-the-top publicity statements. On the look, Hylton explained that Missy Elliott had put the idea in her head. To the hip-hop podcast host Premium Pete, she explains,

> One weekend, I'm hanging out with Missy Elliott and we're talking music and fashion, and you know Missy's mind is fucking off the hook, the things she comes up with. She's so dope; she has ideas for days. And she said, 'You know what? If I was Kim, I'd just have one of my titties out.' And I was like, 'Okay; yeah that would be kind of crazy.' Anyway, the next major event that we had was going to be the 1999 MTV Music Awards, so I created this outfit with one of her breasts out.

> Premium Pete 2017: 24:09–24:49

She explains further that she decided to soften up the look, using 'Indian bridal fabric, the lavender and silver and white. It was really ornate.' On one hand, Hylton remarks, the pastels offset the bold, primary colours Hylton had used in her last styling project for Kim, the 'Crush on You' video. On the other, she notes, 'If you're going to be half-naked, let's soften it up a bit' (Premium Pete 2017: 25:10–25:14). Hylton's emphasis on 'softening' perhaps speaks to a tempering of the look's power and potential. She concludes, 'I really didn't think it was going to have the response that it did. We were just doing Kim, like it was another Kim moment' (Premium Pete 2017: 25:15–25:26).

Despite playing into MTV producers' desire for female spectacle, this particular 'Kim moment' works to subvert those same visual technologies of female spectacularization. That is, the Hylton-designed look – and Kim's confident wearing of it – reactivates 'the figure of the female transgressor as public spectacle,' to borrow from Mary Russo (1994: 61). After arrival and first pictures, Kim then walks over to Rebecca Romijn, model and then-host of MTV's *House of Style*, who asks her about the look: her confidence in wearing it, who made it for her, and where she got the matching purple wig. Romijn asks, 'Did you have to work up to this or were you like, "Yeah, I'll wear that"?' Kim responds with a laugh, 'I was like :Yeah, I'll wear that"!' (MTV 1999: 0:09–0:16).

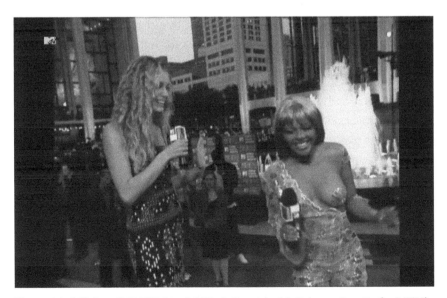

Figure 24 Still from '1999 VMAs: Lil Kim's Onesie', with Rebecca Romijn for MTV's *House of Style* at the MTV Video Music Awards, 1999. © MTV 1999. All rights reserved.

Romijn follows up, asking 'Did someone make this for you?' Lil' Kim explains, 'Yeah, my stylist. Her name is Misa. She's actually here today. She's standing over there in a cowboy hat' (MTV 1999: 0:16–0:23). As Romijn turns to the camera, demanding the videographer zoom in on the look, the rapper laughs (figure 24), and when the camera starts to pan up and down her body, she poses, laughs and laughs some more. Later in the evening, during the awards ceremony itself, when the rapper was co-presenting an award with Mary J. Blige and Diana Ross, Ross leaned over to cup and jiggle Lil' Kim's uncovered breast. She laughs again. It is playful, but also knowing: the cackle of a female transgressor or, what Russo calls, a female grotesque. This feminist figure is performed by Lil' Kim; it was also fashioned by Hylton.

Conclusion

Today, Ambrose and Hylton are recognized for their contributions to the image of hip-hop at the turn of the millennium and, in particular, for the two innovative looks analysed here. Article headlines like 'How Missy Elliott's Iconic "Hip Hop Michelin Woman" Look Came to Be' (Ogunnaike and Ambrose 2017) and 'Misa Hylton: The Woman Who Redefined Hip-Hop and R&B Fashion' (Johnson 2019) routinely appear in media titles concerned with fashion, music, hip-hop and black cultural production. To an extent, then, this chapter contributes to this broader celebration of Ambrose and Hylton's work, twenty years after the stylists embarked on their careers. The chapter also goes beyond mere celebration, to critically examine their work: first, as creativity mobilized in the service of the music industry and the personalities of its stars and, second, as Afrofuturistic artistic practice mobilized 'in the service of reimaging black life' (Nelson 2000: 35). Hip-hop was transformed in the 1990s, a transformation that is often told through analysis of the male figure of the mogul (Fleetwood 2011; Smith 2003), the 'bling' aesthetic (Mukherjee 2006), and a broader realization that hip-hop was not merely an African-American cultural practice, but also a compelling marketing tool through which it 'became the urban lifestyle,' to be sold across the United States and globally (Chang 2005: 419). Despite the recent popular celebration of Ambrose and Hylton's work, the two stylists have not yet been written into histories of hip-hop in the 1990s. This chapter goes some way towards this goal; so too does Lisa Cortés and Farah Khalid's (2019) film *The Remix: Hip Hop X Fashion*, which debuted at the Tribeca Film Festival on 3 May 2019, exactly at the moment of this chapter's submission (Franklin 2019). The

film stars Hylton, Lil' Kim and Mary J. Blige, among others, and is focused on exploring the role of women in hip-hop's fashionable history.

Clear at the time of writing in winter/spring 2019 is that Ambrose and Hylton's contribution to styling was not only in the star images they produced, the way they changed the face of hip-hop on stage and screen, but also in the career pathways they paved. Celebrated as pioneers, the two women are called upon to be mentors for the next generation of stylists. For example, Ambrose was asked to serve as the keynote speaker for the Simply Stylist New York conference in 2015. There, she was interviewed by E!'s Catt Sadler, who asked her to offer advice to a large crowd of aspiring stylists, interested in the professions of celebrity, fashion and personal styling. Her advice to the crowd was tinged with tough love. She says, 'When I started in the nineties, there weren't 5,000 of me. There are 5,000 of us right now. There are conferences built around stylists and television shows', and, as a result, up-and-coming stylists need to be strategic about their goals (Simply 2015: 7:05–7:15). For her part, Hylton has embraced the role of mentor wholeheartedly. In recent years, with her collaborator Jai Hudson, she established the Misa Hylton Fashion Academy, offering tutelage and training in styling. A motto that she repeats across interviews and on her Instagram posts is attributed to Maya Angelou: 'When you get give, when you learn teach' (Hylton 2019). When asked how she would like to be remembered, Hylton responded, 'As a kind, courageous person who took chances with her creativity – as someone who always reached back to pull someone forward' (Roche 2019). Asked the same, Ambrose's response was, 'I think I want my legacy to be, "When I met June Ambrose, she just made me feel good"' (Simply 2015). This chapter has illustrated how Ambrose and Hylton are both making their own artistic legacies and helping others, both musicians and future stylists, find the way to make theirs.

Note

1 "Full episodes" of the show were uploaded to Youtube, sped up and cropped so as to avoid copyright censorship. The timestamps cited here are from these sped-up videos.

References

Anon. (1988), 'Tipper Gore Widens War on Rock', *The New York Times*, 4 January 1988 [nytimes.com; accessed 10 February 2019].

Beebe, R. (2007), 'Paradoxes of Pastiche: Spike Jonze, Hype Williams and the Race of the Postmodern Auteur,' in R. Beebe and J. Middleton (eds.), *Medium Cool: Music Videos from Soundies to Cellphones*, 303–327, Durham, NC: Duke University Press.

Benton, Rashad (2017), 'Misa Hylton Championed Hip-Hop Style in the '90s: Now She's Got a New Mission,' *Billboard*, 16 November [billboard.com; accessed 1 April 2019].

Burns, G. (2006), 'Live on Tape, Madonna: MTV Video Music Awards, Radio City Music Hall, New York, September 14, 1984,' in I. Inglis (ed.), *Performance and Popular Music: History, Place and Time*, 128–137, Burlington, VT: Ashgate.

Chang, J. (2005), *Can't Stop Won't Stop: A History of the Hip-Hop Generation*, New York: St. Martin's Press.

Cortés, L. and F. Khalid (directors) (2019), *The Remix: Hip Hop X Fashion*. Documentary.

Dyer, R. (2004), *Heavenly Bodies: Film Stars and Society*, London: Routledge.

Fleetwood, N.R. (2011), *Troubling Vision: Performance, Visuality, and Blackness*. Chicago, IL: University of Chicago Press.

Franklin, E. (2019), 'MCM Teases New Hip-Hop Documentary at the Opening of Rodeo Drive Flagship,' *The Hollywood Reporter*, 15 March [hollywoodreporter.com; accessed 20 March 2019].

Geczy, A. and V. Karaminas (2013), *Queer Style*. London: Bloomsbury.

Gow, J. (1996), 'Reconsidering Gender Roles on MTV: Depictions in the Most Popular Music Videos of the Early 1990s,' *Communication Reports*, 9 (2): 151–156.

Hall, S. and T. Jefferson, eds. ([1976] 2006), *Resistance through Rituals: Youth Subcultures in Postwar Britain*. New York: Routledge.

Hoye, J., D.P. Levin and S. Cohn (contributors) (2001), *MTV Uncensored*, New York: Pocket Books.

Hylton, Misa (2019), Instagram post @misahylton, 27 April 2019 [instagram.com; accessed 27 April 2019].

Jhally, S. (1990), *Dreamworlds: Desire/Sex/Power in Rock Video*, Amherst, MA: University of Massachusetts Communication Service Trust Fund.

Johnson, K. (2019), 'Misa Hylton: The Woman Who Redefined Hip-Hop and R&B Fashion,' *Black Enterprise*, 3 January [blackenterprise.com; accessed 17 February 2020].

Kaiser, S. (2012), *Fashion and Cultural Studies*, London: Berg.

Lane, N. (2011), 'Black Women Queering the Mic: Missy Elliott Disturbing the Boundaries of Racialized Sexuality and Gender,' *Journal of Homosexuality*, 58: 775–792.

Lewis, R. (2015), *Muslim Fashion: Contemporary Style Cultures*, Durham, NC: Duke University Press.

Lifter, R. (2018), 'Fashioning Pop: Stylists, Fashion Work and Popular Music Imagery,' in L. Armstrong and F. McDowell (eds.), *Fashioning Professionals: Identity and Representation at Work in the Creative Industries*, 51–64, London: Bloomsbury.

Lynge-Jorlén, A. (2016), 'Editorial Styling: Between Creative Solutions and Economic Restrictions,' *Fashion Practice: The Journal of Design, Creative Process and the Fashion Industry*, special issue on Fashion Thinking, 8 (1): 85–97.

Marks, C. and R. Tannenbaum (2011), *I Want My MTV: The Uncensored Story of The Music Video Revolution*, New York: Plume.

Mediabistro (2012), 'June Ambrose on Styling "Mo Money, Mo Problems" Video (Part 1 of 3),' hosted by Donya Blaze [https://www.youtube.com/watch?v=8JhwTcc6k-8; accessed 6 February 2019].

Mercer, K. (1994), *Welcome to the Jungle: New Positions in Black Cultural Studies*, London: Routledge.

MTV (1999), '1999 VMAs: Lil Kim's Onesie,' MTV Video Music Awards, 9 September 1999 [mtv.com; accessed 1 February 2019].

Mukherjee, R. (2006), 'The Ghetto Fabulous Aesthetic in Contemporary Black Culture,' *Cultural Studies*, 20 (6): 599–629.

Negus, K. (1992), *Producing Pop: Culture and Conflict in the Popular Music Industry*, London: Edward Arnold.

Negus, K. (1999), *Music Genres and Corporate Cultures*, London: Routledge.

Nelson, A. (2000), 'Afrofuturism: Past–Future Visions,' *Color Lines*, Spring: 34–37.

Nelson, A. (2010), 'Afrofuturism,' uploaded by Soho Rep., 20 November 2010 [https://www.youtube.com/watch?time_continue=363&v=IFhEjaal5js; accessed 30 March 2019].

Ogunnaike, N. and J. Ambrose (2017), 'How Missy Elliott's Iconic "Hip Hop Michelin Woman" Look Came to Be,' Elle.com, 17 May 2017 [elle.com; accessed 1 April 2019].

Premium Pete (2017), 'The Premium Pete Show: Misa Hylton,' uploaded 18 August 2018 [https://soundcloud.com/thepremiumpeteshow/misa-hylton-1; accessed 19 January 2019].

Roche, E. (2019), 'Misa Hylton Is Ready to Show the Next Generation of Stylists How It's Done,' *The Daily Front Row*, 9 February [fashionweekdaily.com; accessed 10 February 2019].

Rose, T. (1990), 'Never Trust a Big Butt and a Smile,' *Camera Obscura: Feminism, Culture, and Media Studies*, 8 (2): 108–131.

Roy, W. (2004), '"Race records" and "Hillbilly music": Institutional Origins of Racial Categories in the American Commercial Recording Industry,' *Poetics*, 32 (3): 265–269.

Russo, M. (1994), *The Female Grotesque: Risk, Excess and Modernity*, New York: Routledge.

Sellen, E. (2005), 'Missy "Misdemeanor" Elliott: Rapping on the Frontiers of Female Identity,' *Journal of International Women's Studies*, 6 (3): 50–63.

Simply (2015), 'Simply Stylist New York 2015: Keynote June Ambrose Interviewed by Catt Sadler,' published 19 December [https://www.youtube.com/watch?v—Ti1zc6z4I8; accessed 8 February 2019].

Smith, C.H. (2003), '"I Don't Like to Dream about Getting Paid": Representations of Social Mobility and the Emergence of the Hip-Hop Mogul,' *Social Text*, 21 (4): 69–97.

Starstracks29 (2018), '(1999) Lil' Kim, with purple hair and exposing her left breast,' YouTube, published 26 February [youtube.com; accessed 1 April 2019].

Terrie, Jeovanna (2015), 'Styled By June -1x2- Trina Goes Glam [Full Episode],' YouTube, published 21 June [youtube.com; accessed 5 April 2019].

Texier, C. (1990), 'TV View: Have Women Surrendered in MTV's Battle of the Sexes?,' *New York Times*, 22 April [nytimes.com; accessed 11 February 2019].

Tulloch, C. (2010), 'Style-Fashion-Dress: From Black to Post-Black,' *Fashion Theory*, 14 (3): 273–304.

Tulloch, C. (2018), *The Birth of Cool: Style Narratives of the African Diaspora*, London: Bloomsbury.

White, T. R. (2013), 'Missy "Misdemeanor" Elliott and Nicki Minaj: Fashionistin' Black Female Sexuality in Hip-Hop Culture – Girl Power or Overpowered?,' *Journal of Black Studies*, 44 (6): 607–626.

Witherspoon, N. O. (2017), '"Beep, Beep, Who Got the Keys to the Jeep?": Missy's Trick as (Un)Making Queer,' *Journal of Popular Culture*, 50 (4): 871–895.

Questioning Fashion's Parameters: An Interview with Benjamin Kirchhoff

Susanne Madsen

Benjamin Kirchhoff came to fashion as one part of Meadham Kirchhoff, the critically acclaimed label he fronted with Edward Meadham from 2006 until they closed its doors in 2015, leaving behind a cult body of highly crafted work that reverberates with youth revolt, gender equality and set designs that alternated between psychedelic candy land and riot scenes. In 2012, Kirchhoff was asked to style for magazines and shows, becoming an integral part of the Maison Margiela team before joining *Arena Homme+* and *POP*. Of Southern French origin, he grew up in Guinea, West Africa before moving to France in his teens to attend school and then London, where he studied menswear at Central Saint Martins. Similar to how Meadham Kirchhoff disobeyed fashion's rules, Kirchhoff to a certain extent still plays against them. His work often portrays marginalized figures and non-traditional models, presenting his subjects with a kind of raw tenderness and graceful honesty, offering an alternative to the images and references mainstream fashion relies on. In addition to his role as fashion director of *Replica*, Kirchhoff contributes to *Re-Edition*, *Another Man* and *Dust* and consults and styles for international brands.

Susanne Madsen: How have you experienced the trajectory from designer to stylist and editor?

Benjamin Kirchhoff: I don't really consider the two as very different, because I think what I specifically did with Meadham Kirchhoff was more production and the living element of clothes past the catwalk. I've always thought of clothes as being a set of parameters that control the context of one's life. With styling, you decide to dress someone because you see it as relevant within their context, whether they're a woman in Western Europe or a trans woman in Georgia, or a belly dancer in Istanbul. You have to understand, respect and have a good

knowledge of where you are and what surrounds you and how you react to it. What's interesting to me is making the dots connect, particularly now.

SM: When you speak about respecting the people you work with, this of course leads us to your casting because you work with a lot of people who aren't strictly models or the hot new face.

BK: I don't have a problem with either. I think modelling and casting are different things today. It really depends on what it is that you want to push. I work with both and I think they both have a point and a relevance.

SM: In your edit of images for this project though, there's such a cross-section of individuals that aren't conventional models or perhaps fall within the Western ideal of beauty. Is that a deliberate thing, not wanting to just use models?

BK: Not necessarily, because recently a lot of the people I've been shooting have been either like-minded people or people I've had an interest in working with. There is all this talk today about individuality, yet at the same time we use all the same codes. You see more and more people wanting to belong, to eat the same, to paint themselves into the same filtered idea of beauty. There is a scary sense of pressured formality. My interest in and my attraction to people depend more on a sense of engagement and a sense of how people actually have the capacity to project themselves as opposed to projecting what is expected of them, or worse even – wait for someone to project onto them.

SM: So does your approach then become a kind of subversion? Are you motivated by an idea of subversion? How do you feel about that word?

BK: Subversion is a good word. It indicates a rebalance of levels. I think that's also part of what I'm trying to do, whilst remaining apolitical. I feel that there is more value at the moment in asking questions that there is in offering answers, especially when it comes to idealistic objectives of pictorial sense of inclusions.

SM: It becomes tokenistic?

BK: It's a calculated checklist of picking up the right assortment of characters in order to make something seem relevant. I think it's great advancement for society to have these discussions but there is also a very lenient tendency towards fear. Fear of offending, fear of reprisals, fear of rejection or misunderstanding. Where is the Oliviero Toscani for Benetton HIV+ campaign today? Or Tom

Ford's YSL Opium perfume campaigns? Where are the polemics, the risks or the provocations?

SM: **One image that really struck me as an example of non-tokenistic casting is your story from *Dust* in the snowy landscape (see plate 8). What's the story behind that?**

BK: That was shot on the border of Georgia and Chechnya on Mount Kazbegi. When Alessio Boni and I were asked to go to Georgia we knew that the situation in Georgia is looking promising and positive. It's a country that has legalized homosexuality and banned discrimination based on sexual orientation by law since 2000, but it's also a deeply religious country. Still, it acts as a beacon in an otherwise very conservative region of the world. At the time, a friend of a friend was producing this t-shirt that said 'Heterosexuality? Nein danke' based on the seventies Danish Smiling Sun anti-nuclear power slogan. It isn't so much against heterosexuality as such as is it against heteronormality, I had to borrow one and shoot it on the border between Georgia and Chechnya. What you see on the other side of the monastery in the picture is Chechnya.

SM: **I'm also very interested in the back story to the *Replica* shoot from Istanbul with the image on the cobbled street (see plate 11).**

BK: The photographer, Olgaç Bozalp, approached me to do a shoot with the male belly dancers of Istanbul. They're called zennes. Only a handful of them exist in the city and it obviously comes with a lot of positivity and interesting back stories, also really sad ones. The guy we shot is Yilmaz Birsen, a really important character and choreographer who brought back the art of male belly dancing to contemporary Turkish culture in the sixties. He lives in semi-poverty in central Istanbul and he's also got Alzheimer's or dementia. He didn't turn up when we were supposed to shoot him so we grabbed some clothes and went to his place. On the way there we bumped into him in the street and I only had time for a few pleasantries and quickly put some clothes on him. And he started performing for us in the street. Out of the blue. There was something really magical about it. A character who has been an important part of contemporary Turkish culture that has been celebrated yet at the same time frowned upon and forgotten. A strange set of circumstances. Very special.

SM: **How do you feel about the word queerness in relation to your work?**

BK: Queerness, I don't know. It's really hard to define. To be honest I feel really weird by pinning down a specific identity onto something or someone. I'm just

careful not to be identified by one thing or another. I hope that when I go do those kinds of fashion stories that it doesn't come across as misery porn or exploitative because that's one thing I'm very careful of not doing. Not dehumanizing people or betraying their trust. I don't want them to feel abused when they see the outcome of a picture. I want my work to be celebratory. People are very complex and context is very complex.

SM: Another example I see in your work of opening things up is this idea of homoeroticism. I feel like your work around that places it in a new light where it becomes more multi-layered than the traditional fetish-y kind. There's a kind of romance or emotion to it.

BK: I don't believe in making sexuality work by a sense of definition or by a checklist of expectancies. Homoeroticism is more often than not promoting a body type, an activity or set of gear that would define homoeroticism or fetish as you mentioned. I think things are much more intertwined than that. I have a big problem with the classic viewpoint on homoerotics and how sexuality is depicted in general. It's still unfortunately an area that requires a lot of work in order to refute the comparative element that surrounds our basic intro to sexuality through porn. It often lacks humour, complexity and a general sense of individual aesthetics.

SM: It's funny you mention humour because when I look at the Andy Bradin images you chose for this, there's such a sense of humour to that sub-dom scenario (see plate 7).

BK: The sort of subversive image also goes a bit deeper than that. It was a closed set with close friends and collaborators and we felt very free to do what we wanted to do. These pictures were based on the images from Abu Ghraib, the prison in Afghanistan circa 2003–2004. You remember?

SM: Oh, yes, with the prisoner torture. And here I was saying how I found it witty.

BK: We took that point of reference using essentially torture images from Afghanistan but then turning the situation into a very domestic, Western European setting. This happens everywhere, they're things that are shocking within a given context but end up being extremely banal in another. But again, everything is possible image-wise as long as you do them with enough self-awareness and control.

SM: I think so much of what you and Edward did with Meadham Kirchhoff, also with the menswear, and you're probably sick of hearing this, but it was so

ahead of its time. It predated so much of what's happening now. I think your trajectory from the brand to styling is interesting, because so much of what we see now you were doing then, and so ultimately what you're doing now is again different from everyone else.

BK: I'm doing it in a way that's more personal to me rather than what Edward and I did. We did have a business and people that were working for us and we had to survive and make other people survive and sometimes, you know, successfully or not, unfortunately. It also took me a long time to sort of own up to what I did within Meadham Kirchhoff and not just see myself as the administrator, to actually accept the degree of creative responsibility that I had within the label.

SM: And you still do the catwalk now, just in a different way. Like the work you did with Margiela.

BK: Yeah, I think it's a collaborative viewpoint. When I was with Margiela that was something I enjoyed a lot, obviously aside from the house. I came at a time with an amazing archive and amazing set of guidelines and also a moral background that was irreproachable.

SM: I think it's interesting you use the word moral. This might be a stupid question as I suppose everyone wants their work to have integrity but I'm just not sure it's something everyone in fashion thinks about?

BK: I see as much value in silliness and hedonism as I do in something that is more serious. As long as the author has conviction and is eloquent. But you are right, the word integrity is better than the word moral.

SM: There's also a darkness to some of your images that I really enjoy. Like your *Another Man* story with the boy lying on a chintzy bed and he's covered in a plastic sheet. This idea of death and beauty coming together.

BK: Yeah, and so do I but I think I'm more concerned now with not wallowing in it. One thing I'm really careful about at the moment is not to preach only to the converted. I think that's really important in the current political and culture void, to promote inclusion rather than exclusion. I'm also really careful to make sure that the audience gets a sense of the questions being asked behind the image.

SM: If you say you don't want to preach to the converted, you do shoot for a lot of magazines that I guess you could say share your beliefs or your values in a way, so in order to preach to the non-converted, how would you do that?

BK: 'In a way' being the operative words of your question. I don't want to preach, I am making sure that my images are readable and not just obscured by egos – mine, the photographer's, the magazine's. What is important is that the image leaves you thinking of something other than a set of clothes, a model or a location.

SM: We've touched upon you not being at ease with certain aspects of the fashion industry. I know you say that you don't necessarily view what you do as strictly fashion but I suppose I'm interested in this idea of disrupting something from within. Is that something you think about?

BK: It's important to show the other side of the coin or change the guidelines when new ones are being invented. And yet they all seem to be going in the same direction, this relationship between inclusion and exclusion. How we formulate our sense of being an outsider is more often than not a formulation based on ready-established guides. Is it because they seem to be relevant for the moral guidelines of today or do we provoke them because we actually believe in them? If there is a general desire behind it to differentiate and distance yourself from the given codes and regulations, then you're heading in the right direction. Whether or not one likes the aesthetic result I think is completely beside the point at this moment. We should be entering a new era of experimentation, of doing, of making, and not in wallowing in nostalgia. We can't change anything by pushing forward already established set of codes.

SM: So what should creatives be doing instead?

BK: I cannot answer that on the behalf of creatives. I see things on a smaller scale or at least a more personal, domestic scale for my work. I am making it more internal. But there is such a sense of boredom, of staleness in the 'creative' in general. It's no secret we're moving backwards on the social advancements we made in the last thirty years. The world is more fragmented yet appears more homogenized. Travelling a bit in the Middle East, Eastern Europe and Central Asia and meeting with other like-minded people I found the point of subcultures again.

SM: I suppose to the Western person they might also seem like some of the only countries where there are still genuine subcultures? Which might sound predatory but we've lost so much subculture in the West.

BK: Subcultures are healthy reminders in any society that there is a problem that's deeper rooted than the ones we controvert. Subcultures are very many

things. It's a bit of a predatory thing to say, as you said, so I'm very careful when approaching, whether it is for a story or not. Being a predator or a parasite are the two worst offences in my book.

SM: I imagine predators might sometimes be hard to avoid in fashion?

BK: It's very hard in any artistic or creative arena. I can't be an ass to the contributors. I value their time and contribution too much. Whereas I can be petulant when it comes to the brands.

SM: Why? Do you mean in terms of the creative rules that brands try to enforce?

BK: Yeah, it's another area of discontent and it makes me really tired when I request something and you hear, 'are you going to shoot it on models or talents?' Another one I get all the time is 'please make sure you use the women's clothes on female models and the men's clothes on male models'. I find that really gross in 2018. If this discourse were to be extended into any other area of fashion at the moment there would be a fucking uproar about it. And there *should* be a fucking uproar about it. You can tell me these things but I will dress people in the clothes the models feel are more appropriate to them.

SM: It also doesn't correlate at all with the line of communication from brands now about their genderless clothes and diversity.

BK: It's now, what, five years that we've been talking about gender, body issues, race issues, ageism and sexism and yet we still have to address people by their physical attributes. I find that really reducing about this industry. Which is why I'm very careful not to define my work as queer or anything else for that matter. My appearance, my sexual preferences, the way that I do my work, they're all part of what makes me. That's it. I think you have to go past the way that your place in the world is perceived.

SM: When I look at your work it really does strike me as being very much on the terms of your subjects and how you consider them in the way that you style them. Although I'm not sure a word like styling perhaps quite covers what you and your contemporaries in this book do?

BK: I think you're right. I recently had to work with a publication where my area was essentially that of a wardrobe person. I found it very difficult to handle because I was given all the parameters and was under a degree of pressure to please the person I was working with rather than delivering something I would

be happy with. It takes a lot of freedom away from any artist and you're right, the people you have in this book are essentially artists or editors or creative directors. Everyone I engage with is a creative in their own right. And just because *a* name is present on a project doesn't necessarily mean that it's *the* name for you and the right choice you should be making in your career. Similarly, concessions are okay but you should never compromise. It's a collaborative thing but as long as there is discussion, engagement and you see the result that you're aiming to achieve, then you're fine. And I'm talking whether it's working for brands, a money job, an editorial or a personal project. I think you should engage with everything with respect and without fear, essentially.

SM: So you pick projects that are true to you?

BK: I try to as often as possible. Otherwise I would just do pure 'styling'. I can't just style without it having a sense of a back story or storytelling. Even if it's just a languid movement within a picture or a facial expression or the way somebody looks at the camera, I'm always quite careful to give directives when I can.

SM: It almost borders on directing a movie?

BK: I would actually love to be able to direct a feature length film. Playing with all the different parameters.

SM: I remember when I went to your shows with Meadham Kirchoff that I often thought there should be a movie to go with them, particularly the witches one.

BK: Thank you for picking that up because not everybody did but what's in the past is dead, essentially, is the way that I see things now.

SM: And now you're living in Berlin, which has also been a new beginning.

BK: Yes, I really like it here. I felt like I had to perform my life in London towards the end. I'm much more interested in using the industry to say what I have to say or what I want to say. Again, to ask questions rather than pretend to have the answers.

Exploring the Female Gaze: An Interview with Roxane Danset

Francesca Granata

From working at Margiela to becoming a fashion editor for *Self-Service* and *Acne Paper* to striking out on her own as an independent stylist, Roxane Danset has retained a unique approach to styling and fashion more generally, often challenging ideas of conventional luxury and female beauty. Integrating ready-made objects and using ordinary materials such as colour tape and tin foil to style her looks and create set-designs, Danset developed an experimental aesthetic, simultaneously playful and off-kilter, which sets her aside in the world of contemporary styling. Initially based in Paris and now rooted in New York, she has styled for a number of publications, including *Purple* and *SSAW*, and collaborated with a number of photographers, many of them women. It was through her on-going collaboration as both model and stylist with Dutch photographer Viviane Sassen, that Danset started exploring female friendship and 'the female gaze'. This process culminated in two books, *Roxane* and *Roxane II*, and continually influences her approach to styling.

Francesca Granata: You started out working for Margiela when Martin Margiela was still at the company. It was a really important time for the aesthetics of Margiela. How did that experience influence what you do in your practice now?

Roxane Danset: It didn't just influence my styling, but my overall approach to fashion and to creation. I studied men's pattern cutting, so I can tailor a man's suit perfectly, and that's really where I was coming from. I wanted to be making clothes, not necessarily even designing them but making clothes and working with the body and understanding how the clothes fall on the body and make that my craft. The reason I got into fashion was actually because of Margiela's work. It was this image: these women walking on coffee tables, with their faces covered

by a veil, bomber jacket tied with rope, just soles of shoes wrapped [to the feet] in Scotch tape. I tore that image out from a magazine. I was raised in France on the border with Belgium, in the region called Flanders, so the Belgian influence was very much there and the image was in a local magazine. It was not a fashion magazine – I think it was a magazine about tourism, actually. So I tore this image and it remained with me. I still have it. When I finished my studies, I understood that men's tailoring would maybe not be my lifelong activity. I went and knocked on Margiela's door in the 18th [arrondissement], in the very grim part of Paris. And I knocked at the door and met the press person at the time and asked if there was a place for me to work and they took me on. There were only seven people working for the company. I had no idea what press was, what it involved, I didn't even know that fashion needed PR people or anything. So, I started there in 1999 and stayed until 2005. I started as an intern and worked my way up doing press meetings, working on shows, on exhibitions, working on casting. It was never working with professional models. I worked on street casting, helped [Martin Margiela] in the fittings and on the look book shoots. So I worked very closely with him, while not having a title, because nobody there really had a title. It was a small team and very organic. Even at the time I didn't know what I was standing for, but I knew I was participating in building this brand on the PR level, on the image level, and just being a part of this whole atmosphere. But it was very important for me to work with someone like him in this industry because fashion is hard work, if you will believe it. So at hard times, if I couldn't go look at the racks and look at the clothes and feel like I understood why I was doing this, it couldn't have been bearable.

FG: Did you start styling at *Self Service* or were you styling all along?

RD: I was with Martin every season helping, styling the look books, the shows, participating in the fittings, the casting process. So I was learning the process of being a stylist without knowing it and without really understanding what that job was. But I was actually doing it. I started at *Self Service* after Diesel bought Margiela. It was fun for a while, but it became too much of a culture clash. I also felt that it was time for a change. I could have had a very comfortable living for many more years there. But I wanted to push myself and do things for myself. So, I went to *Self Service*. I started there as a fashion editor.

FG: I don't think of your work as creating a classic version of beauty, particularly female beauty. It's a little bit off-kilter. There is something slightly

disorienting about it, but also funny and playful. Your styling looks a bit DIY incorporating handmade objects. Did it start at *Self Service*?

RD: Actually, it's funny that you mention *Self Service* because they were not really embracing my aesthetics at the time. I only stayed one year there. I think my work, like you said, was too removed from the classic beauty that they were looking for. Which is fine. There is room for everything. And that's where I guess I understood that my aesthetic was different. I didn't realize that before. Coming from Margiela, there was no financial group behind that brand. So having to work with many financial restrictions is part of it. I always like to look around. I get inspired by the art scene in Chelsea, but also working with what's found on the street. Art has always inspired me, and what simple material can be turned into is really fascinating to me.

FG: There are a lot of found objects in your work, a lot of 'poor' objects.

RD: It's true, but I don't believe in poor objects. I really believe that everything – whether it's an expensive dress, something found on the street or a piece of cloth – has worth. I think it's really about the context. I don't have a judgement value on pieces, which is funny working in this field where everybody will rush for the new Balenciaga sneakers. To me that has little value. It's really what you make of things that matters in that process and ultimately I love creating images and I always think about the end result. I don't think that fashion is a priority. I believe in the set design, I believe in the photographer, I believe in the spontaneous element, in what the model can bring. I really believe in all these organic functions. It must be from that Margiela school, but it was probably in me and that's why I felt good at Margiela. When I'm on set, I'm a stylist, but I really come with a spirit of also being a set designer. I always have a bag of tricks. I have the wardrobe, obviously. I will have worked on the casting, the hair and makeup idea, but I have a big bag with plenty of things that will end up in the big picture. It's not just the clothing.

FG: After *Self Service*, you went to Acne. Was it still in a fashion editorial capacity?

RD: Like I said of the *Self Service* relationship, we didn't necessarily click in an aesthetic sense. After a year, I realized that it wasn't meant for me. Obviously, I had been working in an environment with Martin that was very fashion but at the same time so outside of the fashion realm, such a unique endeavour, that it really suited me. And I needed to create for myself an environment that would

be similar. Acne was mostly a Scandinavian market at the time that wanted to become global. I think it was around 2007. One of my former colleagues from Margiela was going to start the structure and creating the office for them in Paris and organizing themselves worldwide to make them global. She wanted me to do PR. To which I said, 'I'm not a PR anymore. I'm a stylist now.' And she said, 'Well, that's absolutely fine. Acne is a very forward-thinking type of company and you can build the brand and also build your portfolio on the side and work with *Acne Paper*.' This fluidity was really appealing to me. I felt like I had a wider range of talents I could explore. So, I took the challenge and three years later Acne got to the success we know. It was yet again time for me to move on. An agent reached out to represent my job as a stylist, which was a first step for me to think, 'People see me worthy of being represented and want to promote my work and help me make it spread wider.' That was it!

FG: Your self-definition as a stylist was pretty organic. Do you think the fact that you know how to make clothing and studied tailoring influence the way you style? So much of your styling is what you do with the clothing?

RD: Yes, I do know what it takes to make a garment. That's really not lost on me. I guess it's kind of a homage to garment-making, trying to add to it, enrich it, and make it even more ornate. It's really like a celebration of the garment in my opinion and that's what I think I'm doing when I'm bringing all these elements to it. And not just take a piece for granted, put it in front of the camera and photograph it. That always feels really sad and unsatisfying to me.

FG: You are creating these interesting juxtapositions and sometimes the image that comes out is surprising. Sometimes it doesn't fall within the codified ideal of female beauty.

RD: What is the ideal of female beauty?

FG: Also your styling is often not in line with what we think of when we think of luxury. I'm thinking of the editorial you styled for *Purple* with the photography of Viviane Sassen in which the models had plastic bottles, bread or wraps, and then workers' helmets (see plate 21). How do you come to it? Was it intuitive? What's your process?

RD: I never wish to disrespect women or women's image. I cherish women and women's vision and women's perception of other women. I grew up in this industry, I've been working in it since I was nineteen, I've worked in creating visuals, worked on helping brands grow, worked on being a model myself when

Martin asked me, or people asking me to stand in the image. I've been questioning this ideal of the woman's body. To be honest, I never was quite comfortable with my own image and I feel like the whole path has been trying to figure out how to handle this envelope of mine. I mostly work with women photographers, as I feel much more inspired by them. I feel like this female gaze that I have is never ludicrous. It's always very much done in respect. Anything I put out I do consider as beauty.

FG: And yet it challenges traditional ideas of beauty. It creates a different kind of beauty which is a bit more playful perhaps, or uncanny sometimes. So it's not that it's not beautiful, I think it's differently so. It doesn't seem to objectify the female body as some images in fashion might.

RD: This is why I reached out to Viviane to work on our books. The books that we did are very much two female gazes on the female's body. Because these images you have in mind, a lot of them are created by men, and in them the women are often very submissive. When I work with women, I let them be. Of course, I bring tricks, and I have propositions, but it's a dialogue. What comes out is very much what the women give me.

FG: In another of the editorials I was looking at, in the Autumn/Winter 2018 issue of *SSAW*, you styled Thom Browne's AW 2018 collection. There was an uncanny feeling to the images. Browne's work for this particular collection was creating a lot of bulbous bodies and in the editorial they were paired with objects you brought in that we don't generally associate with a fashion shoot – a clay mask, fringe curtain . . . You also use simpler material that you find in the kitchen, like tin foil. It created a kind of surrealist quality. You see these materials in a different way. How do you develop these images and the use of material in this way?

RD: I'm very much like a magpie and I've been collecting images. I'm around the Chelsea galleries every week. Wherever I travel for work, I can't *not* go to the museum that the city offers. It's like people who drink two litres of water a day – I need an influx of beauty per day. It's really become a necessity. I cannot go to bed if I haven't had my fix of beauty. I don't really drink, I don't do drugs, but I need my fix of intense beauty. Also, working in New York where commercial styling work is extremely – how will I put it – well, commercial, I really need to figure out the balance for my own sake. So I've been collecting, looking, gathering. Every step of the way, I'm recording images, taking pictures, getting objects home. It's funny, because after a certain number of years, you realize, I have a

bunch of tin foil reference, or I have these plastic things. I guess I'm attracted to this without knowing it. So, it is this build-up of information that suddenly clicks and makes sense within you and then they become your go-to when you work. You know, these materials mean something to you, they represent something in your subconscious and you want them to be part of your world.

FG: So, you are almost collecting things and then you realize what it is that you are drawn to.

RD: Absolutely.

FG: I'm thinking of another editorial you did with the photographer Bibi Borthwick, in which again you seem to explore different ideas of female beauty. It reminds me a bit of that Kawakubo's collection 'Body Meets Dress,' but done in a different way through styling. How did you develop it?

RD: Again, I think it's just me remembering my pattern-cutting days and wanting to create improbable body shapes and trying to work with something that is unworkable or wouldn't be considered pretty.

FG: How do you choose your collaborators?

RD: Whoever's work will move me. I saw that Bibi was doing something really interesting. I liked the directness of her pictures. And there was a rawness to her work, a very humble accessible and unpretentious approach to her work that really interested me (see plate 22). It's very much about the girl. It's not about the makeup and the grinning. And in the case of Chloé [Le Drezen], it was more about that Thom Browne collection, which I definitely had an interest in working with. I wanted to bring in some poetry and Chloé's pictures are definitely that – they have a kind of out-of-this-world dimension, like a dream or whisper or something of a wonderland.

FG: How did you then develop your collaboration and relationship with Viviane Sassen?

RD: Viviane goes way back. I was at Acne at the time and Jop van Bennekom and Gert Jonkers from *Fantastic Man* were about to launch *The Gentlewoman*, the new magazine. They came to me and wondered if I would collaborate with Viviane for the first issue of *The Gentlewoman* and do a story on Pierre Cardin. I'd never met Viviane, but they offered me to do it with her and I would model for it and I would be styling it. We met on that shoot and we instantly bonded. And she offered me to work on our first book together. That's how the first book came about.

FG: You were the model for it, which at that point was something you were really not doing and you also were the stylist. You have described the experience as akin to performing.

RD: Again, from the place where I came from with Martin when I never had a real title and never until later considered myself a stylist, I think working with myself and my own body made it easier to push what I had in mind. Because it was me, I didn't have to ask someone to do it. So that really eased me in to the process of understanding how I would approach styling. Also, that process helped me to start accepting myself. And it was like performing, first of all because those pieces were really architectural, gigantic bags, dresses with circles. And actually this is one of the stories for which I didn't bring any other element than the clothes. And that story really influenced me. I want every one of my shoots to be so outstanding, even if the clothes don't have that quality by bringing elements to make it as architectural and graphic and with a sense of construction. You know, those clothes were so elaborate, like it almost didn't feel like it was me. I was hiding behind them. It made it really easy.

FG: How did your collaboration with Viviane develop?

RD: It started with Pierre Cardin, which is funny because we started with such elaborate pieces of clothes and now with the last book we stripped everything down.

FG: The first book was shot in Paris, and you were the model and the stylist (see plate 23). In the second book, you and Viviane introduced nudity (see plate 24).

RD: It was a few years later. I moved to New York, and we were less in touch. And I was pregnant. She wanted to photograph me pregnant. It didn't happen. Then came the book number two, which was very much about this female gaze on the female body.

FG: There is something subtle and sensitive and touching about it. What was your role in it?

RD: It was a very sweet process, from the time I reached out to her to suggest we do another book, and she was really into the idea. We started bouncing back references and visuals. That's how we function. So, I would throw a few images at her and she would send me something back and that's it. And from there on, we don't need to talk anymore. We rented a house in the south of France with our

families. And I remember it very well, in the second morning our husbands go away, take the kids to the beach. We don't even speak. We both bring out our bag of tricks to the table and we started shooting. And that whole book was shot in two days.

FG: I really like the way in which the photographer was also part of the photograph, in a weird way. There were a lot of shadows of Viviane in the photos and she made imprints of parts of her body with paint, and then added them to the photographs. It was almost a symbiotic thing.

RD: It's a confusion of messages. It's a body, either naked or with paint that I would draw on myself, a body naked with colours applied afterwards through filters, or a body naked with paint with then colours again. The whole process gets really confusing. But you can definitely tell the collaboration and the exchange we had through these days in the pictures.

FG: How has your experience of having been a model changed your work as a stylist?

RD: Sometimes it makes me want to step out of the process. [Modelling] is an amazing and frustrating job. It wouldn't be for me. I have a huge respect for people who do it. The desire of someone to work with you based on what you look like, I think is a very harsh process. Sometimes, I feel bad for being a part of that. But at the same time, it also means that when I'm on set with models, I'm trying to be as respectful as possible. It also helped me try to pick models that are willing to take part in the process.

FG: Is there a feminist element to your work with Viviane? You wanted to show women and female nudity in a way that's not objectified or for male consumption. You talked about the female gaze.

RD: Well, it's also about our friendship as well as the female gaze. I definitely identify more with strong, independent, fierce, brave, forward-thinking women. I remember one thing my mom told me as a kid, and maybe, as they say, your past always comes back in your work. I don't do therapy, so maybe my work is a sort of therapy. My mom always told me, be independent. Do something for yourself. Love will come. If love comes it will come, but this is not the priority. Your priority is to be independent, and find your way, and understand who you are, and do what you want to do, and be happy with what you are doing. And so, I followed.

Building Little Sculptures:
An Interview with Vanessa Reid

Susanne Madsen

As one of the defining voices of styling today, Vanessa Reid operates in an ever-shifting framework of dynamic silhouettes and surprising colour and composition, taking classic poses in unexpected directions that vibrate with equal movement and statuesque calm. Her female-centric and historically aware work spans titles such as *System*, *Re-Edition*, *Italian Vogue*, *Self Service*, *M by Le Monde*, *T Magazine*, *Arena HOMME+* and *Purple*, alongside her long-standing position as fashion director at *POP*. Reid originally studied cinema at Edinburgh University, but was introduced to styling during a year in Paris on a work placement. From there, she began assisting, working at British *Vogue* before moving to Paris to spend three years with *Vogue Paris'* Marie-Amélie Sauvé. Subsequently, Reid branched out on her own, going on to form close working relationships with the likes of Juergen Teller, Mark Borthwick, Craig McDean, Inez & Vinoodh, Viviane Sassen, Collier Schorr, Harley Weir and Talia Chetrit. She now resides in London.

Susanne Madsen: One of the things that strikes me about your work is this idea of things being undone, or coming undone. Not unfinished, but perhaps in a state of undress.

Vanessa Reid: I love the process of dressing and undressing and through that exploring a feeling of freedom and looseness. Often you'll be working the look specifically for a certain camera angle and beyond the frame it's a hot mess – tape, pins, clips, whatever it takes to create the vibe.

SM: I like the word mess, because it does kind of figure in quite a few of your stories. A beautiful mess, which feels honest and not so stylized. Like the image you did with Harley Weir for *POP* SS16 with the unzipped corset and bulldog clips (see plate 33).

VR: I find the process of styling itself very beautiful. I often work with women that don't necessarily fit into samples. You have to make it work. One bulldog clip isn't enough, so you use three, four, a bit of tape. And before you know it, those things morph together into something more interesting. It was really extraordinary seeing [model Aomi Moyock] with that killer body she has wiggle into this corseted Celine top with incredible sleeves. We had also just undone her hair band but it was still half held together. I like how you can show that in a really poetic and playful way, and how sculptural it looks.

SM: It also really lays the constructs of fashion bare for everyone to see.

VR: Yeah, that's a great way of looking at it. [Fashion] is all an illusion, I guess. It's interesting to build this constructed world and then get a glimpse of the 'becoming', so to speak. Up until now, the illusion was generally kept, maintained. Now the system is changing, shifting more towards realness behind the scenes. It's interesting to work with the appetite of the viewer for authenticity without it becoming too literal in that BTS way. In the end, it's funny since all of that is smoke and mirrors too.

SM: One thing I've noticed is that you work with a lot of female photographers.

VM: I don't consciously choose to work with female photographers for the sake of breaking the glass ceiling! I feel very happy to have been a part of championing the female voice, but I don't work with these artists based on their gender. There is an interesting exchange and a different gaze on both sides, which I enjoy. When I started out on my own, I noticed that there were photographers, men and women, that weren't part of the status quo. That included 'art photographers' too. I didn't want to be limited by the established hierarchy of talent. In regards to women, it is hard-core how long it's taken for them to get to the top, but this is part of the struggle in every industry. Interestingly, I have had particularly long-standing relationships with the female photographers I work with. Viviane [Sassen] and I have worked together for over ten years and we have created a language together, which feels like a conversation that doesn't finish.

SM: When you left *Vogue Paris'* Marie Amelie Sauvé to go freelance, what was that change like in terms of your visual language?

VR: One of the first photographers I worked with editorially was Mark Borthwick. We went on a trip to Spain together. I had been working within the confines of the perfect image, super controlled and retouched, and Mark's work

is the polar opposite to that. Working with him was the start of my creative emancipation! He is very important to me and integral to the way I've evolved my approach to fashion and images.

SM: So what was that first trip with Mark Borthwick like?

VR: I had prepped my looks very precisely and had a clear idea of how I expected them to turn out. He was shooting on film, which was unusual in itself at that moment in fashion, and he'd go and open the back of the camera 'to bless it with the light'! I didn't know him that well at that point. I was dying. I'm there thinking, 'oh my god, the fashion is gone'. But ultimately it was the most liberating experience. To live in the moment and open up to the sea of possibilities, understanding that your idea can travel into unexpected places. You can have your ideas, your research, but on the day of the shoot you've got to let it bleed because that's when you get something magic.

SM: What I see a lot in your images is this sense of female empowerment, but it doesn't feel insistent or at all geared towards the male gaze, just inherent. It's poetic and nonchalant. There's a Craig McDean image of a very casually assertive Freja Beha sitting in front of an electric fan with her legs open, fully dressed in a gossamer suit.

VR: Whether it's a pose like that or a story that involves an element of nudity, it always develops very naturally. Nothing is contrived, it's a moment, and everybody's feeling it. I enjoy a natural expression of sexuality in an image and different models have different ways of conveying that. Freja is very confident in this sense. Recently, I worked together with her and Collier Schorr for a story in *Re-Edition* and it was a joy to be part of the exchange. It's a beautiful intimate portrait of her, almost like a painting. It's very sensual but not objectified. These vibes can't be premeditated, it all happens spontaneously.

SM: The Daria editorial you did with Juergen Teller for *POP* is a beautiful example of that, and it's a pretty legendary story (see plate 32).

VR: The way it came to life was a lot of fun. We spoke about it, and had to turn it around in twenty-four hours. Daria happened to have the morning available and the shoot itself was done in an hour. We had an idea of shooting at the Gare du Nord in Paris. We loved how iconic that was as a location. The energy around there is wild. Daria came along and it was all very lo-fi production. Guerrilla style – no permits. It was four of us, a few looks I'd quickly put together, and we were just bashing it out, getting changed in the back of the car. There was no hair

or makeup, it was just raw. Other shoots might involve several racks of clothes, a more extensive timeframe, hair, makeup and all the getup, but regardless of the circumstances, in the heat of the moment it's all intuitive, putting stuff together as you go along.

SM: There are many interesting sculptural shapes in your work, and also this idea of movement without it being the fashion jump.

VR: When I first began working on my own there were a lot of Jumping Jack Flash pictures around that didn't feel so fresh for what I was doing at the time. I think there are so many different ways to move the body. It's about revealing the internal dance. The movement can be subtle but still charged. I like giving girls a character or an idea in their head about something. It makes the clothes come to life, which then gives the whole image a silhouette. I sometimes do actually get the girls to dance. The other day I got a girl to headbang to Nirvana. She didn't know who Kurt was and I felt like a dinosaur.

SM: That is quite funny. I do think the arresting or unusual silhouette is quite integral to your work.

VR: Totally. Silhouette is key. I love how it synchronizes with the sculptural side of the image. I've always liked the mannerist qualities of the painters and sculptors I'm influenced by and I suppose I'm often accentuating certain parts of the body or giving a different perception of what that body could be. It's interesting to see somebody who is perhaps super skinny suddenly have an exaggerated hip.

SM: Like the Bodymap shoot you did with Oliver Hadlee Pearch for *System* (see plate 36). There was one image where the model's legs look almost separate to her body because there's an optical illusion of white. Her top half is over to the left, and then her legs are over to the right.

VR: That was so fun that shoot, and very important to me. It was electric to have the opportunity to work with heroes of mine and to work with their archive that had been in boxes since the eighties. I was very grateful to have the opportunity to collaborate with them. There was an amazing vibe that day with all these different players from that scene mashed up with the new generation and it felt very celebratory. There have been a lot of people blatantly copying Bodymap and nobody really acknowledges that.

SM: Yeah, it gets extra embarrassing when even critics don't call out obvious rip-offs.

VR: Also, a lot of kids won't know it and will be like, 'who's Bodymap?' It's a privilege to be able to reignite interest in their legacy. This is a really important brand that encapsulates the progressive identity of the eighties and it feels very relevant again today. It has a cult history that anticipated the future, and it was wonderful to suddenly feel part of that history. Fashion is often derivative, or at least referential, and the visionaries often get forgotten in the mix. I really love following the lines back to their original source – it allows you to understand what's going on now in its true light.

SM: Aside from going straight to source, what is your work process like?

VR: I'm constantly researching and exploring. I look to areas such as art, music, film and especially travel for inspiration. I'm open to everything but there's always some sort of emotional connection to what I do. I always try to experiment as much as possible, otherwise I get bored. I don't like being put in a box. I have lots of different influences and crossbreeding of references. I constantly question myself and can be overcritical of what I do, but I guess that keeps me pushing on and taking risks.

SM: Going back to the making of the image, what also interests me about that is it also kind of highlights styling as a practice. The hands in the Daria images, or seeing Viviane Sassen's silhouette in an image (see plate 31). It puts what you do in the image in a double way.

VR: I mean, I've never thought of it like that but I guess that's really interesting. The hands add an element of something mysterious and surreal. It provokes curiosity and makes you look beyond the surface.

SM: It's perhaps another aspect to the illusion element we talked about before?

VR: Yeah. You're so right.

SM: It makes it very human as well, this idea of touch.

VR: Totally. The hands connecting, the sensuality of it.

SM: Another thing is this idea of obscuring faces. Is that a deliberate thing?

VR: It happens sometimes but I don't go out of my way to do this. However, it is seductive as a device. The anonymity of the faceless form becomes this kind of abstracted silhouette and enables the viewer to appreciate the image without the

distraction of personality. You can interpret the image however you want and the mystery keeps the eye stimulated.

SM: That word keeps coming up. Mystery.

VR: I like an image to be challenging to understand sometimes. And that's why I love Viviane's work because there's always a double take. There's always something else going on within the image. It has all these different layers and dimensions. I guess a lot of the photographers I work with have that. Their work exists beyond the fashion image while simultaneously appreciating and understanding the fashion image.

SM: What are your thoughts on the fashion industry?

VR: I am somebody who has huge amounts of respect for fashion and fashion as an industry, despite all its obvious faults. It's a business like any other so to that extent you take it for what it is, though as a creative it's obviously frustrating when the balance between art and commerce holds back creativity, experimentation, etc. This is increasingly problematic as media evolves.

SM: Why do you think this rule of only shooting full looks has taken hold so much?

VR: The relationship of power between the advertisers and the media has obviously shifted in the last decade, so it's a way of capitalizing on a brand's image. Also, the dissemination of a brand's image through the unregulated sphere of social media and the web means that brands want to control their image more and more since they aren't sure of what the results might be. They'd prefer not to take the risk and the total look also streamlines their publicity.

SM: It also really changes the role of the stylist, doesn't it?

VM: Yeah, styling has changed a lot. Unfortunately, the total look syndrome means we're all shooting the same thing and so there's less room to interpret the runway collections in a fresh way. This is how I aspire to work but it's getting harder and harder. Also, these days there is increasingly less room to include vintage or make stuff due to advertiser credits. Whereas you look back on someone like Anna Cockburn and there would be, like, two credits in the whole story and the rest would be found stuff, made up stuff … new things which I think is so important to inspire the industry, designers, etc.

SM: How do you feel about fulfilling advertiser quotas for stories?

VR: It is part of the business and I respect it. I'm good at making advertisers look as though they're part of the story. I love that challenge. I love that whole play between lo-fi, hi-fi, these clashing worlds.

SM: What strikes me about your campaign images is how much of your editorial work is in there, rather than taking things in a more commercial direction.

VR: I think that campaign images should be just as strong as anything else that you do, if not stronger. You can't really get away with doing what is called a commercial campaign anymore. Today we are bombarded with insane amounts of images, so there's a lot of competition for attention. If you suddenly do this sort of tepid commercial campaign, then you're fucked.

SM: I'm also interested in the consulting work you do for brands. At what point in the process do you come in?

VR: It depends on the client but generally it's important to start at the beginning of the season so that you both build a story and exchange ideas throughout the process. It's a permanent dialogue with my clients, constantly bouncing ideas off each other. I really enjoy the collaboration and the relationship you build together. Each client is different. You have to develop ideas bespoke to their brand. This involves spreading the research wide so that the vision is unique to them while making sure that you guide them in their constant evolution. You cannot stand still in an industry that is constantly accelerating and so it's really useful for the designer to have a perspective coming from outside the brand. The same principle would apply to the way that I work with a magazine or a photographer as well. It's important to me that the exchange has its own identity based on a new line of research provoked by that particular situation.

SM: This is interesting because some of this perhaps overlaps with designing?

VR: I'm not a designer, but I can see the whole picture and help to nurture it with attention to details. There's so much more to design than what I do. A good designer can make things happen. I'm there giving ideas, but giving ideas is one thing, making it happen is another. With consulting, you're constantly questioning, challenging and pushing for perfection! It's really rewarding to work with designers on building something. It's a different part of the industry and I love doing the 360.

Part Three

Global Fashion Media and Geographies of Styling Practices

The Stylist's Trade: Fashion Styling in Milan in an Era of Digitization

Paolo Volonté

Introduction

Fashion stylists often use a codified narrative when trying to describe their job. It can be easily deduced from interviews and books (see, for example, Baron 2012; Mower 2007) that celebrate the profession – a profession that over the last two decades has broken into the small circle of publicly recognized fashion creators. In short, that narrative states that stylists are extraordinary, creative individuals who – inspired by the creations of haute couture, street styles, and the imaginary conveyed by the multiple channels of high, popular and mass culture – transgress the rules of 'regular' clothing, thus contributing to radically innovating our clothing imaginary (see Cotton 2000: 6).

It is increasingly being recognized that in the current fashion system, stylists make a significant contribution to the complex process of clothing innovation. Indeed, fashion photography is a driving force of the system, capable of encompassing both artistic creativity and commercial power (Shinkle 2008: 1–2). As aptly stated by Caroline Evans, 'in a culture in which the fashioned garment circulates in a network of signs as both image and object', the image is 'no longer representation', but it is 'frequently the commodity itself ... be it in a fashion show, magazine, website or even as an idea' (Evans 2008: 23). In this framework, fashion images have often privileged the construction of an abstract and 'synthetic' beauty ideal over a mere representation of the concrete beauty of the woman (or model) wearing the dress (de Perthuis 2008). They have often aimed to produce an innovative imagery, rather than the two-dimensional reproduction of a range of existing clothing possibilities.

The idea of the stylist as an unconventional creator, courageous subversive of fashion rules, is consistent with this context. However, it neglects the fact that

alongside the more experienced fashion consumers, eager for radical innovation, there is a large audience of ordinary people. They are attentive to the dictates of fashion, not for their innovative strength, but because they fix a shared aesthetic order, a way of dressing that does not stand out for its originality compared with the dominant choices. To be more precise: it neglects the fact that alongside niche fashion magazines (*Dazed and Confused*) there are women's magazines for the mass market (*Cosmopolitan*) that utilize the creative ability of fashion stylists. Although less conspicuous from the point of view of aesthetics and fashion content, these magazines are far more influential in determining the socially widespread imaginary of the dressed body.

Those stylists who acknowledge such a 'mass' audience bring a different tone to their story. Pure creativity no longer prevails, but mediation instead. When a stylist, who is also the fashion editor for a women's weekly magazine, is asked about the fundamental features of their work, they will likely resort to expressions like 'arbiter of taste', 'guide' to consumers' choices, the readers' 'mentor' or 'trainer'. Such a self-conception is not totally lacking among the most prominent of figures. For example, Judy Blame argued in an interview that 'it was from working with people like Neneh [Cherry] that I realized that I was in fact educating other people' (quoted in Baron 2012: 32). However, those are isolated moments in which the dominant rhetoric of artistic creativity gives way to a different awareness of the function of the fashion imaginary in social life. It is to the most ordinary figures of styling that we need to turn to be able to isolate this professional figure from the glow created by celebrity culture and to more clearly grasp the role of the stylist within the broad system of clothing innovation.

For this reason, I will base my argument in this chapter on a study of Milan fashion stylists, in which reputation was not a consideration when selecting my respondents. The focus on Milan has helped in this. Albeit a fully-fledged fashion capital, Milan in fact plays a minor role in the production of photographic imagery. The most influential Italian stylists work mainly abroad. Accordingly, the Milanese scene facilitates the study of routines, practices, prevailing attitudes and the culture of the profession.

Drawing from research data, I focus on one particular issue. Ordinary stylists perceive themselves as mediators of collective taste. However, at the very moment when, in the last few decades, others have come to acknowledge their role and they are celebrated by a larger audience, technological developments have triggered a process of 'disintermediation' (Bessi and Quattrociocchi 2015; Gellman 1996), by which stylists' function as arbiters of taste has begun to be stripped away. With the diffusion of new technologies, especially of social media,

the spread of cultural novelties rests more and more on the activity of lay people rather than on the work of professional mediators. How do the protagonists experience this shift? What are their typical reactions? How are they adapting or not adapting to technological developments? How is the profession changing? Are the processes of clothing innovation changing? These are the kind of questions I will address here.

Gatekeeping and disintermediation

The role of certain cultural intermediaries of the Western fashion system as mediators of collective taste ('tastemakers'; see Mears 2011: 121–169) was first investigated by Joanne Entwistle (2009), who used Blumer's theory of collective selection to study the professions of buyers and models. Blumer (1969) has shown that clothing innovation is based not only on the creative drive of social or cultural elites, but also on the practice of those cultural intermediaries who, anticipating the trends of collective taste, actually take it in one direction or another. Cultural intermediaries (Bourdieu [1979] 1984) are gatekeepers at major stages in the process of production and circulation of cultural products. In their professional roles, they have to select a limited number of items from a multitude of products created by the industrial system, thus contributing to the shaping of collective taste.

These concepts can be suitably applied to the work of styling. Composing the outfits that will appear in the show, defining the look of celebrities, building the imagery conveyed by advertising and editorials, stylists cooperate as intermediaries of taste in fashion. In fact, fashion is not dictated exclusively by those who produce garments or accessories, or exclusively by the behaviour of those who choose, buy and use (or do not use) those items. Fashion is mainly made up of looks (Entwistle and Slater 2012), or, as I prefer to say, it is made up of 'vestimentary possibilities' (Volonté 2008): clothing styles that have acquired a space of possibility in the cultural landscape of a given community. It is not the designer alone who creates such possibilities, or fashion editors, stylists, photographers, buyers, visual merchandisers or final consumers. Instead, this is the perpetually unstable and transformational result (see Entwistle and Slater 2012: 17) of a complex process, to which all these individuals contribute.

However, in the process of continuous transformation of the cultural landscape, some people occupy a more privileged position than others. This is especially true of communications professionals. Their selection among many

vestimentary possibilities does not affect just a limited number of bystanders, as happens to the average consumer in everyday life, but a wide and diverse audience. They operate in a similar way to those who select the information that reaches the audience in the media system, known as 'gatekeepers' (Shoemaker and Voss 2009). Their special position enables them to influence a large number of actors simultaneously. Within fashion, the stylist – which in Italy, by the way, is one of the professional roles shielded by the Association of Journalists – carries out this gatekeeping function in a substantial and powerful way. The stylist, in fact, decides which of the countless possible outfits made available by the fashion industry and consistent with the prevailing cultural context will have the privilege of entering directly into the collective imaginary through the medium of photography in specialized magazines, the wider press or on urban streets.

In today's system of communications, disintermediation has severely weakened the position of traditional gatekeepers. This was first noted with respect to the work of journalists (Singer 1997), but today it is especially apparent in the field of fashion, where print magazines are coming under increasing pressure from fashion blogs and social media (Pedroni 2015; Rocamora 2011). Up until twenty years ago, magazines – and therefore editorial stylists – occupied a key position in the selection of vestimentary possibilities, because they were both the only point of access to the closed world of fashion shows and the main instrument of mass diffusion of looks. Today, the continuous and instantaneous flow of images via the Internet, where shows are broadcast in real time and everybody can post looks as they wish, relegates magazines and stylists to the margins and to chasing trends that are developing elsewhere (Lynge-Jorlén 2017: 4–5).

Hence my focus on understanding how Milan's stylists perceive, interpret and react to this transformation. However, to assume that disintermediation is complete and that the opposition between print magazines (and stylists) and social media (and influencers) is a clash between two alternative worlds would be to oversimplify matters. The original debate on disintermediation showed that the on-going process does not lead to the elimination of communication intermediaries, but to the replacement of old intermediaries with new ones, such as platform owners and online service providers (Colombo et al. 2017). In the field of fashion, the assimilation of influencers into the industrial production and distribution system has already occurred. Born as street-style bloggers (i.e. as bearers of an alternative bottom-up understanding of fashion), they have quickly become part of the 'working machinery' of the four main fashion weeks: New York, London, Milan and Paris (Luvaas 2018). So much so that, today, it

cannot be said that the digital breakthrough has led to a severing of fashion communication from the production system (Titton 2016).

In short, the fact that a significant proportion of fashion communication is relocating to social networks does not water down the gatekeeping function, but instead transfers it in part from one group of individuals to another: from stylists to bloggers and influencers. Overall, stylists are bound to a traditionally analogue work environment and share a professional culture based on the rhythm of seasonal cycles, and a social capital derived from their professional activity. Influencers, by definition, operate in a digital professional environment and are characterized by a more flexible professional culture: poorer, faster, and based on a richer and more ephemeral social capital. We will see – through the eyes of Milan's stylists – that although this transition weakens the profession of styling, it does not jeopardize the stylists' gatekeeping role in determining clothing innovation.

The Milanese setting

This chapter is based on data gathered for a sociological study on fashion stylists working in Milan. The investigation used a non-standard methodology consisting of in-depth interviews (professional life-stories according to the model proposed by Bertaux 1998) with individuals working as stylists for at least five years, follow-up interviews with the same stylists, semi-structured interviews with privileged witnesses, and an ethnographic observation of photo shoots. Snowball sampling has been tuned through weighting to include multiple career stages, both freelancers and employees, and specializations in women's and men's fashion. Since my aim was to focus on the role of photographic images in the fashion system, I excluded personal stylists and stylists for television and popular music (Lifter 2018). The interview guide was aimed mainly at detecting attitudes, perceptions and personal experiences. For the purposes of this chapter, I carried out a qualitative content analysis (not software-assisted) of fifteen professional life-stories collected in 2013–2015. The analysis, which adopted interpretive coding, was limited to categories relevant to the topics of technological innovation and digitization of work practices.[1]

As mentioned, Milan's strength in the fashion system is not styling. Despite the fact that the city is home to almost all the national fashion editorial offices, despite it hosting Fashion Week, influential magazines such as *Vogue Italia* and *L'Uomo Vogue*, and a large number of fashion brands producing major advertising

campaigns, the jobs involved in the production of images are less developed than in the other fashion capitals. There is indeed a lot of 'ordinary' work (editorials for newspaper supplements, campaigns for minor brands, catalogues), with high-status jobs often commissioned abroad. Internationally renowned Italian photographers and stylists are frequently based in New York or Paris. Above all, Italian brands and magazines usually engage foreign photographers and stylists – for example, this is standard practice for *Vogue Italia*.

Regardless of the evidence, this was undoubtedly a feeling shared by the stylists interviewed, who often emphasized the 'provincialism' of the Milanese setting compared with the other fashion capitals. An interviewee accurately summarized a number of recurring considerations:

> Here they never let you develop, you remain an assistant until you are thirty-five … I must say that Milan seems to me very provincial unfortunately, like Italy in general. It is very small, and if you travel you realize that if you go to other cities there is a completely different level – in a way, of trust. Some famous stylists are twenty-five years old, I guess, or twenty-eight. They are not fifty. Here few have reached an international level … Also, magazines have become so truly commercial! The client has gained power, so perhaps even the reader will realize that nothing is spontaneous or creative anymore. There is no courage to do things, to dare, and therefore you always stay at a rather mediocre level … And then, dropping sales, dropping budgets. I mean, I see that even *Marie Claire* has lowered the budget: they cut, they cut a lot. So it is hard to produce good editorials, or editorials that are a bit different from one another, or to propose something different.
>
> <div align="right">Mi3/F49, 0.19′17″, 14 November 2013</div>

Three issues are addressed in this excerpt. First, gerontocracy: as in other sectors of Italian social life, in fashion, and specifically in styling, young people are given little credence. Since the reliability of seasoned professionals is preferred to the creativity and openness of newcomers, there is no room for the professional development of the latter. The system rewards young stylists good at carrying out editorial work, rather than those who display artistic creativity. Compared with the other fashion capitals, it is not considered a stimulating environment. Second, the excerpt mentions the overwhelming power of clients, namely that the contents of fashion editorials are increasingly dictated by the commercial needs of the brands. Such an implicit pact has always governed fashion publishing (Titton 2016: 212–215): when a brand buys advertising space in a magazine, it expects the editorials to show and name its products also (see also Lynge-Jorlén 2016: 90–91). The feeling of the interviewees was that this pact is progressively

reducing their freedom, their ability to invent stories and create images according to their own tastes, and to make their own aesthetic choices. As Angela McRobbie noted in the 1990s, in the magazine environment creativity conflicts more directly with commerce when the industry goes into recession (McRobbie 1998: 159). The third topic addressed by the interviewee is the crisis in print publishing, including fashion magazines. Due to the digital revolution, magazine sales are falling and budgets are being slashed, placing limits on creativity. As highly skilled photographers and famous models are no longer in reach, and studios are preferred to outdoor locations as backdrops, the homogenization of editorials is widespread. Another stylist expanded on this point as follows:

> Recently fashion editorials are becoming rather like catalogues, windows to show products, to the detriment of creativity. There are no financial resources to invest, so between an average and a good photographer I take the average one, because it's cheaper. I shoot around the corner rather than two kilometres away, so I don't have to pay the van, the day rental, and so on . . . All in all, I see much more exciting things (regarding editing, styling, lighting) on e-commerce sites, which are cleverly replacing press (but the press hasn't noticed yet).
>
> Mi8/M36, 1h.09′57″, 23 January 2014

I will return to the crisis of print magazines and their relationship with the Internet later. For now, I want to emphasize that these issues, which affect not just the Milanese stylists (see, for example, Roitfeld 2011: 46), lead them to consider themselves marginal compared with stylists based in the other fashion capitals. Indeed, such marginality affects the overall composition of the Milanese styling world, where press-related jobs prevail over more profitable jobs for brands (advertising, catalogues, fashion shows) and for celebrities (which are relatively uncommon in Italy).

The much-lamented effect of this (relative) marginality is that working in Milan makes it difficult to establish oneself on the international stage, so much so that becoming successful usually means moving to Paris, London or New York. Such recrimination is often accompanied by a resentment towards the Italian fashion industry, accused of not recognizing the high calibre of Milan's stylists. Sometimes, the preference for stylists based abroad is connected to the strong bond that often exists between stylist and photographer, and that derives from the practice of the shoot itself, which is intrinsically collaborative. It is not unusual for a photographer to prefer to work with a limited and trusted number of stylists, and vice versa. Frequently, photographer and stylist couples work as a stable professional unit. Since most of the established fashion photographers are

based abroad, it is understood that the most influential stylists will be as well, as elaborated by the following interviewee:

> In this environment there is a lot of xenophilia, in the sense that the stylists working with great designers, even our own, are almost never Italian … Why? Because all the big photographers …, also those of the most important magazines, who are the brains from both a commercial and an image point of view, are American or foreign (English and so on). Therefore, they have their own [stylists].
>
> Mi9/M47, 1h.19′45″, 24 January 2014

Other interviewees intimated such 'xenophilia' has a reputational dimension:

> Between an Italian stylist and a foreigner, the foreigner wins, because they possess an international allure. There is a lot of xenophilia. This applies to photographers and to stylists. In most of the fashion shows that are held in Milan, the stylists are foreigners, they are not Italians – even if you have Italians at your disposal and you can do a couple more meetings, and maybe they are also following the casting, and probably are at the same level as the foreign stylist. It is always considered more trendy to work with a foreign stylist.
>
> Mi8/M36, 1h.35′19″, 23 January 2014

Here, the preference for foreign stylists is traced back to the allure they possess, to the fact that they stand out more, hence the importance of displaying their name. Apparently, the name adds something to the value of the product (the image or the fashion show) and of its producer (the magazine, the brand). We will see that this reputational dimension constitutes a fundamental aspect of the self-perception of fashion stylists.

Mediating taste

Based on the characteristics of their role, professional stylists are sometimes portrayed as feeble and worthless in relation to their creative contribution, which is equated to that of a prop master. Indeed, Milanese stylists often report disparaging remarks from colleagues who occupy a higher position in established professional hierarchies. Photographers, for example:

> [Oliviero] Toscani used to call the stylist 'pincushion'. This really says it all … Before achieving a relationship of trust and respect you spent years in which you were called a pincushion. That is: 'Fix those pins correctly please, to tighten the jacket, I'll take care of the rest'.
>
> Mi4/F56, 1h.04′10″, 29 November 2013

Or journalists:

> The Association of Journalists considers us as seamstresses. They told me: 'You are the people who sew'. [laughs]
>
> Mi1/M35, 1h.01'53", 2 September 2013

Therefore, stylists usually emphasize the creative role they play in the construction of fashion images. Often they define themselves as 'directors' of the editorial or fashion show, akin to film directors. When referring specifically to the narrative content, they use terms such as 'scriptwriter' and 'story writer'. But it is especially common for them to define themselves as 'fashion interpreters', as if comparing the designers' collections with mere collections of musical notes that require interpretation to become meaningful, interesting, pleasing to the public.

For many interviewees, interpreting fashion means 'translating' a raw material into a language that is comprehensible to an untrained audience, teaching them 'good taste' in using what the fashion system provides, avoiding the easy trap of vulgarity:

> For me a vulgar woman is a woman ... who lacks a clear style. She is a very well accessorized woman, very ... well, actually not 'eccentric', because eccentric for me has a positive meaning. She is an excessive woman, who piles on things that would not be needed, an excess of femininity, therefore an excess of makeup, accessories, hair, bonnets, things, colour, a jumble of stuff, then I find it vulgar. When I go around with my friends, with colleagues, I often say: 'We do a useless job'. Because we see people who dress badly, who have no style ... I feel that women are not very careful at all, I mean, few people know how to play to their strengths. Here it is: for me style means playing to one's strengths.
>
> Mi3/F49, 27'00", 14 November 2013

There is an educational dimension to all of this, the idea of 'teaching' the public good taste in taking care of their appearance. Stylists – especially those working for popular magazines – present themselves not only as style creators, but also as educators of consumers, arbiters of good taste. They are intermediaries in the sense of veritable creators and legitimators of fashionable vestimentary possibilities. Although they do not create objects, they create the tastes according to which objects ought to be used (see figure 25).

The self-perception of stylists as gatekeepers of the circulation of vestimentary possibilities makes them very sensitive to technological transformations that have widened the conduit of information flow and/or created alternative channels. This is what happened with the birth of social media and the consequent diffusion of first, fashion blogs, and then social networks, which have decentred

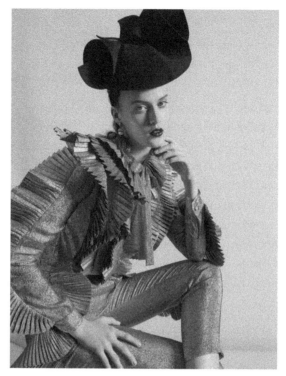

Figure 25 *Io Donna*, March 2017. Photography: Dancian. stylist: Alessandra Corvasce. Courtesy of *Io Donna*.

the geography of fashion tastemakers (Rocamora 2013: 159). As mentioned, the digitization of fashion communication did not entail the disintermediation of image production, but instead the creation of new intermediaries who took charge of gatekeeping on the Internet. While previously stylists were the main protagonists of the mediation of the fashion imaginary, today's technologies have not only put an end to that exclusivity, but in some cases have even subordinated stylists to other figures, such as those who categorize fashion shows' snapshots ('flowers', 'white', 'punk', etc.) on Internet platforms. All of this reduces the space available for their professional creativity.

Consequently, many of Milan's stylists portrayed an attitude of passive resistance to the Internet and hostility towards the new protagonists of the fashion media sphere, in tones not too dissimilar to those often used publicly by magazine directors (Godwin 2010; Menkes 2013; see also Findlay 2017). The following excerpt from an interview with a rather young stylist is representative of a widespread attitude:

Now with Photoshop everybody is a genius. Now everybody considers themselves great photographers or great stylists. It's like the bloggers phenomenon, isn't it? Or that of those who get dressed to be photographed during the fashion shows, which is something that enrages me. Maybe I'm old-fashioned, but ... You see people wearing the most shocking things on their heads just to be photographed. Then those people – fashion bloggers – consider themselves to be fashion stylists, which I think are two completely different things. Either you are a blogger or you are a stylist. I mean, you can be a fashion blogger, so you talk about fashion, fashion shows, how this person was dressed, how that person was dressed, but then you don't go to a fashion designer or a fashion house saying: 'I also do styling, I'll do the show, I'll do the campaign'.

Mi1/M35, 22'10", 2 September 2013

Not all of the interviewees were equally closed to the opportunities offered by new technologies. Some of them did update their Instagram profile. Some confessed that they did not commit to social networks simply because their everyday editorial work did not leave them the time to do so. But even those who recognized that the web could be a great opportunity for stylists did so in opposition to the 'non-professional' competition of bloggers and influencers:

We should find a way to bring our experience into the world of web communication. This would make a difference vis-à-vis the bloggers ... In the meantime, we are being surpassed by those who are improvising: talented, quick, smart, but not professional. And they will never know how to shoot a fashion editorial, they do not know the photographers, they do not know about the lighting, they do not have all this expertise. Yet in no time they communicate with the world using codes that are up-to-date, and I wonder: knowing those codes, is there a way to bring our expertise into that same world?

Mi6/F50, 1h.34'17", 17 January 2014

The resistance to new technologies displayed by the interviewees is probably related to features of the Milanese context: generational factors (the gerontocracy mentioned above is not prone to change), the structure of the labour market (press-related jobs prevail and many freelance stylists are actually tied to a magazine with exclusive contracts), or the fact that the most dynamic personalities have moved elsewhere. However, I want to stress here and tackle in the next section a different issue. Digital technologies are the terrain of a fundamental contrast between two professional figures that, as Bourdieu would say, are struggling for the same stake (1993: 176–191). For stylists, blogs and social media are the materialization of the risk of losing their role as fashion

tastemakers. For them, digital technology is not relevant in itself, but as the tool used by influencers to emerge on the scene.

Building a reputation

In 2019, five years after the interviews cited above, against the expectations of the stylists the phenomenon of social media influencers showed no signs of going away. Instead, influencers had been further assimilated into the fashion system, losing their bottom-up connotation (Pedroni 2015), and becoming fully integrated into the processes of mediation of institutional fashion (promotion of brands and products, dissemination of trends, etc.). Internet popularity has become a criterion for choosing the professionals of fashion communication. In a follow-up interview, one stylist commented:

> I can definitely see that – everyone says this, both big and small players, but especially the small ones – they look a great deal at how many [followers one has]. We see it in casting as well: now one immediately looks on Instagram at how many followers a model has. The same can be said for stylists. Or at any rate these influencers – who are often also called upon to design capsule collections (of shoes, clothes) – are called because they are reported to have a lot of followers on their Instagram.
>
> Mi3, follow-up interview, 3 January 2019

As these comments make clear, Internet popularity is very much a consideration because the number of followers has a twofold effect on the power to influence the circulation of fashion imagery: directly, as it reveals an audience whose size is unattainable to print magazines (the most influential bloggers have tens of millions of followers); and indirectly, because, depending on the number of followers, influencers also have the opportunity to determine the institutional expression of the fashion imaginary (namely fashion shows and advertising campaigns). Importantly, this second effect is based on reputational dynamics typical of gatekeeping activities: if one has a reputation as a stylist or influencer – as witnessed by Instagram – the brands will attempt to enhance their own reputation by entrusting that person with the direction of fashion shows or the art direction of advertising campaigns.

In his influential essay on art worlds, Howard Becker (1982) showed that the creation and destruction of reputations (of works, artists, schools, disciplines) is a fundamental mechanism of contemporary Western art. The same applies to

several of the creative sectors, including fashion (Entwistle 2009: 6–7). Becker, however, did not consider the fact that reputation has an essentially relational character and can be transferred as a currency – it can be earned and wasted. Artists acquire a reputation not only by creating works of exceptional value, but also by 'absorbing' the reputation of the galleries in which they exhibit, the museums that display their works, the critics who praise them and the collectors who buy their works. Likewise, the reputation of a critic, museum or gallery also depends on the reputation of the artists whom they praise, exhibit or trade. Similar to what happens in the field of science (Latour and Woolgar 1979), reputation is a form of credit, a transferable asset that can be used to acquire economic capital, goods and services, but above all to expand one's own possibilities for action – one's credibility within the system.

Pierre Bourdieu ([1979] 1984: 291; 1986) addressed the importance of reputation for cultural intermediaries through the concept of symbolic capital, the credit and authority that is bestowed to a greater or lesser extent on those who belong to a certain social field (e.g. the field of fashion). It is a form of 'capital' because it is a reward of the field that can be transformed into economic capital or power. The main characteristic of symbolic capital is to be a competitive resource. Symbolic capital produces hierarchies because the acquisition of capital by one agent means the loss of some form of capital by others. For this reason, the use of reputational dynamics ends up unifying the world of fashion tastemakers, placing traditional fashion editors and influencers in the same struggle to appropriate the (reputational) stakes of the field.

Bourdieu's theory has been applied to fashion by Agnès Rocamora, who describes the field dynamics between fashion bloggers and fashion journalists as a struggle between newcomers and established players (Rocamora 2016: 244–247). The former adopt a subversive strategy, appealing to authenticity and independence from the constraining role of advertising, as a tool to undermine the established players and their central position in the field. In contrast, the latter rely on their own centrality (through the governance of magazines) to claim for themselves the critical skills to express informed and objective judgements on fashion. The opinions of the Milanese stylists cited above corroborate such an interpretation. But there is more.

The stylist operates in a reputational dynamic that involves magazines, brands, colleagues, photographers, designers and models. Competition in the field relies on the credit that actors can grant to other actors by accepting them as part of their own network. A photographer and model decide whether to take a job for a magazine not only on the basis of any financial incentive, but also on whether

their reputation is likely to be enhanced. In addition, these decisions have obvious repercussions for the reputation of the magazine and the people who work or will work for it, as one interviewee noted:

> The quality of photographers [of the magazine] with this new French art director has increased, some photographers are seeking us out and want to work for us, whereas earlier it was more difficult ... Because there is a whole hierarchy of models as well. It's not that you can have all the models you want. Unfortunately, if a newspaper is not appreciated, if the photographer is not appreciated, they don't give you beautiful women.
>
> Mi3/F49, 1h.07'33", 14 November 2013

Put simply, reputation has the following characteristic: those who credit others put their own credibility on the line. Therefore, the choice of offering or not offering, of accepting or not accepting a job involves a calculation of reputational costs and benefits. By choosing photographers and stylists, the magazine director not only enhances their reputation, but also puts the reputation of the magazine on the line, so that it may prosper – or not – over time. Even photographers and stylists can see their reputation increase or decrease after the publication of an editorial in a particular magazine, and this may depend not only on the intrinsic quality of the editorial, but also on the reputation of that magazine.

Considering this characteristic of reputation, and referring notably to the scientific field, Bourdieu ([2001] 2004) showed that the cycle of credit works among a community of peers who strive for the same symbolic capital. In fact, those who are not engaged in defending their professional reputation do not experience strong constraints in crediting others. To 'like' on a social network has very low costs and can be granted carelessly. This implies, however, that 'free' opinions are rather unstable, whether they are about science, fashion or political issues. Credits become stabilized only when crediting involves the risk of a loss: a stable reputation emerges within a community of peers who fear jeopardizing their personal reputation, and are therefore cautious in the choice of those with whom they associate.

This makes a difference between the work of intermediation that is prevalent in styling and influencing. The key issue is that the mechanisms helping to stabilize reputations in cultural industries are based on a mutual bond that is lacking in the social rating typical of social media. Those who credit a stylist (e.g. in the headlines of an editorial) challenge their own professional reputation in doing so. In contrast, the reputation of bloggers relies on the choices of

individuals ('followers') who have nothing to lose. This different origin of reputation also exerts a different pressure on the practice of professionals, and hypothetically on their products as well. When an image-maker works as a stylist within the field of fashion, the creativity, originality, innovativeness and magnificence of his or her images, even when these target the final consumer, do not address the taste of the general public, but that of the professionals on which his or her reputation depends: magazine directors, photographers, designers, art directors. This pressure is less, or even absent, for those image-makers that deal only with the general public, e.g. fashion bloggers. Both figures mediate taste for clothing and looks, but there is a difference in the stabilization of their authority. This might help to explain why successful influencers strive to work as stylists, consultants, designers within the field of fashion.

The following excerpt is a clear example of such an attitude:

> I am the first to sometimes think more about the editorial, the criticism of those in the industry, more so than [the reader] even. I mean, you think a lot about what your colleagues will tell you, the esteem they have for you, what they think. Well, this is because we ourselves are merciless ... in judging editorials ..., therefore one always thinks about what your colleagues could tell you.
>
> <div align="right">Mi6/F50, 1h.14'24", 17 January 2014</div>

In short, the driving force of the system and the bond that keeps it united is, within a reputational dynamic, the fact of getting your face out there, and risking your reputation. For this reason, stylists started to 'play' the game of fashion when they started to sign editorials, i.e. to take responsibility for them. Signing an editorial (once again, taking credit) and shaping a recognizable style are fundamental tools for building one's reputation, which of course is based on the recognition of authorship:

> There is always a way to find your direction, to give your twist, which in my opinion is perhaps the only thing that allows a stylist to sign, to put in something of herself. Just like the photographer has a much more direct way of signing a service, which is not just their name, it is precisely their photographic style. For us it is a little bit more difficult. The eminence of a stylist is not to be good or not good, of dubious taste, it is to be recognized, which is not an easy thing. Few in the world in my opinion can be identified right away, just by looking at ten images.
>
> <div align="right">Mi14/F44, 8'12", 13 October 2015</div>

The eye that identifies the stylistic signature of a stylist at first glance, 'just by looking at ten images', is not the eye of the consumer. It is the eye of the peer, of

the professional who is part of the fashion system, the possessor of know-how that cannot be improvised. Therefore, stylists do a lot of work for the sole purpose of acquiring status in their field. For instance, it is common for stylists to invest time and money in the production of fashion editorials that will be published for free in high-status niche magazines, such as *i-D, Dazed and Confused,* and *Tank.* I will not dwell on this point, which has already been widely discussed by scholars (Lynge-Jorlén 2016; McRobbie 1998: 157–160; Rocamora 2018). I add only that the same objective pushes editorial stylists to pursue a creative outcome even when the context penalizes them. Editorial stylists have to constantly mediate between the creative drive and the restrictions deriving from both the target audience of the magazine and the producers of the photographed items. These two opposite requirements – free creativity and compliance with contextual restrictions – are given a special synthesis by professional stylists. Several interviewees stated that they did not perceive the constraint of having to show in the editorials mass-market products, which are hardly exciting and fashionable, as a limit to their creativity, but as a challenge that makes the work even more interesting:

> So you make twenty pages and you have twenty [advertiser] names to do. This, unfortunately, is how it is. But then it's up to you to mix, choose all the designers, brands or accessories you want, and then be able to make a beautiful story all the same, even though you have to show brands ... Actually I enjoy it even more, as it's a challenge. I mean, if you make a total look, it's easy, isn't it? Damnit, the story could even be better. But it's a challenge being able to take good images, a nice editorial, with barely beautiful clothes.
>
> <div align="right">Mi3/F49, 12'19", 14 November 2013</div>

Conclusion

The fresco of the Milanese styling world emerging from these pages – rather closed, resistant to technological innovation, nostalgic of the glamorous eighties, envious of the success of those who chose an international path – contrasts with the public image of the most influential Italian stylists. However, it is consistent with some major characteristics of Milan at the beginning of the new century: a widespread conservative attitude affecting consumers even more than brands (Mora 2009); the prevalence of commercial interests over artistic ones (Segre-Reinach 2006); the care of a sober and psychologically accessible elegance, that elsewhere I call the 'culture of wearability' (Volonté 2012).

While all this is typical of the Milan setting, the consequences of the so-called disintermediation of fashion communication have a wider significance. Social dynamics are often used to explain how fashion works. I have claimed here that reputational dynamics, in particular, could help to better understand the forces that drive the processes of clothing innovation. Entwistle and Rocamora (2006) suggest that fashion can be considered as a social field in the sense of Bourdieu, and to call fashion capital the capital specific to the field of fashion. In this view, symbolic capital (reputation) is crucial. Unlike celebrity, reputation is a capital that stabilizes only when it is conferred by peers in the same field, who are therefore cautious in attributing it, since they are vying for the same stakes. Both stylists and influencers participate in the definition of our clothing landscape through their respective work of cultural intermediation. However, the weakness – or even absence – of a mutual bond in social rating among influencers, compared with that which exists in the traditional reputational dynamics, differentiates the celebrity that they possibly enjoy online from the very idea of fashion capital. While celebrity is a vehicle of change in the clothing landscape, it does not entail the same power of institutionalization of trends as professional reputation.

Styling is a profession that goes far beyond the invention of particularly original looks. It performs a gatekeeping function in the production and circulation of vestimentary possibilities. Placed at the intersection of brands' economic power and consumers' commercial power, it cannot allow the stylist's individual choices to be released from the incipient collective taste. At the same time, however, it needs to leverage the individual creativity of the stylist, on which the creation of vestimentary possibilities depends. Reputational dynamics are an effective social tool through which the stylist is pushed both to innovate the clothing landscape and to do it within the constraints imposed by the community of tastemakers. They are not merely a manifestation of the struggle for the symbolic capital in the field of fashion, but also a tool for the fashion system to stabilize the process of fashion innovation.

Note

1 Although quotations from interviews are anonymized, each respondent has been assigned a code composed as follows: number/personal data (i.e. sex and age at the time of the interview), timing of the excerpt's first word, date of the interview. For sake of legibility, the transcription is not completely faithful and integral. I have

removed all signs relating to the paralinguistic system and uncertainties of the spoken language. Other cuts and interventions are indicated by ellipses. However, I have tried to maintain the liveliness of oral language.

References

Baron, Katie (2012), *Stylists: New Fashion Visionaries*, London: Laurence King Publishing.

Becker, Howard (1982), *Art Worlds*, Berkeley, CA: University of California Press.

Bertaux, Daniel (1998), *Les Récits de vie*, Paris: Editions Nathan.

Bessi, Alessandro and Walter Quattrociocchi (2015), 'Disintermediation: Digital Wildfires in the Age of Misinformation', *AQ – Australian Quarterly*, 86 (4): 34–39.

Blumer, Herbert (1969), 'Fashion: From Class Differentiation to Collective Selection', *Sociological Quarterly*, 10: 275–291.

Bourdieu, Pierre ([1979] 1984), *Distinction: A Social Critique of the Judgment of Taste*, London: Routledge & Kegan Paul (original edition: *La Distinction. Critique sociale du jugement*, Paris: Minuit).

Bourdieu, Pierre (1986), 'The Forms of Capital', in J.E. Richardson (ed.), *Handbook of Theory of Research for the Sociology of Education*, 241–258, Westport, CT: Greenwood Press.

Bourdieu, Pierre (1993), *The Field of Cultural Production: Essays on Art and Literature*, Cambridge: Polity Press.

Bourdieu, Pierre ([2001] 2004), *Science of Science and Reflexivity*, Chicago, IL: University of Chicago Press (original edition: *Science de la science et réflexivité*, Paris: Raisons d'agir).

Colombo, Fausto, Maria Francesca Murru, and Simone Tosoni (2017), 'The Post-intermediation of Truth: Newsmaking from Media Companies to Platform', *Comunicazioni sociali*, 3: 448–461.

Cotton, Charlotte (2000), *Imperfect Beauty: The Making of Contemporary Fashion Photographs*, London: V&A Publications.

Entwistle, Joanne (2009), *The Aesthetic Economy of Fashion: Markets and Value in Clothing and Modelling*, Oxford: Berg.

Entwistle, Joanne and Agnès Rocamora (2006), 'The Field of Fashion Materialized: A Study of London Fashion Week', *Sociology*, 40 (4): 735–751.

Entwistle, Joanne and Don Slater (2012), 'Models as Brands: Critical Thinking about Bodies and Images', in J. Entwistle and E. Wissinger (eds.), *Fashioning Models: Image, Text and Industry*, 15–33, London: Berg.

Evans, Caroline (2008), 'A Shop of Images and Signs', in E. Shinkle (ed.), *Fashion as Photograph: Viewing and Reviewing Images of Fashion*, 17–28, London: I.B. Tauris.

Findlay, Rosie (2017), *Personal Style Blogs: Appearances that Fascinate*, Bristol: Intellect.

Gellman, Robert (1996), 'Disintermediation and the Internet', *Government Information Quarterly*, 13 (1): 1–8.

Godwin, Richard (2010), 'Blog and Be Damned', *ES Magazine*, 27 August: 13–16.

Latour, Bruno and Steve Woolgar (1979), *Laboratory Life: The Social Construction of Scientific Facts*, London: Sage.

Lifter, Rachel (2018), 'Fashioning Pop: Stylists, Fashion Work and Popular Music Imagery', in L. Armstrong and F. McDowell (eds.), *Fashioning Professionals: Identity and Representation at Work in the Creative Industries*, 51–64, London: Bloomsbury.

Luvaas, Brent (2018), 'Street-style Geographies: Re-mapping the Fashion Blogipelago', *International Journal of Fashion Studies*, 5 (2): 289–308.

Lynge-Jorlén, Ane (2016), 'Editorial Styling: Between Creative Solutions and Economic Restrictions', *Fashion Practice: The Journal of Design, Creative Process and the Fashion Industry*, special issue on Fashion Thinking, 8 (1): 85–97.

Lynge-Jorlén, Ane (2017), *Niche Fashion Magazines: Changing the Shape of Fashion*, London: I.B. Tauris.

McRobbie, Angela (1998), *British Fashion Design: Rag Trade or Image Industry?*, London: Routledge.

Mears, Ashley (2011), *Pricing Beauty: The Making of a Fashion Model*, Berkeley, CA: University of California Press.

Menkes, Suzy (2013), 'The Circus of Fashion', *The New York Times Style Magazine*, 10 February. https://www.nytimes.com/2013/02/10/t-magazine/the-circus-of-fashion.html [accessed 24 January 2019].

Mora, Emanuela (2009), *Fare moda. Esperienze di produzione e consumo*, Milano: Bruno Mondadori.

Mower, Sarah (2007), *Stylist: The Interpreters of Fashion*, New York: Rizzoli International.

Pedroni, Marco (2015), 'Stumbling on the Heels of My Blog: Career, Forms of Capital, and Strategies in the (Sub)Field of Fashion Blogging', *Fashion Theory: The Journal of Dress, Body and Culture*, 19 (2): 179–199.

de Perthuis, Karen (2008), 'Beyond Perfection: The Fashion Model in the Age of Digital Manipulation', in E. Shinkle (ed.), *Fashion as Photograph: Viewing and Reviewing Images of Fashion*, 168–181, London: I.B. Tauris.

Rocamora, Agnès (2011), 'Personal Fashion Blogs: Screens and Mirrors in Digital Self-portraits', *Fashion Theory: The Journal of Dress, Body and Culture*, 15 (4): 407–424.

Rocamora, Agnès (2013), 'How New Are New Media? The Case of Fashion Blogs', in D. Bartlett, S. Cole, and A. Rocamora (eds.), *Fashion Media: Past and Present*, 155–164, London: Bloomsbury.

Rocamora, Agnès (2016), 'Pierre Bourdieu: The Field of Fashion', in A. Rocamora and A. Smelik (eds.), *Thinking through Fashion: A Guide to Key Theorists*, 233–250, London: I.B. Tauris.

Rocamora, Agnès (2018), 'The Labour of Fashion Blogging', in L. Armstrong and F. McDowell (eds.), *Fashioning Professionals: Identity and Representation at Work in the Creative Industries*, 65–81, London: Bloomsbury.

Roitfeld, Carine (2011), *Irreverent*, New York: Rizzoli.

Segre Reinach, Simona (2006), 'Milan: The City of Prêt-à-Porter in a World of Fast Fashion', in C. Breward and D. Gilbert (eds.), *Fashion's World Cities*, 123–134, Oxford: Berg.

Shinkle, Eugénie (2008), 'Introduction', in E. Shinkle (ed.), *Fashion as Photograph: Viewing and Reviewing Images of Fashion*, 1–14, London: I.B. Tauris.

Shoemaker, Pamela J. and Tim P. Voss (2009), *Gatekeeping Theory*, New York: Routledge.

Singer, Jane B. (1997), 'Still Guarding the Gate? The Newspaper Journalist's Role in an On-line World', *Convergence*, 3 (1): 72–89.

Titton, Monica (2016), 'Fashion Criticism Unraveled: A Sociological Critique of Criticism in Fashion Media', *International Journal of Fashion Studies*, 3 (2): 209–223.

Volonté, Paolo (2008), *Vita da stilista. Il ruolo sociale del fashion designer*, Milano: Bruno Mondadori.

Volonté, Paolo (2012), 'Social and Cultural Features of Fashion Design in Milan', *Fashion Theory: The Journal of Dress, Body and Culture*, 16 (4): 399–432.

Commercial Styling: An Ethnographic Study on Styling Practices at H&M

Philip Warkander

Introduction

My job is to create outfits that will make the H&M consumer want to buy H&M garments. The people who work in the buying division spend a lot of time thinking about who their respective consumers are, which they then communicate to us – stylists – through descriptive texts such as: 'The LOGG-consumer is 25–35 years old and lives in a large city. Doesn't care about trends but finds it important to be well dressed. Gets their style inspiration from social media and celebrities, like David Beckham and Jude Law'. Then they send us approximately five sketches on how they imagine that this consumer would style the LOGG clothes that will be released in store between, for example, week three and week eleven. In this time period, LOGG will release about 120 different garments, so based on these five sketches and key words I am supposed to create 120 unique outfits. For me, the creative aspect comes into the process when I interpret the information from my colleagues and apply it to the beige pants that I will 'style': Would this bloke wear a shirt like this one or would he prefer that one? It's similar to dressing a character in a TV series. Is it believable? Could I imagine this person in front of me to be wearing this? Will the model look credible in this outfit or do I have to adapt the concept of the LOGG guy so that the model in question can 'pull it off'? All of these are questions that I as a stylist have to answer. Not counting the time that I spend on answering e-mails and administration, this is what I spend all my time on. Which shirt? Which shoes? Which earrings? What pose? Which colour? This or that? And in the end, what guides me as a stylist is my intuition. To me, that is creativity. Working as a stylist at H&M is, however, less creative because you have restrictions and guidelines that keep your inner fashion lion if not in a cage then at least fenced in: 'To go with these kinds of pants we want a certain kind of shoe'. 'This consumer doesn't

want a tie'. 'This consumer won't wear a lot of jewellery', and so on, which means I have to adapt my intuition to rules I might not agree with. That makes my work less creative.

In this quote, full-time stylist Linda is answering my question on how she understands the concept of creativity in regards to her job at the e-commerce department at H&M.[1] She sees creativity in commercial styling as a process of interpretation of a brief where she is building a believable, and to the consumer, appealing character. Linda's reflections are telling of the demarcations between commercial styling and editorial styling, where, roughly, the first prioritizes the appeal to the consumer and the latter is based on suggestive image-making. The interview is part of the empirical material gathered for this chapter, exploring contemporary styling practices in the Swedish mass fashion industry, primarily within the H&M conglomerate, as well as with the general discourse of the ideologically influenced organization of labour in Sweden.

Based on semi-structured interviews with stylists working for H&M, either on a freelance basis or employed full-time, this chapter aims to explore commercial styling practices in the field of mass fashion. Situating the informants' work within the culture and history of Swedish politics and organization of labour, I examine how models are used to increase symbolic value, gendered aspects of the working environment, as well as the split between money and creativity in the field of large-scale fashion production. The study is part of a larger research project, based on empirical material gathered through ethnographic fieldwork, including observational studies and semi-structured interviews with approximately seventy informants – of whom nine were stylists – all conducted in the years 2015–2017.[2]

A brief history of the Swedish fashion industry

As a result of the outsourcing of the garment industry to cheap-labour countries in the 1970s, the Swedish fashion industry today is primarily concerned with producing fashion, rather than garments. The production of 'fashion' in Sweden – as in most other Western countries – is in many ways separated from the production of 'clothes' not only in time but also in space. Even though Sweden is part of Western Europe, from a fashion system point of view, it is often – as is also the case of its Scandinavian neighbours – perceived as a peripheral player in the field of international fashion.[3]

Entwistle (2002, 2009) claims that fashion is an 'aesthetic economy'. Unpacking this concept, she states that, 'in aesthetic economies, aesthetics are not something "added on" as a decorative feature or after-thought once a product has been defined; *they are the product/s* and, as such, are at the centre of the economic calculations of the practice' (Entwistle 2002: 321; original emphasis). She further specifies that in aesthetic economies, 'economic calculations are intertwined with cultural concerns, bound to forms of cultural knowledge, capital and acquired taste, and to social, cultural and institutional relations' (2002: 319). What is considered 'on trend' in fashion is contextually specific and as such inherently volatile and unstable, and can quickly change from one season to the next. Those who work in fashion production need to be particularly skilled at translating cultural and social development into images and other aesthetic commodities. In this way, Entwistle's 'aesthetic economy' can be considered interlinked with Richard Florida's concept of 'creative class', or at least be defined as part of the 'creative economy' mapped out by Andrew Ross (Florida 2002; Ross 2008).

The Swedish fashion industry is dominated by the presence of the H&M conglomerate, which includes several mass fashion-brands, such as Arket, & Other Stories, Monki, Afound and Weekday. Economically speaking, the H&M conglomerate is the most dominant actor in the Swedish fashion system, which indirectly implies that Swedish fashion is heavily influenced by commercial aesthetics. In recent years, this image has been made more complex by the emergence of smaller and more concept-driven brands, such as Lazoschmidl, Emelie Janrell, Minna Palmquist, Ida Klamborn and Johannes Adele, to name but a few. However, studies show that these kinds of smaller brands rarely survive financially for more than a few years (Sundberg 2006). There are of course a few exceptions to this, most notably Acne Studios, Our Legacy, Gudrun Sjödén, Eton shirts, Stutterheim, Filippa K and HOPE Sthlm, all of which have combined strong aesthetic visions with long-term financial stability. Yet H&M remains the most financially successful actor in Swedish fashion.

Carina Gråbacke has stated that the current work tasks in Swedish fashion often are radically different from what they used to be, underscoring that the digitalization process has created new assignments that often lack historical counterparts. Social media influencers, bloggers and podcasters are now considered to be increasingly significant players in the fashion system (Gråbacke 2015: 311–314). This media attention, often focused on what David Hesmondhalgh has defined as 'symbol creators who achieve name recognition', adds to the seductive narrative of finding joy in creative work, subsequently

leading to new members joining the workforce, in hope of one day becoming one of the 'small number of highly rewarded superstars' (Hesmondhalgh [2002] 2013: 261).

In recent years, budgets and work opportunities for freelance photographers and stylists have decreased dramatically due to the effects that digitalization have on traditional fashion media and communication. Bea first started working in the fashion industry as a model in the early 1980s, before becoming a freelance stylist. As a stylist, she produced editorial content as well as working on commercial campaigns. Since the early 2000s, she has worked as an independent producer, with clients ranging from Bergdorf Goodman and *Vogue Paris* to H&M and Ellos.[4] In an interview with me, she summarized the situation from a financial and organizational point of view:

> At the moment, we are in a very difficult time. A while ago, I went through my old papers from 2006. What I noticed was that the budgets for a photo shoot then were three times the size that they are now. Also, it involved considerably less work for the photographers. Now they are required to, besides taking maybe eight photos, also make a film and some content-related material for social media. Simply put, it's more work for less money … Today, there are new people with new titles, like 'content manager' and 'creative manager', it's all very pretentious, and this reduces the stylist to someone who more or less just pins a hem or steams a shirt, and who is told by some young person without any experience what to do. It's difficult for experienced stylists to get good work. The majority of Swedish stylists are struggling. No one wants to pay for the job anymore, and nowadays it's more common to hire someone in-house. More and more brands have in-house stylists and even in-house photographers. The only people who still make any money are the hair stylists. I wonder what will happen; it's obvious that social media has changed the business from the core, but I don't know where it all will go from here.

The digitalization process has reduced wages and budgets and undermined work security for freelancers in the fashion system, while also impacting the organization of work in related industries, such as advertisement and PR. However, already before this technological development, there is a long history of unpaid work in the fashion industry. Many who aspire to work in fashion start out as unpaid interns and assistants. In the interviews that I conducted as part of this study, it was regularly stated by the informants, including stylists with international careers in high fashion, that even those who are considered seniors in their field are regularly expected to work free of charge, especially when producing editorial content for fashion magazines. The question of how work in

the contemporary fashion industry is organized thus involves a number of important aspects, from technology to power structures, from creative influence to the balance between work and free time. Contemporary fashion, Rocamora states, is a 'global post-fordist industry'; its markets are becoming increasingly fragmented, while mass fashion challenges the hegemonic position previously held by high couture (Rocamora 2002: 359). This development has affected not only the consumption and diffusion of fashion but also its modes of production, including styling.

The fashion industry is in no way an isolated entity, but should rather be understood as a complex part of a larger field of cultural and creative industries, defined by the fundamental ambivalence through which symbolic creativity is produced, organized and circulated (Hesmondhalgh [2002] 2013: 7). The change in job opportunities for stylists described by Bea is thus not an anomaly but a defining characteristic of the fashion industry – not only is the industry engaged in the ritualized production of change through its season-based and trend-driven form of communication and launching of new commodities, it is also in itself marked by a volatile and unstable way of organizing creative work, with the effect that people engaged in fashion production often find themselves in vulnerable and financially uncertain positions. In addition, cultural industries are easily affected by changes in the political climate and international economy, which translates into being susceptible to erratic and unexpected developments on a larger societal level, such as the one illustrated by Bea in regards to the current digitalization process.

Styling Swedish mass fashion

Swedish fashion is, both financially and symbolically, dominated by the presence of the H&M conglomerate, which is one of the world's largest fashion businesses, with both retail outlets and offices spread internationally. While it is difficult to demarcate certain brands as specifically 'Swedish', it could be said that their organization of work is informed by Swedish culture. H&M's headquarters are located in central Stockholm, they are registered as a Swedish company, pay taxes in Sweden, and it is also in Stockholm that they produce most of their visual content, most notably for their vast e-commerce business. They regularly produce campaigns that are photographed on location, more often than not in places outside of Scandinavia, and for these assignments they primarily work with external actors, employed on freelance contracts. Returning to the interview

with Linda, she continued by explaining how, in her opinion, being a stylist at H&M differed from other forms of fashion styling:

> I have no experience of working for other large corporations, as I was a freelance stylist before joining H&M. But, I do know that at Zara they only take seven photos per day, while we do thirty-five. In other words, they have a lot more time to create interesting fashion photography and creative outfits. That way, they produce flashy fashion editorials while we work in a factory. However, H&M has a much larger consumer group. H&M wants everyone, from fashionistas to guys working at the gas station, to shop at H&M. Because of that, [at H&M] you can't be too niche in how you approach styling, you have to adapt from one day to another and from concept to concept. So what is the trendiest look at H&M is not at all as trendy as the trendiest at Zara, but that's because we have a wider assortment for a greater variety of people.

Working with a brand that has an inclusive design strategy as well as a business model centred on large-scale production affects which in-house styling practices are considered appropriate. Primarily, the desired styling is not that which is most fashionable or on trend, but that which is in line with the brand identity and particular diffusion line. It is therefore interesting to notice how Linda separates her work as an H&M-employed stylist not only from 'niche' styling but also from the commercial styling carried out at other mass fashion brands. In this context, H&M stands out as a company deliberately avoiding coming across as too fashion-forward and consequently, as part of its visual communication, is downplaying high fashion elements in its styling.

Sanna, one of Linda's colleagues, is in her late thirties and has worked as an in-house stylist at H&M for a number of years.[5] When asked to explain the underpinnings of the creative process, as it is organized at her place of work, she explains:

> I work with e-commerce at H&M. On average, we shoot thirty-five photos per day. It's challenging because we are often on a tight schedule – we work with models that are at the absolute top level, internationally speaking, and so logistically we have to think of their flight times: they don't live in Sweden and are usually only in Stockholm for this particular shoot. But, even more importantly, expensive models equal expensive overtime, and so we can never shoot more than the hours that we have already prepared for. We just don't have the money to continue shooting after the allocated time is up. H&M are very strict about not wanting to pay the overtime charge, as it is often huge when it comes to these models. So it's quite stressful in order to get everything done in time.

Even though the department Sanna is employed by is focused exclusively on e-commerce, which is a sector of image production with low symbolic value, H&M invests huge sums of money to secure international top models. Ironically, this does not always translate to the finished product, as the models are often cropped in order to focus specifically on the garments, with the effect that the face is not always visible in the final image. The in-house staff, however, do not realize a similar financial investment:

> Recently, and of course I'm only talking about the e-com aspect of the company, we replaced the art director [AD] with an in-house stylist. We've always had in-house stylists when shooting e-com, but now the stylist also has to do the tasks of the AD, which are different and actually require another kind of expertise that we don't always have. But, what I am talking about now only concerns H&M, I know that at Arket, for example, it's different. Also, at Arket they work primarily with freelance stylists, though they also have a few in-house stylists as well ... As a stylist at H&M, there are some restrictions to what I do. Sometimes, when we are very busy and don't have time to do it ourselves, already before the photo shoot, someone [external] has been hired to match the clothes together, so I actually don't put together the outfits, but this is done beforehand, often using freelance staff; people who normally work as freelance stylists for magazines who come in and create the looks. In addition, I have to make sure that we don't mix clothes from different lines. For example, when shooting Divided [diffusion line for ages 15–25], we only use Divided clothes, and so on. Before, I used to be involved in the image edit, but now we use an image editor who does the final.

When comparing the experiences of Linda and Sanna, it is clear that commercial styling within the H&M conglomerate is organized around a certain set of constraints, based on the visual identity of the brand. The work of a stylist, as defined by Ane Lynge-Jorlén, can be summarized as, '[t]he action of selecting clothes and arranging them in a particular way through the means of a style that is clearly identifiable as individual, yet flexible enough to conjure up the client's desired style. A stylist adds style to fashion imagery by arranging and rearranging clothes' (2016: 89). This both supports and diverges from how Sanna and Linda describe the process. Even though they match garments in order to create a look, they are at the same time restricted from adding too much 'style'. This is supported by Linda's further statement that, 'as long as you follow all the guidelines, hold a moderate degree of fashion capital in your styling and keep your deadlines, you can do more or less what you want'. The creative process at H&M is thus similar to how styling is executed in other fields in fashion, but there are also notable differences, as a consequence of the specific position that

H&M wants to maintain in the market. A production market, as classified by Aspers, is a social phenomenon, and the value of its goods is decided by a complex set of interactions, organized along the lines of consumers and producers (Aspers 2001a: 49–50). In the case of H&M, the company operates in a market defined by the large-scale production, low cost and low symbolic value of the product. This impacts all interactions that take place, not only between consumer and producer but also between the various actors engaged in the creative process of producing this particular form of fashion. In this context, stylists are not the only creative agents who experience limitations to their 'aesthetic freedom' when working commercially in mass fashion. As illustrated by Aspers, this is also the case for photographers (as well as for other actors, such as designers, art directors, makeup artists and others that are part of the same creative processes) (Aspers 2001b: 4).

H&M is a conglomerate that has grown rapidly in just a few decades (Pettersson 2001). The strategy of working with top international models is not new, but was initiated in the 1990s when the company began working closely with famous models such as 'The Big Six': Elle Macpherson, Cindy Crawford, Naomi Campbell, Claudia Schiffer, Christy Turlington and Linda Evangelista. This strategy has worked well in terms of adding 'fashion capital' (Entwistle and Rocamora 2006; Lynge-Jorlén 2017; Rocamora 2002) to the mass fashion brand, and in 2004, the first designer collaboration, with Karl Lagerfeld, was presented. Using famous models targets the 'average' consumer, who presumably will recognize that H&M is working with the same faces that are seen in ads from luxury brands, and thus the symbolic value of these other brands will be transferred to the mass fashion products. But, as evident in the statements made by Linda, this fashion capital needs to be negotiated in order for H&M to not appear to be *too* fashionable, which is why the styling is regulated to make the brand appear accessible to potential consumers.

Combining 'creativity' and 'work'

At H&M, 76 percent of employees are female, while 72 percent of people in management positions are women.[6] Further on during the interview, Sanna touched upon an interesting fact that is not strictly related to the styling practices at H&M but to the company culture in general. She claimed that H&M has developed a particular kind of work environment, which specifically has affected the experience of being a working parent:

At my department, it's mainly women who work. This is true of most departments at H&M, I think. I don't know exactly why this is, but it's a family friendly company, it's easy to work here when you have kids, and I know that a lot of my colleagues appreciate that, they want a certain, family-based lifestyle and that's easy to have when working here.

Being a stylist at H&M is thus not merely about engaging in creative work, but about the potential of achieving a particular work/life balance, made possible by how the company views not only the employee's work but also their desire to have time off with their families. In order to understand the context of working as a stylist in the Swedish mass fashion industry, Bea's point mentioned earlier – that both freelance missions and budgets are decreasing – is relevant, but it is also important to consider how life is organized in a wider perspective. Working as a stylist at H&M is thus not only about creative expression but also about job security and having the possibility of having time off to spend with one's family. This challenges the claim made by Bridget Conor that women working in cultural and creative industries were less likely than their male counterparts to have children (Conor et al., 2015). The experiences of Sanna are contrary to this statement, and instead working creatively at H&M – a company defined as being part of the cultural and creative – seems to be organized around the (female) worker's family life.

In the larger Swedish public debate on work, a quote by former social-democratic minister of finance Ernst Wigforss is repeatedly used by journalists and politicians: 'If the aim of societal development were that we should all be working to the maximal extent, we would all be insane. The aim is instead to liberate man, so that we can be as creative as we can be. Dance. Paint. Sing. Whatever you want. Freedom.'[7] Wigforss was a part of government during two periods, 1925–1926 and 1936–1949. The first half of the twentieth century in Sweden was marked by increasing industrialization, where many chores were mechanized, making the human worker superfluous. Basing his ideas in this industrial development, Wigforss hoped that workers in the future would work even less (while machines took over the tasks), so that people could devote their time to creative expressions, or whatever else they wanted to do with their time.[8]

It is clear from the quote above that Wigforss treated work and creativity as two opposing concepts. To him, work was associated with making money, while free time was reserved for creativity. On this perspective, it makes sense to want to limit the hours one spends working, in order to further liberate the wage-dependent person.[9] Wigforss can thus be considered as representing a Marxist

understanding of labour organization, where creativity is more or less detached from the definition of work.[10] It is difficult to fit creativity in fashion into this rather limited understanding of 'work'.

Regarding the development of work in a historical perspective, the relationship between work and free time, or more specifically between production and consumption, becomes even more complicated. According to Peter Englund, workers in early modern times preferred, even when offered a significant increase in wages, to work less instead of spending more, which was a problem for employers during the early stages of capitalism (Englund 1991: 169). Englund associated this new financial system with the development of a new set of emotions: discontent, uneasiness and desire. This 'modern sense of discontent' was, according to Englund, based in a desire that can never be fulfilled (1991: 191; my translation). As modern consumers, we desire goods we can't afford and long to go to places we can't easily reach, in order to compensate for the underwhelming experience of working full-time. Englund states that the reason for this is that workers at one point stopped wanting to work less, and instead began to organize for the opposite, the right to work full time, allowing them to consume more goods, as an internalization of the capitalist system.

For Sanna and the unnamed co-workers she is referring to, work appears to be something that primarily functions as a financial support for family life. This suggests that the creative fulfilment of working in fashion, or more particularly, being a stylist, was not deemed as important as having a full-time job with a regular, monthly salary. In this way, Sanna's description of creative work at H&M is a specific Swedish case that undermines not only the image of childless female workers (painted by Conor et al.), but also the image offered by Hesmondhalgh of an industry focused on 'symbol creators'. Instead, it demonstrates an approach to creative work based not on the tasks carried out while being on the job but on what happens outside of work, as an effect of having an income. Drawing from Harrison White's work, Aspers claims that markets in fashion can be divided into primarily two categories, one consisting of high-quality producers and the other low-quality producers. Aspers states that, 'the producers see themselves, the competitors and the results of their decisions, in the mirror of the market' (2001a: 37). Applied to the empirical material presented in this chapter, based in the fact the stylists working at H&M are part of the low-quality market, the low symbolic and economic value of the H&M garments influences how they assess their own position in the wider field of fashion. This would explain why they focus more on work stability and time for family life than on portraying themselves as strong and innovative creative forces in fashion. Angela McRobbie has argued that the

'aura of creativity' that certain jobs have make them appear more interesting and appealing than others (2016: 150). This argument is in line with research carried out by Ulrich Beck (1992), who also pointed to the fact that, generally speaking, regular and full-time positions are increasingly being replaced by uncertain, project-based employment and freelance jobs. But McRobbie's view is not only questioned by Sanna's description of her job, but also by freelance stylist Karl during an interview:

> Before, I enjoyed traveling but I don't anymore, now I prefer just being in a studio ... I'm content with that. Travels are demanding and you have to be social basically around the clock, it's like they own your time. Travel also used to be quite wild, a lot of wine and such, but today it's more business. But this is a general development that I have seen throughout the industry, before it was more informal whereas now there is a line between the personal and the professional.

Karl had been working as a stylist for several decades, freelancing not only for H&M but also for high-end fashion brands such as Hermès, Jil Sander and McQueen as well as styling editorials for 'cool' magazines including *10 Men*, *Dazed and Confused* and *Another Man*. This combination of work in different fashion fields – luxury, niche and mass fashion, producing both editorials and commercial content – is, Rocamora explains, not uncommon. Rather, it is customary practice for 'players in the field of fashion ... [to] move between fields' (Rocamora 2002: 348). For Karl, working as a freelance stylist – producing both high-paced, commercial H&M images as well as niche fashion editorials – was something that he used to enjoy and that he used to find rewarding in itself, but today he is happy with considering himself a small part of larger machinery, a more or less anonymous worker who instead has clear lines between when he is at work and when he is off duty. To understand the experiences of working as a stylist, it is therefore important not just to consider the actual tasks involved or the mechanisms of the fashion system, but also the relationship between work and free time.

Image creation and changing beauty standards

In 2018, H&M introduced new guidelines for image production, severely limiting the possibility of adjusting the images during the postproduction process. Speaking with H&M in-house stylist Karin, she told me of a recent incident:

I had an interesting experience a few days ago. We were shooting a bra, and the arms just didn't look good, the bra didn't fit as it should and the woman was also larger than usual, we were shooting a plus size line. She was so big she had lines in her arms that were vertical. I spoke with the photographer about this and we just didn't know what to do, how to solve it. Before, we could have fixed this in postproduction but that's not allowed anymore. So we talked, and after a while we came to the realization that there was nothing wrong with her arms, it was our perception that had to change. We had to reconsider what we thought was beautiful. So in the end, we left it as it was.

What Karin is describing is the kind of challenge that Entwistle has outlined as a fundamental part of being an actor within an aesthetic economy. More specifically, Karin's statement outlines how styling is often about more than just creating a style that is considered fashionable at a certain place and point in time. Working as a stylist, regardless of the segment of fashion, entails being informed on current events and cultural debates, not least concerning representation, agency and gender, subjects at the core of many public discussions on fashion and which consequently will play a large part in how a campaign is received. The creative process thus includes more than merely being present in the studio combining garments and making the model dress a certain way – it also encompasses media habits and staying updated on current affairs. It was necessary for Karin and the photographer to have a certain cultural awareness of the debates on beauty ideals and the normative function of advertising in order to interpret the guidelines and to merge the aim of the photo – to sell the bra – with new perceptions of what is acceptable in terms of retouching and other forms of postproduction. Entwistle states (2002: 338):

> The aesthetic sensibilities and cultural capital, as well as the social, cultural and institutional connections which sustain aesthetic commodities, are critical to the commercial transaction of such commodities, generated internally within the field of cultural production itself. Economic calculations in aesthetic economies are always, by definition, cultural ones.

Karin was well aware of the commercial intent behind the photo, something that was apparent in how she reflected on the actual making of an image as a process with the primary purpose of aiding the consumer to make a buying choice. This underlines the specificity of the image genre she is part of producing. As stipulated by Aspers, fashion photography is marked by 'two basic dimensions: the economic and the aesthetic' (2001b: 5). Thus, according to Aspers, the freedom to experiment aesthetically is generally more restricted in commercial

contexts, where larger sums of money are at stake. In addition, when photographing underwear, there is little matching of garments, which makes the presence of a stylist bordering on the superfluous, even though of course there are still considerations as regards how the garment fits the body, which is also part of the responsibilities of the stylist. But, by viewing Karin's experiences in the light of Entwistle's definition of work in aesthetic economies, the creative process of commercial styling is affected by on-going discussions in contemporary media on ideals, beauty and gender. Due to shifts in the mindset of the general public, at H&M it is no longer culturally legitimate to continue adjusting aspects of the images in postproduction. Images are now considered more fashionable and 'aware' when appearing less edited and more 'authentic', which not only affects the visual aspects of fashion but also creates new ways of doing fashion behind the scenes which changes the job of styling and photography. Writing on the subject of aesthetic labour, Gernot Böhme has stated that it 'designates the totality of those activities which aim to give an appearance to things and people, cities and landscapes, to endow them with an aura, to lend them an atmosphere, or to generate an atmosphere in ensembles' (2003: 72). To edit less would thus not be considered an act of making images more authentic or genuine, but of changing the aesthetics of the 'aura' in order to better fit with changes in consumers' expectations and ideas of what is fashionable at a particular moment in time. In this way, this case study shows that even though H&M is part of the mass fashion segment and operates with rather innocuous aesthetics, it is still part of the aesthetic economy and thus requires all participants in its business to be aware of wider societal and cultural changes in ideas, trends and aesthetic expressions in the same way as in other parts of the aesthetic economy.

Conclusion

Both Hesmondhalgh and McRobbie have claimed that there is a certain seductive quality to the idea of working in fashion, and that this is what attracts people to work in the cultural and creative industries. As McRobbie (2011: 32) states,

> For a start, the emphasis on 'pleasure in work', the idea of finding yourself in creative practice, is very seductive indeed. It appeals to all of our own narcissistic and private desires, that somehow under the right conditions we will plug into a core of talent that will relieve us of the burden of wage labour, a tedious job or unrewarding work.

Styling – the act of combining clothes in order to create a certain look – is very much one of these creative practices. But, as demonstrated through interviews with stylists who work within Swedish mass fashion, the creative aspect of the work – defined by Linda in the introductory quote as having the possibility to intuitively interpret the guidelines set up by other departments – often appears to be of less importance than financial stability, continuity and the amount of free time that working as an in-house stylist provides. In order to unpack these narratives, speaking particularly on the driving forces behind and the organization of labour within commercial styling in mass fashion, it is important to examine the social context of this work. Relying on the theoretical underpinnings of Bourdieu's research on high culture and high fashion, Rocamora has applied his concepts to the field of contemporary fashion, subsequently stating that the field of cultural production is divided into two subfields: large-scale production and restricted production (2002: 344–345). This terminology should be understood in tandem with Aspers' previously outlined thoughts on low-quality producers vs. high-quality producers. H&M, with its wide appeal, low degree of fashion capital and wish to be perceived as accessible to a wide range of consumers, is situated in the context of the former, as part of both the subfield of large-scale production and the market of low-quality producers. This explains why the actors active in this context do not express the same kind of narratives – focused on viewing creativity as a means of self-expression – that, according to McRobbie and Hesmondhalgh, is often found in the other subfield – restricted production and high-quality production – of the fashion system.

At a company that is as female-dominated as H&M, family life has affected the organization of labour, which makes it an attractive workplace for people who want to be in a creative environment but who don't want to compromise regarding the time they spend together with their families. To understand creative work in this sector of Swedish fashion, one therefore has to look beyond the oft-repeated myths of creative work as self-fulfilling and a way to express oneself creatively. In the context of working as a stylist in the 'H&M factory', creativity is defined more in terms of being able to properly interpret guidelines from other departments while maintaining intense deadlines and a fast pace of production. Based on the empirical material gathered from stylists working in mass fashion, the historical and ideological underpinnings of the Swedish labour market are clearly relevant to how the informants perceive the value of working, not primarily as a way to reinforce one's image as part of the fashion industry or even the larger field of cultural and creative industries, but as a way to secure paid holidays, paid parental leave as well as free time away from work. This

reinforces yet again Rocamora's Bourdieuian analysis that fashion is not a single industry but is instead constituted of two different subfields. Yet, as demonstrated through the examples of Bea and Karl, it is important to bear in mind that these categories are amorphous and slippery, and that there is continuous and ongoing interaction in-between them, not just symbolically and financially, but also on an individual level. Thus, the commercial styling practices highlighted here may have many things in common with styling in other parts of the fashion system, but from an organizational point of view, there are important ideological distinctions and differences in market values to consider.

Notes

1 The names of all informants have been changed. The interviews were carried out in Swedish and translated by me into English.

2 The project is funded by Helsingborgs handelsförening and carried out as part of the research programme at the Department of Fashion Studies at Lund University.

3 For further reading on the role of Scandinavian countries in the Western fashion system (particularly in regards to fashion magazines), see Ane Lynge-Jorlén (2017), *Niche Fashion Magazines*, 7–10.

4 Ellos is a Swedish mail-order catalogue, operating in the same low-quality, low-cost market as H&M.

5 The term 'in-house' refers to the fact that she is not an external worker but is employed by H&M.

6 These numbers were given to me by their marketing department via e-mail on 6 November 2016.

7 See, for example, Fredrik Virtanen's 2013 editoral in *Aftonbladet*, 'Vi jobbar skiten ur oss eller får inte jobba alls'; Hampus Andersson's 2015 article in *Dagens Arena*, 'Vi måste våga tala om arbetstid, S'; and Feministiskt initiativ Gotland's 2015 blog post, 'Årets tillväxtkommun? Nej tack'.

8 In the late 1950s, Hannah Arendt summarized the research field on the division of work and free time: 'The same trend to level down all serious activities to the status of making a living is manifest in present-day labor theories, which almost unanimously define labor as the opposite of play. As a result, all serious activities, irrespective of their fruits, are called labor, and every activity which is not necessary either for the life of the individual or for the life process of society is subsumed under playfulness' (Arendt [1958] 1998: 127). Thus, it is evident that Wigforss' idea of the division of work and free time is not unique but part of a larger context.

9 This view on work dates back to Aristotle, who believed that free citizens also should be free from labour, so that time could be spent pondering philosophical matters.

Slavery existed thus to liberate the citizen from labour (further discussed in Arendt [1958] 1998). The division of work and free time therefore often masks a class contempt, expressed in the devaluation of physical labour and a high appraisal of intellectual tasks. See Aristotle (1944), *Politics*, 15–31.

10 Under the rubric 'The Working Day', Karl Marx developed his view on the relationship between time, work and capitalism (Marx 2015: 162–218).

References

Andersson, Hampus (2015), 'Vi måste våga tala om arbetstid, S', *Dagens Arena*, 7 September.

Arendt, Hannah ([1958] 1998), *The Human Condition*, Chicago, IL: University of Chicago Press.

Aristotle (1944), *Politics*, Cambridge, MA: Harvard University Press.

Aspers, Patrik (2001a), *Markets in Fashion: A Phenomenological Approach*. Stockholm: City University Press.

Aspers, Patrik (2001b), 'A Market in Vogue: Fashion Photography in Sweden', *European Societies*, 3 (1): 1–22.

Beck, Ulrich (1992), *Risk Society: Towards a New Modernity*. London: Sage.

Böhme, Gernot (2003), 'Contribution to the Critique of the Aesthetic Economy'. *Thesis Eleven*, 73 (1): 71–82.

Conor, Bridget, Rosalind Gill, and Stephanie Taylor (2015), 'Gender and Creative Labour', *The Sociological Review*, 63 (1): 1–22.

Englund, Peter (1991), *Förflutenhetens landskap: historiska essäer*, Stockholm: Atlantis.

Entwistle, Joanne (2002), 'The Aesthetic Economy: The Production of Value in the Field of Fashion Modeling', *Journal of Consumer Culture* 2 (3): 317–339.

Entwistle, Joanne (2009), *The Aesthetic Economy of Fashion: Markets and Value in Clothing and Modelling*, Oxford: Berg.

Entwistle, Joanne and Agnès Rocamora (2006), 'The Fields of Fashion Materialized: A Study of London Fashion Week', *Sociology*, 40 (4): 735–751.

Florida, Richard (2002), *The Rise of the Creative Class, and How it's Transforming Work, Leisure, Community, and Everyday Life*, New York: Basic Books.

Gråbacke, Carina (2015), *Kläder, shopping och flärd: modebranschen i Stockholm 1945–2010*, Stockholm: Stockholmania.

Hesmondhalgh, David ([2002] 2013), *The Cultural Industries*, London: Sage.

Lynge-Jorlén, A. (2016), 'Editorial Styling: Between Creative Solutions and Economic Restrictions', *Fashion Practice: The Journal of Design, Creative Process and the Fashion Industry*, special issue on Fashion Thinking, 8 (1): 85–97.

Lynge-Jorlén, Ane (2017), *Niche Fashion Magazines: Changing the Shape of Fashion*. London: I.B. Tauris.

Marx, Karl (2015), *The Capital: A Critique of Political Economy*, vol. I. Moskva: Progress Publishers.

McRobbie, Angela (2011), 'Re-Thinking Creative Economy as Radical Social Enterprise', *Variant*, 41: 32–33.

McRobbie, Angela (2016), *Be Creative: Making a Living in the New Culture Industries*, Cambridge: Polity Press.

Pettersson, Bo (2001), *Handelsmännen: så skapade Erling och Stefan Persson sitt modeimperium*, Stockholm: Ekerlids förlag.

Rocamora, Agnès (2002), 'Fields of Fashion: Critical Insights Into Bourdieu's Sociology of Culture', *Sociology*, 2 (3): 341–362.

Ross, Andrew (2008), 'The New Geography of Work: Power to the Precarious?', *Theory, Culture and Society*, 25 (7/8): 31–49.

Sundberg, Göran (2006), *Mode Svea: en genomlysning av området svensk modedesign*, Stockholm: Rådet för arkitektur, form och design.

Virtanen, Fredrik (2013), 'Vi jobbar skiten ur oss eller får inte jobba alls', *Aftonbladet*, 23 February.

Online sources

https://www.teko.se/wp-content/uploads/modebranschen-i-sverige-2016.pdf [accessed 5 December 2018].

http://figotland.se/blog/arets-tillvaxtkommun-nej-tack/ [accessed 5 December 2018].

Twisting References: An Interview with Lotta Volkova

Susanne Madsen

There is a hedonistic spirit at play within Lotta Volkova's work but not at the expense of images with a deeper meaning. Her visual language has become highly influential and freely embraces codes from a multitude of aesthetics, weaving them together into a postmodern amalgam loaded with commentary and also humour. Shooting for titles such as *System*, *Re-Edition*, *Dazed* and *Vogue Italia*, Volkova's trajectory to styling was via design. At the age of seventeen she left her native Russia to study at Central Saint Martins in London, where she was part of a new wave of club kids coming through the city's creative ranks. A move to Paris in 2007 introduced her to styling and her major breakthrough came as an integral member of Demna Gvasalia's Vetements and Balenciaga collectives (see plate 1), along with her work with Gosha Rubchinskiy. Volkova's work transgresses conventional beliefs about East and West, internalizing Russian and Western culture as well as global cultural references with a sense of ease and vast historical awareness. Similarly, traditional ideas of elegance are challenged and magnified to encompass new values. Volkova currently resides in Paris.

Susanne Madsen: As I was going through all your work and previous profile pieces, one thing that kept popping up was stories about how you've become a benchmark for what's cool. What does it feel like to be referred to as this arbiter on fashion for your generation?

Lotta Volkova: I have always been interested in underground culture, the dark side of the human brain, exploring what can lie beneath the surface. I'm intrigued by subjects not generally spoken of. My work is pretty much talking about that and it's not necessarily trying to break the rules. Certain types of people inspire me and that just naturally floats into my work through collaborations.

SM: You've also been linked a lot to this idea of good taste versus bad taste.

LV: To be honest, I am pretty sick of being described that way. I've never been interested in good taste and I've never been interested in bad taste. I even find it's kind of very arrogant for someone to say that, for example, the love Russians have for sportswear or wearing their trousers pretty high waisted is bad taste. Just because they're not used to seeing this, just because they're not aware that in other places people might think differently, look differently or wear different kinds of clothes, they automatically pinpoint that into something that is bad taste. I think that's also why it's important to talk about all sorts of different movements and subcultures and types of people wearing clothes for different reasons or, to put it in really simple words, people who have a different lifestyle, but in reality I think that's what's been crowned as bad taste in the Western world. Personally, I don't find anything bad about that taste and to me it has never been an intention to blur the boundaries and play with the two or make bad taste deliberately good taste. I don't see that at all in that way and I find it quite arrogant of one to even establish, 'oh, this is good taste'. It's a very privileged position. This differentiation doesn't exist in my world at all. I find beauty in all of it.

SM: It's a very good point that fashion has been governed by a highly Eurocentric idea of good taste.

LV: It's something that you're used to and that you've established all the codes for which good taste relies on. Good taste relies on tradition, on the bourgeois, on money. I think in some cultures that's also bad taste! (*laughs*)

SM: How do you feel about the term post-Soviet when people apply it to your work?

LV: I am not a big fan of tags and boxes. But the reality is that when people work together and build a scene it's much easier to react towards, as an audience. It's easier to take it seriously. Suddenly people feel more convinced. I feel 'post-Soviet' is something that felt new and relevant for a moment, a nostalgia for a time of our childhood that was very naive.

SM: Correct me if I'm wrong but I also sometimes see quite a few references to American culture in your work.

LV: I really love travelling through the States. I grew up watching American movies. Whether it's New York, New Orleans or LA, I'm just fascinated with how

different every state and city is, how wild the nature is, how different people can be. You can walk down the street and it just feels like you *are* in some kind of movie. It also reminds me quite a bit of Russia. It's a very big country with its ups and downs. In general, I just love travelling and experiencing something new. I've been shooting in Korea, in China and in Japan and I get really obsessed with places and immediately want to go back and do a project there and go deeper into it and document all these crazy things we come across.

SM: Tell me about the SS19 Prada special you shot with Johnny Dufort with the nude people sitting around with the models in clothes (see plate 6).

LV: It was based on this 1975 movie called 'The Black Moon' by Louis Malle. It is a very trippy movie, quite abstract, talking about the end of the world where a gender war is happening. This girl tries to escape the world and whilst running through the woods she encounters a talking unicorn that takes her to a mansion where weird things start to happen. It's a very seventies movie and politically quite dark and very beautiful at the same time. There's a scene where the family that lives in the mansion are cooking dinner for a whole group of children and the children are running around naked. It's basically this kind of oasis sheltered from what is going on outside. The nudists were actually from the British nudist colony and were very excited to participate in the project, all very jolly. It was all very funny and very sweet. Interestingly, I feel like they had an almost exhibitionist nature. I think it's very funny in these times when we are so sensitive towards nudity. It was great to involve people who not only get a kick out of it but it's also their lifestyle and through this show this type of subculture

SM: Yes, it's a subculture I for one know very little about.

LV: Me too. And I also find it quite interesting when nudism sort of blurs its boundaries with exhibitionism. Who is the true nudist and who is there for other reasons?

SM: It's funny you say exhibitionism because when I look at this image they hold themselves in a way where they seem as if they're wearing the best outfit ever. Very confident, as if they're the ones wearing the Prada outfits. It's funny because we're in an industry that's about selling clothes . . .

LV: Yeah, absolutely. And this picture, Johnny asked them to do musical chairs so he played Nina Hagen's 'New York New York' and that image was taken kind of in the middle of that. Which was quite entertaining.

SM: Knowing that only adds to the beautiful absurdity of the image. That must have been a great shoot to be on.

LV: Yes, you've got to have fun. And it's fun when everyone is enjoying it. It's fun when an original reference or an original idea starts to have a life of its own through the collaboration with the team and all these different people. I think that's when it becomes interesting and gains another message, another context, another strength.

SM: The *Re-Edition* cover with the vagina head is another example of fun with a message (see plate 5).

LV: Yes, that was a limited edition cover we sold at a launch at Idea Books in Dover Street Market during the Frieze Art Fair in London. They only printed about 150 of those and yeah, that cover was amazing! What's so funny about that is it went to quite an extreme. It wasn't just a vagina head. It had eleven more vaginas on the DIY top. That's what's kind of interesting to me, to take it to a point where it doesn't even make sense anymore. It becomes more abstract and yet it's pretty hardcore in its message.

SM: Yes, whilst also being witty and extremely clever. Speaking of, I read that you were into watching Eurotrash when you were growing up?

LV: Yes, we didn't really get it on TV regularly, it was more a pirate channel thing shown past midnight because of its content I guess. I remember being in my very early teens thinking, 'Wow, who are all these crazy people who are so different and have these crazy lives, sitting naked in trees and talking to each other?' Gaultier was interviewing someone and they were both naked, sitting up there in the trees and I was like, 'I want to know who these people are'. Here I am, shooting nudists in Kent and Prada! So I guess it all came full circle.

SM: When you made the move from designing to styling, what was your first ever shoot like?

LV: When I moved to Paris I realized it was really hard to make clothes. Back in London it was a very small business, very DIY and self-sponsored, with all of my friends helping out. In Paris it became really complicated. It was difficult to find factories that would produce your small numbers, freelance seamstresses to make your prototypes, without you being a big house. I was hanging around and I met Ellen von Unwerth at a nightclub and she liked the way I looked and suggested we do a test together with me as the stylist. So we did this test shoot

together and it was really fun. One of the things I remember is how it felt so easy, compared to designing and making a collection, which is such a long-term process from your starting point idea to seeing that come into reality with a piece of clothing and then finally photographing it and turning it into a look book or campaign. It's a six-month process that involves so many people and so much money. And I was like, 'Wow, here you can actually produce that final image so easily. You just find some clothes and put it on a person and somehow you can direct an image'. That was what I was always interested in even when I tried to make clothes for such a short moment in time. I always wanted to make this final image rather than I felt the joy of making clothes. I just wanted to see that picture with the right model cast by me in the right situation. So for me it was quite refreshing and a revolution, like, 'Wow, this job can be kind of cool'.

SM: And how great that your first shoot was with Ellen von Unwerth. That's such a baptism of fire.

LV: I love Ellen! Yes, I know, it's funny. We did another shoot together straight after that for Sang Bleu and it kind of went from there. I brought the images to a friend of a friend of mine who had an agency called Artlist. I didn't really have any real work or real clients or anything, not even a real book, I just showed him a bunch of loose photographs and he liked them and I think perhaps more liked my personality and how I looked and so he was like, 'okay, let's work together' and so I started to work with them. But it took a very, very long time in Paris to really establish myself and for people to actually care or listen to somebody new and somebody who didn't come from France. Moving to Paris was a very different experience for me than moving to London, where people are so open and so friendly and they're all about discovering something new. As soon as you make new friends, you decide to do a project together. I find London a very creative environment. That is something I did not have at all in Paris and it was something I had to struggle and work through, it was almost a corporate way of working within styling. You'd have an idea but then it would be hard to realize because not many people would be that adventurous or would actually share the same references or creative world. I clearly remember everything started to change when I met Gosha [Rubchinskiy] and then Demna [Gvasalia]. To me it was a natural progression in a way but what really made the difference was that this was the first time in my experience where designers would be like, 'oh yeah, let's do this, let's go for this, this sounds like a fun idea, we should just do this'. That spirit of not being afraid and a sense of unity within the group that shared all these references, I feel that's why it worked and that's why people reacted to it

the way they did and that's why both Vetements and Gosha created that buzz and energy back when they did.

SM: Did you ever assist?

LV: I never really assisted stylists. I never really fit into any system. I was more sort of like a club kid in London. I met so many amazing people in clubs like NagNagNag, Trash, Kashpoint, Cock. At that point there was a whole revival of the eighties with electroclash and I was really into New Wave and post punk and New Romantics and when I came to London I basically met people like Princess Julia, Steve Strange, Matthew Glamorre – the original club kids who were there in the first place in the eighties. It was so inspiring and so fun and they kind of taught me the codes of nightclubbing and even styling. For example, to never wear out the same outfit (*laughs*) twice. You would basically be forced to create a new 'look' every time you went out and at that point we literally went out every night of the week.

SM: I think punk is really important in terms of your work. And punk in the true sense of the word, where it isn't to do with leather and safety pins.

LV: I find it more interesting when things are not what they seem. When you see a character and suddenly you notice something is a bit off about them and it makes you look twice and wonder, 'What is that person about actually? Is she a happy housewife or is she a black metal cross dresser?' (*laughs*) Everyone can have different roles in their lives, and that's why I find it interesting to explore and subvert those characters.

SM: When you say black metal, when I first saw your image from *System* it registered in my brain as heavy metal face makeup (see plate 3). And then you look again and it's a religious painting.

LV: There are so many magazines, photographers and stylists in our industry. So many stylists have to use the same collections. So what is it that makes you go back a page and look at the image again? It's really important to grab somebody's attention and whether this person is surprised or shocked or fascinated, I think it's interesting to get that strong reaction. I don't care if someone loves it or hates it. I love the whole, 'hold on a second, is it what I thought it was?' That particular image was for a special on Italian designers for *System* magazine, which was accompanied by an article by Angelo Flaccavento on Italian fashion. We even shot archive collections of designers like Walter Albini and Romeo Gigli. I personally really love Italy and Milan.

SM: Liking Milan is a rarity in this industry.

LV: I find Milan extremely beautiful, dark and very romantic. I really love its brutalist architecture, the hidden palazzos, secretly opulent courtyards. A friend of mine, Karl Kolbitz, did an amazing book on the entryways of Milan. I called Karl up and asked him to help us with locations because I thought it was a chance to make an amazing story, not just about Italian designers but also about Italian culture and Milan itself. We went on from there. What else is iconic about Italian culture? We thought of Raphael's paintings and that's how that image came up. An angelic Raphael painting resembling murals in the cathedrals, twisting that and putting that on the faces. It's about exploring that world that you're trying to create. And I enjoy creating a world, which blurs the borderlines and abstracts meanings between the traditional and new, masculine and feminine, etc.

SM: Your story from *Vogue Italia* with Johnny Dufort shot in front of the church is another one I'd love to hear the background to (see plate 2).

LV: That was shot in Russia in this tiny little village called Chikinskaya, which is a ten-hour drive from Arkhangelsk north of St. Petersburg. The wooden church, Tserkov' Bogoyavleniya Gospodnya, dates back to 1853. It's located in a tiny village with just a few houses. It's this wooden structure that is now falling apart and I find it extremely beautiful. I randomly found an original image of that church on Instagram and just thought it was so dark, so beautiful and really cool. I was speaking to Johnny about a forthcoming shoot and he suggested we go shoot there. He probably said it as a joke but that was that. We flew to Moscow, then to Arkhangelsk, then a ten-hour drive. It was a crazy mission and challenge even to get to that church. Everything went crazy wrong around that shoot. We missed our flight, the other flight was delayed, the suitcases didn't arrive, we had to sleep on the airport floor. We had to cross two rivers by car to get to the village. The day we were shooting the only way to bring the wardrobe was to put this one little rail on this wooden boat with three guys pushing the boat. It was very much a 'Mission Impossible' situation! It's such a beautiful, rural place and neighbourhood. I never realized before how beautiful the north of Russia really is. People who live there really look after their villages and they're very proud of their heritage and the history of the area.

SM: I like how you have these two incredible elements in the picture of the church and the model. And yet they somehow have your equal attention.

LV: It all came from intuition, even with the choice of the model. I wanted to shoot this girl Günce, she is Turkish but it turned out that she was studying

Russian language. It was almost a little sign. The story is kind of about a quest for belief and exploring the idea of belief and religion and celebrating this church. It was interesting to play with different references. Of course, we have the orthodox church and then the almost Buddhist makeup and opulent clothes, which were fashion but could almost look quite relevant in a religious context. So it's about adding and mixing all these references and you can kind of make your own story in your mind.

SM: **It has the kind of richness and cultural references that are also in the Sovietsky Hotel image you did with Harley Weir for the SS15 issue of *Re-Edition* (see plate 4).**

LV: This shoot was one of my first shoots in Russia and that image was for the first ever issue of *Re-Edition* and maybe my third shoot with Harley. I was looking for a variety of items that could fit into the traditional Russian environment and, being a big fan of Bless I came across this Bless archive jumper with a carpet insertion. Carpets have always been a big part of every Russian household and could be found not only placed on the floor but also on the walls and sometimes even the ceilings. So I thought it was interesting to bring that Bless jumper back to where the inspiration could have come from. At least that's how I interpreted it. I think it's sometimes interesting when things are obvious. They're obvious for a reason, and to bring them back to where they come from, I find that quite fun.

SM: **It might not be obvious to some people, though? But you're showing the root of it.**

LV: Yeah, maybe it's just obvious for me! (*laughs*)

16

Creating Orderly Chaos:
An Interview with Naomi Itkes

Maria Ben Saad

Stockholm-based Naomi Itkes' professional career started at the turn of the millennium when, aged just twenty-one, she began working for Swedish *Bon Magazine*. From 2005 to 2008 she ran *Litkes*, a magazine that combined fashion and literature, simultaneously building her career as a stylist. Profiled as being conceptual and intellectual in her approach, today she is well established on the Swedish fashion scene (she was voted Stylist of the Year at Sweden's *ELLE* Awards in 2014) with assignments from household brands such as Rodebjer, Ann-Sofie Back, Filippa K, Stand and Hope, as well as collaborations with artists like Robyn, Neneh Cherry and Lykke Li. For several years she has also done editorial work for a number of influential magazines outside of Sweden including recurring assignments from *Purple Fashion* and *Buffalo Zine*. At present, her practice can be described as a combination of traditional styling assignments, creative consultancy and self-initiated projects like, for example, *Illustrations & Conversations*, a book created together with illustrator Liselotte Watkins. Her most recent project is RBN, a limited capsule collection designed by Robyn and herself for fashion and sportswear brand Björn Borg.

Maria Ben Saad: **How did you start out as a stylist? Did you have any role models to show you the way?**

Naomi Itkes: I had just started studying philosophy at university when, quite by accident, I was offered an internship as editorial assistant at *Bon Magazine* in 2000. Prior to that I was largely unaware of the fact that there were people called stylists. I was drawn to styling through a fashion story that designer Marina Kereklidou did for *Bon* featuring various women wearing burkas. To me this was so liberating. That a stylist could embrace the world in this manner. That fashion could be like this. And I have always had an obsession with clothes. Even when I

was ten years old I knew exactly what I wanted to wear. When I was somewhat older I became a 'kicker' [a member of Swedish subculture 'kickers', reminiscent of casuals or chavs, *Editor's note*], influenced by the social networks where I grew up: in Bergshamra, which is part of suburban Solna to the north of Stockholm. I played basketball and wore bomber jackets, Buffalos and Carhartt denim. But there were influences from elsewhere that I adopted and interpreted in my own particular way. My parents are Polish Jews who fled to Sweden in 1968, and I have always been surrounded by people with roots in other countries. In my social context we never felt particularly Swedish or, rather, we were Swedish in our own way. This experience of diversity has been a major influence in my life.

MBS: In *Litkes*, which was subtitled 'The literary fashion magazine', you wanted to combine fashion and literature. How did literature make its way into your life and, from your perspective, how does literature connect with fashion?

NI: Books have always been important to me. During my youth, I read authors like Charles Bukowski, Sture Dahlström and Kathy Acker. Everything that mirrored my state of mind and made my world bigger. But I could also choose authors who examined their interiors, like Virginia Woolf. Or, when I was little, fantasy books like *The Legend of the Ice People* by Margit Sandemo. Just as I have identified myself with certain brands, I have also done so with literature. Books nourish my imagination, and many of my visual images I find in what I happen to be reading at the moment. Not that they transfer directly to my styling, but they can affect the general mood or atmosphere. Fashion magazines don't play the same role. *Purple* was one of the few magazines that I was reading when I started out. At the end of the 1990s, *Purple* came in different editions [*Purple Prose*, *Purple Fiction*, *Purple Sexe* and *Purple Fashion*, *Editor's note*], so when buying the magazine, you got access to a whole world of wittiness and aesthetic boldness. A more avant-garde perception one could say. Also the fashion was part of a larger context. Fashion can be rich in imagination and this can be liberating, but I identified myself more with *Purple*'s conceptual and realistic approach to fashion. I have always needed to embrace things theoretically in order to be able to breathe, to establish a context and to understand. And *Purple* was good for that, and its fashion images were closer to my own state of mind. When I was creating *Litkes* with my pals, it was all about our perspective on the world.

MBS: What made you devote yourself wholeheartedly to styling?

NI: I think that this happened when I got to know stylist Robert Rydberg about ten years ago. He made me realize what it means to be a stylist; that it is a

matter of finding a balance between creativity and commercial thinking. But it is only in more recent times that I really feel that I have grasped my profession. During my time at *Bon*, I realized that I wanted to do fashion in my own way and I tried out my ideas while doing assistant work for various stylists and, at the same time, starting up *Litkes*. When I began working with Robert, I had already started *Litkes* and he rapidly became a part of it. I see my work today as a sort of trinity: business, styling and human interaction.

MBS: What motivates you in your work?

NI: There are many ways of being a stylist today but I would suggest that it requires a certain degree of creativity or artistic skill, an ability to see. That is the basic content of the operation. I have always been motivated by the same things: my passion for style and my need to understand the world around me. It is just a question of moving on, of learning more. And one doesn't have to do exactly what everyone else is doing. One can start with whatever is going on in one's own head. It is very much a matter of having faith in one's own visions. This has always been my most important guide: to look at my surroundings and to believe in my vision. The image that one suddenly becomes conscious of. I have also rearranged my professional life quite a lot in accordance with my personal situation. I am now living in Stockholm with my child after a separation, which has changed certain practical aspects of my life. It now suits me better not to travel as much as I used to do and I have chosen to work on more extended processes. I have always worked close to designers but now I play an active role in developing collections. I take part right from the beginning and help to build up the collection. This is something that I really like and hope to do more of in the future. You own the process in a completely different way from when you just work with the public aspects of a brand.

MBS: Is this also something that has to do with the development of the entire fashion industry – that the stylist's role is expanding and becoming more diversified? How, for example, have social media and the Instagram culture affected your way of working?

NI: Digital media have led to a democratization of certain aspects of styling as a profession. Setting looks and creating a style, an identity, are accessible to far more people today. Fashion has previously been a fairly elitist type of club so the system has definitely changed. Personally, I use Instagram for research but I could be sharper on the self-promotion part of it! (*laughs*) When I enter a lengthier process I act as a curator. I go in and edit, add whatever is needed,

remove whatever is not needed. A gifted stylist is a gifted curator. And I am personally extremely grateful that I have been able to work in this way. There are opportunities in Sweden as long as one knows how to navigate the culture. You can start up *Litkes* and get it to function. You can produce a book with Liselotte Watkins. One large project that I have been working on in recent times is a capsule collection for Björn Borg in collaboration with pop star Robyn and designer Anders Haal. I think that this diversification of my operation reflects both my own needs and the way in which styling has developed in general.

MBS: You have been voted Swedish *ELLE*'s Stylist of the Year and you have assignments from seminal international magazines. What has been decisive in your reaching the position you have today? What do you think are your personal strengths as a stylist?

NI: The fact that I have not compromised my own vision. My path was quite a long one before I managed to establish myself to some degree in Sweden. There are almost certainly all sorts of views about how I have done different things, but I really don't care about them. It doesn't bother me what people think but I rely on my own judgement. What attracts me and what I see. And I also want to believe that I am good at creating ideas. And launching them. I am a sort of engine that never stops turning. But most important of all is being true to oneself, not merely adapting to one's surroundings. In Sweden we have a consensus culture. We try to agree on things, and it can be difficult to push one's own views. Particularly if you are a woman. I have talked a lot to my friend Carin Rodebjer [the Swedish designer, *Editor's note*] about this, about how to navigate the system. Women with strong views will meet greater resistance than men, this is a cultural fact, so women more often have to work twice as hard to get through the needle's eye. But to me resistance is a good thing, it makes you humbler about life. I have also dealt with considerable resistance within myself; anxiety about failing. Of not being good enough. Not being able to deliver. Not being able to support my child. It's like a stab in the back. At the same time, and this is a bit schizophrenic, I trust my gut.

MBS: You are often described as an intellectual or conceptual stylist. How do you relate to this image of yourself?

NI: Theorizing about one's ideas was not usual when I started. At least not in Sweden. I think that it worried people a bit. When we launched *Litkes*, for example, we were described as pretentious in an interview. But pretentions are important. There was a lack of somewhere to reflect critically on fashion at the time. I was

merely providing something that I felt was missing. I don't really know how I should relate to the word intellectual. What does it actually mean to be intellectual? Thinking independently and with complexity? To me this is normal. There are times when I have a feeling that people equate intellectual with being serious. To me that's a very narrow path to walk when measuring thoughts and ideas. Perhaps this is an image that other people have of me. And one has to accept that. We all try to categorize each other and we need our shared images. I think that the fact that I have not just done one thing at a time but have worked on several projects in parallel has been seen in Sweden as somewhat irritating. Besides styling I may also write for a newspaper or appear on the radio. And this probably makes it difficult to compartmentalize me. This may worry people thinking of using me for a job. But I have learnt not to feel responsible for other people's anxieties. People who have been very important to me professionally are Carin Rodebjer, Liselotte Watkins, Robyn and Carsten Höller, who is the father of my child. They have all gone their own ways. And they have not apologized for doing so. It is entirely possible to formulate or invent oneself.

MBS: You have done some of your most conceptual work for *Purple Fashion* (see plate 45). Is there a greater understanding of your approach there than in a Swedish context?

NI: Well, every market has its codes and its rules. I met Olivier Zahm in 2012 and he gave me a great deal of freedom. He turned out to be a person who appreciates theorizing and complexity. He is very knowledgeable and reflective. And I suddenly found myself feeling very secure, having previously felt rather insecure. As regards being Swedish, this is something that I am still trying to understand. When I have been working with Robyn on our collection for Björn Borg – who is something of a national symbol – we have talked a great deal about being Swedish. The Swedish culture in which we grew up has so many positive qualities – for example, unique social organizations that welcome everyone. People can go out and demonstrate on the streets with a homemade banner and that is very beautiful. There is a public morality and a feeling for justice, or for fighting injustice, that I can miss when I work in other countries. But when it comes to my own mind and how it works I feel that there are restrictions in Sweden. In the Parisian culture I don't seem to be that complicated! (*laughs*) This is just a cultural matter.

MBS: There are certain photographers who turn up very often in your portfolio, for example Anders Edström from Sweden and Casper Sejersen

from Denmark. How do you organize your collaborations? Do you both take part in creating the images?

NI: We have different roles. Both Casper and Anders are conceptual, though in different ways. We step into each other's worlds and respect each other's space. I work in a fairly concrete way with Casper (see plate 43). He often has a strong idea for a picture, a narrative, and so I relate to that. But then something always happens at a photo shoot. There are things that you can never plan ahead. With other photographers it may well be that I come with the idea myself. What I like about Casper is that he has such clarity; our ideas readily interlock. Anders is also very clear about what he wants. We let each other be. Anders has that special gift of being able to portray what is 'in-between' in the image; a presence, a state of being (see plate 46). And he is extremely skilled at captivating shapes in garments. When I look through my editorial work I can see when I matured as a stylist and this is particularly evident in the first job that Anders and I did together for *Purple* (S/S 2015) (see plate 44). It is a matter of being able to understand the complete image, a composition. Something very easily goes wrong and, basically, I am never completely satisfied with an entire series of photos, but in that particular case there is a composition that works all through. When there is something missing in the composition, the image is not really finished.

MBS: How does communication between you and the photographers function with regard to the image itself? Do you discuss it while working on the shoot? How much say do you ultimately have as stylist?

NI: A great deal takes place afterwards. Anders, for example, doesn't say much during the shoot. I never seek to interfere. This has to do with the fact that I trust the photographer implicitly. Ultimately one tends to work only with people one trusts. It's also a matter of personal chemistry. Everything is so hyper-personal. Sometimes a relationship develops bit by bit, but with some photographers it, say, clicks directly. That's how it was with Casper. He is also fairly quiet during the actual shoot so when we discuss images it is during editing. A fashion story is not just a matter of clothes or style. For a job to function there are a lot of elements that have to interact. The photographer's connection to the model is super-important. The whole team. It's a collective undertaking. If everything works, the final result can be really good. But it seldom happens that everything just slots into place. As a stylist I appreciate having an active role within the entire process.

MBS: What are you looking for when it comes to casting? In many of your stories, the models appear to be very strong personalities, especially the women. The book that you produced with Liselotte Watkins also has female strength as its theme.

NI: When *Purple* celebrated its twenty-fifth anniversary, Anders and I did ten pages on Alek Wek (see plate 47). That was one of my favourite jobs regarding casting. I really like it when someone has a lot of character. I find it difficult casting people I haven't met. It's very seldom that a model has as much presence as Alek Wek. She has an extreme authority. But that can also lead to difficulties. At times a forceful model can outshine the image. In the case of Anders and I during this shoot everything worked really well. Alek Wek managed with her power to personalize the clothes, she embodied every look, which all strong models do. It is so much a question of interaction. Anders is very perceptive and he succeeded in really communicating the feeling. The best images are the ones where feelings come through, also from models. In general, I prefer models or individuals who are very present. I find it difficult to work just with aesthetics. But every collaboration naturally demands its sensitivity to the needs of the client. Usually, it is beneficial for both yourself and the client when there's a shared point of view and when the methods to secure the result are similar. I can't escape from myself regardless of what I do and it is wonderful when the client's ideas harmonize with my own.

MBS: When do you think that a job you have done turns out to be typically 'you'? Is there a consistent expression or characteristic?

NI: It is difficult to say. An orderly chaos perhaps. There has to be a contrast of some sort. I have a hard time accepting that there is nothing that interrupts the image – for example, photographs that are cropped so that there is space in all the corners and edges. I prefer it when images are unpredictably cropped. When models on a catwalk go from tall to shorter. When the garments being shown have different lengths and it is, perhaps, completely black in the middle. Or when something suddenly acquires a different attitude and 'rhythm' in the styling. If it gets too tonal I get bored, but I can really appreciate when the image is tight and conceptual. When I look at the work of other stylists, I appreciate when there is symmetry, when one can see that the concept has been carefully considered, though I am better myself at creating symmetry that is interrupted. With regard to casting, I have a vision of completely different individuals. I want the models to reflect different moods. It should feel like when my son Noah and I step out

into the crowded street where we live in central Stockholm. Human in some sense.

MBS: Something that recurs in your images is rather enclosed spaces. The room is defined but not necessarily in a realistic manner. It is relatively abstract but, at the same time, palpable. Sometimes almost claustrophobic, as in a story you did with Kirsten Owen and Casper Sejersen for *Purple* S/S 2017.

NI: I like things to be rather enclosed. It's like when I go to bed. Before actually getting into bed, all the doors in my room have to be shut. I have a wardrobe which is open to the room and I have to ensure that it is completely drawn in. I work quite a lot like that. I can't begin a working process without everything being shut and just so. It needs to have been cleaned in a specific manner. There has to be order. Not least to make room for other things. An enclosed space is relatively easy to deal with. A messy environment can upset the vision in your head. The story with Kirsten Owen is much more Casper, I think. And also her. She really entered into her role. Prior to the shoot she received some instructions and then she took them where she wanted to. Kirsten Owen is a model with an extreme amount of character. Sometimes models even overshadow the image itself.

MBS: How do you go about choosing clothes for an assignment? It seems that colours are very important to you.

NI: That's a difficult one. It has to do with the process. But I am totally obsessed about getting the colours to function together. Colours are very important. I can't explain how it happens. Or what is required. But I want the colours to be restful to the eye. We are governed by colours just as we are by sounds. When things get too cluttered it becomes impossible to absorb the image. One stops looking. It's like the visual arts in general: successful images have a great deal to do with how things relate to each other, which materials can live together, and so on. What I always work on is symmetry and asymmetry in various constellations. It's a matter of orderly chaos, as I have noted previously. This may sound like a cliché but I really can't think of a better answer. When I package or edit a collection, there are often a large number of themes to relate to, different programmes that one has to take into account for various reasons. But in order to keep the viewer's attention, I need to build up a scenario, create a story. And colours play a really important role here. Generally speaking, I would argue that a good stylist knows how things work together. I can be totally absorbed by certain of my colleagues, Max Pearmain, Lotta Volkova, Camille Bidault-

Waddington. They have that rare gift of being able to innovate and, at the same time, to get everything to cohere in a self-evident way.

MBS: Fashion is sometimes compared with art. How do you relate to this yourself? Can one be completely free in one's expression as a stylist?

NI: No, one certainly can't. Styling is not an artistic activity. At least, that is not how I see it. I have never seen myself as doing art. There is always someone I deliver to as an assignment. But certain editorial assignments can be pretty free. I am currently preparing a job for *Buffalo Zine* and I have been given a theme to interpret rather freely. But I still have to relate to their theme. And when I finally deliver the job, the magazine will work it over. This does not mean that I am not free. It just means that my freedom is relative and negotiable. I never have the last word because I deliver my work to someone else. For me it is absurd to compare styling with art. They are basically two different professions. Of course, the role of the artist has changed over time. And many stylists and photographers have an artistic approach in their work – for example, with how images are to be treated. Personally, I like a fairly raw type of expression in my pictures. But this does not make it art. Most important to me is knowing that I am still within a context in which I can continue to dream. If I am not able to dream in relation to a person or to the assignment I am working on, then I feel a bit lost.

Translation: William Jewson

Index

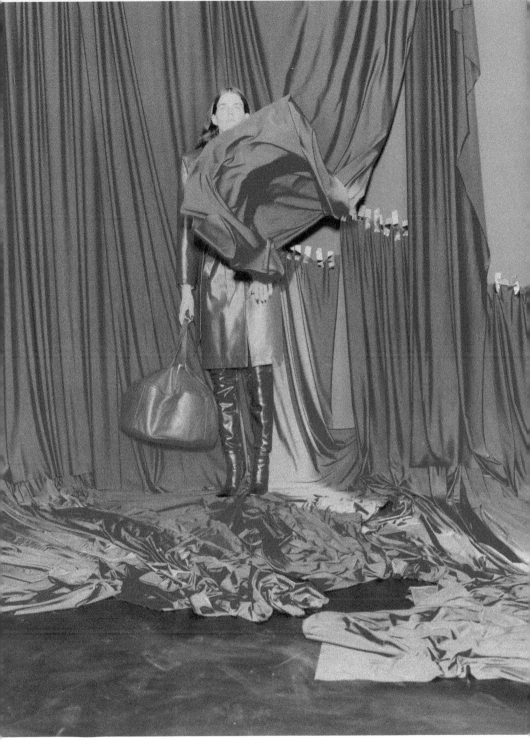

Plate 1 Balenciaga, S/S 2017. Photography: Harley Weir. Styling: Lotta Volkova. Courtesy of Harley Weir.

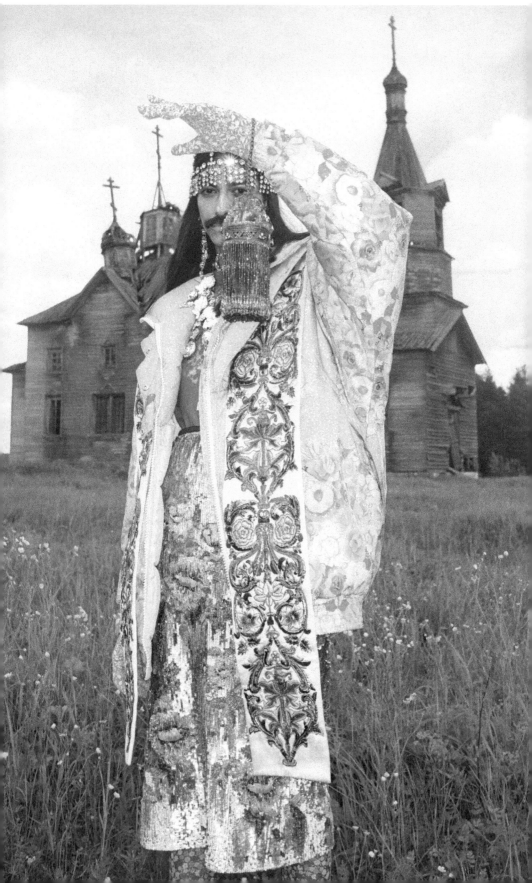

Plate 3 *System Magazine*, 'Italian Fashion Is Torn between Nostalgia and Progress', F/W 2018. Photography: Johnny Dufort. Styling: Lotta Volkova. Hair: Gary Gill. Makeup: Thomas de Kluyver. Model: Litay Marcus. Jumpsuit by Schiaparelli haute couture. Courtesy of Johnny Dufort.

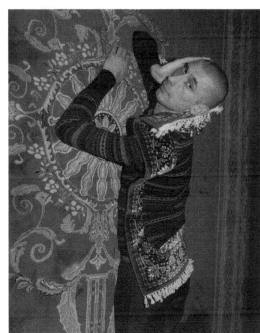

Plate 4 *Re-Edition*, 'The Sovietsky Hotel', S/S 2015. Photography: Harley Weir. Styling: Lotta Volkova. Courtesy of Harley Weir.

Opposite page
Plate 2 *Vogue Italia*, 'Chikinskaya', September 2018. Photography: Johnny Dufort. Styling: Lotta Volkova. Hair: David Harborow. Makeup: Nami Yoshida. Model: Gunce Gozutok. Clothing: Padded jacket of crumbled nylon with appliques, shirt with lace details, skirt in embroidered tulle, headgear with crystals: all GUCCI; earrings and necklace of gold metal: DOLCE & GABBANA; collier of Swarovski crystal: ATELIER SWAROVSKI BY ATELIER SWAROVSKI; jewel bag: vintage Bagteria PASSAGE ARCHIVES; tights: ANNA SUI. Courtesy of Johnny Dufort.

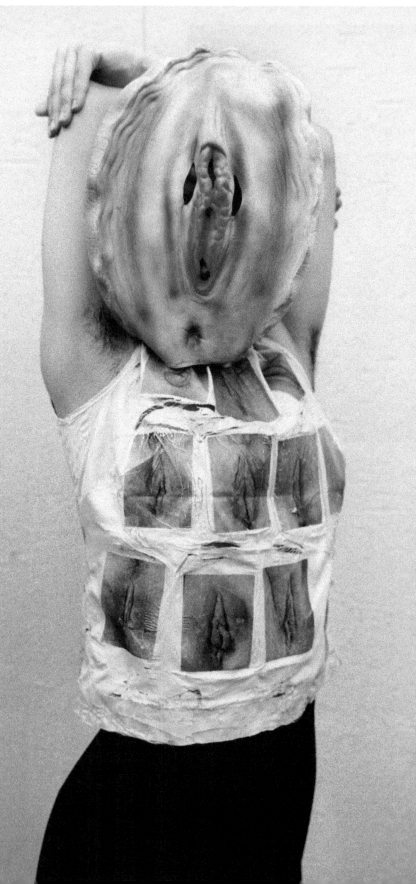

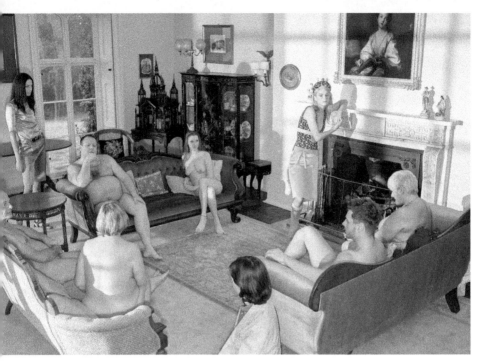

ate 6 Prada Special, S/S 2019. Photography: Johnny Dufort. Styling: Lotta Volkova. Hair: Gary Gill. akeup: Nami Yoshida. Set design: Polly Philp. Models: Lexi Boling, Litay Marcus & the kent nudists. othing by Prada. Courtesy of Johnny Dufort.

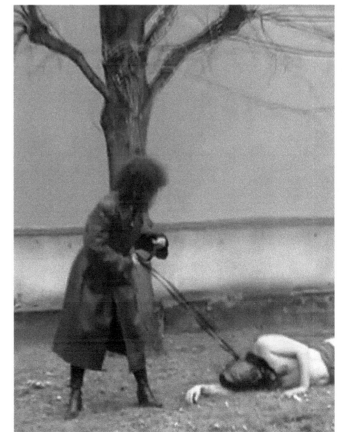

pposite page
ate 5 *Re-Edition*, 'Jeju Island',
W 2018. Photography: Harley
eir. Styling: Lotta Volkova.
urtesy of Harley Weir.

Plate 7 *In Present Tense*, 'Mes Douces', issue 1, 2018. Photography: Andy Bradin. Art direction and styling: Benjamin Kirchhoff. Courtesy of Andy Bradin.

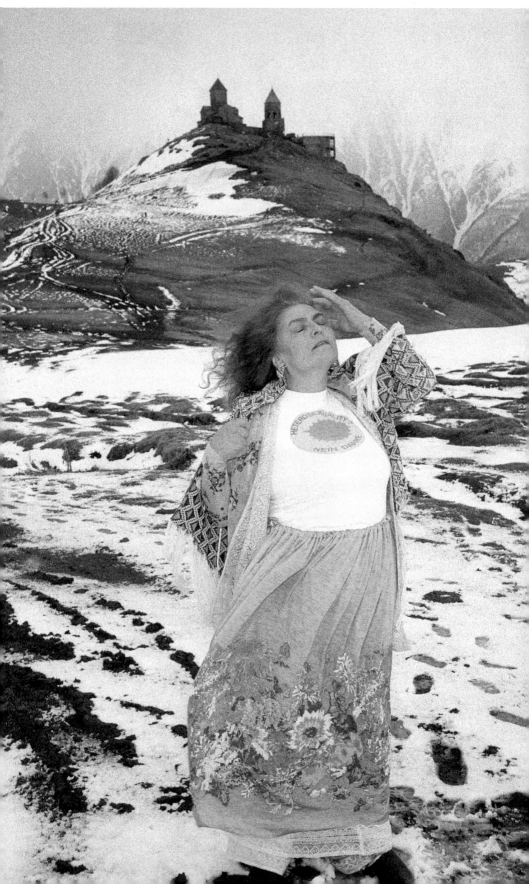

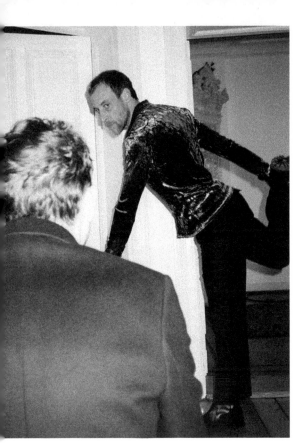

Plate 9 *Replica*, issue 5, May 2018. Photography: Andy Bradin. Art direction and styling: Benjamin Kirchhoff. Courtesy of Andy Bradin.

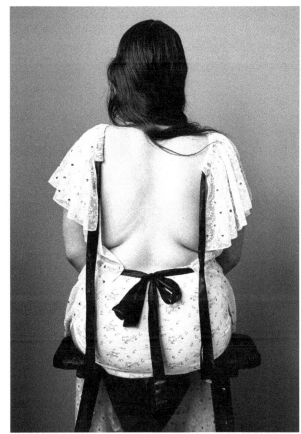

Opposite page
Plate 8 *Dust*, 'Georgia', issue 12, 2018. Photography: Alessio Boni. Art direction and styling: Benjamin Kirchhoff. Courtesy of Alessio Boni.

Plate 10 *Hearts magazine*, issue 5, AW 18/19. Photography: Thomas Hauser. Art direction and styling: Benjamin Kirchhoff. Courtesy of Thomas Hauser.

Plate 11 *Replica*, issue 4, December 2017. Photography: Olgaç Bozalp. Art direction and styling: Benjamin Kirchhoff. Courtesy of Olgaç Bozalp.

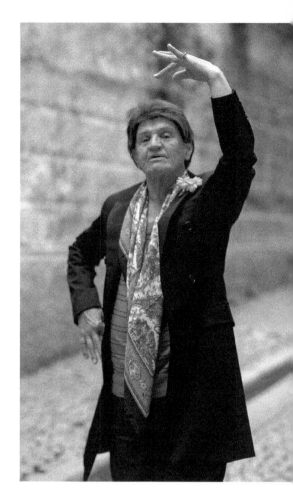

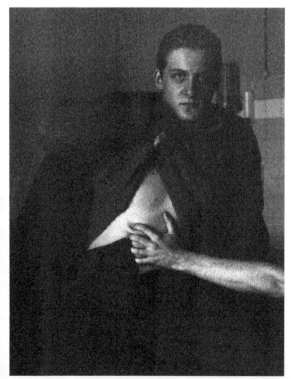

Plate 12 *Another Man*, October 2018. Photogra[...] Salvatore Caputo. Art direction and styling: Benjamin Kirchhoff. Courtesy of Salvatore Cap[...]

Opposite page
Plate 13 *Document Journal*, 'Cape Town' S/S 2017. Photography: Pieter Hugo. Styl[...] Anders Sølvsten Thomsen. Courtesy of Pieter Hugo.

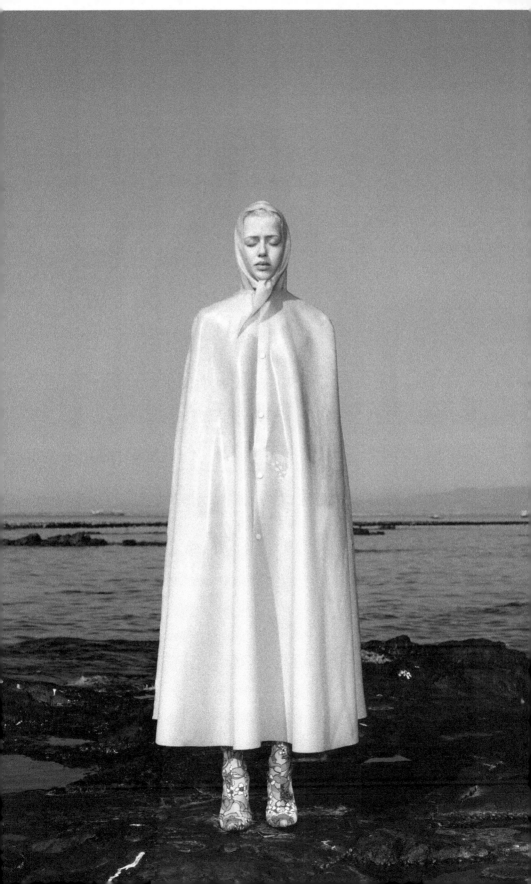

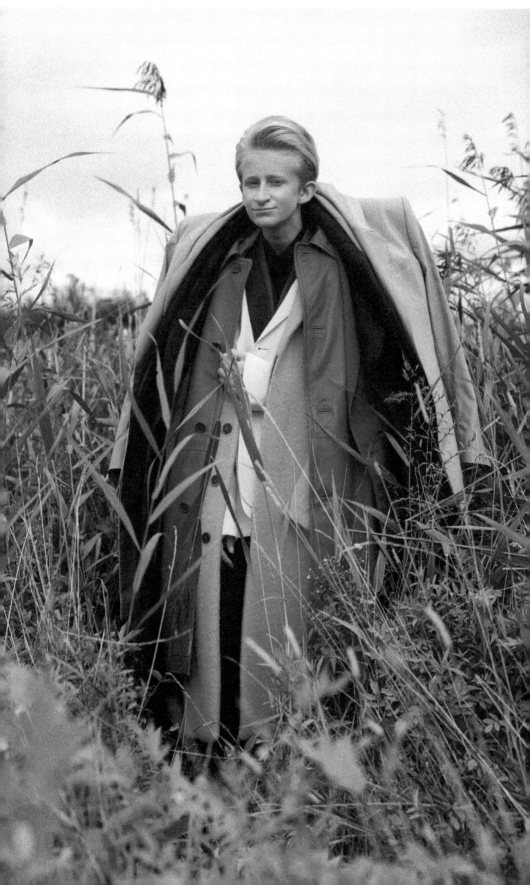

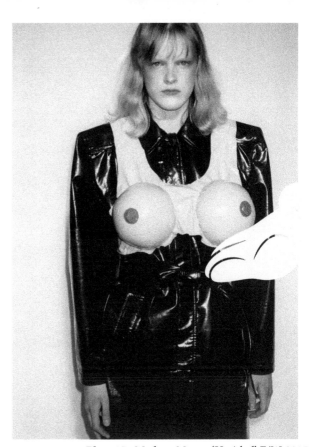

Plate 15 *Modern Matter*, 'Untitled', F/W 2017.
Photography: Olu Odukoya. Styling: Anders
Sølvsten Thomsen. Courtesy of Olu Odukoya.

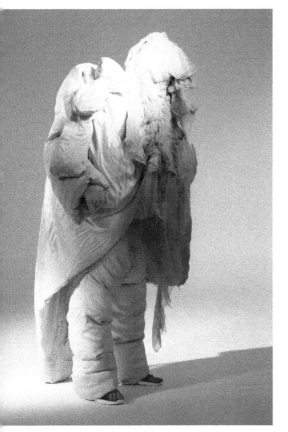

Plate 16 *Office Magazine*, 'They the Sacred,
They the Profane' F/W 2016. Photography:
Benjamin Lennox. Styling: Anders Sølvsten
Thomsen. Courtesy of Benjamin Lennox.

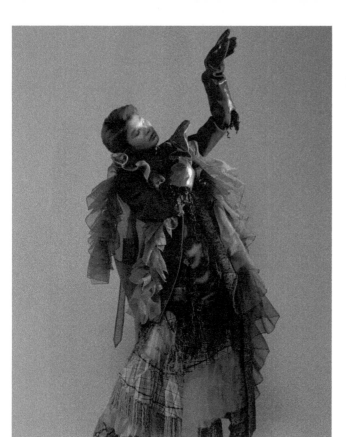

Plate 17 *Office Magazine*, 'Example:
Breach, Morals of Escape', F/W 2018
Photography: Benjamin Lennox. Sty
Anders Sølvsten Thomsen. Courtesy
Benjamin Lennox.

Opposite page
Plate 19 *Vogue Poland*, 'Queen
September 2018. Photography:
Kacper Kasprzyk. Styling: Roxa
Danset. Courtesy of Kacper
Kasprzyk.

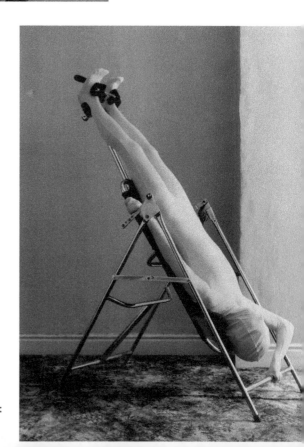

Plate 18 *Replica Man*, 'I Know Both
Sides, for I Am Both Sides', F/W 2018,
Photography: Thurstan Redding. Styling:
Anders Sølvsten Thomsen. Courtesy of
Thurstan Redding at Parent.

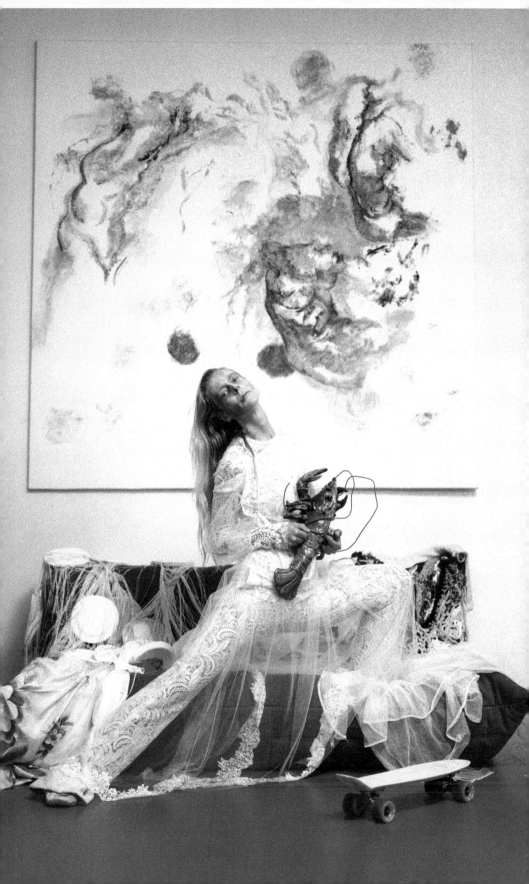

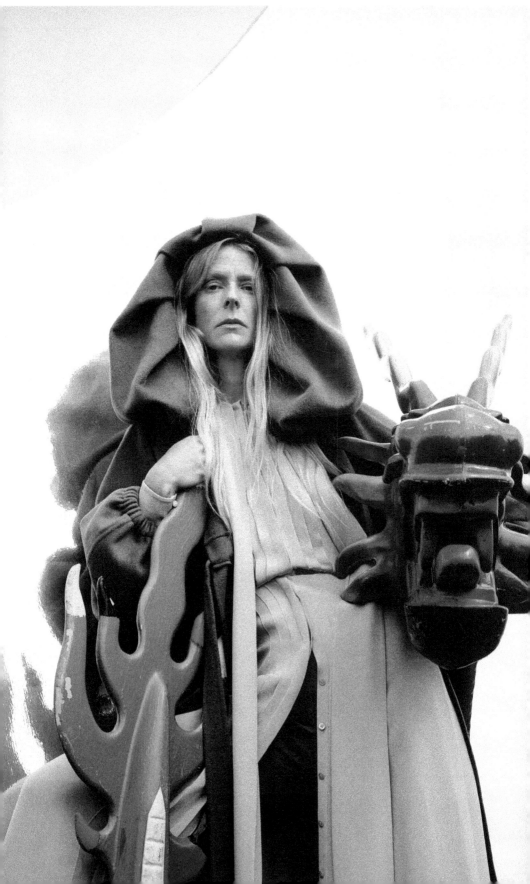

Opposite page
Plate 20 *Vogue Poland*, 'Queen Bona', September 2018. Photography: Kacper Kasprzyk. Styling: Roxane Danset. Courtesy of Kacper Kasprzyk.

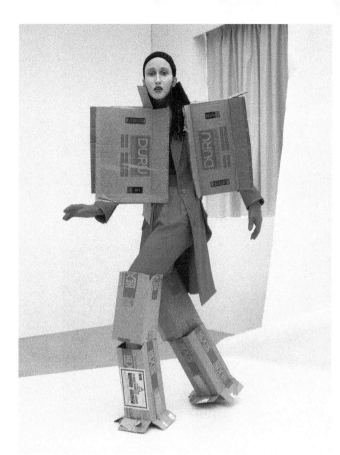

Plate 21 *Purple Fashion*, 'Anna Cleveland', 25 Year Anniversary Issue, F/W 2017. Photography: Viviane Sassen. Styling: Roxane Danset. Courtesy of Viviane Sassen.

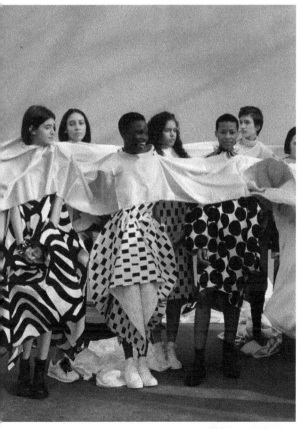

Plate 22 *SSAW*, 'Inside Outside USA', S/S 2018. Photography: Bibi Cornejo Borthwick. Styling: Roxane Danset. Courtesy of Bibi Cornejo Borthwick.

Plate 23 *Roxane*, 2012. Photography: Viviane Sassen. Styling and model: Roxane Danset. Courtesy of Viviane Sassen.

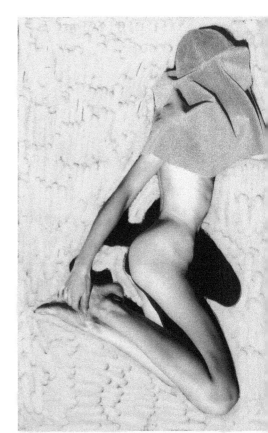

Plate 24 *Roxane II*, 2017. Photography: Viviane Sassen. Styling and model: Roxane Danset. Courtesy of Viviane Sassen.

te 25 *SSAW*, 'Linger', F/W
6. Photography: Suffo Moncloa.
ling: Elizabeth Fraser-Bell.
urtesy of Suffo Moncloa.

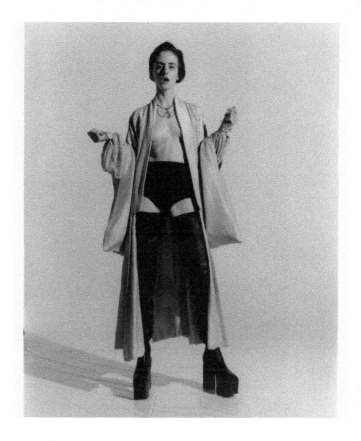

Overleaf
Plate 27 *Dazed*, 'Cloud Nymph',
April 2016. Photography: Charlotte
Wales. Styling: Elizabeth Fraser-Bell.
Courtesy of Charlotte Wales.

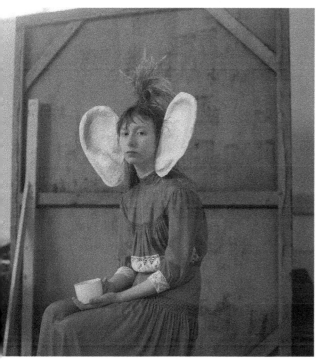

Plate 26 *Dazed*, 'Understudies',
Winter 2017. Photography: Hill &
Aubrey. Styling: Elizabeth Fraser-
Bell. Courtesy of Hill & Aubrey.

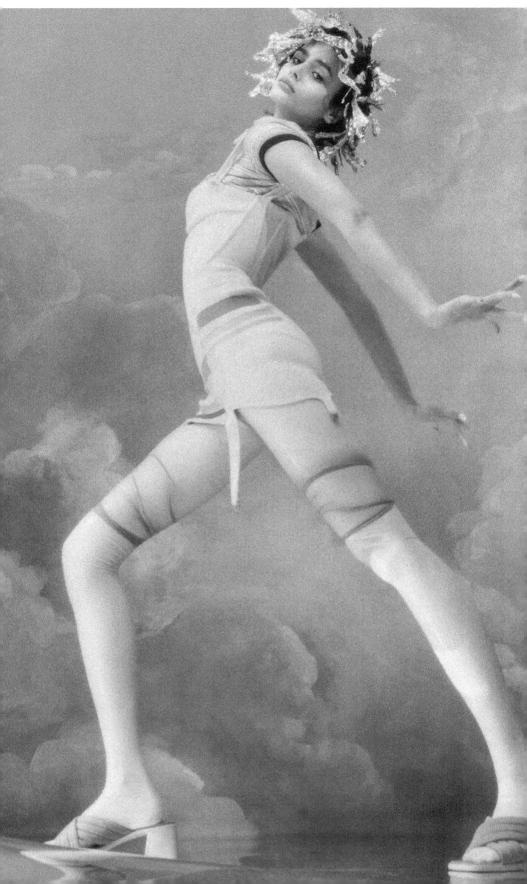

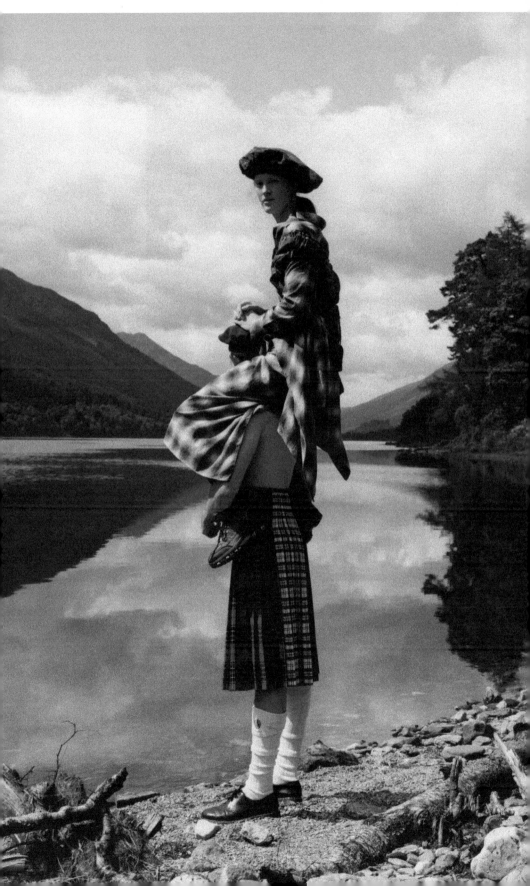

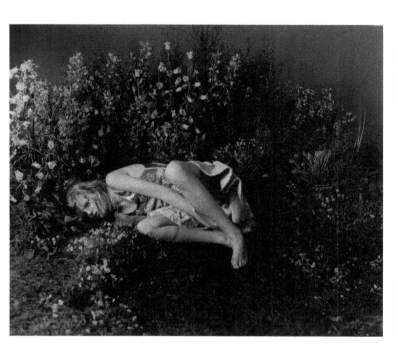

Previous page
Plate 28 *Dazed*, 'Loch Voi
A/W 2017. Photography: ¨
Johnson. Styling: Elizabeth
Fraser-Bell. Courtesy of To
Johnson.

Plate 29 *Dazed*, 'Outdoor
Indoors', Spring 2014.
Photography: Harley Weir
Styling: Elizabeth Fraser-B
Courtesy of Harley Weir.

Plate 30 *Dazed*, 'Horny
Railways', vol. 4, Spring 2017.
Photography: Coco Capitan.
Styling: Elizabeth Fraser-Bell.
Courtesy of Coco Capitan.

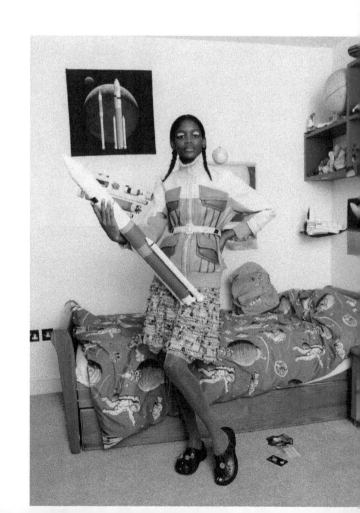

Opposite page
Plate 31 *POP*, 'Moon Rocks',
issue 26, S/S 2012.
Photography: Viviane Sassen.
Styling: Vanessa Reid.
Courtesy of Viviane Sassen.

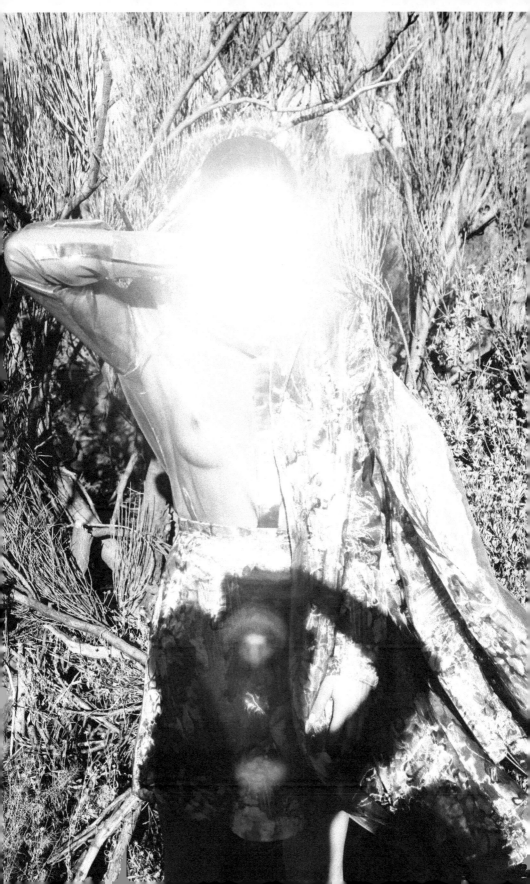

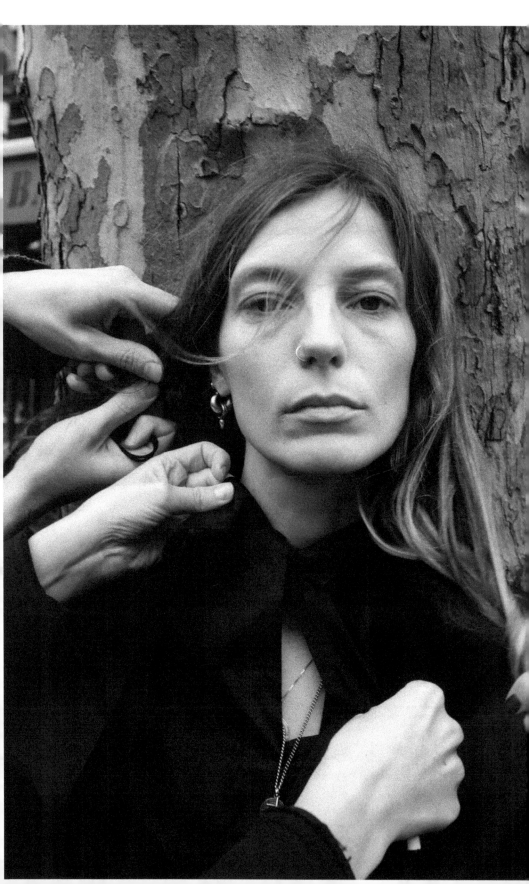

opposite page
ate 32 Daria Werbowy No. 9, Paris
15. © 2015 Juergen Teller. All rights
erved. Styling: Vanessa Reid.

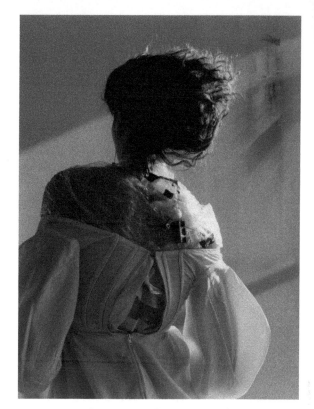

Plate 33 *POP*, 'Aomi Muyock', issue 34, S/S 2016. Photography: Harley Weir. Styling: Vanessa Reid. Courtesy of Harley Weir.

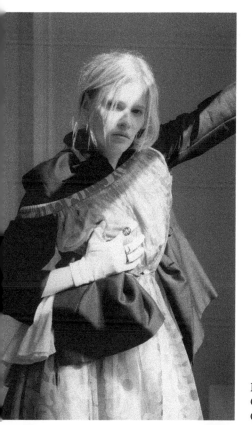

Plate 34 *Re-Edition*, issue 7, S/S 2017. Photography: Colin Dodgson. Styling: Vanessa Reid. Courtesy of Colin Dodgson / Art Partner.

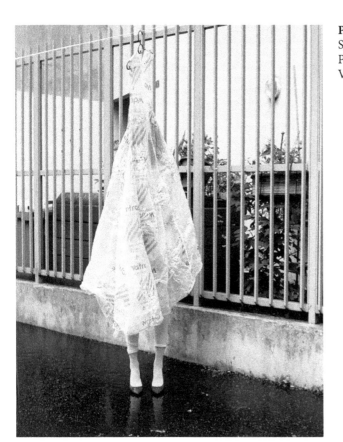

Plate 35 *Re-Edition*, 'Before Morning Shall Be Here', issue 5, F/W 2016. Photography: Mark Borthwick. Styling: Vanessa Reid. Courtesy of Mark Borth...

Opposite page
Plate 37 *Dazed*, 'Ideal Self', February 2019. Photography: ... Gambarte. Styling: Akeem Sm... Courtesy of Pascal Gambarte.

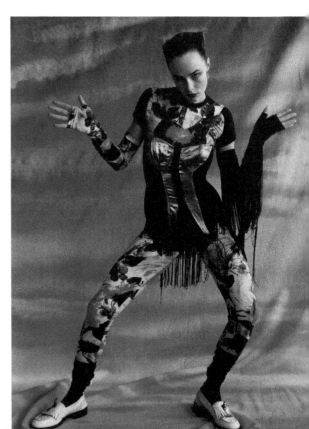

Plate 36 *System Magazine*, 'BodyMap was a movement', November 2018. Photography: Oliver Hadlee Pearch. Styling: Vanessa Reid. Courtesy of Oliver Hadlee Pearch.

ANATOMY OF POWER CHICK

NO BLUSH

DEAL MAKING IS OUT

EYEBROWS SHOULD BE SISTERS NOT TWINS

SHEER LIPSTICK

DRESS LIKE WOMAN WHO NEVER GETS PMS

BLACK MAKES ME LOOK THINNER

I NEVER STRW MY THINGS

THESE PANTS DON'T FIT

CONVENIENT HOLE

BOOTS ARE A HALF SIZE TOO SMALL

MY FEET ARE KILLING ME

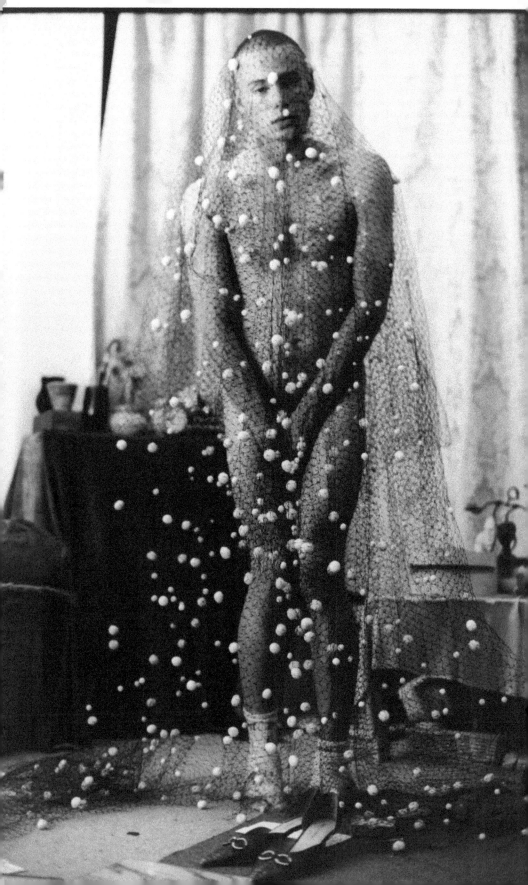

Plate 39 *Arena Homme +,* 'Interior w/Wardrobe Extension', F/W 2017. Photography: Charlotte Wales. Styling: Akeem Smith. Courtesy of Charlotte Wales.

Opposite page
Plate 38 *Replica*, F/W 2016. Photography: Hanna Moon. Styling: Akeem Smith. Courtesy of Hanna Moon.

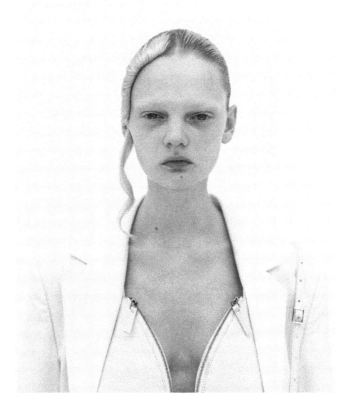

Plate 40 Helmut Lang, Spring 2018. Photography: Nicolai Howalt. Styling: Akeem Smith. Courtesy of Nicolai Howalt.

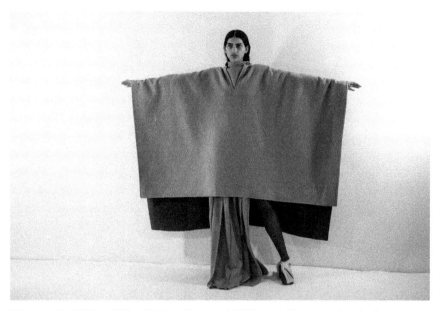

Plate 41 *Re-Edition*, 'Why did the Ghost cry', F/W 2018. Photography: Anders Edström. Styling: Akeem Smith. Courtesy of Anders Edström.

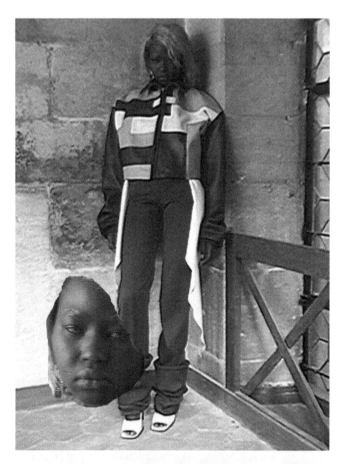

Opposite page
Plate 43 *Purple Fashion*, 'Conceptual Non-Conformity', F/W 2016. Photography: Casper Sejersen. Styling: Naomi ▯ Courtesy of Casper Sejers▯

Plate 42 Section 8, 2018. Photography: Sharna Osborne. Styling: Akeem Smith. Courtesy of Sharna Osborne.

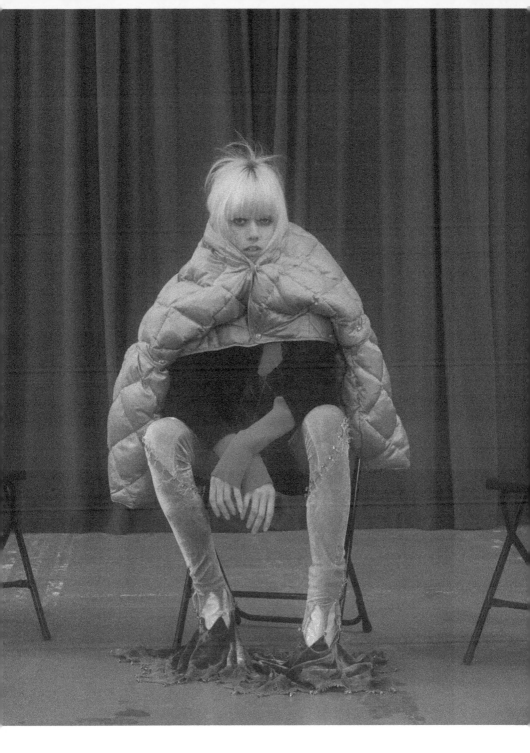

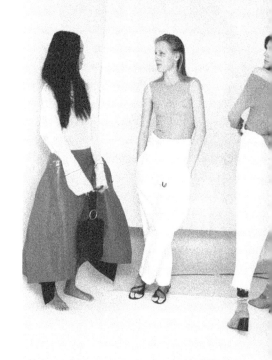

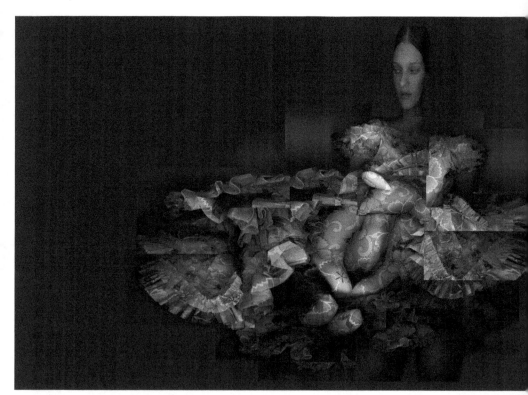

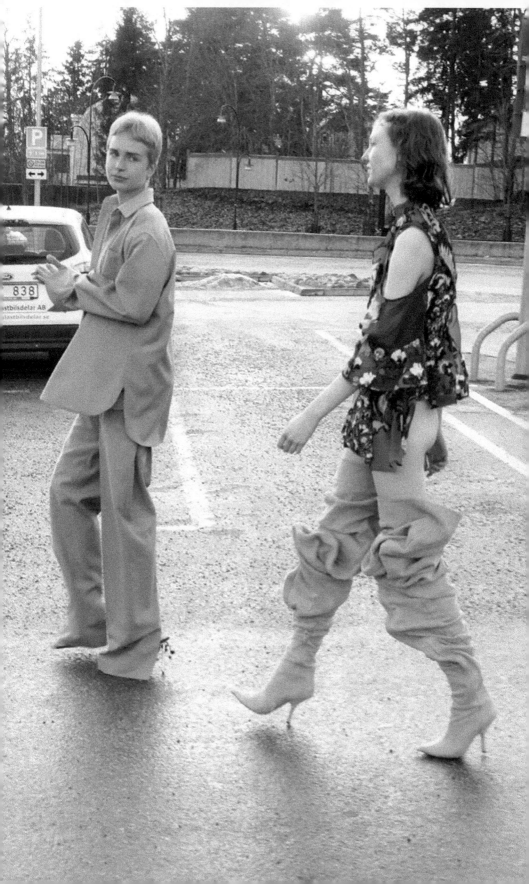

Plate 47 *Purple Fashion*, 'Alek Wek', issue 28, F/W 17. Photography: Anders Edström. Styling: Naomi Itkes. Courtesy of Anders Edström.

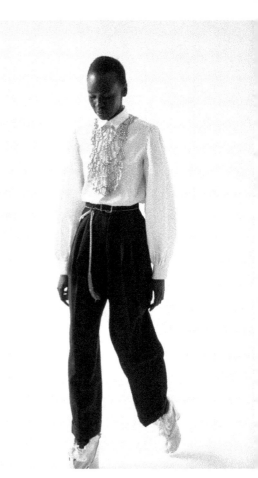

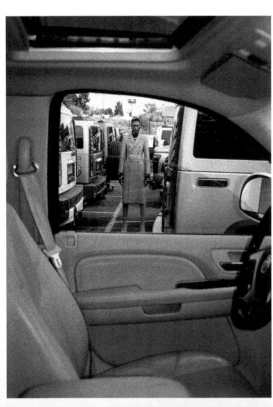

Plate 48 *Purple Fashion*, 'Los Angeles Trafic Ale issue 30, F/W 2018. Photography: Kira Bunse. Styling: Naomi Itkes. Courtesy of Kira Bunse at Production.

Milton Keynes UK
Ingram Content Group UK Ltd.
UKHW022216060824
446611UK00001B/2